TUTANKHAMUN
THE TREASURES OF THE TOMB

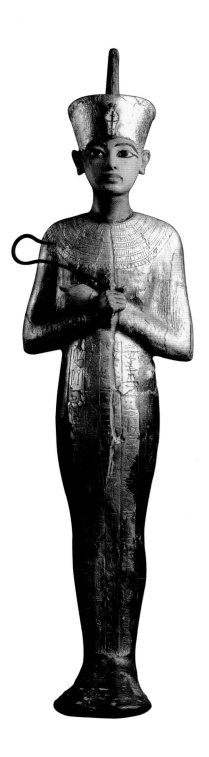

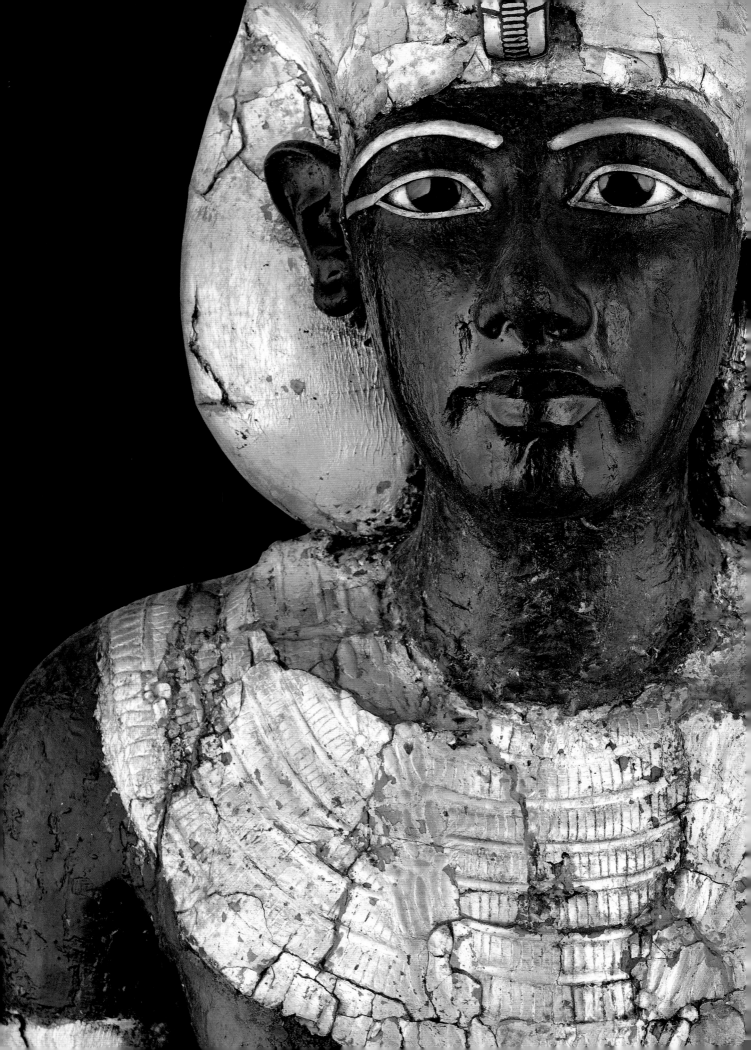

ZAHI HAWASS

Photographs by SANDRO VANNINI

TUTANKHAMUN
THE TREASURES OF THE TOMB

with 324 illustrations, including 26 foldouts

Thames & Hudson

DEDICATION

This book is dedicated to my friend
the great artist Farouk Hosni

On the cover: (front) *The third coffin of
Tutankhamun (p. 109; detail); (back) name
pendant of Tutankhamun (p. 185).*

Half-title: *Shabti of Tutankhamun (Carter 330d).*

Title page: *Detail of the guardian statue wearing
the* khat *headdress (p. 29).*

Pages 4 – 5: *Pectoral in the form of a solar hawk
(Carter 267m(1)).*

Pages 6 – 7: *Detail of the Small Golden Shrine
(p. 59).*

Endpapers: *Detail of the corselet (p. 44).*

Tutankhamun
© 2018 Zahi Hawass / Laboratoriorosso s.r.l.

Designed by Maggi Smith

First published in 2007 in hardcover in the
United States of America by Thames & Hudson Inc.,
500 Fifth Avenue, New York, New York 10110

www.thamesandhudsonusa.com

This compact hardcover edition published in 2018

Library of Congress Catalog Card Number 2017959381

ISBN 978-0-500-29390-4

Printed and bound in China by C & C Offset

ACKNOWLEDGMENTS

I would like to thank the many people who
assisted me on this book. First, my gratitude
to Mohamed Megehad, Heba Abdel Monem,
Wesam Mehrez, and Sherief Sabann, who assisted
me in collecting some of the published material
about Tutankhamun. In addition, I would like to
thank my dear friend Mark Linz, who worked
very hard on the publication of this book, and
Maggie Bryson and Laurie Flentye, who also
assisted with research. But my sincere thanks to
my colleague and friend Janice Kamrin, who
helped in editing this book.

CONTENTS

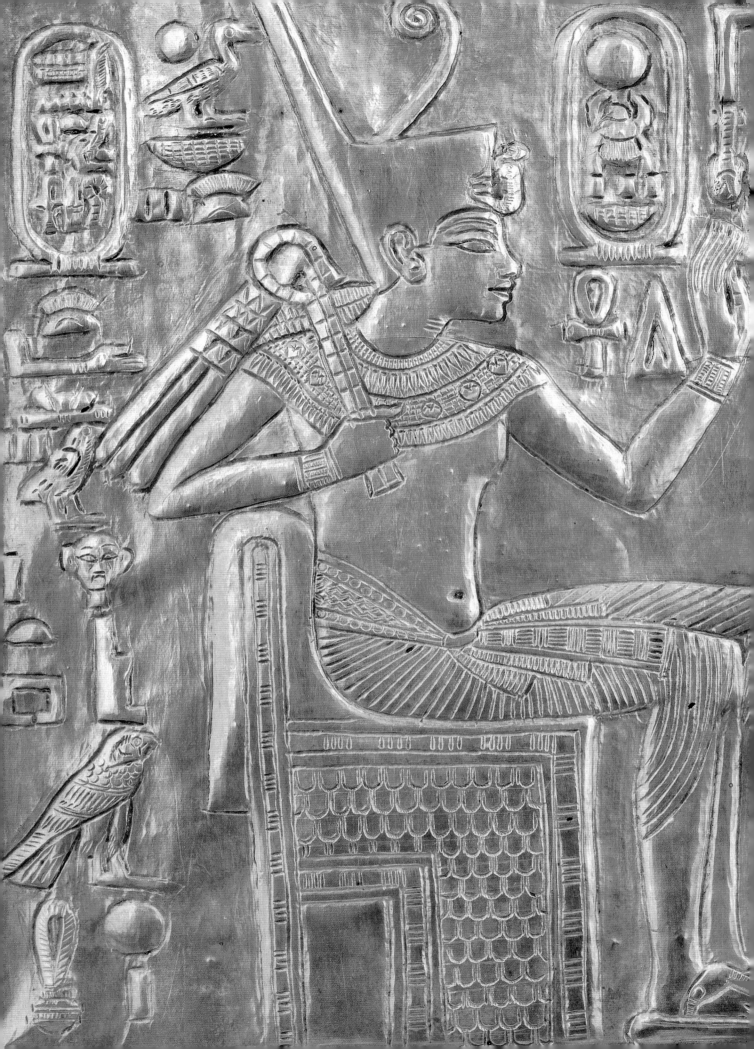

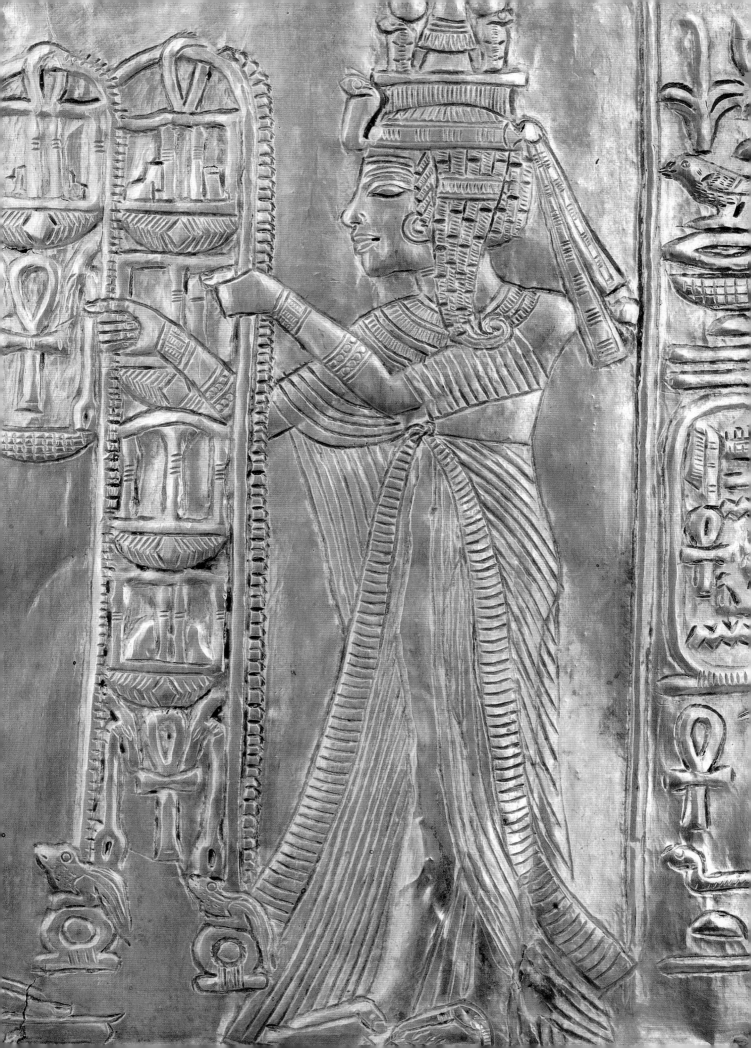

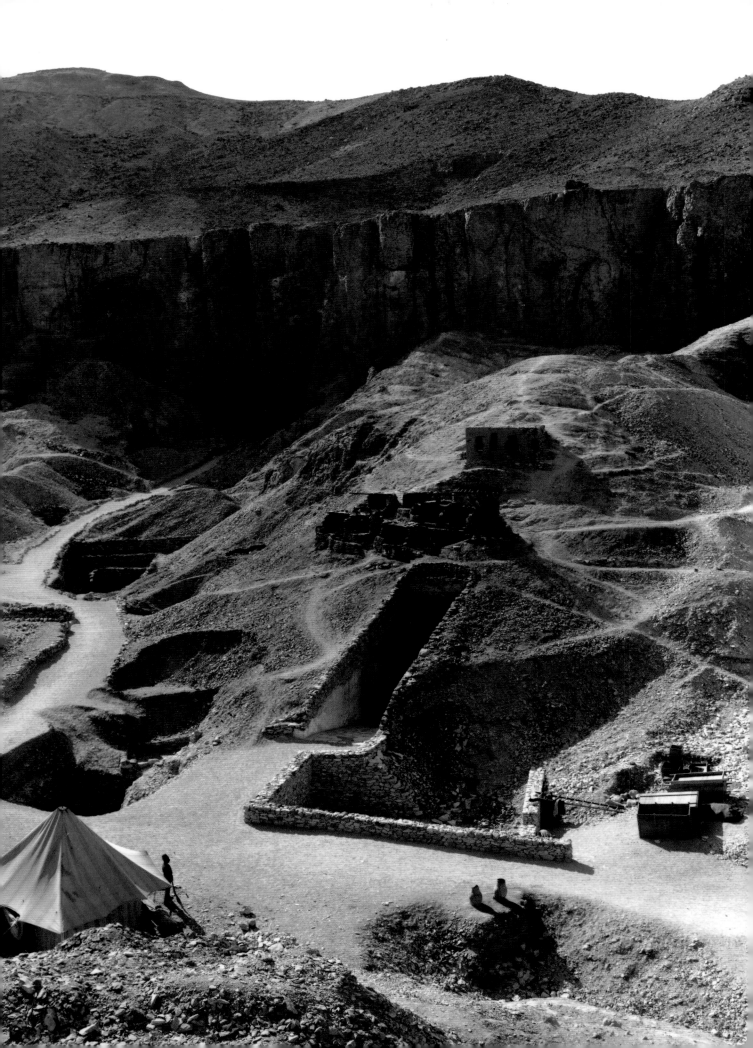

INTRODUCTION

THE ADVENTURES OF HOWARD CARTER AND ZAHI HAWASS

The Valley of the Kings during Carter's excavations. The tomb of Tutankhamun, with the low wall built around it, lies just in front and to the right of the grand entrance to the tomb of Ramesses VI. Photograph by Harry Burton.

THE VALLEY OF THE KINGS is one of the most romantic places on earth. Twenty-six of the most powerful kings in the history of the world, monarchs from the Golden Age of Egypt (the New Kingdom: *c.* 1539 – *c.* 1069 BC), were buried in this necropolis. Their treasure-filled tombs were carved into the rock of the floors and walls of the ancient canyons that comprise the Valley, tucked away in hidden corners by their builders in what was, for the most part, a vain attempt to conceal and protect them from tomb robbers. The sere beiges, browns, blacks, and reds of the striated limestone that forms the cliff walls, the golden sand, and the blue sky all combine to make this a realm of magic by day. When the sky turns crimson and then black with the setting of the sun, the Valley of the Kings becomes one of the most mysterious places in the world.

I still remember the first time I visited the Valley. It was the winter of 1964, when I was a 17-year-old on a university trip to Luxor. That was the year in which I took my first course in Egyptology and began what would become a life-long fascination with the history and archaeology of ancient Egypt. I immediately felt that the Valley was a place of silence and enchantment. Our professor told us the story of how British archaeologist Howard Carter had found the tomb of Tutankhamun in 1922; I said to my classmate Salwa that Carter was incredibly lucky to have discovered this unique tomb and become the world's most famous archaeologist. Together, Salwa and I looked toward the Qurn, the triangular peak that surmounts the Valley and echoes the man-made pyramids of the Old and Middle Kingdoms (*c.* 2650 – *c.* 1630 BC) elsewhere in Egypt, whose shape symbolized both the primeval mound on which the creator god stood to bring the world into being and a stairway to the sky. Unlike the pyramid complexes of these earlier eras, in which the tomb and its temples were close together, the tombs and temples of the New Kingdom pharaohs were separated: their burial places lay in the Valley of the Kings while their temples were to the east, along the edge of the Nile floodplain.

It was perhaps Senenmut, architect and possible lover of the early New Kingdom Queen Hatshepsut, who first chose the Valley. Like her ancestors, Hatshepsut wished to be buried in the Theban hills. Ineni, architect to her father Thutmose I, had successfully concealed his monarch's tomb in this area, bragging in his own tomb biography: "I built the tomb of my Majesty, none seeing and none hearing." He did this so well that it has still not been identified with certainty by archaeologists, and in fact may not yet have been found. So I believe it was Senenmut, on Hatshepsut's behalf, who carved the first tomb in the King's Valley, directly behind the queen's great mortuary temple at Deir el-Bahari. The queen's mummy and burial equipment were hidden away in a chamber deep beneath the earth; and the body of her father was brought from his original tomb to join her there.

I believe this Valley was chosen because of the pyramidal Qurn, and also because it was a place that was both well hidden and easy to guard. While the great pyramids had been impressive, they were also easily breached; even the labyrinths of corridors that lay under the pyramids of the Middle Kingdom had been penetrated and robbed. But it would take only one guard standing on top of the Valley's cliffs to watch, and to listen for the steps of

those trying to rob the tombs of the pharaohs. Around 65 tombs of various sizes (labeled KV – King's Valley – 1 to 65), 26 of which are royal, were cut into this Valley. Every king's tomb was unique, designed according to the vision of the individual monarch or his priests to reflect their own conception of the netherworld and also to outdo those who came before. Their mazes of passages, tunnels, and chambers were decorated with beautiful scenes meant to assist the dead king on his journey to the next world, where he would be greeted by the ruler of the netherworld, Osiris.

The eastern branch of the Valley contains most of the royal tombs, including that of Tutankhamun (KV 62), which lies not far from the entrance to the canyon and below the later tomb of Ramesses VI (KV 9). Tutankhamun's was the first tomb I entered in the Valley. I remember peering from behind the wooden fence, built to protect the burial chamber, at the huge quartzite sarcophagus that Carter had left *in situ*, with the king's outermost coffin visible inside beneath a sheet of glass. I could not believe that the mummy of the king was still within. I asked the guard if I could go into the burial chamber and look more closely on the face of the pharaoh. The guard watched as I climbed two steps at the north end of the sarcophagus and came face to face with the effigy of the king on his coffin. I felt right away that Tutankhamun had been a man of dignity, someone who understood the secrets of this Valley. No one could have predicted that 37 years later, I would look upon the actual face of the mummy, revealing the secrets of Tutankhamun himself.

I returned to the Valley early in my career as an archaeologist when I was appointed to accompany a University of Pennsylvania expedition to Malkata, the immense palace of Amenhotep III (probably the grandfather of Tutankhamun) that lies on the west bank of the Nile at Luxor. This experience gave me the chance to work with great archaeologists and immersed me in a fascinating era of Egyptian history. The 18th Dynasty was a period of great expansion. Its pharaohs reclaimed the country following the expulsion in the mid-16th century BC of the foreign Hyksos kings – who had controlled much of Egypt during the Second Intermediate Period – and the defeat of their Kushite (Nubian) allies, and built an empire through repeated campaigns to the north and south. By the middle of the dynasty, after the many battles fought by warrior pharaohs such as Thutmose I, his grandson Thutmose III, and Amenhotep II, Egypt held sway over a realm that stretched from the Euphrates River in the northeast to the Fourth Cataract in the south.

These kings, originally from Thebes, were dedicated to the worship of their local god, Amun, who was merged with the Memphite sun god to become head of the Egyptian pantheon as Amun-Re. Tribute from Egypt's vassals and defeated enemies flowed into the coffers of this and other important gods, and many major temple-building projects were inaugurated. In the late 18th Dynasty, just before Tutankhamun came to the throne, a controversial figure reigned for 17 years: Akhenaten, the "heretic" pharaoh. Son of Amenhotep III and great-great-grandson of Thutmose III, Akhenaten set in motion a chain of events that rocked Egypt to its core. Violently rejecting Amun-Re in favor of the disk of the sun, the Aten, he is remembered as the world's first monotheist. He built a new city, now known as Tell el-Amarna, in the middle of Egypt, and dedicated it to his beloved Aten; later, he closed the temples of the other gods and had their names effaced. Under his direct guidance, building on directions seen in his father's art, his artists created a new, exaggeratedly naturalistic style; this softened as his reign progressed, but left echoes in all Egyptian art that followed.

It was during Akhenaten's reign that Egypt's grasp on its empire began to slip. The Hittites emerged from Anatolia (modern Turkey), flexing their muscles and threatening Egyptian interests. Akhenaten does not seem to have been willing or able to come to the aid of his vassals or brother kings in the northeast, and the balance of power began to shift. After his death, his probable son Tutankhamun, who came to the throne at the age of about nine, either sent or led his armies into battle with this new enemy. This boy king, perhaps under the influence of older advisors, also initiated many internal reforms, re-establishing the supremacy of the Amun priesthood and re-opening the old temples. Early in his reign, Tutankhamun abandoned Tell el-Amarna, which was never occupied again. His successors,

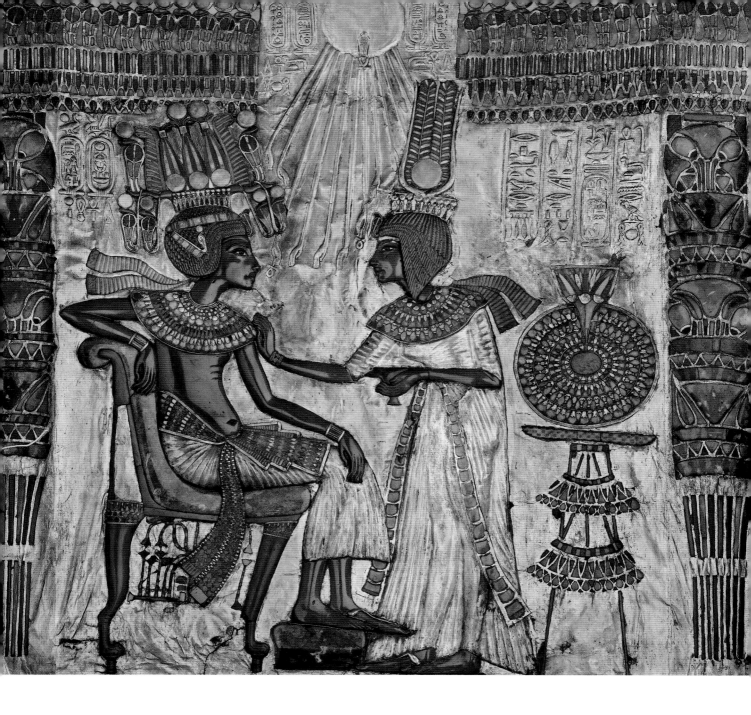

The image on the back of Tutankhamun's Golden Throne (p. 56) shows the king being anointed with scented unguent by his queen, Ankhsenamun, while above their heads the rays of the sun disk – the Aten – extend toward them, holding *ankh* (life) signs.

Ay and Horemheb, continued his reforms. Both died, as Tutankhamun had, without heirs, and the throne passed to the Ramesside 19th Dynasty.

This era of Egyptian history has always intrigued me, and I was thrilled to be assigned to Malkata in 1974. I began to meet people and hear stories of Carter, and of the other archaeologists who had excavated in the Valley of the Kings. The most fascinating of these people was Sheikh Ali Abdel Rassoul, who was 70 years old when I first met him. A tall, galabia-clad man with a moustache, he had deep eyes in which I could see the thrill of the past and the wisdom of experience. At that time, there were about 30 foreign expeditions working on the west bank of the Nile, each of which included an Egyptian inspector. In the heat of the afternoon, most of us would come to Sheikh Ali's hotel, the El-Marsam. But Sheikh Ali felt that I was different from the others, telling me he could see in my eyes that I would become an important archaeologist some day. He would invite me to join him in a beer, and tell me wonderful stories – ones that cannot be found in books.

Sheikh Ali was one of the famous Abdel Rassouls, long-time residents of the west bank with a reputation as tomb robbers. "People think that we were antiquities thieves," he would

tell me, "but we were not. We thought of the Theban hills and the tombs in them as our own, because they had belonged to our ancestors and we knew everything about them: every grain of sand, and what was hidden behind every rock, more than any archaeologist."

It was his much older cousin, Mohamed, who in around 1871 had discovered the first cache of royal mummies (DB 320), stumbling on this find while tending his goats in the cliffs above Deir el-Bahari. The deep shaft tomb contained the mummies of a number of New Kingdom kings and queens, along with those of the later High Priests of Amun who had hidden them here. The family kept its discovery secret for years; it was not until 1881 that the Antiquities Service forced them to reveal its location and removed the mummies (categorized by a customs official, for lack of a better title, as salted fish!) and tomb equipment to the Cairo Museum. Then, in 1891, the family led antiquities officials to the Bab el-Gasus, a cache of mummies of many of the 21st Dynasty High Priests of Amun and their family members. And in 1898, the Abdel Rassouls were also involved in revealing the location of the tomb of Amenhotep II (KV 35), where more royal mummies had been hidden in antiquity, to the then-director of the Antiquities Service, Victor Loret.

Sheikh Ali was a young man of 18 in 1922, when Howard Carter found Tutankhamun. Members of his family worked for Carter, and he remembered the moment of discovery well. In this book, I will tell this story, which has been told many times and by many people, through both Carter's eyes, and through the eyes of the Egyptians who worked alongside him. Come with me now on a journey back in time, to the early 20th century.

The Great Discovery

The discovery of the tomb of Tutankhamun was one of the most remarkable events in the history of Egyptology, not only because the tomb was found largely intact, but also because of the many wonderful stories that surrounded it.

Howard Carter was a very active man, and he is remembered for the passion he put into his work. He had pride and personality, and cared deeply about the people who worked with him, as well as about the monuments. I firmly believe that this is what makes him unique to me – not just the fact that he discovered Tutankhamun's tomb. Before being employed by Lord Carnarvon, he had worked for the Antiquities Service. One story about Carter gives us a glimpse of his remarkable character. When he was based at Saqqara in 1905, a group of French tourists came to see the site, and became very abusive toward the local inspectors and tomb guards. Carter confronted them and insisted that they leave. A great furor ensued, and in spite of pressure from the British Consul-General, Carter refused to apologize. As a result, he was forced to leave the Antiquities Service, and suffered serious financial difficulties for several years.

I always tell this story to people who work with me. It is important to be a good archaeologist and to have great knowledge, but it is also essential to have the kind of personality that makes the people working at the site respect you, and also fear you. In my opinion, Howard Carter was like this. He also had the success that comes from being both diligent and lucky. Years before, Carter's horse had stumbled upon a shaft at Deir el-Bahari which hid a beautiful statue of the Middle Kingdom monarch Mentuhotep II. During his time as Chief Inspector of Upper Egypt (1899 to 1904), he had carried out numerous excavations in the Valley of the Kings, including the clearance of the most difficult tomb in the Valley, that of Hatshepsut and Thutmose I (KV 20). It is interesting to read his accounts of this tomb, including the fact that the smell of the bats living in it was overpowering!

Carter's patron, George Herbert, Earl of Carnarvon, had originally come to Egypt for his health, and had been persuaded to undertake excavations to alleviate his boredom. He needed a good archaeologist to supervise the actual work, and was introduced to Carter by the head of the Antiquities Service, Gaston Maspero. Between 1907 and 1914, the team dug in the Valley of the Nobles at Thebes and several Delta sites, as the concession for the Valley of the Kings, where they really wanted to excavate, was held by the wealthy

A photograph of Howard Carter taken in 1899, before his discovery of the tomb of Tutankhamun.

American Theodore Davis. Believing that there was nothing left to be discovered in the Valley, Davis gave up his concession in 1915, and Carter and Carnarvon obtained permission to take over the site. Carter was convinced that they would find the untouched tomb of Tutankhamun, as his mummy was not in either of the royal caches, and several clues had been unearthed in the Valley. Of these, perhaps the most convincing was the so-called "embalming cache" (KV 54), which contained debris that seemed to be associated with Tutankhamun's mummification and funeral. Carter was sure that the king's tomb must be nearby. After several years of fruitless searching (with a gap during World War I), however, Carnarvon began to think that his money had been wasted, and he decided that he could no longer finance the excavations. Carter went to Carnarvon's castle in England, Highclere, to ask for funding for a fifth and final season, but the Earl refused. To Carter's credit, he did not beg, but instead told Carnarvon that he would continue the excavations at his own expense. Impressed by the archaeologist's determination, his patron agreed to fund just one more season.

I can imagine the years Carter spent in the rest-house near the mouth of the Valley, and I go there often to sit in a corner and think about the great days of discovery. The first time I visited it, when I began work in the Valley of the Kings, I could smell the history there. Sheikh Ali told me a lot about Carter's personality, and how all the workmen liked him. He also told me the story he had heard, from eyewitnesses, of the tomb's discovery.

Carter had begun work in the Valley of the Kings in late October 1922. He knew that this was his last chance to find the tomb, and he was determined to leave no stone unturned. The only area not yet cleared was in front of the tomb of Ramesses VI, where a group of workmen's huts lay. The archaeologist ordered his team to record these huts, and then dig a trench right through them.

It is important to provide the workmen who labor under the hot Egyptian sun with plenty of water, and every excavation, even today, has a boy who brings water to the site in earthenware jars with rounded bottoms. On the morning of 4 November 1922, Carter's waterboy arrived at the site with full jugs and went to dig a hole where he could bury the bases to keep them upright. While he was digging, his stick struck stone. Brushing aside the sand, he saw the top of a flight of steps, and immediately ran back to Carter to tell him what he had found. I think Carter knew right away that this was the hidden entrance to the tomb. We do not know how the archaeologist rewarded this boy, and the truth is that Carter does not mention him in any of his publications. However, despite Carter's neglect, the waterboy became famous, although no one now remembers his name. Sheikh Ali told me that in later years, each of the villagers of Qurna claimed to have been that boy!

Carter began to clear the stairs, and by the late afternoon of the following day had found a blocked doorway. It was covered with the stamps of the ancient necropolis guard: a jackal (symbol of the god Anubis) over nine bound prisoners. Some of the plaster blocking looked as though it had been replaced, suggesting that whatever lay beyond had been disturbed, but that the attempted robbery had been detected and the tomb resealed by royal officials. As soon as he was sure that they had found a tomb, Carter sent a telegram to Lord Carnarvon. The famous words that he wrote are engraved in the annals of history:

> At last have made wonderful discovery in Valley; a magnificent tomb with seals intact; re-covered same for your arrival; congratulations.

It is written in many books that Carter had brought a canary in a cage with him to the Valley for that fifth season of excavation. When the workmen saw it, they said that it would bring them luck; and it did, in the form of the discovery of the tomb. But when Carter came back to his tent after sending the telegram to Carnarvon, a snake had eaten the bird. I asked Sheikh Ali about this, and he said that he did not see a snake, but he did hear that the bird had died. Other people think that the bird lived and was left with the wife of Carter's photographer, Harry Burton. But whether it was heralded by the death of the bird or not, there was trouble in store for Howard Carter.

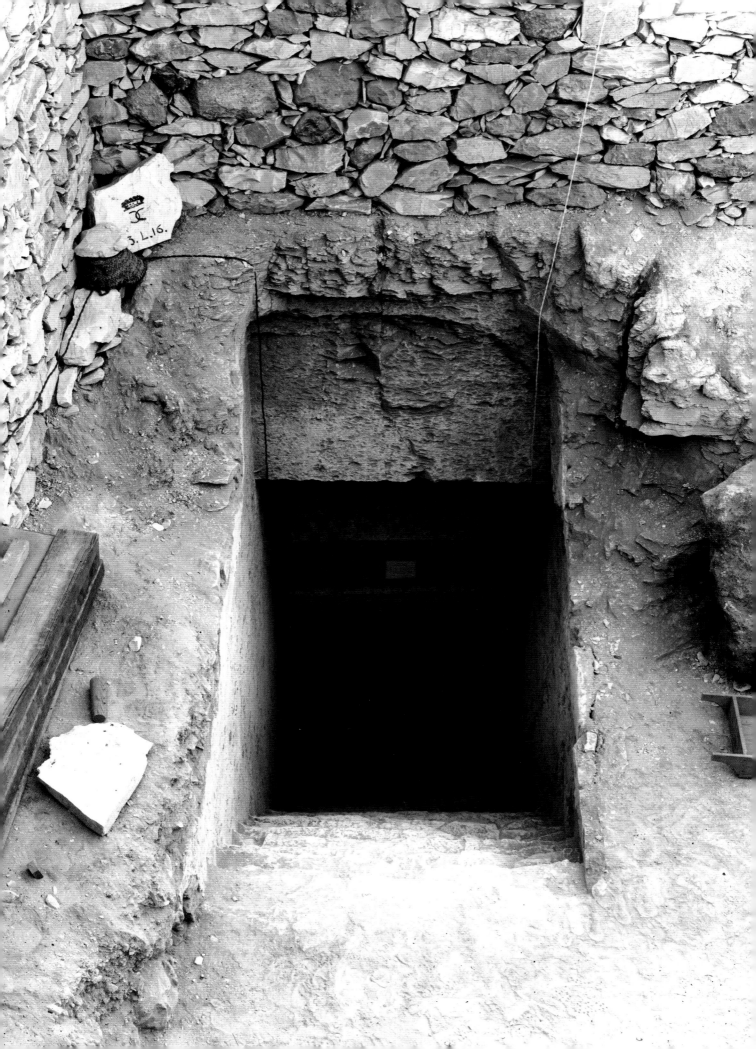

THE STAIRWAY AND
ENTRANCE CORRIDOR

View of the top of the stairway leading to the entrance corridor of Tutankhamun's tomb. The stone in one corner is painted with the crest of Lord Carnarvon. Photograph by Harry Burton.

LORD CARNARVON AND HIS DAUGHTER, Lady Evelyn Herbert, came to Egypt as quickly as they could, arriving in Cairo on 20 November 1922, where they were met by Carter, and continuing on to Luxor soon afterward. Work on the tomb began again on 24 November, after almost a three-week hiatus. The team cleared the rest of the stairway, and to their great excitement found the seals of Tutankhamun himself on the lower part of the doorway, confirming that whatever lay beyond dated to the era of this king. The debris collected in the clearance contained fragmentary objects such as bits of wood, ivory, resin, glass, dockets and seals from jars, reeds, fragments of pottery and stone vessels, and a scarab of Thutmose III (Carter described the scene as "Helter skelter in rubbish covering the last few steps and threshold of the doorway, as if dropped or cast away").

Also found in this area were parts of a box bearing the cartouches of Ankhkheperure Neferneferuaten and Akhenaten, along with the name of Meritaten, eldest daughter of Akhenaten and Nefertiti. The identity of Ankhkheperure Neferneferuaten is still debated, but there is evidence that this pharaoh, who apparently ruled beside Akhenaten for a time, was female; some scholars believe this was the great queen Nefertiti herself under a new name. According to the tag, this fragmentary box once held fine linen. A second broken and empty box, labeled as containing silver vessels, had belonged to Tutankhamun himself. Supposedly, Carter also found a fragment bearing the name of Amenhotep III, probable grandfather of Tutankhamun, but whatever object bore this inscription has now disappeared.

Carter found this jumble of names rather dismaying, and in his diary entry for this day records his fears that the tomb was only a cache – a reburial of objects from earlier, disturbed tombs. Perhaps, he thought, it would be material from Tell el-Amarna, such as had been found 15 years earlier by Theodore Davis and Edward Ayrton in KV 55. What would lie beyond? After years of struggle and hard work, the moment of discovery was finally at hand.

The blocking at the foot of the stairway was recorded and dismantled on 25 November 1922. In front of the excavators lay a mass of rubble packed with chips of limestone. The upper left-hand corner, where the ancient robbers had clearly tunneled through, had been refilled with larger lumps of rock. Bits and pieces had been mixed in with this fill: sherds from stone vessels, sealings, splinters of wood, fragmentary artifacts of faience, gold, ivory, ebony, and even some dried fruit. In fact, evidence suggests that the tomb had probably been entered at least twice by robbers, soon after the king's burial, but that both attempts had been detected by the necropolis guards, who hurriedly cleared up, putting many objects back in the wrong places.

HEAD OF NEFERTEM
Wood, gessoed and painted
Height 30 cm
Carter 8

This wonderful head of Tutankhamun as a child was apparently among the first objects Carter discovered, lying in the Entrance Corridor next to a pile of waterskins. However, it seems he did not report this piece to the authorities immediately; it was discovered by representatives of the Antiquities Service in the tomb of Ramesses XI (used by the excavation team for storage) on 30 March 1924, carefully wrapped and packed in a wooden Fortnum and Mason's wine crate. At the time, Carter was in the United States on a lecture tour. The Egyptians immediately suspected that he had been planning to steal this fabulous statue. Herbert Winlock from the Metropolitan Museum of Art in New York tried to help out by suggesting that Carter had purchased it for Lord Carnarvon from excavations at el-Amarna in 1923, but the archaeologist himself insisted that it had been found in the tomb, and had simply been packed for regular transport to Cairo. What is the truth here? It is interesting that Carter does not mention this piece in his original notes, detailing excavations on the day when this object should have been discovered:

> As we cleared the passage we found mixed with the rubble broken potsherds, jar seals, and numerous fragments of small objects; waterskins lying on the floor together with alabaster jars, whole and broken, and coloured pottery vases; all pertaining to some disturbed burial, but telling us nothing to whom they belonged further than by their type which was of the late XVIIIth Dyn. These were disturbing elements as they pointed towards plundering.

Why didn't Carter mention the head? It is certainly one of the most spectacular pieces from the tomb. Carved of wood, then plastered and painted in warm, life-like colors, it represents the king as the god Nefertem, incarnation of the sun god at dawn. The head rises from a lotus blossom, which closes at night and opens at sunrise, and was thus symbolic of resurrection and rebirth. In one version of the Egyptian creation myth, the infant sun god was born on top of a lotus blossom that arose from the primordial waters, and created light through his eyes. In two-dimensional art, Nefertem is often identified by a lotus-blossom crown on his head; this piece instead places the god on the lotus, as if he is being reborn from the heart of the flower.

If the head was indeed found in the corridor, the link with rebirth is strengthened, as it might have been placed there by Tutankhamun's priests to magically ensure that the king would leave the tomb through the eastern corridor each morning to be reborn with the sun. Alternatively, it might have been dropped in the corridor by the tomb robbers, who would not have been interested in the head itself but in the jewelry that might once have adorned it. None of this jewelry remains, save the back and post of the earring that once dangled from the pierced left ear.

I always use the head of Nefertem as an example to show people the excellent work done by Egyptian conservators over the years. It traveled overseas with the first Tutankhamun exhibition (in the 1970s and 1980s), and was skillfully restored at this time. Also, I like to show this piece to people who object to the fact that Egypt sends treasures abroad, arguing that they can be damaged. I tell them to look at Nefertem: if it had not traveled, it would not have been restored so beautifully. Objects that travel receive more attention from the museum conservators, and this is surely a good thing.

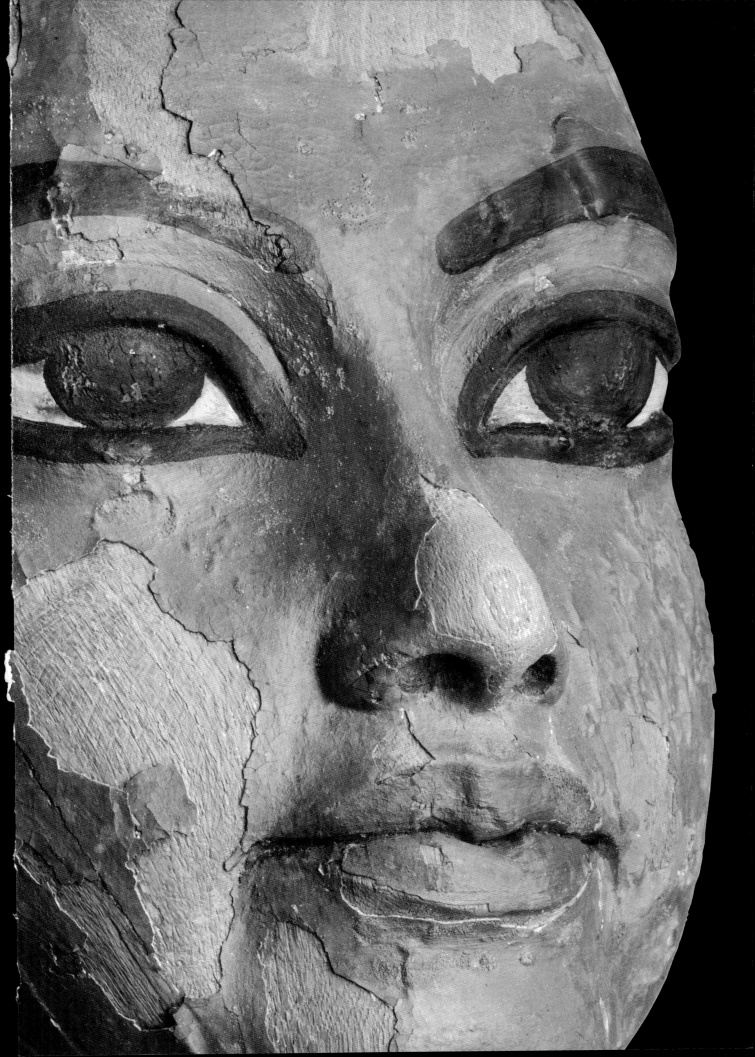

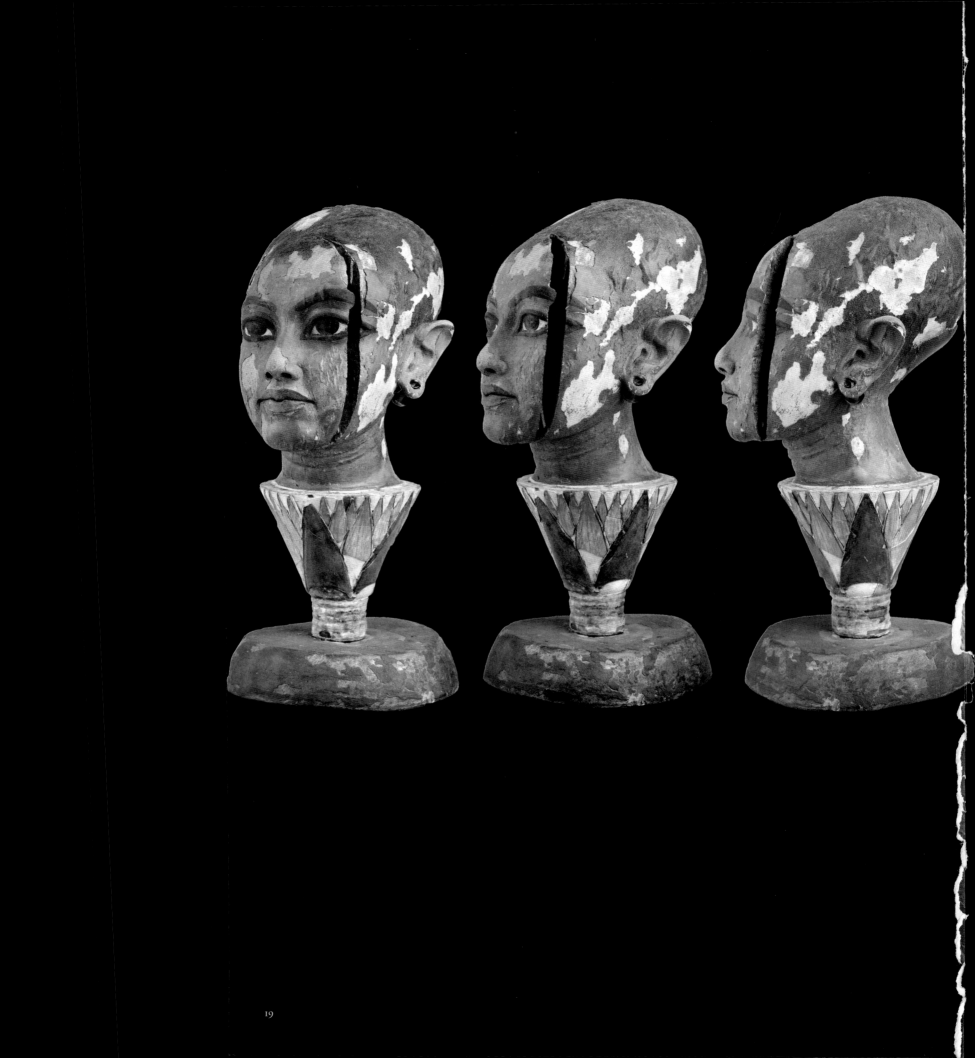

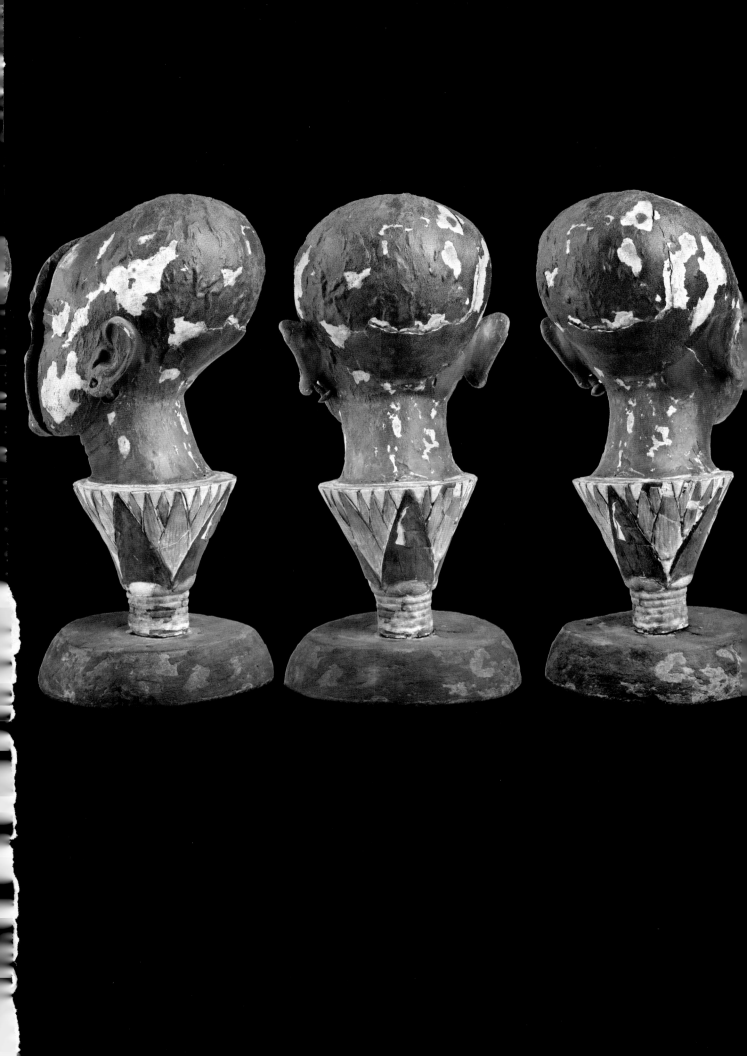

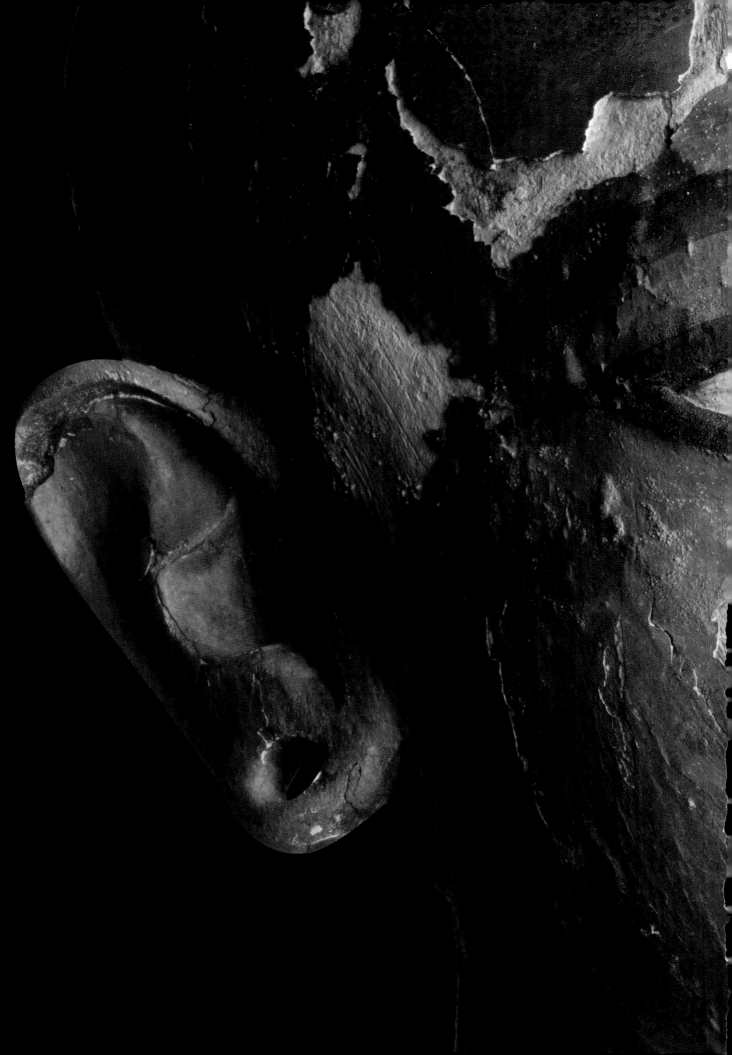

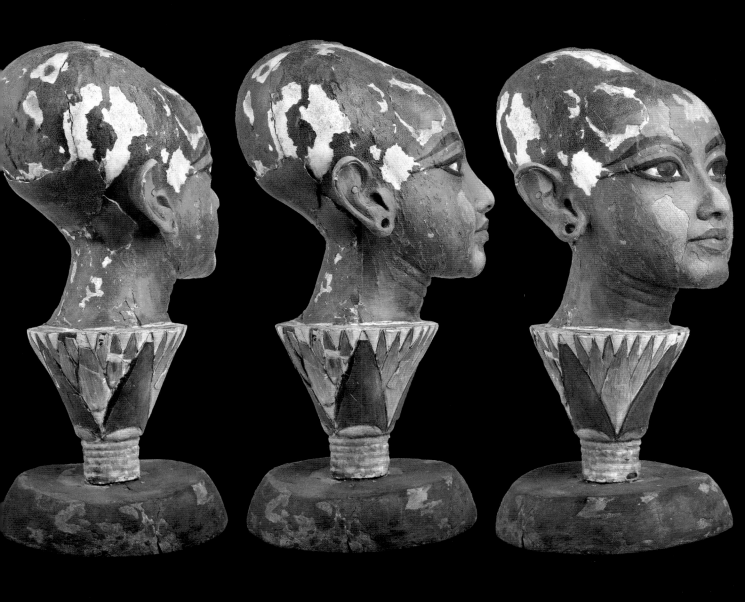

THE ANTECHAMBER

O N 26 NOVEMBER 1922, at 4:00 in the afternoon, Howard Carter, along with Lord Carnarvon and his daughter Lady Evelyn, as well as architect Arthur Callender, opened a hole in the blocked doorway at the end of the Entrance Corridor and inserted an iron rod. The probe met with no resistance: there was empty space beyond. Taking a candle, Carter peered through the hole. I quote here Carter's own words:

> … Lord Carnarvon said to me 'Can you see anything'. I replied to him Yes, it is wonderful. I then with precaution made the hole sufficiently large for both of us to see. With the light of an electric torch as well as an additional candle we looked in. Our sensations and astonishment are difficult to describe as the better light revealed to us the marvellous collection of treasures: two strange ebony-black effigies of a King, gold sandalled, bearing staff and mace, loomed out from the cloak of darkness; gilded couches in strange forms, lion-headed, Hathor-headed, and beast infernal; exquisitely painted, inlaid, and ornamental caskets; flowers; alabaster vases, some beautifully executed of lotus and papyrus device; strange black shrines with a gilded monster snake appearing from within; quite ordinary looking white chests; finely carved chairs; a golden inlaid throne; a heap of large curious white oviform boxes; beneath our very eyes, on the threshold, a lovely lotiform wishing-cup in translucent alabaster; stools of all shapes and design, of both common and rare materials; and, lastly a confusion of overturned parts of chariots glinting with gold, peering from amongst which was a mannikin. The first impression of which suggested the property-room of an opera of a vanished civilization. Our sensations were bewildering and full of strange emotion.… A sealed doorway between the two sentinel statues proved there was more beyond, and with the numerous cartouches bearing the name of Tut.ankh.Amen on most of the objects before us, there was little doubt that there behind was the grave of that Pharaoh.

From my own experiences, I can understand what was really in Carter's heart. Words are never sufficient to express our sensations at such moments. Although I try, I am never able adequately to describe the intensity of the emotion I feel when I open a tomb for the first time, or hold a statue I have discovered in my hand.

The official opening of the tomb was on 29 November. In attendance were a mix of Egyptian officials and European archaeologists and dignitaries. Pierre Lacau, then head of the Egyptian Antiquities Service, arrived the next day. To Carter's surprise, in the days after the opening there was also a massive influx of "Egyptian notables of Luxor" who wanted to see the tomb; he was forced to refuse them entry until measures could be taken to protect the artifacts. On 1 December, Carter closed the tomb until proper preparations could be made for the excavation to come. These included fitting the entrance with a steel door, buying supplies, and putting together a team, the key members of which would be Carter's assistant, Arthur Mace, photographer Harry Burton, chemist Alfred Lucas, and Arthur Callender. The tomb was reopened on 16 December, and work began in earnest.

HUNTING BOX

Wood, gessoed and painted
Height 44 cm, length 61 cm, width 43 cm
Carter 21

The first object to be removed from the tomb was this painted chest, known as the "Hunting Box" because of its decoration. Carter himself considered this "one of the greatest artistic treasures of the tomb," stating that he and Carnarvon could hardly tear themselves away from it on their first visit. No less impressive than the box itself were its contents, which included garments, such as the costume of a priest (p. 26) and elaborately woven robes, sandals, and slippers, as well as a gilded headrest. Some of the clothes were child-sized, and must have belonged to the king when he first ascended the throne at about the age of nine.

Painted on the two long sides and the vaulted top of this chest are scenes of Tutankhamun in his chariot, slaughtering foreign enemies or hunting dangerous wild animals. On one side, the king and his soldiers trample a horde of Nubian soldiers; on the other, the enemies have Semitic features, and thus come from the Levantine and Syrian areas. These battle scenes show the Egyptian army marching in regular rows, with the king accompanied by royal fan-bearers. In contrast, the enemies are shown as a disordered mass, with warriors, horses, and the dead and wounded all jumbled together below the hooves of the pharaoh's steeds. In the hunt scenes, the animals are lions, gazelles, and wild asses, denizens of the desert savannah that bordered the Nile Valley. Inscriptions on the chest reinforce these images, identifying the king as brave and strong, the slayer of all enemies.

Such images of the pharaoh triumphant served the important magical purpose of representing the victory of the proper order of the Egyptian cosmos over the chaotic realm that constantly surrounded and threatened it. Foreign lands, and their inhabitants, were one symbol of this chaos; the wild desert was another. These scenes are not necessarily meant to represent reality: they are icons of royal triumph, similar to scenes found in Egyptian temples, but here rendered in miniature. They also identify the king as a god, and associate him with the natural world.

Judging from the large number of weapons of various sizes and types found in his tomb, Tutankhamun was a keen sportsman. In fact, beside the Valley Temple of the 4th Dynasty king Khafre at Giza (c. 2500 BC) was a hunting lodge that Tutankhamun used when visiting the desert at Memphis (known as the Valley of the Gazelles), a favorite royal hunting ground in the New Kingdom. It was once generally thought that Tutankhamun never actually led the Egyptian army into battle, and that his commander-in-chief, Horemheb, went in his stead. However, relief fragments found in Luxor and reconstructed by scholar W. Ray Johnson suggest that the king himself may have gone to war.

Our CT-scan of Tutankhamun's mummy in 2005 confirmed the observation of Carter's forensic team that the king had fractured his left leg, and added the intriguing information that this most likely occurred shortly before his death. Could this perhaps have been the result of a hunting accident, or even possibly have occurred in battle?

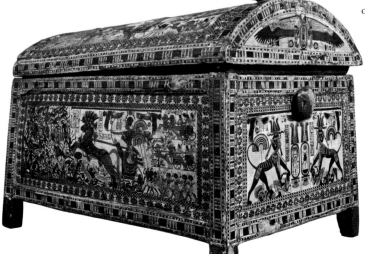

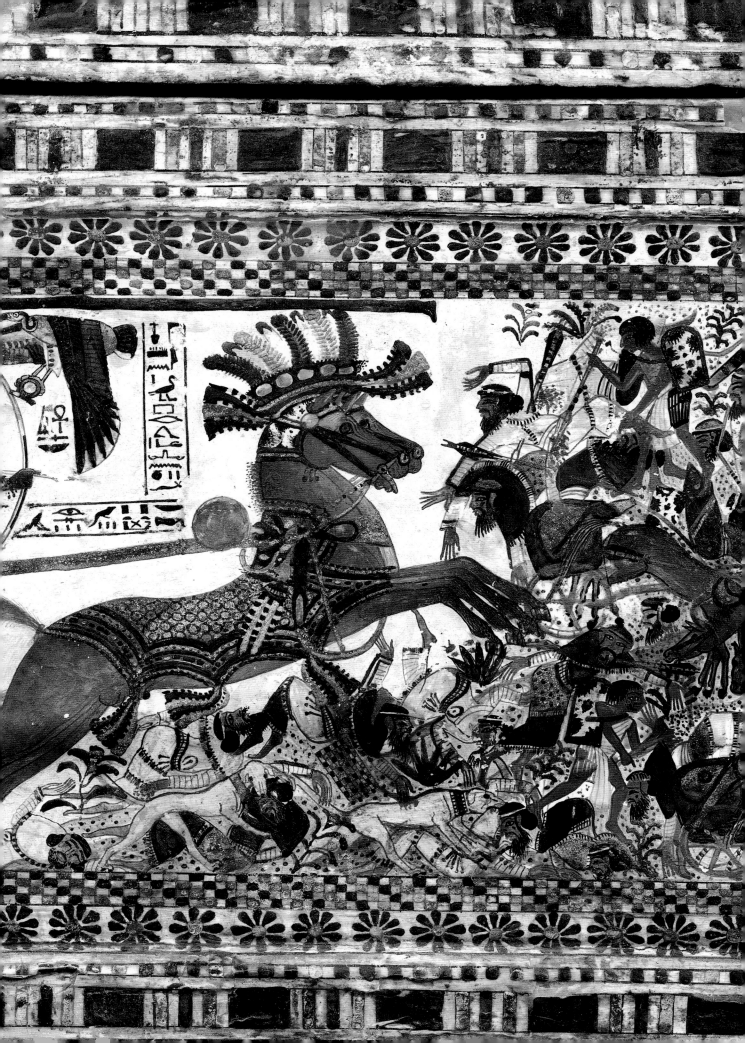

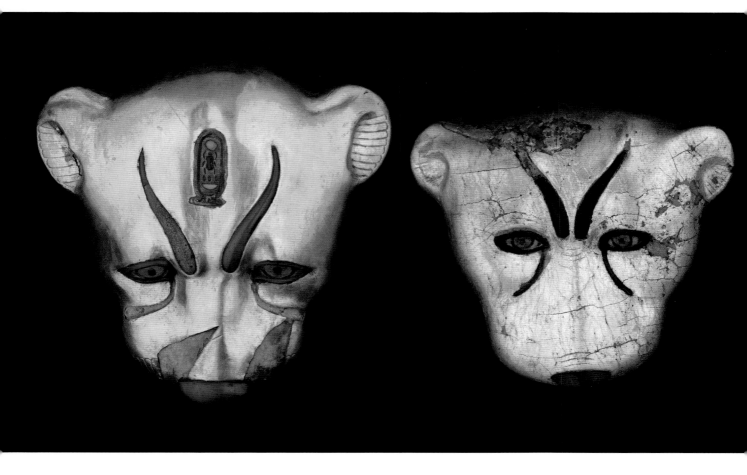

TWO LEOPARD-HEAD APPLIQUÉS

Plastered and gilded wood, crystal, glass, calcite
(Egyptian alabaster), bronze
Heights 17.5 cm (Carter 44q) (left),
13 cm (Carter 21t) (right)

FRAGMENT OF A PRIEST'S ROBE

Cloth, silver, gold
Carter 21t

Represented here are the remains of two robes made in imitation of leopard skins. The smaller head and the textile fragment (perhaps worn by Tutankhamun as a child) were found inside the "Hunting Box" (p. 24); the other, larger head came from an elaborate gilded and inlaid casket, also found in the Antechamber. Both leopard heads were carved from wood and then coated with plaster and gilded. The eyes were inlaid with crystal: the corners were washed with red paint to indicate capillaries, while the pupils were painted in black and the irises in red. The outlines of the eyes, the eyebrows, the noses, and the tear-shaped markings beneath the eyes were inset with blue glass, some of which is missing on the larger head. The ears and muzzles have engraved detail. On the forehead of the larger leopard, the throne name of the king, Nebkheperure, is inlaid in colored glass and calcite.

Both heads were edged with small bronze rings by which they could be attached to a cloth robe. The tapestry-woven textile fragment shown here (left) was part of one such robe. It is covered with small five-pointed stars of gold, sewn onto the cloth through holes in the points. This decoration is intended both to mimic the markings of the leopard and also to evoke the star-spangled night sky. Claws of silver were attached to four "legs," which are difficult to discern now due to the decayed state of the garment. The king would have worn the robe thrown over one shoulder, with two claws hanging in front and the other two down his back.

One of the most important functions of the pharaoh was to serve as the head of Egypt's priesthood. Tutankhamun would have worn these robes when he played the role of a *sem*-priest, the principal officiant at the ceremony of the Opening of the Mouth. This important ritual, carried out during the funeral, served magically to restore the functions of life to the mummy and any images of the deceased, so that they could be effective in the afterlife. *Sem*-priests were identified with Horus, son of Osiris, king of the dead, who secured his right to inherit by taking responsibility for his father's burial. It is tempting to imagine the young Tutankhamun (perhaps while he was still called Tutankhaten) wearing the small robe shown here in the rites that accompanied the burial of his predecessor, although some scholars believe that *sem*-priests were officially reviled during the Amarna period.

DRINKING CUP IN THE SHAPE OF A LOTUS

Calcite (Egyptian alabaster)
Height 18.3 cm, width 28.3 cm,
diameter of cup 16.8 cm
Carter 14

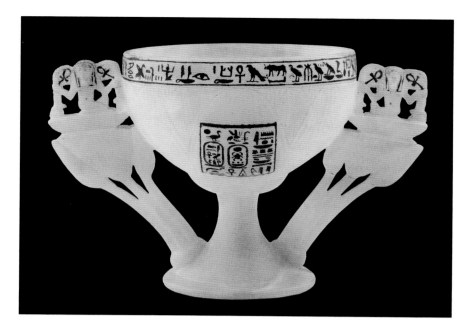

Found just inside the inner blocking of the Antechamber doorway, where perhaps it had been dropped by the thieves, this goblet, nicknamed the "Wishing Cup," is in the form of the opened blossom of a white lotus flanked by other blossoms and buds. To each side, the god of infinity, Heh, kneels on a basket. In each hand he holds an *ankh* sign (symbol of life) and the notched palm rib that signifies "millions of years." Below the ribs are tadpoles, the hieroglyph for "100,000."

The names and titles of the king, who is said here to be beloved of the god Amun, are incised on the belly of the cup and painted in blue. The horizontal inscription around the rim reads "May your *ka* (lifeforce) live, and may you pass (live) one million years, one who loves Thebes and dwells in it, your face toward the northern wind: may your eyes see the good place." A powerful symbol of rebirth, this lotus cup, from which the king would probably have drunk water or wine, magically offered resurrection, happiness, and eternal life to Tutankhamun.

Egyptian artisans had already mastered the art of carving hard stone by the beginning of the Early Dynastic era (around 3000 BC). Examples from the early periods of Egyptian history, made from stones such as granite, diorite, basalt, schist, and calcite, have a bold simplicity of design and execution. Stone vessels went out of fashion after the early Old Kingdom, but stoneworking techniques were never lost and the art was revived in the New Kingdom. Far from the simple shapes seen in the Early Dynastic period, however, many of the over 80 calcite vases from Tutankhamun's tomb are elaborate, complex expressions of the stonecarver's art.

This elegant cup was carved from a single piece of calcite, except for the separately carved handles. The stone came from the site of Hatnub in Middle Egypt, the name of which means "Place of Gold," and it is thought that this material was associated with the sun god, Amun-Re, and thus with the king in his identification with this deity.

CARTOUCHE BOXES

Wood, ivory

Length 12.2 cm, width 5.5 cm (Carter 14b) (right)
Length 11.2 cm, width 4.6 cm (Carter 367k) (center)
Length 12 cm, width 5.4 cm (Carter 620(95)) (left)

Carter found these small boxes, made of a reddish wood with ivory knobs, in different parts of the tomb – one in the Antechamber and two in the Annexe. They are cleverly designed to open by a swivel mechanism at one end. Each box is in the shape of a cartouche, the oval frame that enclosed two of the king's five names: his birth name and throne name. Tutankhamun (or Tutankhaten,

as he was originally called) was the king's birth name, and Nebkheperure, which means "Lord of the Forms of Re," was his throne name, taken at his coronation. These boxes are decorated with the latter, written with a sun disk (Re), a scarab with strokes indicating the plural (*kheperu*), and a basket (*neb*).

The cartouche, a depiction of a circle of rope tied at one end, is an elongated version of the hieroglyphic sign *shen*, which represented the all-encompassing circuit of the sun. It symbolized the king's dominion over everything within his realm, and also afforded magical protection and long life to his name, and by extension to his person.

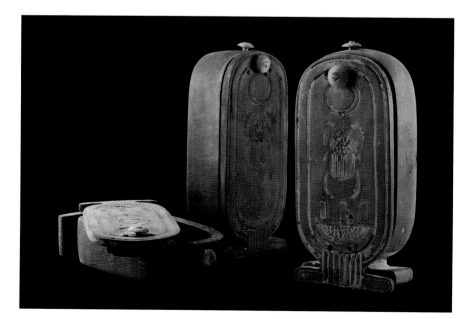

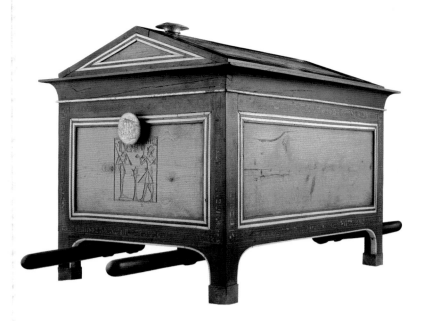

TRAVELING CHEST WITH CARRYING POLES

Wood, ebony, ivory, gold leaf, copper alloy
Length 83 cm, width 60.5 cm, height 63.5 cm
Carter 32

Traveling chests such as this one appear in tomb scenes from the Old Kingdom on, but Tutankhamun's is the only actual example known. Found beneath one of the ritual couches (p. 32), this chest, made of cedarwood with ebony veneer, could be carried on poles by two bearers. It was filled with a miscellaneous collection of objects: vessels made of glass and of various stones, including serpentine and calcite; several stone knives; pieces of incense; garlic bulbs; dried fruit; and several ostrich feathers.

Most of these objects can be linked to the ceremony of the Opening of the Mouth, and the bands of hieroglyphs that decorate the chest include spells from the ceremony, emphasizing this association. Carved on one end is a figure of the king offering jars of water or wine to the god Osiris (detail, right). It therefore seems likely that the chest was designed for funerary use, most probably to carry implements for the Opening of the Mouth rituals.

Four separate carrying poles are attached to the underneath of the chest with bronze clamps. Two gilded knobs, one on top and one on the front, would have been used to "lock" the box: a string would have been wound round the knobs and then sealed with a lump of mud impressed with a signet.

The ebony for the chest would have come from far to the south of Egypt, and the cedar from the area that is now Lebanon. Evidence for the use of cedar can be traced back to the dawn of Egyptian history. It is mentioned on the Palermo Stone, a fragmentary stela listing important events during the first five dynasties, including a journey of 40 ships to Byblos to bring back this precious wood. And at Giza, two full-size but dismantled cedar boats were found buried in pits next to the Great Pyramid of Khufu (c. 2500 BC). The use of such expensive imported materials testifies to the importance of the objects kept inside.

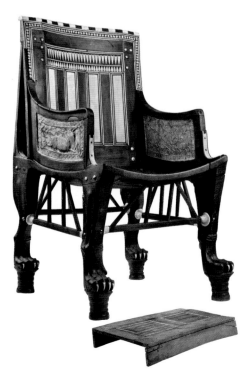

CHILD'S CHAIR

Ebony, ivory, gold, bronze
Height 71.5 cm, width 40.6 cm, depth 39.1 cm
Carter 39

FOOTREST

Wood, ivory
Height 5.7 cm, width 37.4 cm, depth 21.7 cm
Carter 92

One of six chairs discovered in the tomb, this was found jumbled together in a pile of furniture and boxes. It has the same shape as the Golden Throne (p. 56), but is diminutive, apparently made for the king when he was a child.

The slightly rounded and tilted back, reinforced with three vertical slats joining the toprail to the seat, is decorated with a geometric pattern created with veneers of ebony and ivory. The seat, made from five slats, is doubly curved. The armrests have insets of gold foil embossed with naturalistic scenes: on the insides are plants within a border of rectangles, and on the exterior are recumbent goats, their heads turned backward to fit them into their frames of running spirals. Like many of the motifs in the tomb, this decoration has its roots in the Syrian and Aegean repertoires.

The legs end in lions' paws, with claws inlaid with ivory, set on high, ringed tenons. Between the legs are struts capped with papyrus umbels made of ivory. The chair's construction is superb – each part is carefully carved and the various pieces are held together with gilded bronze rivets.

The footrest shown here was not found with this chair, but was discovered near the Golden Throne. It is carved from a reddish wood, thought by Carter perhaps to be cedar, with the top fastened to the sides by wooden pegs. It is inlaid in a geometric design with a darker wood, probably ebony, and ivory, and thus complements the child's chair well.

as an incarnation of the sun god during his nocturnal journey *(khat)* and then as the reborn god during the day *(nemes)*.

The texts on the statues reinforce this symbolism. The inscription down the front of the kilt of the *khat* figure identifies it as "the *ka* of Horakhty, the Osiris, King, Lord of the Two Lands, Nebkheperure, true of voice." Osiris was the deceased king, and the final epithet here, "true of voice," or "justified," is only used with the dead. This, then, is to be seen as Tutankhamun's *ka*, an aspect of his personality that survived death and was able to receive offerings. The gilding on both statues emphasizes the connection of the king to the sun god as he guards the Burial Chamber; the maces and staffs are tools that he would use in the beyond.

The inscription on the statue wearing the *nemes* is identified as "the good god ... Nebkheperure, son of Re ... Tutankhamun, ruler of Southern Iunu, given life forever, like Re, everyday." The references here, including Tutankhamun's epithet as ruler of Southern Iunu (i.e. Thebes – modern Luxor – the southern counterpart to Iunu, otherwise known as Heliopolis, center of the sun cult), are all to the sun god, Re.

Remains of such "guardian" figures have been found in other royal tombs. However, in addition to being the best preserved and most complete, Tutankhamun's figures also appear to be the most "expensive" – there is no evidence that the other examples were heavily gilded. This is also the case for many of the other ritual figures found in Tutankhamun's tomb, which are covered with gold, whereas other kings seem to have been content with gessoed wood covered with black.

At least one scholar has suggested that this extensive use of gold is a tribute to how much Tutankhamun's subjects loved him, perhaps because of his restoration of the traditional Amunist religion after the "heresy" of his father Akhenaten. It may also reflect increased access to the treasure houses of the Amun temples.

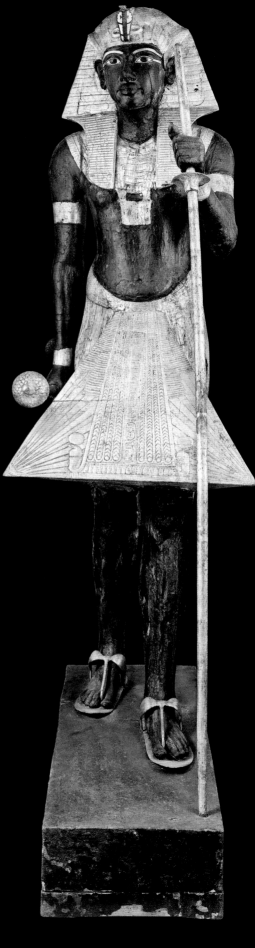

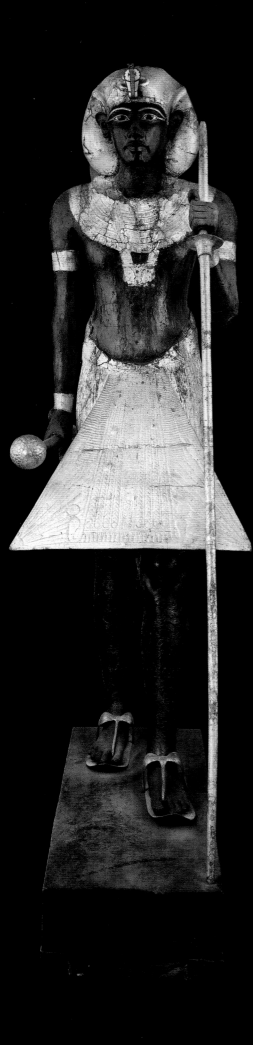

GUARDIAN STATUES

Painted and gilded wood, bronze, limestone, obsidian
Height 190 cm (both)
Carter 29 (*khat*; left) and Carter 22 (*nemes*; right)

Flanking the entrance to the Burial
Chamber were these two life-size statues
of Tutankhamun. They are carved of wood,
covered with plaster and then painted and
gilded. Although they are very similar to
one another, there are several important
differences between them. Both show the
king standing, his left leg extended in the
typical male striding pose, holding a papyrus
staff in his left hand and a mace (p. 80) in
his right.

In both statues, Tutankhamun is shown
wearing a broad collar (p. 125), a shrine-
shaped pectoral decorated with a winged
scarab on a wide chain, armlets and
wristlets, a pleated knee-length kilt with
starched trapezoidal front panel and sporran,
and sandals. The skin of both figures is
painted black, the rich color of soil soaked
by the nutrient-laden Nile floodwaters,
which carried connotations of fertility.
Details such as kilts, staffs, jewelry, and
eyebrows have been rendered in gold, which
was associated with divinity. The sandals, the
hooding cobras (*uraei*) on the foreheads, and
the outlines of the eyes are of bronze covered
with gold; the eyes are made of crystalline
limestone and obsidian.

The principal difference between the
two figures lies in their headdresses. One
(left) wears the *afnet*, or *khat*, also known as
the bag wig, a crown seen almost exclusively
in funerary contexts and which is thought to
connote night and the journey through the
netherworld. The other figure (right) wears
the *nemes* – a striped cloth with lappets that
fell over the king's shoulders in front and
was tied in a pigtail down the back. This is
one of the crowns most frequently worn by
Egyptian kings and is believed to be linked
with Re-Khepri, the sun god at dawn. It is
also thought to identify the king as Horus,
in his guise as both the son of Osiris, king
of the dead, and the son of the sun god Re.
The two headdresses are often paired,
perhaps to convey the concepts of night and
day. In this instance, then, it is possible that
the statues are meant to represent the king

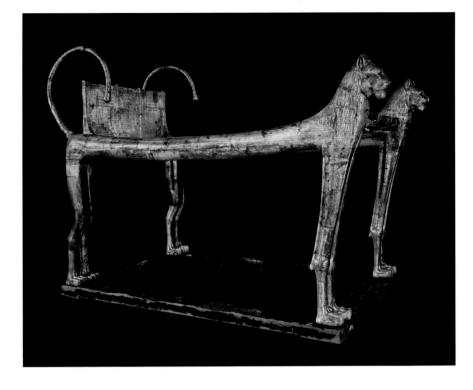

RITUAL BEDS
Gilded wood, glass, semiprecious stones, ivory

Lion bed
Height 161 cm, length 228 cm, width 91 cm
Carter 35

Cow bed
Height 187 cm, length 223 cm, width 128 cm
Carter 73

Ammut bed
Height 141 cm, length 234 cm, width 91.3 cm
Carter 137

These three enormous beds were placed along the west wall of the Antechamber; on top and beneath them were piles of various other items of tomb equipment. They are thought to have been used in religious rituals connected with the mummification and funeral, although their exact purpose is not completely clear. One theory suggests that the royal mummy rested on each in turn while undergoing specific rites.

Fragments of such beds were found in other New Kingdom royal tombs, and images of similar pieces of furniture are known from scenes on the walls of the tomb of Seti II. Each bed consists of four large pieces of wood fixed together with hooks and staples: the two sides; the bed itself with footboard; and the base. The two side-sections of each are in the shape of a divinity. One bed represents a lion deity; the second is in the form of a cow goddess; and the third takes the shape of a mythical creature named Ammut.

Written in black on the various pieces are hieroglyphs indicating how the elements were to be fitted together. It is interesting to note that the cross-rail of the lion bed is inscribed with the name "Mehit-weret," a goddess usually seen in the form of a cow, while the cow bed is inscribed as Isis-Mehtet, who was traditionally a lioness (although the name here ends with a cow's head). It is possible, therefore, that either the scribe who wrote the inscriptions or the workmen who put the beds together mixed them up.

Made primarily of gilded wood, the beds have details inlaid in other materials. The nose and the areas under the eyes of the lion have been added in blue glass, while the eyes themselves are of clear quartz, with the pupils painted in black on the reverse – as are those also of the cow and the Ammut couches. The skin of the cow has been adorned with trefoils of blue paste; Ammut's teeth and tongue are of ivory, the latter stained red. All three have footboards decorated with alternating *djed* and *tjet* signs, symbols of Osiris and his sister-wife Isis respectively.

The lion was an important symbol in pharaonic times, associated with strength and virility. Lion's legs were frequently used in furniture, so that the king and his authority would be "upheld" by this powerful creature. The Egyptians imagined that the horizon was flanked by two lions, and that the sun rose between them each morning. Thus the king's body could be reborn from this bed (pp. 31–32), just as the sun was reborn above the horizon. However, given the inscription (on the cow bed, but perhaps to be applied to this one) with the name of the lioness deity Isis-Mehtet, it is also possible that, despite their manes, the animals on this bed are meant to be lionesses.

The cow represented on the second bed (pp. 33–34), with the sun disk between its horns, although labeled as Isis-Mehtet, is more likely to be identified with Mehit-weret, goddess of the flood and one of the divinities most closely linked with the creation of the world. According to myth, she bore the sun disk from the primeval mound to the horizon both at the beginning of the world (the "First Time") and at the daily reiteration of this moment. The decorated hide of these cows echoes the starry sky with which this goddess was associated, and the eyes are in the shape of the *wedjat*, the eye of the sky god Horus. Thus the cow bed is also connected with the cycle of rebirth and resurrection.

The third bed has sideboards in the form of a composite animal with the head of a hippopotamus, lion's legs, and the body of a crocodile (pp. 35–36). As the inscription on the wooden "mattress" confirms, this is Ammut, known from vignettes on funerary papyri as the devourer of evildoers. She figures prominently in the Judgment of the Dead, also known as the Weighing of the Heart.

In such scenes, the deceased was brought before Osiris, and his or her heart placed on one pan of a weighing scale, with an ostrich plume representing *ma'at* (the proper order of the universe) on the other. If the scale balanced, the deceased was presented to Osiris, accepted by him as one of the blessed dead, and granted eternal life. If not, the heart was fed to Ammut, and the person died forever.

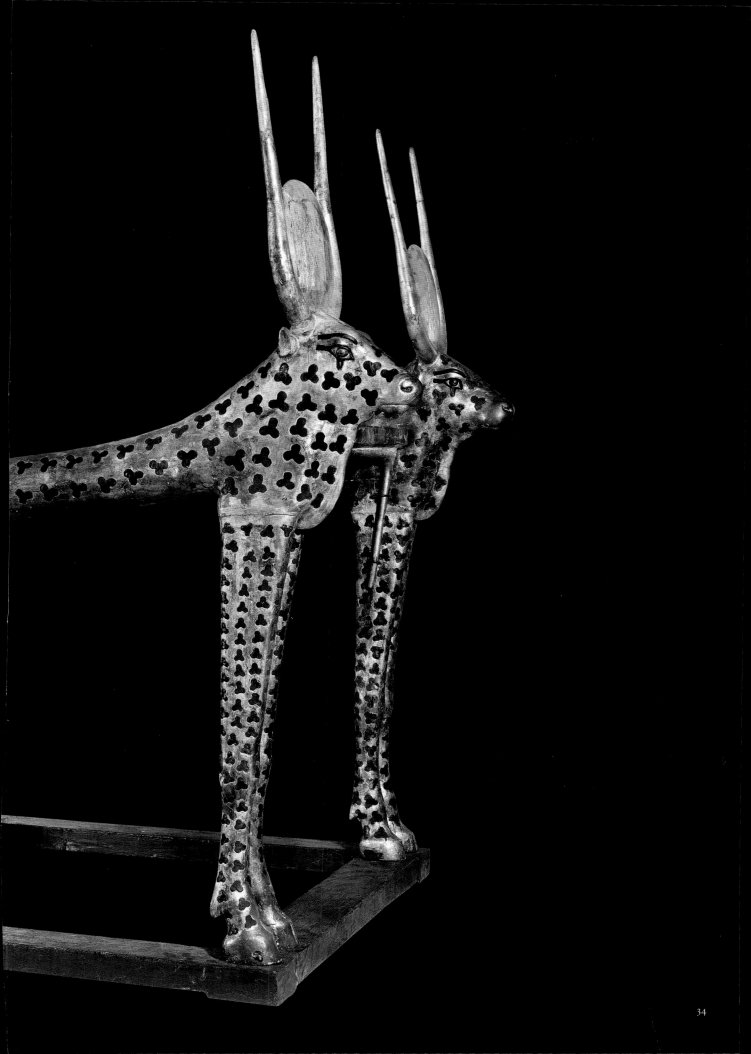

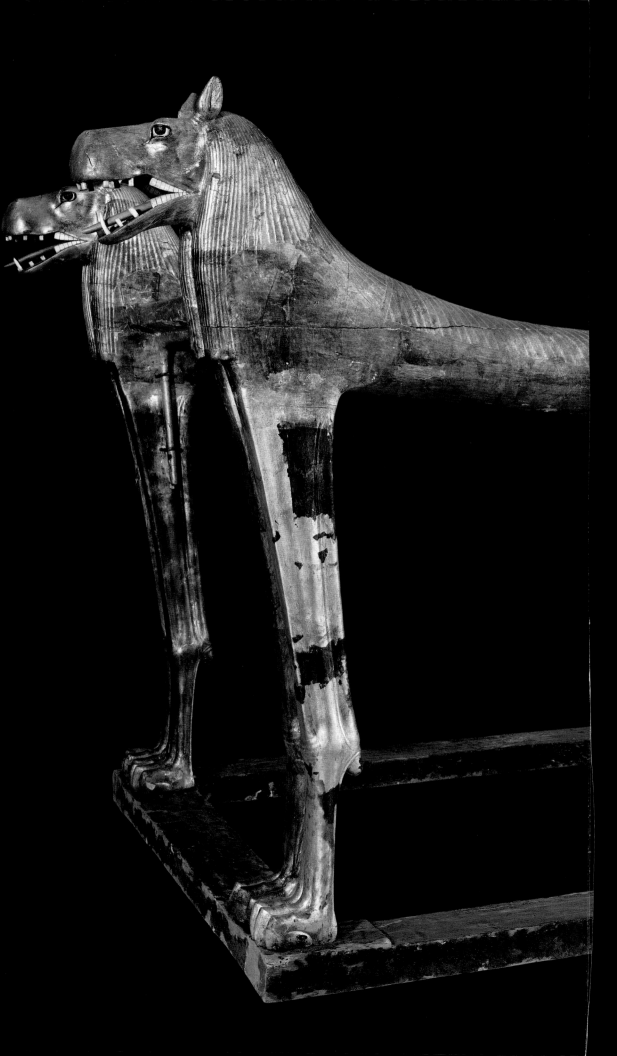

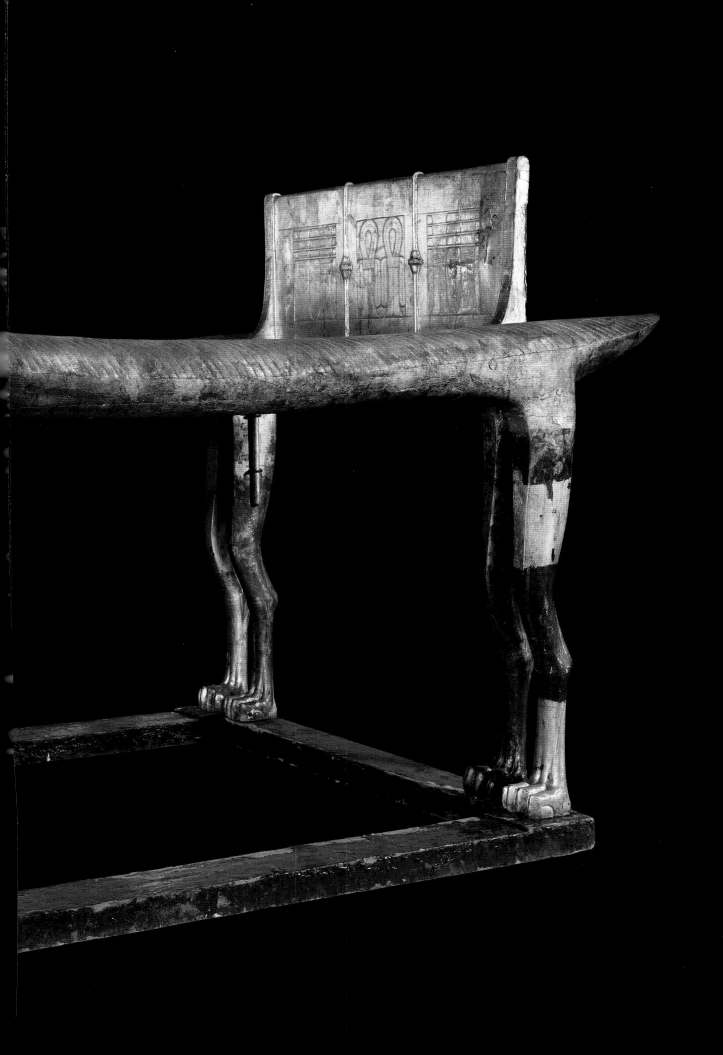

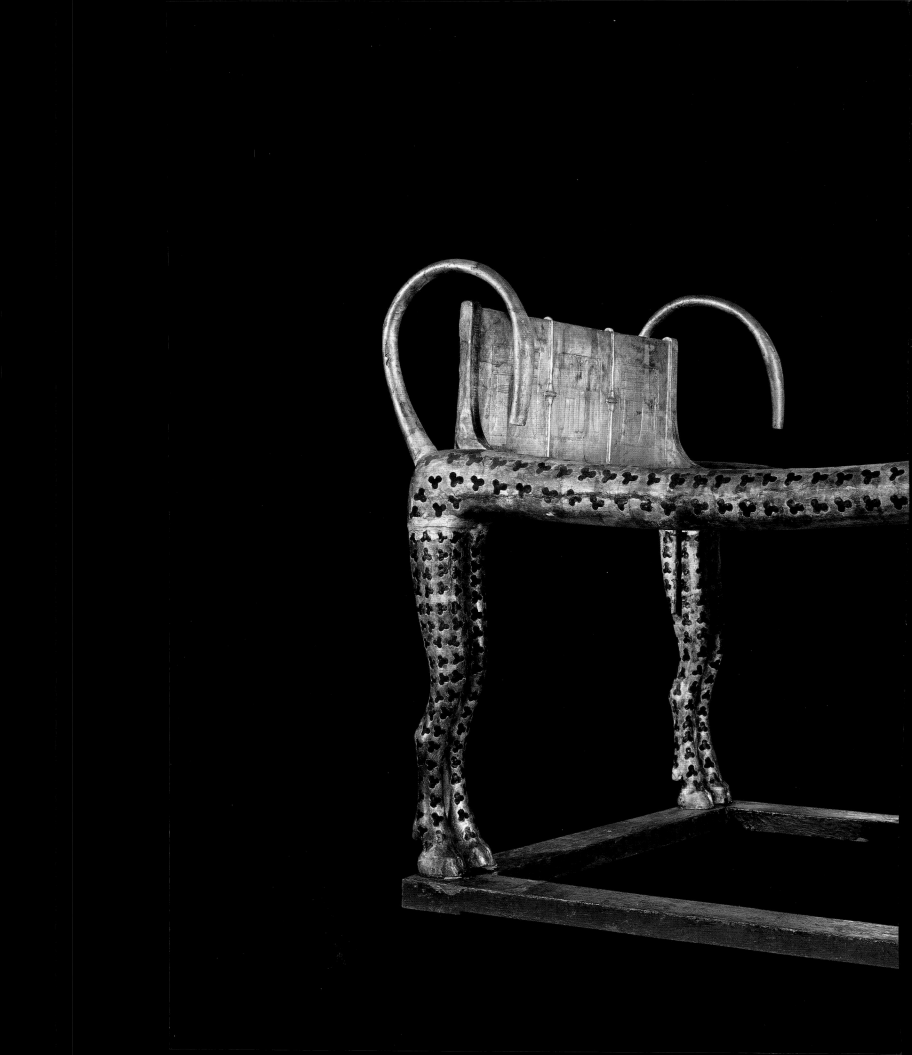

TORCH-HOLDER
Bronze, wood
Height 23.8 cm
Carter 41c

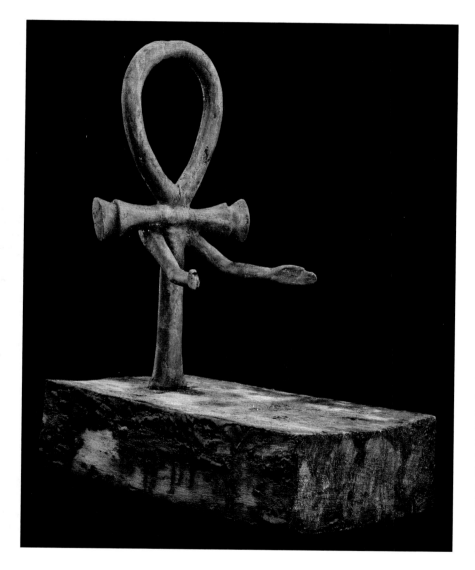

Four of these inventive lamps were discovered in the tomb, set on top of the lion bed (p. 32). It is interesting to note that Carter believed they were originally stored in a box from the Treasury that is the right size and had traces of the same black varnish with which the bases of these lamps were coated.

The torch-holders take the form of anthropomorphized *ankh*s, the hieroglyphic sign for life. Each *ankh* is made of several pieces of bronze and is set into a black-varnished wooden base. The *ankh*s are equipped with arms stretched out to hold small cups, bronze examples of which survive in two of the lamps. One lamp also has a wick in the form of twisted flax, placed upright inside the cup. Oil would have been put into the cup to soak the wick and keep it burning. Carter believed that the cups from this lamp and its twin were made of gold, and were stolen by the thieves.

Like many of the objects in the tomb, these lamps were probably intended to ensure eternal life for the king. In art of the Amarna period, just before and into the beginning of the reign of Tutankhamun, the disk of the sun, the Aten, is often shown reaching down its rays, which ended in human hands, to present *ankh*s to the royal family (see p. 11). In other eras of Egyptian history, the same concept is also embodied in the frequent images found in temple reliefs showing gods offering *ankh* signs to the king.

SHEBYU COLLAR

Faience, fiber
Length 57 cm
Carter 44cc

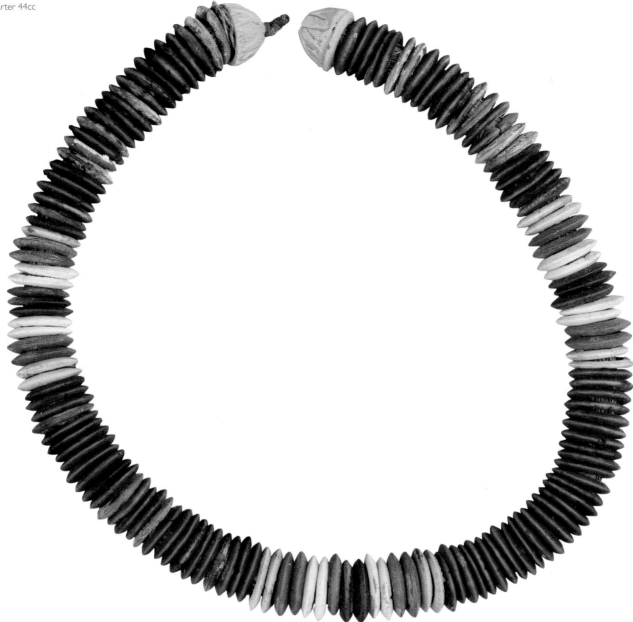

This collar is made up of disk-shaped beads of faience (a silicate-based type of ceramic) strung on a cord of an unidentified fiber. The majority of the beads are bright blue, with regularly spaced bands of yellow, red, and white beads. At each end of the collar is a larger yellow bead in the shape of a lotus blossom, and the strings of the cord are knotted and tasseled.

The collar would have been worn with one or more other similar necklaces, and fitted snugly around the neck of the wearer. Although this example was made of faience,

as were several others found with it, it is reminiscent of necklaces called *shebyu*, which were made entirely of gold beads. *Shebyu* collars were awarded by the pharaoh to his subjects in recognition of valor in battle or some other service of special merit, and a number of wonderful tomb scenes show the bestowal of this "gold of honor."

One example is in the tomb of Ramose, vizier under Amenhotep III and Akhenaten; another is in the tomb of Ay, a high official under Akhenaten and Tutankhamun who later became pharaoh himself. *Shebyu* collars

could symbolize a significant change in the status of the recipient, and although they were originally associated with private individuals, they were also worn by the king and are thought to designate his elevation to divine status. They appear to be linked especially with the sun god, and their increasing popularity during the reign of Amenhotep III is indicative of the growing importance of the solar cult during this era. The example seen here may have been an imitation, made specifically for funerary use, of a more valuable golden collar.

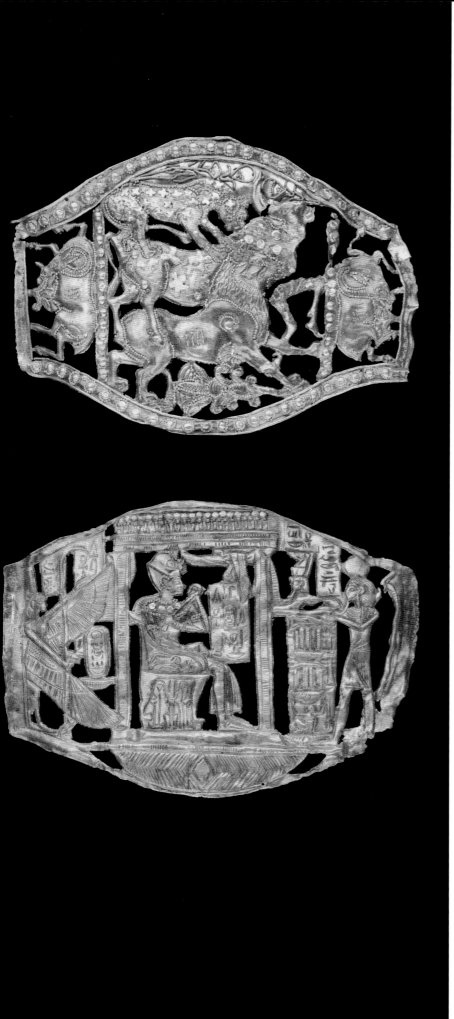

TWO OPENWORK PLAQUES
Gold
Heights 3.3 cm, widths 6.2 cm
Carter 44a(1) (above) and Carter 44a(2) (below)

These plaques are often referred to as buckles, although they do not appear to have attachments that would have made them functional. Carter suggested that a similar piece was a fitting from a harness, but it is probably safer to assume that they were decorative elements that may have been attached to belts or ceremonial garments. These two examples were found in a gilded and inlaid box (Carter 44), mixed together with a jumble of other objects. Carter believed that these miscellaneous items had been recovered from the thieves who had tried to carry them off, and were then simply tossed into this box by the tomb guardians rather than being put back in their original places. The robbers may have ripped them from the textiles to which they were once attached because they were both valuable and portable and could be melted down so that they could not be traced to their royal owner. A similar plaque was donated to the Egyptian Museum in 1946 by King Farouk I.

Made from red-tinted gold (with a high iron content), the plaques are similar in size and shape but vary in their designs. The upper one shows a bull being attacked by a leopard from above and a lion from below. Desert plants fill the open spaces in the composition, while the ends are occupied by grazing ibexes. The scene of a struggle between powerful wild animals was a common motif in the ancient Near East, with antecedents in Egyptian, Aegean, and Western Asian art. When seen in Egyptian art, it is generally thought to symbolize the forces of chaos being overpowered by the forces of order.

The lower plaque bears a regal image of the king seated on an elaborate throne within a portable shrine whose canopy or roof is surmounted by a frieze of *uraeus*-serpents. The shrine itself sits atop a *heb* basket (distinguished by its diamond-shaped decoration from the *neb* basket), the hieroglyph for festival. On the right, a god presents a statue of a sphinx atop a pedestal to Tutankhamun; on the left the goddess Ma'at stretches her wings to protect the king.

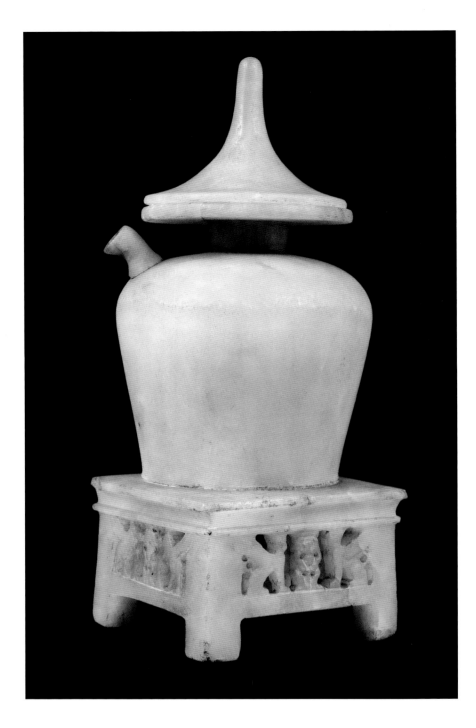

NEMSET VESSEL ON A STAND

Calcite (Egyptian alabaster)
Height 29.5 cm
Carter 45

This squat, spouted vessel, closely resembling a modern teapot, is in the shape called *nemset*. More commonly made of faience and usually much smaller (half this size or less; p. 274), such ewers held libations of water or other liquids for offering to the gods or the deceased. This example has a narrow neck and a flat rim, atop which sits a funnel-shaped lid. *Nemset* lids are frequently shaped and decorated to resemble lotus blossoms, of which this may be a stylized version.

The vase sits on a square stand, also of calcite, carved on two sides with a design showing the god Bes between winged creatures presenting *ankh*s. On the third side, Bes is flanked by winged sphinxes. A gnome-like deity with leonine features, Bes was thought to ward off malevolent spirits and was associated with the protection of vulnerable individuals such as children, women in labor, and sleepers. His image therefore often decorated household objects.

Of the 80 calcite vessels in the tomb, 25 were inscribed. Some of these were heirlooms, bearing names ranging from Thutmose III, Tutankhamun's great-great-great grandfather, to Akhenaten, his probable father.

STAFF WITH A HANDLE
IN THE SHAPE OF A NUBIAN CAPTIVE

Gilded wood, ebony, faience
Length 115 cm
Carter 48c

Numerous sticks and staffs – about 130 in all – were found in the tomb, prompting some scholars to suggest that Tutankhamun was fragile and needed support when he walked. Not all were walking sticks, however; some were ceremonial staffs, while others were weapons such as fighting batons or sticks for killing snakes. They range from child to adult size, and many show signs of use.

A group of objects, including four staffs with captives on the crook (this example among them), a straight stick with a gilded top and another with an ivory top, six compound bows, and one simple bow, was found on one of the king's large funerary beds (p. 32). Carter noted that these had been thrown here carelessly, perhaps by the priests who re-closed the tomb. A rectangular box nearby may originally have contained this staff and its companions.

The four staffs in the set to which this example belonged all feature defeated enemies: three have bound Nubian prisoners, while the fourth has two captives, one Asiatic and one Nubian. When the king used the staffs, he would have grasped the enemies in his fist, symbolically crushing and controlling them. This served not only to reiterate the triumph of Egypt over her enemies, but also to guarantee the proper functioning of the cosmos. In the symbolic realm, foreigners played the role of chaotic elements that threatened the existence of the world, while the king was an incarnation of the creator god whose principal task was to keep chaos at bay.

The body of this staff is made of gilded wood, with details added in ebony. Along its length are engraved alternating patterns of rosettes, feathers, and herringbones. A papyrus flower of faience marked with the cartouche of Tutankhamun forms the base or ferrule. The Nubian enemy that adorns the handle is shown as a prisoner, with his arms tied behind his back at the elbows; the way he is placed on the staff ensured he would spend eternity upside-down. His head, arms, and feet have been carved separately from ebony. He can be identified as Nubian by his features, his hair, and his costume of short-sleeved tunic, calf-length skirt, and hoop earrings (the last of gold).

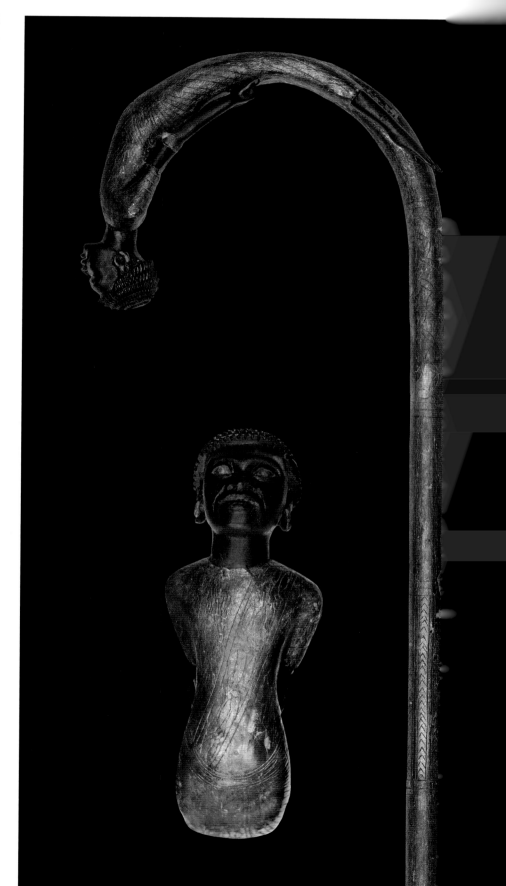

COSMETIC CONTAINER
IN THE SHAPE OF A DUCK OR GOOSE

Ivory
Length 8.5 cm, width 4.5 cm
Carter 54s

It is not clear from either Carter's notes or Harry Burton's photographs exactly where this small ivory cosmetic dish in the shape of a trussed duck or goose (or, if Carter was correct, a swan) was found within Box 54. The main part of the piece is formed by the body of the bird, with its legs tucked up beneath its belly, its wings held to its sides and its head and neck gracefully turned back to lie along its shoulder. The head, neck, legs, and webbed feet have been painted black. The top of the box is attached by a swivel peg so that the lid can be pushed sideways to gain access to the space within. Carter did not report finding any sort of residue inside, but it is likely that it was designed to hold ointment or some other sort of cosmetic. Perfumes, unguents, and equipment used in making up the face, especially the eyes, were very important to the ancient Egyptians, and had both practical and religious functions.

It has been said that a number of small cosmetic boxes similar in style and execution to this one were found in Carter's home when he died. Two of these were almost identical to this one – also shaped like ducks or swans. Another was a clever piece in the form of a grasshopper, with wings that swiveled out to provide access to the interior. None of these are recorded in Carter's notes, and neither is there evidence that they were purchased on the antiquities market. It is thus likely that he took them from the tomb, perhaps considering himself entitled to them as the tomb's finder.

In 1922, it was usual for the excavator to receive some of the artifacts from any discovery. These were pieces that were considered "duplicates" – that is objects already represented in the collections of the Cairo Museum. However, these rules were suspended if the find was considered intact. Although Tutankhamun's tomb had been breached twice in antiquity, the Egyptian government categorized it as intact, and Carnarvon (or in this case his estate, since he died less than six months after the discovery) did not get a share of the finds. Carter and Carnarvon were extremely unhappy with this decision, and it is likely that Carter held back small things for himself here and there. Although I identify with Carter in many ways, this is one aspect of his behavior that I do not understand at all. An artifact without its context loses much of its value. It is only beautiful; its ability to help us see into the past is greatly reduced. In my opinion, the biggest mistake Carter made in his life was in taking artifacts from the tomb, and fighting the decision of the Egyptian government to treat the tomb as intact. On many occasions, after my lectures all over the world, people come up to me and tell me about small artifacts that they have, given to their families by people who visited the tomb during its excavation.

Carter's actions are in direct contrast to those of American archaeologist George Reisner, who in 1925 discovered the similarly intact burial of Queen Hetepheres, mother of Khufu, the builder of the Great Pyramid (her body was missing, and her original burial had clearly been robbed in ancient times, but modern thieves had not found her final resting place). Reisner cooperated completely with the Egyptian Antiquities Service, and was rewarded with the beautiful bust of the vizier Ankhhaf for his sponsor, the Boston Museum of Fine Arts.

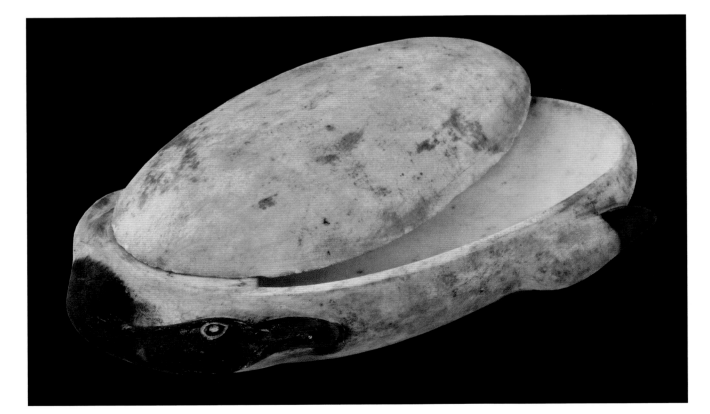

RING BOX

Ivory, gold
Height 13.1 cm, width 15.7 cm, depth 12.6 cm
Carter 54ddd

The material and workmanship of this elegant ivory casket make it unique. It consists of 10 separate pieces of ivory, each carved to imitate a wooden panel. The ivory is of very high quality and clearly came from a large elephant tusk, probably brought to Egypt from southern Africa as a gift or through trade.

The box stands on four short legs, each fitted at the bottom with a cap of gold. The hinges that fasten the lid to the body are also of gold, as are the knobs that form the "lock," one on the top and one on the front. A string, remains of which were found *in situ*, would have been wrapped around the knobs and covered with a lump of mud into which a seal was impressed. On the front of the box is an inscription giving three of Tutankhamun's five names: "The Horus, Mighty Bull, Tutmesut; the King of Upper and Lower Egypt Nebkheperure; and son of Re, Tutankhamun, ruler of Southern Iunu, given life like Re forever." On the top, the king's two most commonly used names appear again, this time with different epithets: "King of Upper and Lower Egypt, Lord of the Two Lands, Lord of Appearances,

Nebkheperure, son of Re of his body, Tutankhamun, living forever." Engraved in very high relief on the back of the box is a column shaped like a lily, the heraldic plant of Upper Egypt.

A hieratic (cursive) inscription in black ink on the lid tells us that this box once contained "Gold rings for the funeral procession," showing clearly that it was made specifically for mortuary use. Instead of rings, however, Carter found inside a random selection of small objects, such as an ivory mirror handle, seven small shells, a winged scarab, and a damaged pendant. Eight gold rings, perhaps the original contents of the box, were found knotted in a cloth inside another box in the Antechamber. It is tempting to speculate that the thieves who violated the tomb stole these rings and wrapped them in the cloth, but that the necropolis officials then confiscated them and returned them to the tomb. Rather than putting them back where they belonged, they threw them in the other chest, and crammed more disturbed items into this box – one of many examples of the carelessness of the ancient guards seen in the tomb.

CORSELET

Gold, semiprecious stones, faience, glass
Height 40 cm, length 85 cm
Carter 54k

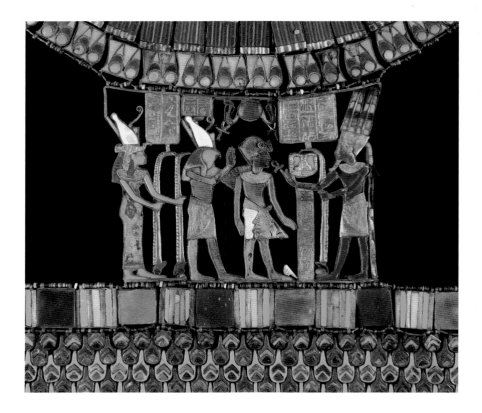

The remarkable work of art shown here is a ceremonial version of the leather and metal chest protector that the king would have worn when he went hunting or into battle. Such body armor is often depicted in temples and tombs, but this is the only actual example known from ancient Egypt. The god Amun, patron of the warrior pharaohs of the New Kingdom, often wears a corselet like this one. It thus has links with the role of the king as the earthly incarnation of Amun, and emphasizes Tutankhamun's connection to this god.

Tutankhamun himself is seen wearing such a corselet on a number of objects found in the tomb, for instance on the golden fan (p. 87), as he rides into the desert to hunt ostriches, and on the Hunting Box (p. 24), where the king is depicted both hunting and riding his chariot into battle. Again, when he stands between Ptah and Sekhmet in the pendant of his "Coronation" Pectoral (p. 186), Tutankhamun wears a jeweled garment similar to this one.

One of the most elaborately worked objects found in the tomb, the corselet consists of several major parts. First is a wide band made up of pieces of colored glass sewn onto a cloth backing, which would have wrapped around the king's torso, covering him from his waist to just below his pectorals. Carter found long golden elements with the corselet; these fastened the garment at the

sides. Thin beaded straps inlaid with glass and an elaborate broad collar held the corselet over the shoulders and around the neck.

The broad collar, both front and back, was composed of alternating rows of pieces of light and dark blue faience and carnelian, with a band of floral ornaments along the outer edge. At the front (above), a pectoral joined the broad collar to the main body of the corselet; it is made of carnelian, green and blue glass, and a whitish material that Carter thought might be agate but has now been identified as an unusual white glass, all set into a frame of gold.

The scene shows Amun-Re, king of the Egyptian pantheon, presenting Tutankhamun with a palm rib representing millions of years, from which hangs a pavilion containing two thrones, symbolizing a long reign. Behind the king is the creator god Atum, shown as a falcon-headed man, and his consort Iusaas.

Balancing this pectoral at the back of the broad collar (p. 48) is an arrangement with a winged scarab beetle with the hind legs of a bird pushing a sun disk, symbol of the dawn; to either side are hooding cobras, one in the white crown of Upper Egypt and the other in the red crown of Lower Egypt. *Ankhs*, the hieroglyphs for life, hang from the claws of the scarab/bird and the bodies of the cobras. It seems that the god Amun was granting the king the rule of the Two

Lands on earth, and welcoming him to the ranks of the divine.

The craftsmanship of this entire piece – the way in which the individual parts were painstakingly put together and the attention to detail evident in the composition – is extraordinary. It seems to me that the artist drew the meaning and shape from his imagination, and began to create his masterpiece. Unfortunately, we do not know the name of the jeweler responsible for this corselet: in ancient Egypt, all art was for the sake of religion, and most ancient artists remain anonymous. I have found one exception to this, however, in a beautiful tomb that I excavated at Giza belonging to a priest named Kai, where the master artisan had secretly signed his name under one scene.

The majority of the corselet was discovered inside Box 54, lying on top of a group of vases. However, as a result of the depredations of the tomb robbers and the carelessness with which the necropolis officials replaced the stolen objects, other elements were found on the floor nearby, and still others were scattered around the Antechamber. Much of the corselet's broad collar was found in the Small Golden Shrine (p. 59); another part was discovered mixed with dates inside a dish; and one of the feather inlays was found jumbled together with pieces of a royal chariot.

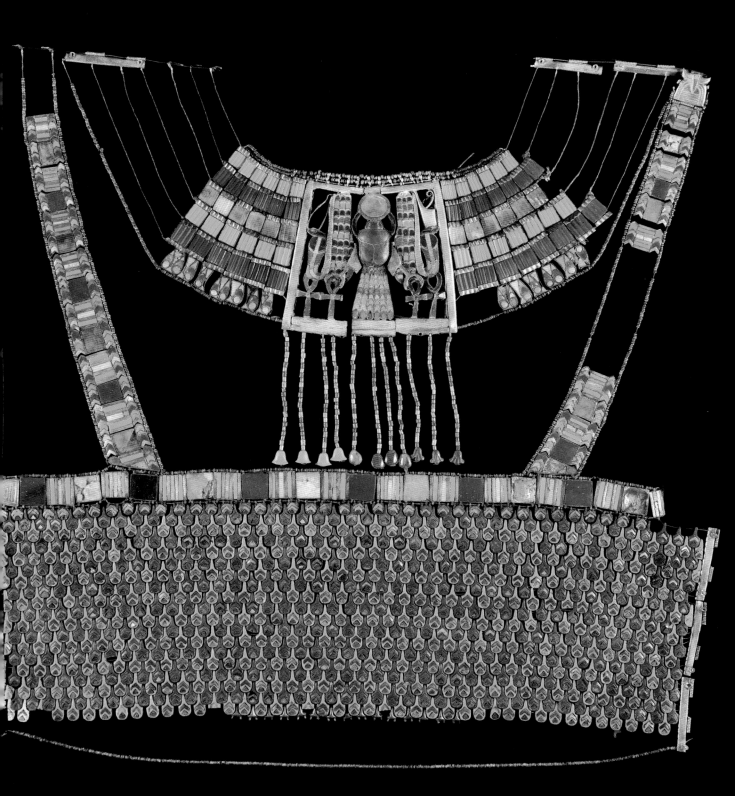

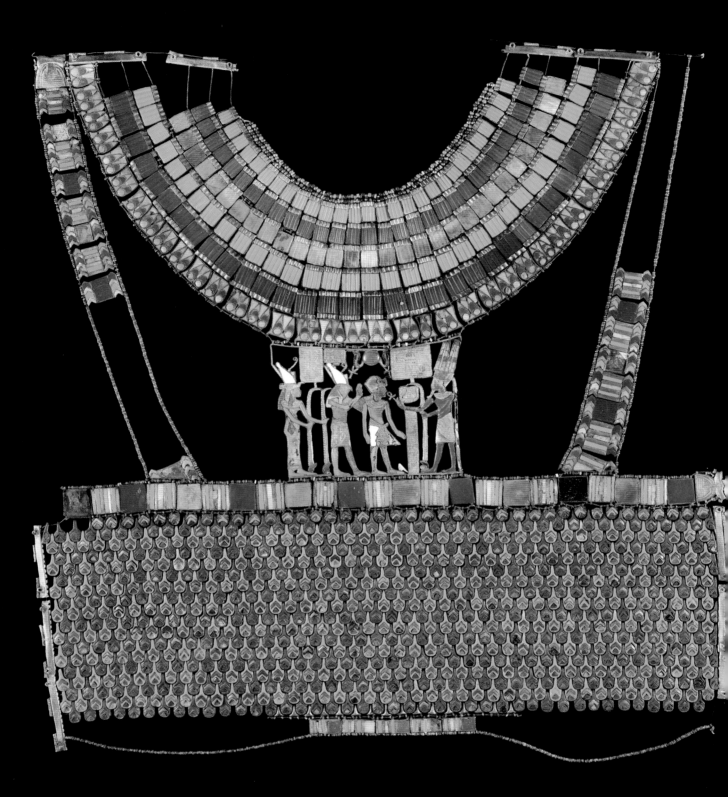

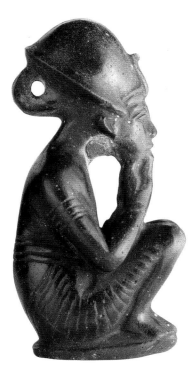

BLUE GLASS ROYAL FIGURE

Glass
Height 5.8 cm
Carter 54ff

Several enigmatic amuletic figures were discovered in the tomb. This example was made of blue glass, and represents a king squatting, with one finger held to his mouth in the traditional gesture of childhood. He wears the "blue" crown or battle helmet, thought by some scholars to indicate his status as both crown prince and war leader. Lines on the king's thighs and upper arms indicate that he is wearing a pleated kilt and tunic. A ring on the back of the head would have been used for suspension. It is likely that this amulet is meant to associate the king with the child Horus, son of Osiris. Egyptian kings were linked with this god from early in pharaonic history, and were seen as his incarnation on earth.

Glass sculpture was rare in the 18th Dynasty, as the ancient Egyptians were only just beginning to become experts in working this material. The figure was probably molded and then polished with an abrasive; its intense blue color may have been achieved through the use of cobalt.

Exactly which king is represented in this statue is still uncertain. Carter believed that it was Akhenaten, Tutankhamun's probable father, but I believe it is Tutankhamun himself. In sculptures of the Amarna period, the neck is longer and thinner than is the case here, although the elongated crown does resemble that worn by Akhenaten in many representations.

RITUAL VESSEL

Faience
Vessel: height 10.2 cm, diameter 10.9 cm
Lid: height 6 cm, diameter 7 cm
Carter 54bbb

Box number 54 was labeled with a docket listing its original contents as "17 blue faience *nemset*-ewers." In fact, it still held 16 such vessels, including the one illustrated here, along with all 17 lids and a number of other miscellaneous objects, such as scraps of cloth and gold sequins, a woven robe, a scarab, a small wooden model tool, two throwsticks, the corselet (p. 44), the duck box (p. 42), the squatting king amulet (above), and the ivory ring box (p. 43). The somewhat random contents of the box, along with the missing ewer, led Carter to suggest that the priests who cleaned up the tomb after one of the robberies used the box as a convenient container for some of the extraneous items that had been left lying around by the thieves.

This *nemset*-ewer in dark blue faience has the typical squat profile of such vessels and a curved spout. The lid is in the form of an upside-down lotus blossom. The inscription gives the birth and throne names of the king in cartouches, along with the wish for eternal life.

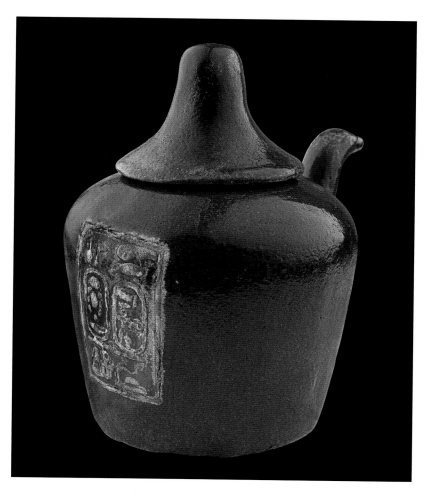

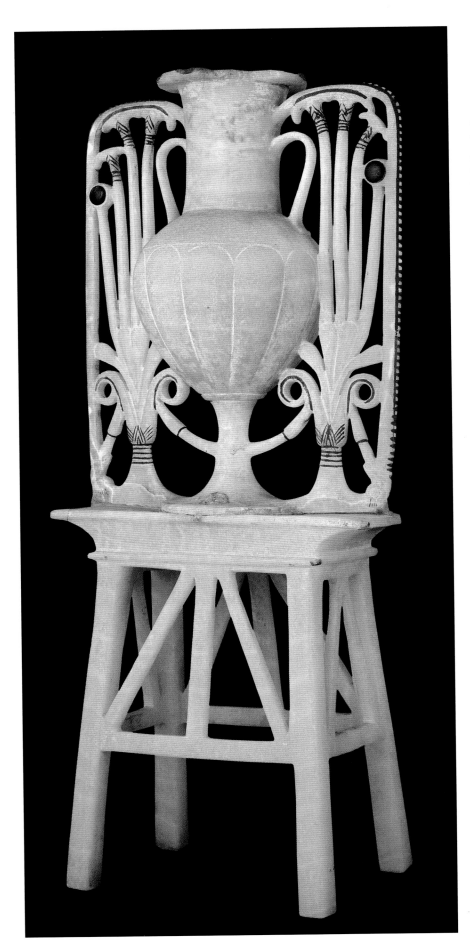

OVOID VASE WITH STAND

Calcite (Egyptian alabaster)
Overall height 65.5 cm
Carter 58

Found between two of the ritual couches (p. 32), this elegant ovoid vase with long neck, tall thin foot, and slender handles, together with the elaborate floral decoration that flanks it, was carved out of a single piece of calcite. As with many other examples of this type of vessel from Tutankhamun's tomb, it is supported on an openwork stand made from a separate block of the same stone. A brownish residue, the remains of some sort of perfumed unguent, was discovered inside the undecorated body of the vase.

The flanking ornamentation represents bundles of papyrus with open blossoms atop an opened lily bud, the whole framed by palm ribs, notched to record individual years and thus symbolizing the passage of time. These palm branches sit on tadpoles, the hieroglyph for "100,000," which are in turn perched atop *shen* signs, representing eternity. Taken together, this combination of signs can perhaps be interpreted as signifying the unification of Upper and Lower Egypt, whose heraldic plants were the lily and lotus, for an infinite number of years. By surrounding the vase with this hieroglyphic message, the contents could be magically imbued with the principal elements necessary for a long reign, which would then be passed on to the king when he used the unguent in the afterlife.

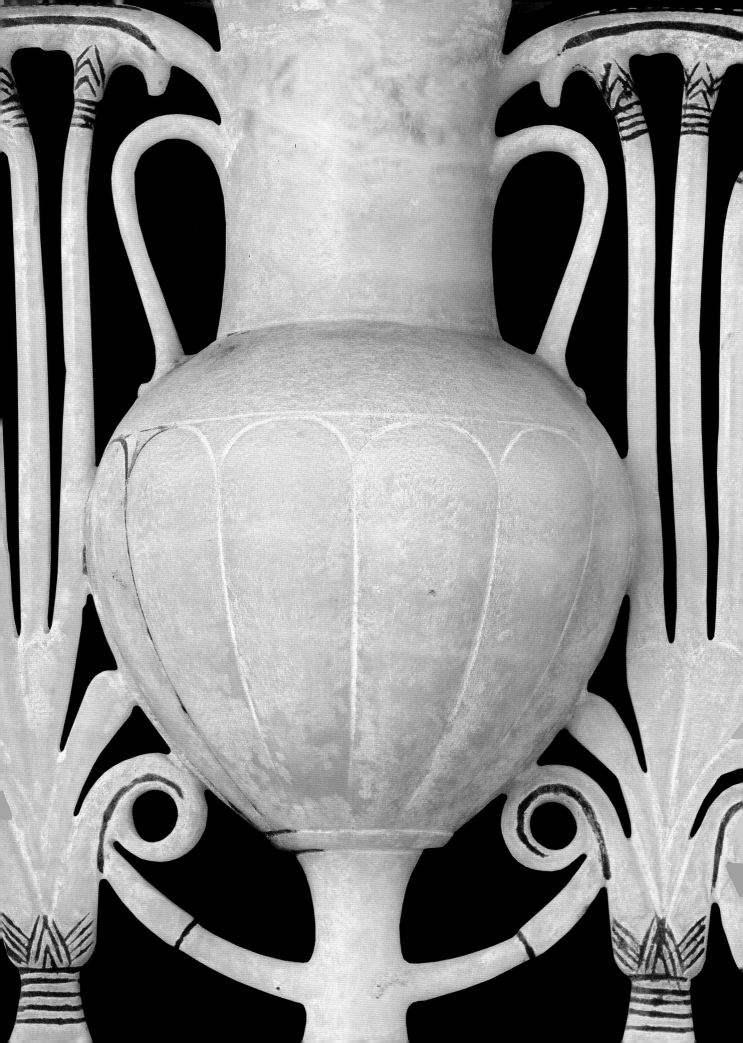

SISTRUM

Gilded wood, gold, copper, bronze
Height 51.5 cm, width 7 cm
Carter 76

The sistrum, a type of rattle, was used in cult ceremonies throughout Egyptian history. When shaken, it produced a gentle tinkling noise thought to echo the sound of papyrus rustling in the wind. Used primarily by priestesses, such rattles were believed to revive the soul of the deceased. Sacred to Hathor, they were especially important in festivals connected with this goddess, such as the Beautiful Feast of the Valley, during which families visited the tombs of their ancestors.

The instrument shown here was found with a second identical example, on top of the cow couch (pp. 32, 33–34); both show signs of use. Each has an eight-faceted handle with a square capital made of gilded wood. The loop on top is made of bronze sheathed with gold; stretched across it are three thin copper wires shaped like cobras, on which have been hung diamond-shaped sounders of the same material.

The form of this sistrum indicates that it was manufactured during the Amarna period. Examples from both earlier and later periods have tops in the shape of Hathor capitals, but Akhenaten, as part of his devotion to one god, the Aten, evidently banned the Hathor capital as heretical. We know that Tutankhamun returned to the earlier style, because one of the images on the Small Golden Shrine (p. 62) shows his wife, Ankhsenamun, shaking a rattle with a Hathor head as she hands the king a broad collar.

It is likely that this instrument and its mate were used during the funeral of the golden king, then abandoned on the couch (also associated with Hathor) as the burial party left the tomb.

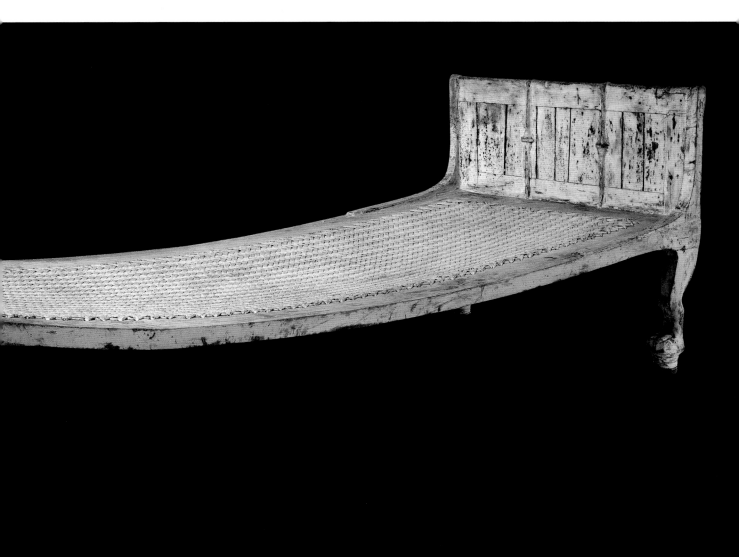

BED WITH LION LEGS

Painted wood, linen, bronze
Length 181.5 cm, width 68 cm
Carter 80

Carter found this relatively simple wooden bed piled on top of the cow couch (p. 32); it had been put there so carelessly that one of the cow's horns was stuck through the mat of linen woven across its frame.

In contrast to the funeral couches, this bed, made of wood and painted white with what is probably a lime wash, is of a type that would have been used by the living. Linen bands were woven across it to support the mattress, which would also have been of linen. A headrest would have been placed at the open end, while the sleeper's feet would have pointed toward the paneled board that today we would expect to find at the head. Some people believe that the head went in

the opposite direction, but others argue that keeping the head low would have improved blood circulation.

The bed stands on carved lion's legs, a decorative element common in Egyptian furniture and one that may have been intended to invoke the animal's magical power to protect the sleeper. Bronze caps were placed over the bottoms of the feet to reinforce the wood. Underneath the woven linen mat, slung between two curved wooden slats that ran between the sides of the bed, Carter found a wooden object which he called a leg support. He interpreted this as a device to allow either the head or the foot end to be raised for the sleeper's comfort.

DUMMY FOLDING STOOL

Wood, ivory, gold
Height 34.5 cm
Carter 83

The ancient Egyptians used both chairs and stools, as can be seen, for example, on the Small Golden Shrine (p. 59), where the king is shown seated on a series of chairs and thrones and his queen is depicted sitting on a variety of stools. This example, one of 12 stools from the tomb, was found in front of the ritual couches (p. 32) and was made in imitation of a folding stool, actual examples of which had seats of leather or animal skin. However, this stool cannot be folded, and so is a dummy example of the type.

The seat, double-curved like most chairs and stools, was made of local wood but was painted dark brown in imitation of ebony, an expensive wood imported from the south. It has been carved and decorated to resemble a cow or goat hide, with inlays of ivory to imitate dappling and legs dangling from each corner; a "tail" ending in an ivory tuft hangs down one side and a "backbone" of lighter wood is shown down the center. Like the two working examples of folding stools found in the tomb, the out-curving, crossed legs end in duck or geese heads. The birds open their beaks to bite the horizontal bars of the base, so that their tongues of red-tinted ivory are visible.

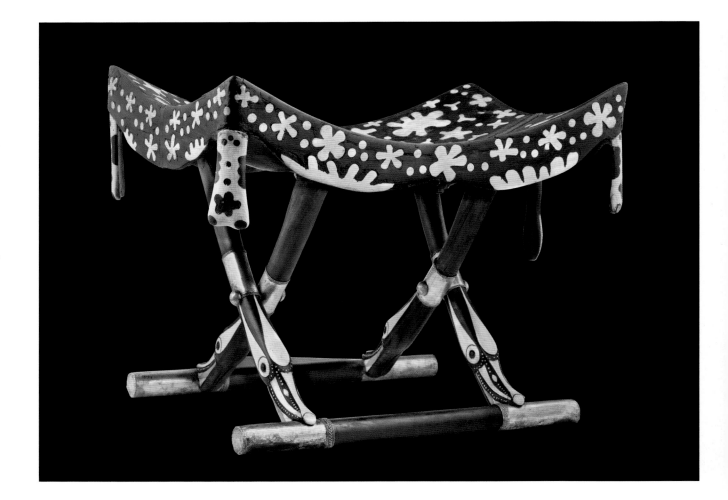

GOLDEN THRONE

Sheet gold, wood, silver, glass, faience, carnelian,
calcite, red paste
Height 104 cm, width 53 cm, depth 59 cm
Carter 91

Found bound with linen bands and hidden
beneath the Ammut couch (pp. 35–36),
the Golden Throne is a match for any item
of royal furniture ever created. It is easy
to imagine Tutankhamun seated on this
exquisite chair, with its slightly tilted back
and roll top, receiving dignitaries from
foreign lands in a stately manner.

Built of multiple pieces of wood
fastened together, the entire chair has been
covered with either painted gilding or sheets
of gold on which intricate images have been
chased and then, in many places, inlaid with
semiprecious stones and colored glass. The
throne is almost completely intact, having
lost only the vertical struts that decorated
the area between the seat and the leg braces.

On the back is an image of the king
seated on a throne apparently identical in
shape to this one. Here, Tutankhamun is
wearing a pleated kilt, a broad collar (p. 125),
and a short round wig held in place by a
fillet (p. 152) and topped by an extremely
elaborate headdress known as an *atef* crown.
Ribbons flutter behind him, and his feet rest
on a footstool, probably decorated with
Egypt's enemies so that he could trample
them symbolically even while seated.

The pharaoh's wife, Ankhsenamun,
stands before him, anointing him with
perfumed oil from a silver vessel. The
bejeweled queen wears a flowing, pleated
robe and a short "Nubian" wig (adopted
from a hairstyle worn by Nubian
mercenaries in the Egyptian army), topped
by a crown composed of two plumes and
a sun disk. Behind the queen is a stand on
which rests a broad collar similar to the
one worn by both figures (shown as if in
a bird's eye view, as the principal purpose
of Egyptian art was to convey information
rather than represent reality). The royal
garments here are made of silver, a metal
much less common in Egypt than gold.

The exposed skin of both king and
queen has been inset with dark red glass.
This is not unusual for a male, as
traditionally men were shown this color.
However, women are more often shown
with golden-yellow skin, presumably
because they spent most of their time
indoors out of the fierce Egyptian sun. Here,
however, husband and wife are both bathed
in the rays of the sun disk – an image of the

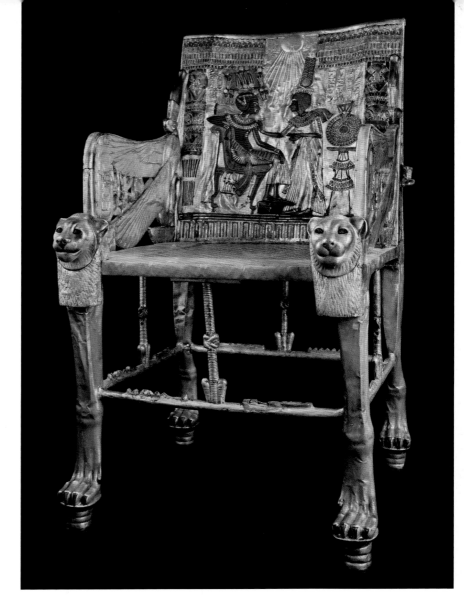

great god Aten – which extend toward them,
offering them life in the form of *ankh* signs.

The arms of the throne (pp. 57–58) are
composed of winged cobras wearing the
double crown of a united Egypt. Between
the tips of each snake's wings are cartouches
containing the name of the king. Smaller
cobras peer out from the space between the
throne's sloping back and the perpendicular
slats that support it; the cobra on the right
wears a tall silver crown – the white crown
of Upper Egypt – and the cobra on the left
wears a short golden crown – the red crown
of Lower Egypt.

This distinction may indicate the proper
orientation at which the throne would have
been set, with the silver-crowned cobra to
the south and the gold-crowned one to the
north, an arrangement probably echoed by
the now-lost struts, with lilies, representing
Upper Egypt, on the right, and papyrus, for
Lower Egypt, on the left. Beautifully crafted
lion's heads adorn the front of the seat, and

the legs are shaped like feline limbs, complete
with inlaid claws.

This magnificent throne clearly dates
from the beginning of Tutankhamun's reign,
if not before: the names which the king
and queen were given at birth and under
which they ruled for almost two years –
Tutankhaten, "living image of the Aten,"
and Ankhsenpaaten, "may she live for the
Aten" – are still visible on the back slats. Both
the iconography and the style of the figures,
with their soft, rounded forms and relaxed
postures, are very much of Amarna period.

The throne is one of the great
masterpieces from the tomb, along with
the mask and the innermost coffin. Carter
himself stated: "I have no hesitation in
claiming for it that it is the most beautiful
thing that has yet been found in Egypt."
I also see it as both a seat on which the
pharaoh could ascend to the sun, and a
wonderful image of the deep love between
the king and his queen.

SMALL GOLDEN SHRINE

Wood, gesso, gold foil, silver
Height 50.5 cm, width 26.5 cm, depth 32 cm
Carter 108

STATUE BASE AND BACK PILLAR

Wood and gold foil
Height 24.8 cm
Carter 108a

Both Egyptologists and the general public alike have always been fascinated by this small shrine, and it is one of my favorite artifacts from the tomb. Carter found it tucked away in the southwest corner of the Antechamber, beneath the Ammut couch (pp. 32, 35–36), just next to the entrance to the Annexe. Some think that it was moved there to allow Carter and Carnarvon access to the Annexe during a surreptitious exploration of the tomb in November 1922. Aside from some jumbled pieces of jewelry, including part of the royal corselet (p. 44), nothing was found inside this shrine, but it looks as if it had been made to hold a statuette.

The shrine is rectangular in shape, with a roof that slopes from front to back set above a torus molding and cavetto cornice, typical elements of Egyptian architecture. It is made of wooden panels that were covered with a thick layer of gesso, into which a series of elaborate scenes and texts were modeled; a thin sheet of gold was then smoothed over them.

At the front of the shrine are two doors that swing outward, closed with two bolts that passed through sets of metal loops. A string (a fragment of which was found *in situ*) would have been tied around a third set of loops and daubed with mud; the mud would then have been stamped with a seal to insure the security of the contents. The entire shrine sits on a wooden sledge plated with silver.

Inside the shrine is a wooden back pillar for a statuette, also lined with gesso and gold sheathing and engraved with formulaic texts that give the king's names and epithets, and wish for him eternal life

and health. Perhaps the most fascinating aspect of this piece is the statue base found with this back pillar. Made of ebony, it was engraved with tiny footprints, just 3.7 cm long and 1.4 cm wide. We do not know whether or not a statuette, perhaps of precious metal, once stood inside, fitted to this base. Carter himself suggested that the shrine was built to hold two images. Other scholars have theorized that the footprints were considered to be magical, and represented some special aspect of the king by themselves, without the need for an actual image.

It is the decoration of the shrine that is the most interesting to me. Like the Golden Throne (p. 56), it is a wonderful testimony to the depth of the love between Tutankhamun and his wife, Ankhsenamun, and to the importance of their relationship to the proper functioning of the Egyptian cosmos. Representations of the royal pair cover the panels of the shrine, portraying them in a variety of outfits and poses. In some scenes the couple are seen attending to one another, and in others the king is depicted carrying out activities, such as

fowling in the marshes, with the queen's assistance.

Much of the imagery here carries sexual overtones: for example, the ducks in the marshes are erotic symbols, as are lotuses and the oils and necklaces offered by the queen to her husband. The words for many of the actions represented, such as pouring, shooting, and throwing, share common linguistic roots with sexually charged terms such as ejaculating and begetting. Sexuality was inextricably intertwined with regeneration and resurrection, thus the shrine helps to guarantee eternal life to both Tutankhamun and Ankhsenamun. At the same time, Tutankhamun functions here as a delegate of the sun and creator god, and acts to maintain the proper order of the universe.

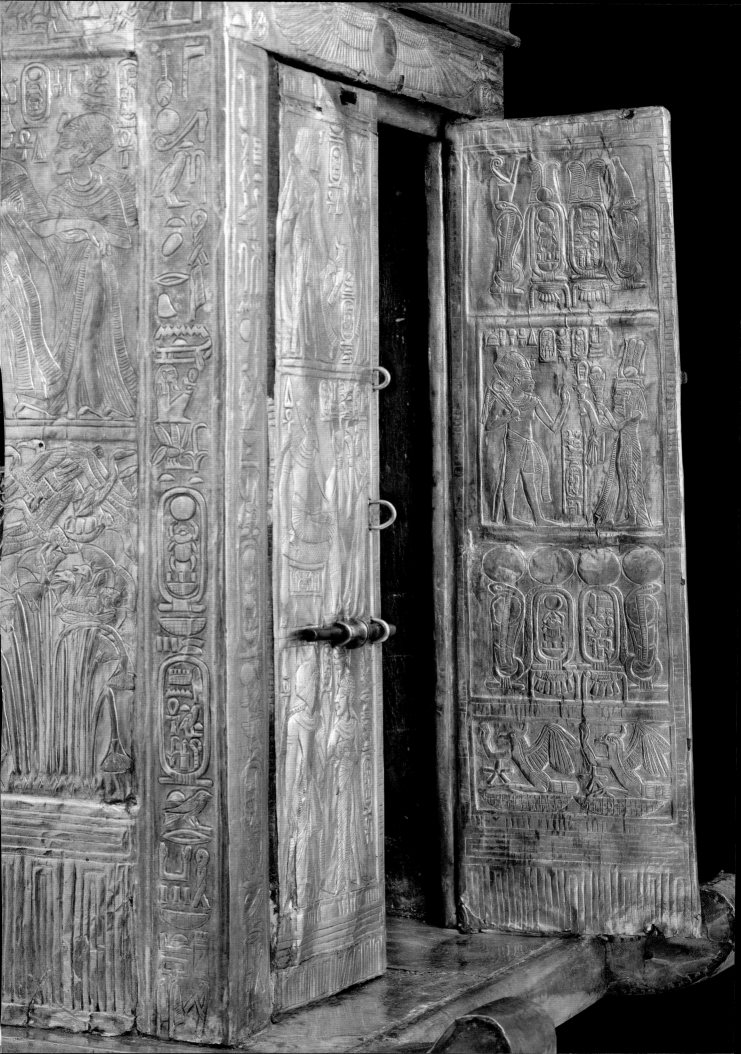

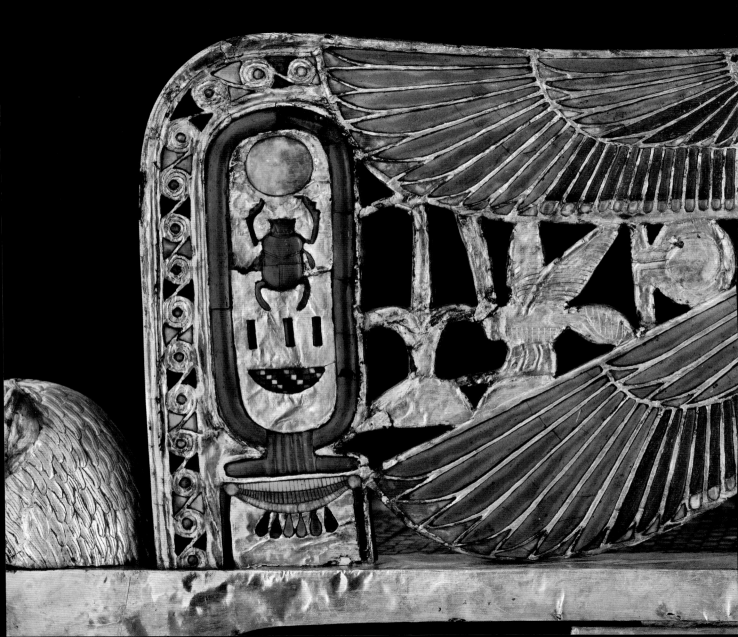

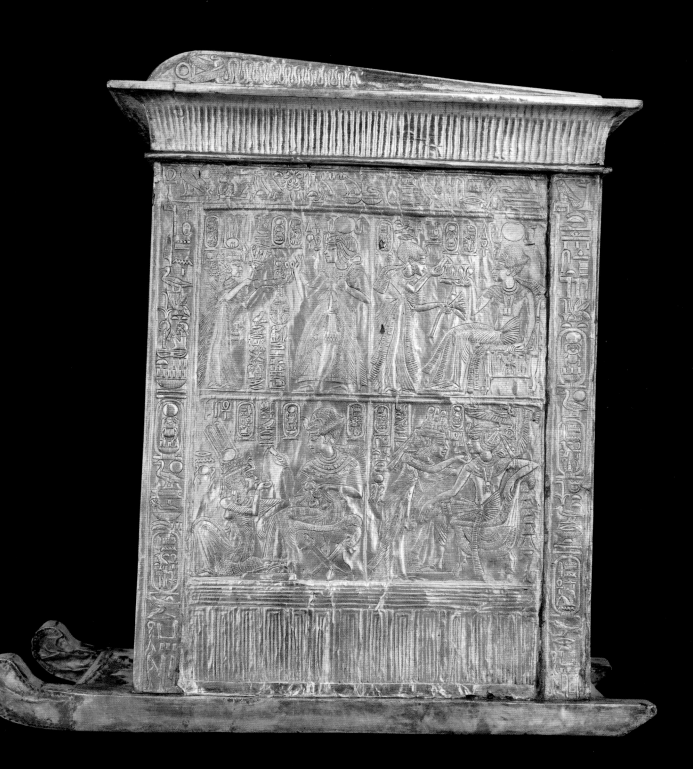

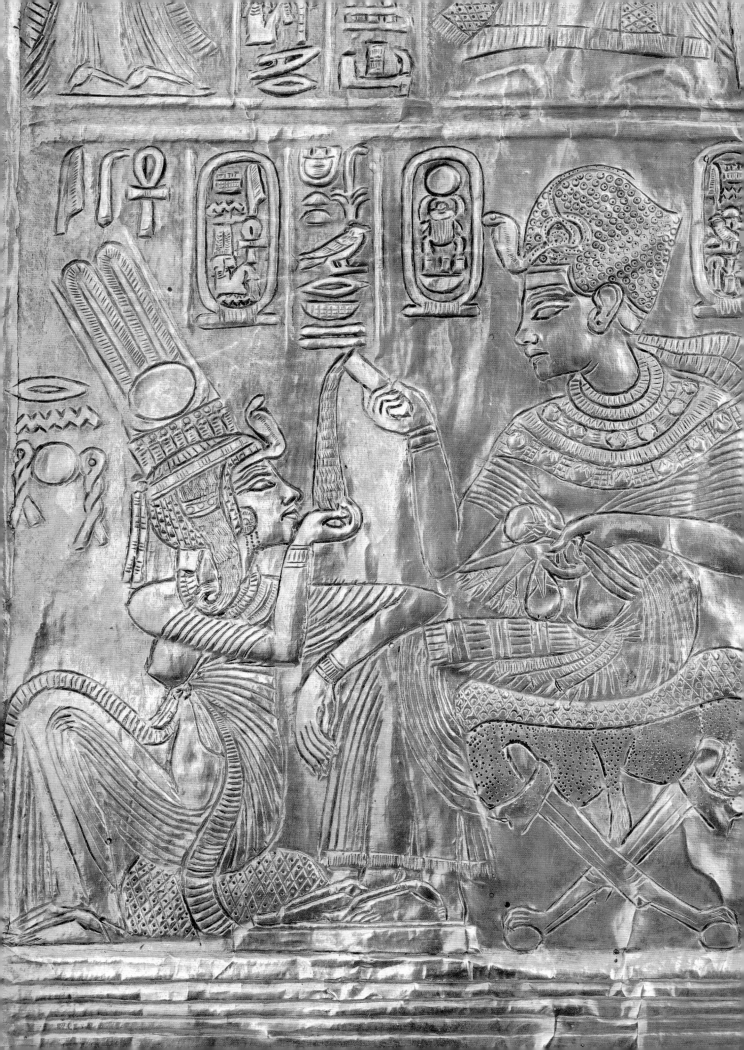

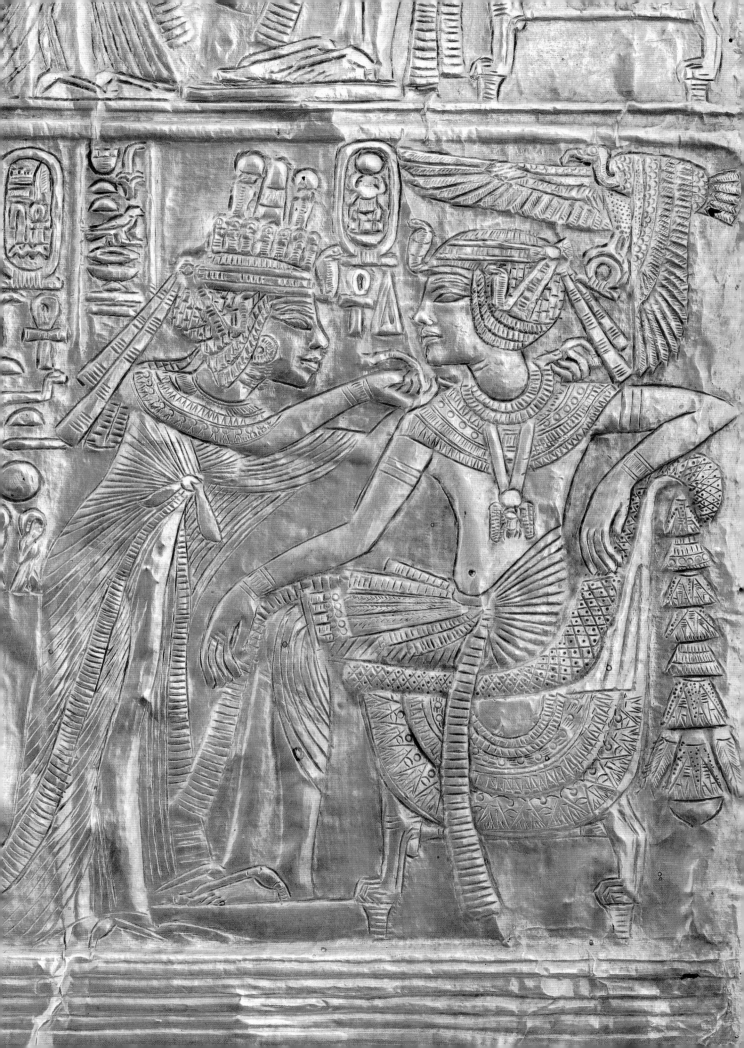

TORSO OF TUTANKHAMUN

Wood, gessoed and painted
Height 76.5 cm, width 41.5 cm, depth 30.3 cm
Carter 116

When I look at this object, found below one of the chariots, I feel as if I am looking directly at Tutankhamun himself. Made of gessoed and painted wood, this unique figure is a life-size model of the head and torso of the king. The colors with which it has been painted – pale yellow for the shirt that covers the torso, yellow for the crown, and a dark reddish brown for the face, with details of the features and *uraeus* on the front of the crown added in other hues – give this an incredibly life-like appearance.

The face is clearly Tutankhamun's, with its distinctive oval shape, full cheeks, rounded chin, large eyes, elegant nose, and Cupid's bow lips. Set next to the Nefertem head (p. 16), there is no doubt that the same youth, albeit older here, is represented. Even the slightly protruding ears, with their large piercings, are a match. To me, this is one of the most beautiful objects from the tomb.

The purpose of this figure remains a mystery to scholars. Only the upper arms are included, and Carter suggested that it was a mannequin, used to hold the king's robes and jewelry in preparation for ritual occasions, or for fittings, like a dressmaker's

dummy. There are marks on the surface that might match a corselet (p. 44), adding credence to this theory. If this were the case, it perhaps once stood in the royal palace, or in a temple. However, I do not accept this interpretation, as it seems to me that it is a European construct – one that would not have applied to an ancient Egyptian object.

It is possible instead that it was some sort of ritual figure, like the Nefertem head. It cannot, however, be interpreted as a *ka* figure for receiving offerings, like many tomb figures, because it has no arms. Scholars have drawn parallels between this and some Middle Kingdom statues that seem to relate to the identification of the king with Osiris and thus his eternal rebirth. It might be linked to even earlier sculptures, seen in several Old Kingdom tombs, where heads or torsos are shown emerging from the floor or wall, but again, these have arms. In some ways it also resembles the ancestor busts found in private contexts in the later New Kingdom, but in other respects is quite different from these. Another possible explanation is that it is only part of a larger statue. Egyptian statuary was often made in

several pieces that were then joined together. In many cases, a variety of materials were used in a single sculpture. Although there are no signs of attachment here, and no evidence for additional pieces was found nearby, I still believe that this might be only part of what was meant to be a complete statue of the king.

The crown here is unusual. It most resembles the flat leather bonnet worn by the god Amun (the head of the Egyptian pantheon at this time), but Amun's headdress does not include a *uraeus* as is seen here. The face also lacks a divine beard, so although some link with Amun can be suggested, the figure cannot be interpreted strictly as an image of the king as this god. The crown also brings to mind a platform crown seen worn by Akhenaten in many relief scenes, but we do not know what it meant to either Akhenaten or Tutankhamun. One thing seems certain: Egyptologists will surely continue to struggle with the interpretation of this object for some time to come.

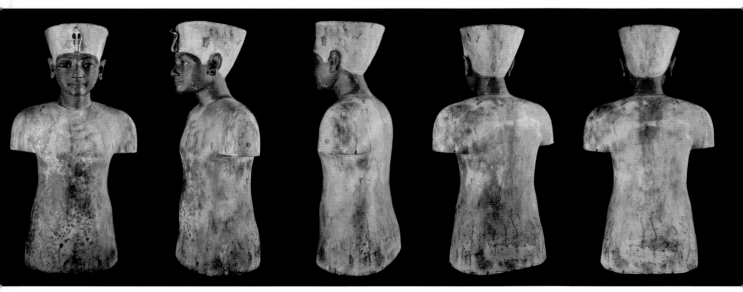

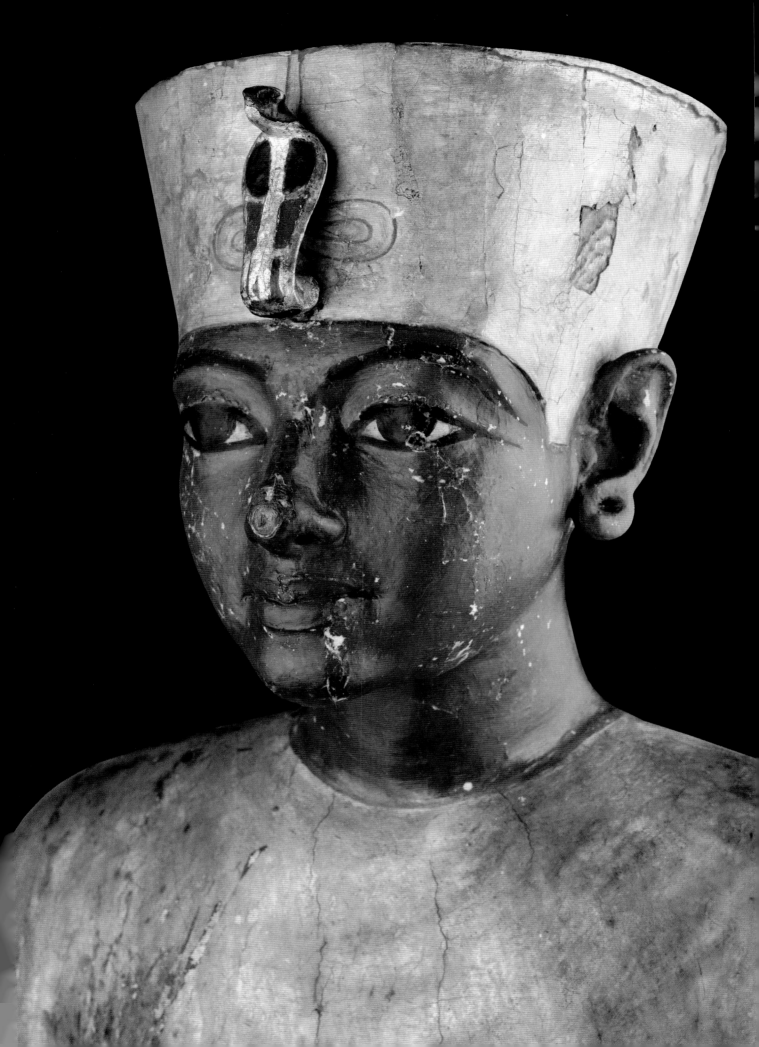

CEREMONIAL CHARIOT

Wood, gold, gesso, glass
Body: width 105 cm, depth 46 cm
Carter 120

CHARIOT FITTINGS

Gilded wood, glass

Blinkers: length 10.5 cm, height 10 cm
Carter 122i

Bes-head disks: height 6.7 cm, height 6.2 cm
Carter 122l

Hawk with sun disk: height 40 cm
Carter 122f = Carter 160

Cheek rowel: length 55 cm
Carter 120j = Carter 152

Detail of harness saddle
Carter 120e = Carter 158

Six complete chariots were found in the tomb, all dismantled in order to fit through the narrow descending corridor. Fragments and fittings from other chariots were also discovered. Four chariots were placed in the Antechamber, stacked against the east and south walls. The state chariot illustrated here is one of the most lavishly decorated and elaborate of the six, which also included several hunting chariots.

The frame of this chariot was constructed of wood, its panels gessoed and covered with gilding. The decoration was impressed into the gesso and the gilding that overlay it. Most of the exterior of the body is covered with a pattern of running spirals, an Aegean or Syrian motif that became part of the Egyptian repertoire during the cosmopolitan

18th Dynasty. A central panel, directly below the king when he stood in the chariot, has cartouches containing three of his names below a winged sun disk; this in turn is flanked by crowned *uraei*, the lily of Upper Egypt, and the papyrus of Lower Egypt.

Much of the chariot's ornamentation is dedicated to the motif of the king's triumph over his enemies. Two prisoners, a Nubian and an Asiatic, their bodies curved backward in eternal discomfort, decorate the ends of the yokes. On the inside of the chariot, below a row of the names and epithets of the king, are the heraldic plants of Upper and Lower Egypt: one lily stalk is tied around the neck of a captive Nubian chief while a papyrus stem binds an Asiatic prince. The remainder of the chariot's interior is filled

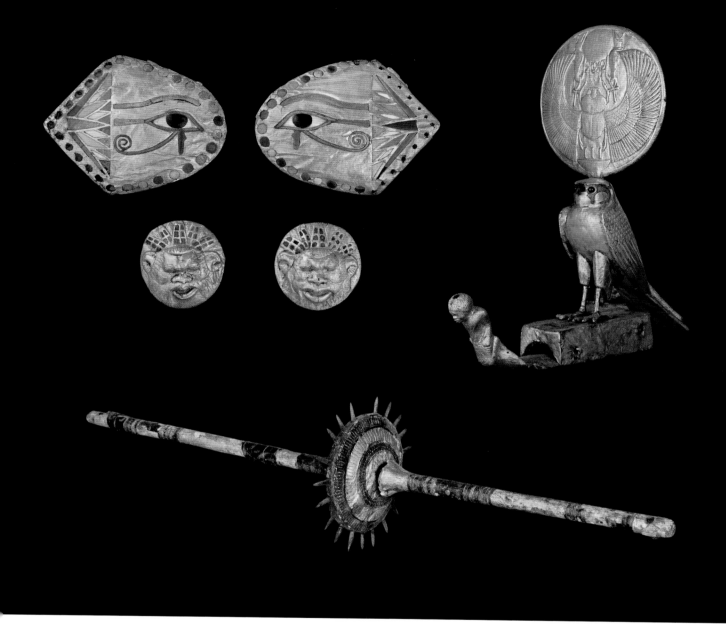

with kneeling enemies of all ethnicities, with ropes tied around their necks and their arms bound in uncomfortable positions.

Another important feature of the chariot's decoration is the prominence of the household god Bes. Bes heads of wood covered with gold, their protruding tongues made of ivory and their crowns inlaid with colored glass, adorn the back of the chariot platform (detail right). These would have flanked, and thus guarded, the king (and the queen, if she accompanied her husband) when he stood on the floor of leather thongs, covered by a leopard skin and imitation fleeces. Additional Bes heads decorate other parts, including a harness saddle (p. 71).

The fittings seen here were found loose, and belonged to both this chariot and the second state chariot, Carter 122. The blinkers with *wedjat* eyes (above, top left) and the cheek rowels (above, bottom) were parts of the trappings of the horses that drew the chariots, while the small Bes-head disks were fastened to it; the gilded wooden hawk would have fitted over the center pole.

The concept of the chariot, a fighting vehicle pulled by horses, came to Egypt during the Second Intermediate Period, about two centuries before Tutankhamun ascended the throne. The Egyptian chariot was designed to carry two people, but was lightweight so that it could be easily maneuvered. A powerful war machine, its effective adaptation by the Egyptian army was one of the weapons that helped the 18th

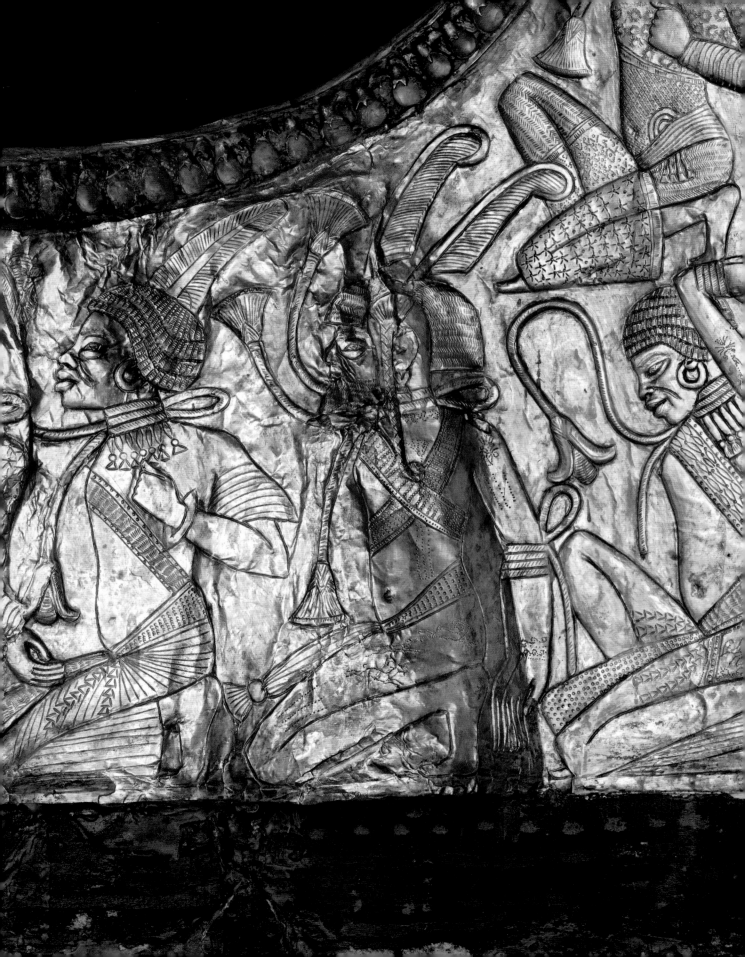

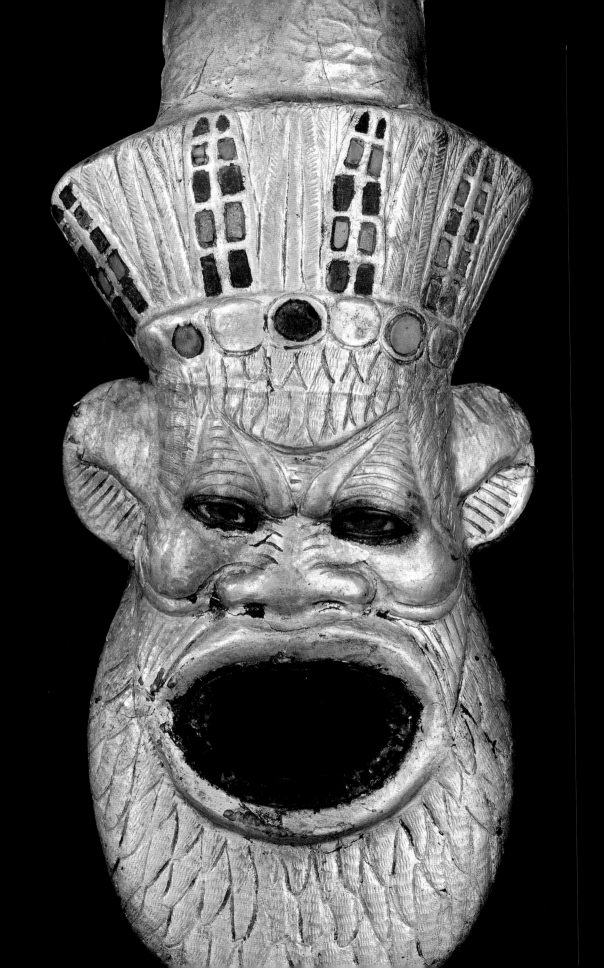

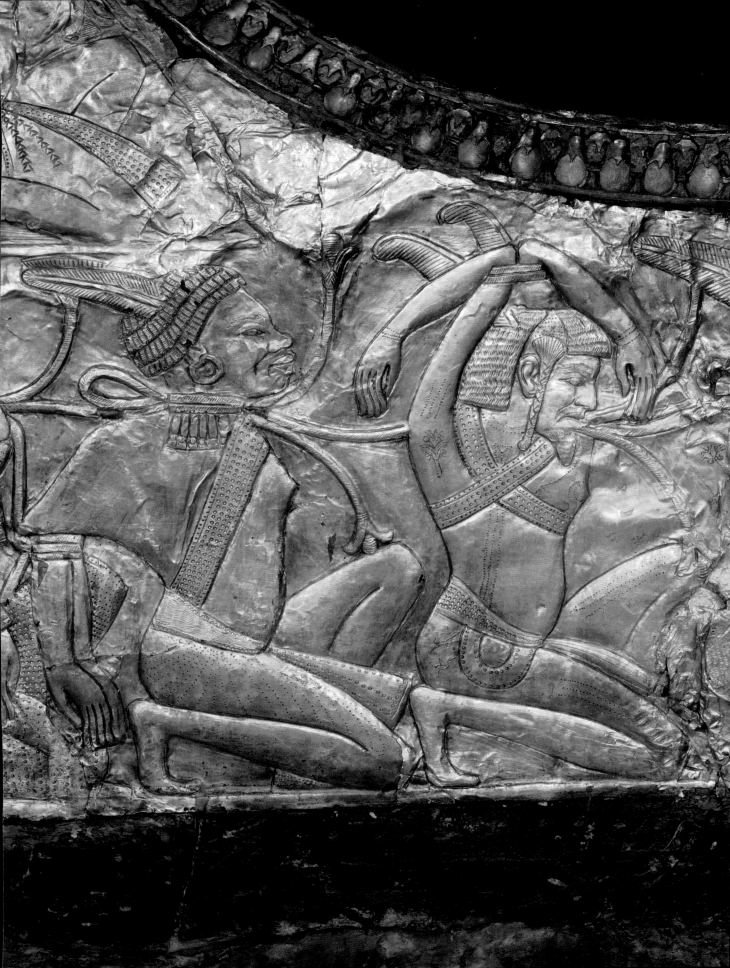

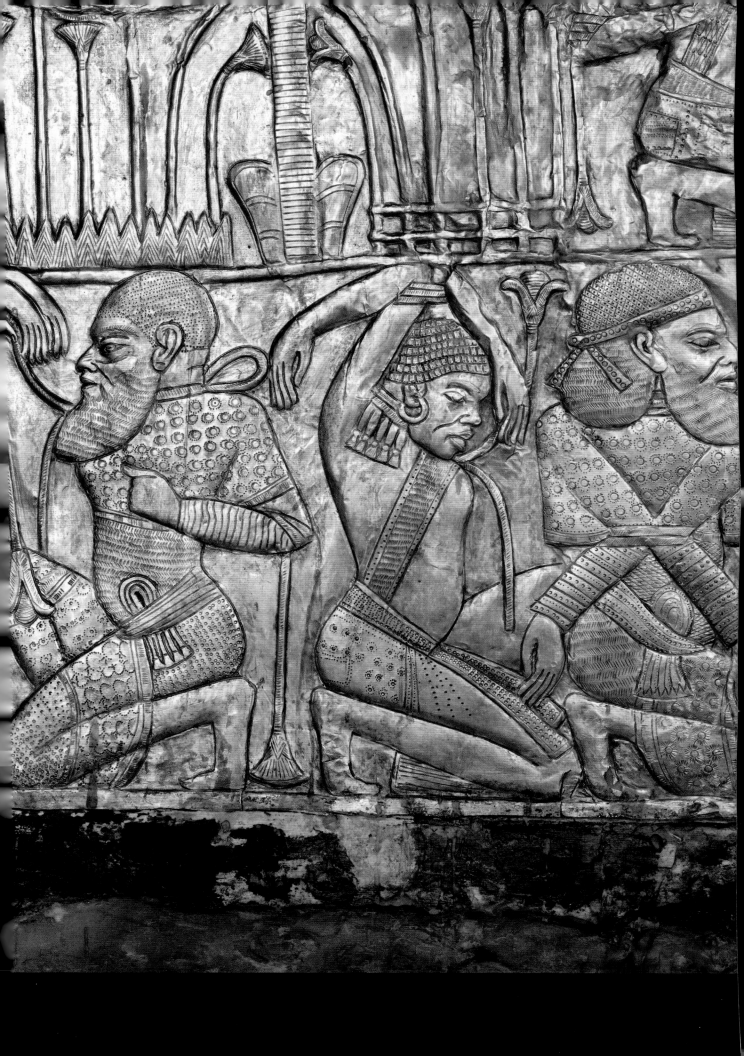

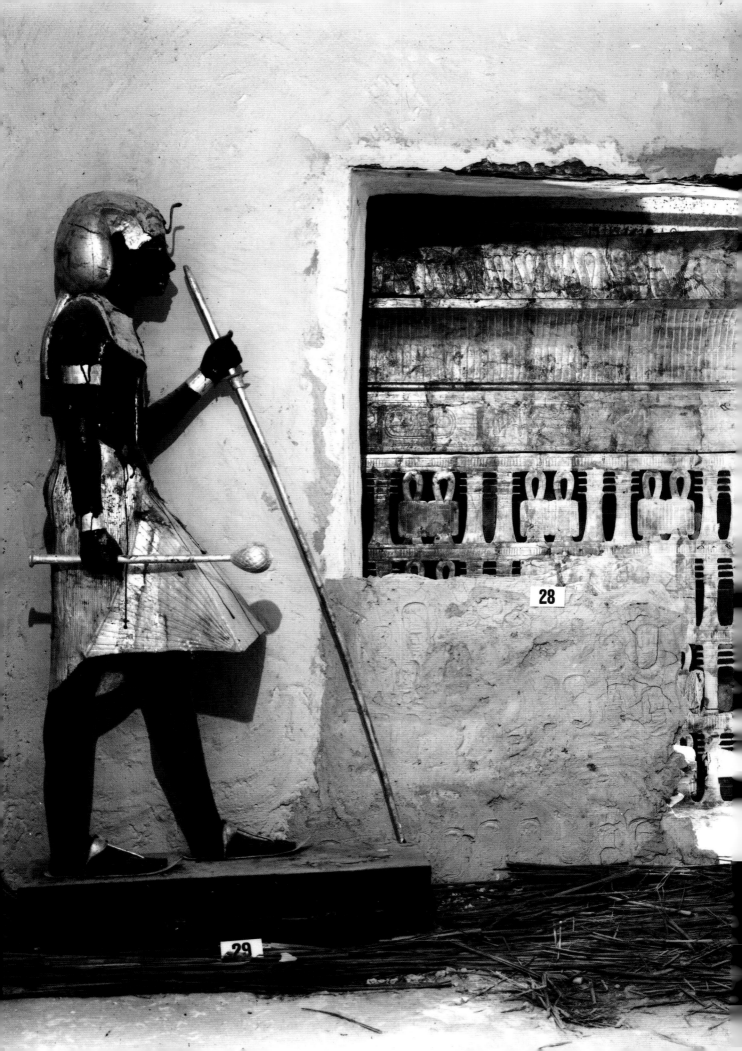

THE BURIAL CHAMBER

Two life-size statues of Tutankhamun (pp. 29–30) guarded the entrance to the Burial Chamber, which is visible on the right of this photograph, with part of the blocking still in place; the wall of the outermost shrine fills the space beyond. The statue shown here, wearing the *khat* headdress, is Carter 29. Photograph by Harry Burton.

THE OFFICIAL OPENING of the room to the north of the Antechamber took place on the afternoon of 16 February 1923. Carter and his team were accompanied by Lord Carnarvon, the Earl's brother Mervyn and his daughter Lady Evelyn, as well as by Pierre Lacau, head of the Antiquities Service, and a number of notable Egyptologists and Egyptian dignitaries. The press had been hovering around for days, suspecting that something was about to happen, but the archaeologists outwitted them, and managed the opening for the most part undisturbed by the media.

The scene was set: the Antechamber had been completely cleared and rows of chairs were set up in it to accommodate the visitors. The guardian statues had been protected by wooden boards, and a platform had been constructed so that the wall could be opened from the top down. Carnarvon welcomed everyone, and then Carter made what appears to have been a somewhat inarticulate speech. With everyone watching, Carter opened a small hole and shone a flashlight inside. Just inside the wall, filling almost the entire chamber, was what looked to him like "a solid wall of gold." This was an enormous shrine, the outermost of four, made of gilded wood inlaid with faience plaques in a pattern of *djed* pillars, symbols of Osiris, and *tjet* knots, emblems of Isis. The observers knew without a doubt that the Burial Chamber (or, as Carter originally called it, the Sepulchral Chamber) lay before them.

Although Carter never admitted this publicly, there is little doubt among scholars (and none at all in my mind) that he, Lord Carnarvon, and Lady Evelyn had entered the Burial Chamber much earlier (probably at night), and knew exactly what lay beyond the plastered wall. The robbers who had violated the tomb in antiquity had gained access to the Burial Chamber by opening a small hole. The necropolis police had then plastered over it and stamped their seal over the patched area; it would not have been too difficult for Carter and his companions to reopen it and get through. In photographs taken of the Antechamber before the official opening of the Burial Chamber, an ancient basket and bundles of reeds can be seen piled up before the northern wall, between the guardian figures. It is likely that Carter put these here himself to hide the evidence of his clandestine explorations. In fact, I would guess that the platform was constructed at least in part to conceal the breach the illegal party had made.

On the day of the official opening, Carter worked for the better part of two hours with a hammer and chisel, removing the stones that formed the upper part of the wall and passing them to his assistant, Arthur Mace. Finally, the hole was large enough for him to enter the Burial Chamber, followed by the rest of those present. The outer shrine filled most of the room, but they could still squeeze in. To everyone's initial disappointment, the doors to this shrine were open, and the seal was missing, perhaps removed by the ancient robbers. Inside, they could see an enormous rosette-spangled linen pall on a wooden frame protecting a second shrine. This pall had disintegrated in front of the doors to the second shrine, and these were still bolted shut – the seals were intact! Everyone present now knew that the mummy of the king must still lie inside, undisturbed by the ancient robbers, but it would be over a year before they could look upon his face.

The week following the opening of the Burial Chamber was consumed by visits from the press and dignitaries (chief among them the Belgian queen, Élisabeth, who was fascinated by the whole process), and then it was time to close the tomb for the season. The following months were still extremely eventful. To begin with, there seems to have been a short-lived falling out between Carter and Carnarvon, caused, some have speculated, by the relationship between the archaeologist and Carnarvon's daughter, Lady Evelyn. I believe that Lady Evelyn did fall in love with Howard Carter, but that he did not return her affections, and thought of her only as a close friend. Whatever their relationship may have been, Lady Evelyn married less than a year after the opening of the Burial Chamber.

The Death of Lord Carnarvon

Following a short vacation, Carter and his team returned to the Valley of the Kings, to work in their laboratory in the tomb of Seti II, preparing objects for transport to the Egyptian Museum. Carnarvon headed to Cairo on 14 March, and several days later, Carter received the dreadful news that his employer and friend had fallen ill. A mosquito bite on the Earl's cheek had become infected, and his immune system, never strong since a car accident many years before, was not up to the fight. Blood poisoning led to pneumonia, and in the early morning of 5 April 1923, Lord Carnarvon died. Arrangements were made to ship the body back to England, and after bidding his patron a final farewell, Carter returned to Luxor to finish the closing of the tomb and to complete the moving of the Antechamber objects to Cairo. On 25 May, Carter set sail for London.

The 1923–24 season was scheduled to begin in October, and Carter was anxious to return to the Valley as soon as possible. He had several promising meetings with Antiquities Service officials on the contentious subjects of press access and visitors in early October. Lord Carnarvon had, perhaps inadvertently, created a great deal of political ill-will when, in January 1923, he signed an exclusive contract with *The Times* of London, guaranteeing that they would be the only news outlet given direct access to information about the excavations. This was unacceptable both to the newly nationalistic Egyptian press, who felt unfairly excluded from the work, and to the other foreign media. The issue of who controlled visitors to the tomb was another point of disagreement: Carter objected to the constant interruption to the work, not to mention danger to the artifacts, created by visitors, and wanted to limit the times when outsiders could enter the tomb.

For the new season, it was agreed that Arthur Merton, formerly of *The Times* but now on Carter's staff, would issue daily press bulletins to *The Times* in the evening and the Cairo press the next morning. Carter proposed that, rather than having regularly scheduled visiting days every week or two weeks, they could arrange a week's worth of visits whenever it was convenient to suspend work in the tomb. Everything seemed fine, and he headed down to Luxor. However, the reality was not so simple: there was much outcry from other members of the press, and the many permits issued for "official" visitors continued to interfere with the work. Negotiations between Carter and the government on the topics of the press and visitors continued, and forced the archaeologist to take a number of trips north to meet with officials.

The other issue still to be resolved was the question of whether or not the tomb should be considered intact. This was a crucial question, since the contents of an intact tomb, by law, had to be kept together, and no division of finds could be made. Carnarvon had invested a great deal of money and time in the search for Tutankhamun, and wanted objects in return, as was the usual procedure; after his death, Carter continued to fight this battle on behalf of Lady Carnarvon.

Finally, on 14 November, a new agreement was signed, and the tomb was reopened five days later. On 2 December, the wall between the Antechamber and Burial Chamber was demolished, and work on the artifacts in the Burial Chamber began.

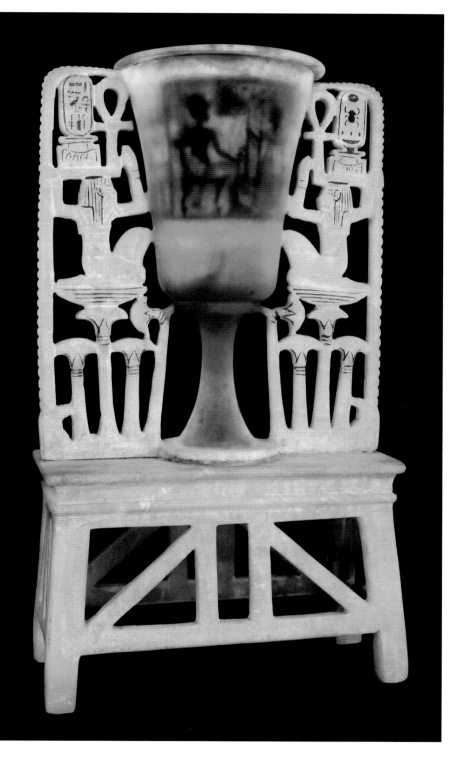

The extraordinary masterpiece illustrated here, designed to function as a lamp, was found in the southeast corner of the Burial Chamber, in what Carter believed to be its original position within the tomb. It takes the form of a tall lotus-shaped goblet attached to a stand. The goblet is flanked by openwork figures of the god Heh gripping *ankh* signs and notched palm ribs, signifying millions of years of life. The twin deities kneel on baskets, meaning "all," and hold cartouches containing the king's birth and throne names above their heads. Below them are clumps of papyrus plants. Taken together, these symbols help to guarantee eternal life to the king, and aid him on his journey to immortality.

The most interesting feature of this lamp is the design painted on a thin slab of calcite that fits into its interior, which can only be seen when the lamp is lit. It shows the king in the blue crown, seated on a chair and holding an *ankh* sign in one hand. His wife Ankhsenamun, dressed in a flowing robe and a Nubian wig, approaches him and offers him notched palm ribs, reiterating the theme of long life. On the other side of the insert is a hieroglyphic inscription. The craftsman here was clearly influenced by the art of the Amarna period, and the connection between light and life had echoes in the solar religion of Akhenaten. The goblet and its flanking symbols have been set onto a low calcite stand carved in a simple openwork trellis.

Most ancient Egyptian lamps found before the discovery of Tutankhamun's tomb were simple pottery saucers which would have been filled with oil (most likely sesame or castor) on which floated a wick of twisted linen. However, it is clear from this object, as well as a second calcite lamp and the *ankh* torch-holders found in the Antechamber (p. 37), that palaces had more sophisticated lighting systems.

SILVER TRUMPET WITH WOODEN CORE

Silver, gold, painted wood
Length 58 cm
Carter 175

Carter found this trumpet wrapped in a bundle of reeds on the floor of the Burial Chamber, underneath the calcite lamp (p 75). It is made of silver with a mouthpiece of beaten gold; the rim of the flared end is also decorated with gold. The bell of the trumpet is engraved with lotus petals, reinforcing its similarity in shape to the blossom of this flower. Between the petals are alternating cartouches containing the king's throne and birth names. The gold band around the rim is also adorned with a pattern of stylized petals.

On one side of the bell, a rectangular area has been reserved for a scene depicting Ptah, patron god of Memphis, being approached by Amun-Re, king of the gods, and the sun god Re. In ancient religious literature, these three gods were considered a holy trinity, with Ptah serving as the body, Amun(-Re) the hidden name, and Re the visible one. By the Ramesside period (less than a century after Tutankhamun), these gods, along with a fourth (Seth), were associated with the principal divisions of the army. In Egyptian art, trumpeters are shown sounding fanfares in military contexts, and one of Carter's colleagues suggested that this trumpet served a military purpose.

A trumpet-shaped wooden core, painted with a lotus design in red, green, and blue, was found inside the trumpet. This was probably intended, as Carter noted, "to prevent [the trumpet] being squashed in transport."

Patterns of wear show that this instrument was used, and not just made for the king's burial. A second trumpet (Carter 50gg), made of a copper alloy and decorated with a similar design, was also found in the tomb.

Both trumpets were played in modern times to satisfy curiosity about what they might have sounded like. It was discovered that they were both tuned to sound in fifths, and were probably played in a rhythmic pattern. In 1939, the silver trumpet shattered when it was blown by a bandsman for a broadcast by the BBC, but was restored immediately and its sound was later recorded. Most listeners today find the tone quite beautiful – not too different from the sound produced by a modern trumpet.

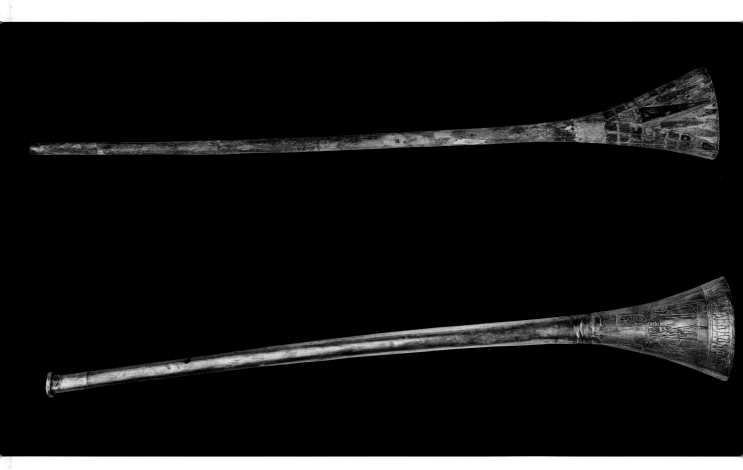

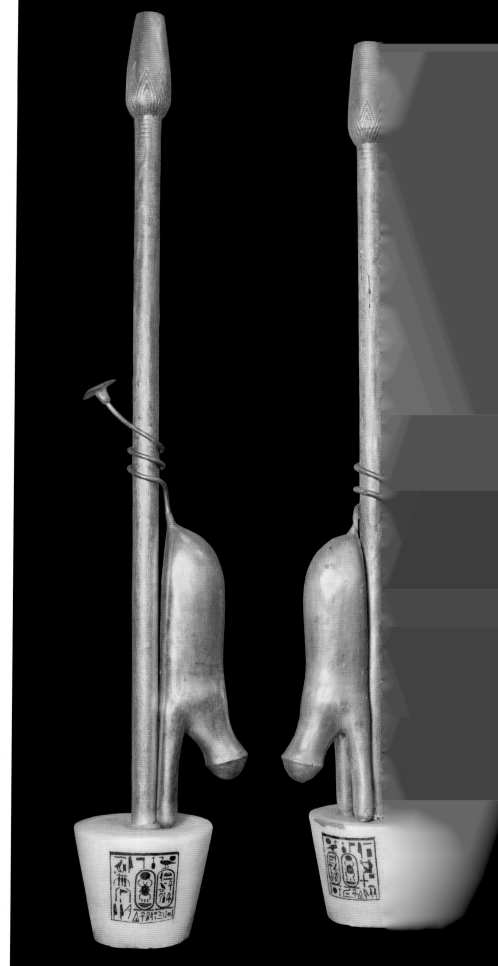

"ANUBIS FETISHES"
Calcite, gilded wood, bronze
Height 167 cm
Carter 194 (left and detail below)
and Carter 202 (right)

These strange objects are emblems of Anubis, the jackal-headed god who was believed to oversee the process of mummification and burial. In ancient Egyptian, they were called *imy ut*, an epithet of this god meaning "he who is in the bandages." Carter found them placed on reed mats on the west side of the Burial Chamber, one in each corner. The west was traditionally associated with death and the afterworld, and their positioning is thus clearly linked with the journey to the netherworld.

 Each fetish takes the form of a representation of a headless animal skin suspended by its tail, which wraps around a pole fixed in a calcite base (described by Carter as a flower pot). The bases are inscribed with the names and epithets of the king, here referred to as beloved of Anubis, "who is in the divine booth" (Carter 194: left in the photograph, with detail below) and "who is in the bandages" (Carter 202). Each wooden pole is topped with a carved lotus bud, and the long, thin tails of the animals open at the end in papyrus flowers. The animals' skins are made of gilded wood, while the tails are of bronze. An actual example of such a fetish made from a real animal skin stuffed with linen is known.

COSMETIC JAR WITH RECUMBENT LION

Calcite, ivory, copper, gold
Height 26.8 cm, width 22 cm
Carter 211

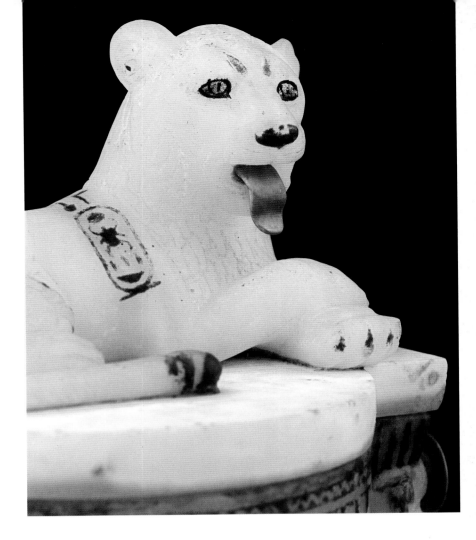

Most of the calcite vessels from the tomb were found in the Antechamber and Annexe. This example, however, lay between the walls of the first and second shrines in the Burial Chamber, and thus may either have had special ritual significance or have played a role in the funeral ceremonies. Carter found residues of a cosmetic substance consisting of a mix of vegetable resins and animal fats inside its cylindrical body. Made primarily of calcite, the jar has additions in ivory and copper and is decorated in the Amarna style.

The sides were carved and painted with an elaborate scene of lions and dogs attacking desert ungulates, which are shown in the natural color of the stone reserved against a background that has been roughened and painted a bluish black. As is usual in such desert hunts, the strict register lines traditional in Egyptian art have been waived, so that the animals are arranged in a seemingly random, yet carefully balanced manner, both on and above the ground line. The desert landscape is evoked by clumps of savannah plants scattered around the scene. The lower edge of the vase is adorned with a band of niches, representing the palace façade so common in Egyptian art from the earliest

periods onward; this motif is seen especially at the base of rectangles called *serekh*s, which traditionally held some of the names of the king. Above the hunting scene is a band of pendant triangles that echo lotus petals, superimposed on stripes of red, white, and black, with wavy lines above and below.

The cylindrical receptacle is flanked by pillars in the shape of lotus plants, inscribed with the names and titles of the king. The petals of the lotuses have been painted green, and a band of gilding divides the columns from the capitals. On the very top of the columns are heads of the god Bes, with features picked out in paint and tongues of pink-tinted ivory. Bes is one of my favorite deities – he is represented as a grotesque dwarf with leonine features, and was responsible for protecting women and the household. Protruding from the base of the jar are four stone heads representing enemies of Egypt, as if the jar had fallen on these unfortunate men and squashed them. Two of the figures are Nubian, carved in black stone, with "gold" hoops (actually of ivory) in their ears; the other two, below the columns, are Asiatics in red stone.

On top of the lid, which opens by a swivel mechanism and was held closed by string wound around knobs, lies a recumbent lion, carved from the same block of calcite. A cartouche of the king ("the good god, Nebkheperure") is carved on its shoulder. The beast lies with its paws crossed and its tail curled around its body. Gilding has been used on some of the features, while the eyes, brows, ears, nose, claws, and the tip of the tail have been highlighted with blue paint. The tongue has been added in pink-stained ivory.

This lion, specifically linked with the king through the inscription on its shoulder (as well as those in the desert hunt), represents power and virility, and associates Tutankhamun with the creator god responsible for maintaining the proper order of the cosmos. The forces of disorder, represented here by the desert animals and the defeated enemies under the base, threatened this order. Both hunting and warfare were associated with the eternally reiterated creation, during which the powers of chaos were defeated and forced to their proper place outside the boundaries of the Egyptian world.

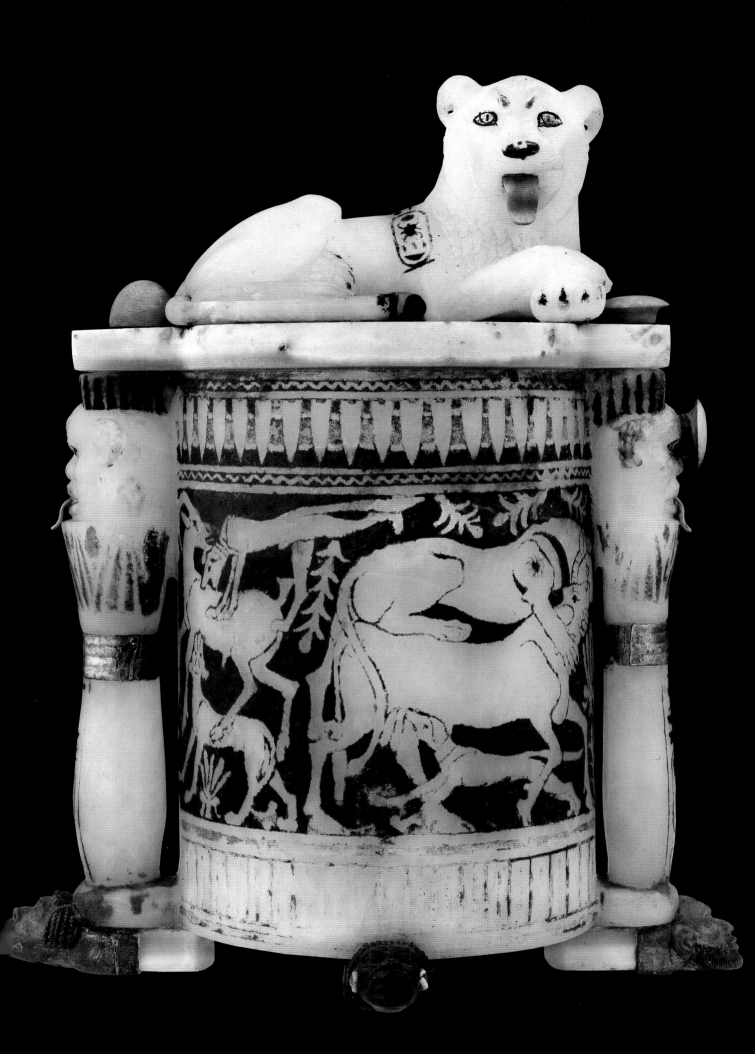

CEREMONIAL MACE
Gilded wood
Length 82 cm, diameter of head 12 cm,
diameter of shaft 3.5 cm
Carter 233

This mace was one of a group of sticks and staffs discovered south of the doors of the second shrine (p. 84). An identical mace was found with a second group of staffs to the north of the door. It is clear that these symbols of royal authority were deliberately placed in positions where they could help protect the body of the king for a very specific ritual purpose, although it is not known exactly what this would have been.

Evidently ceremonial rather than functional, the mace is made entirely of gilded wood and thus would not have been terribly effective as a weapon of war. The head is decorated with a net pattern, and the top of the shaft is adorned with five parallel lines, imitating the ties that in a real mace would have fastened the head to the shaft.

Maces, with wooden shafts and heads of hard stones such as granite or diorite, were used as weapons during the Predynastic and Early Dynastic periods. They would have been formidable in combat, and during these early eras were the chief offensive weapon used by the king. The image of the monarch as war chief raising a mace above his head to strike an enemy held immobile by the hair was an important icon of kingship from the dawn of Egyptian history, seen for example on the Narmer Palette, a ceremonial slate palette dating from around 3050 BC (see p. 290).

Although replaced in actual combat by scimitars and swords, the pear-shaped mace remained important in ritual contexts. As an item of royal regalia, it was presented to the mummy or image of the deceased king during the Opening of the Mouth ceremony. Figures of the king are often shown holding such implements, as seen for instance in the guardian figures that flanked the doorway to the Burial Chamber (p. 29), as well as in many other examples found in the tomb.

STAFF WITH A FIGURE OF THE KING

Silver
Length 131.7 cm
Carter 235b

This unique staff was found wrapped in linen between the two outermost shrines, together with the ceremonial mace (p. 80). In fact, it is one of a pair: this staff is made of silver while the other is gold. The shaft of each is a hollow metal tube, and a separate disk of the same material closes the bottom. A figure of the king, in this case cast in solid silver (in the other it is gold), with chased detailing, is fitted into a base at the upper end of the shaft. Both figures stand with the arms held straight down, the palms flat just above the thighs; they wear the *khepresh*, or blue crown, and a pleated kilt. The gesture made by the figures is most likely one of respectful worship, suggesting that we should imagine that the king is in the presence of the gods. The golden figure leans forward slightly, while the posture of the silver one is more nearly upright.

When Carter returned to Egypt for the 1925–26 season, he visited the Tutankhamun exhibit at the museum in Cairo, and found this staff broken in two:

> I was horrified to find that the silver stick (fellow to the gold stick), now exhibited flat, in one of the glass show cases, was broken in two. This, I was told, was done by one of the European officials when showing it to M. Capart of the Brussels Museum. It seems a shame after all the trouble in preserving

those precious objects and safely transporting them to the Museum, that they should be allowed to be handled by persons that do not know how to handle antiquities.

In general, staves and sticks were symbols of royal authority. As demonstrated by the variety of examples found in Tutankhamun's tomb, they took different forms and could be topped with various insignia; each style was associated with a different ceremonial function. It has been suggested that this staff and its pair were related in some way to the king's coronation, but it is also possible that they were used in connection with the funerary ritual. Their placement within the shrines in the Burial Chamber certainly supports this interpretation.

Carter observed that the golden figure appears "extremely youthful" in both body and face. The silver one, in contrast, may be meant to show the king as an older man. Thus the golden (solar) staff may represent youth and the hours of the day, while the silver (lunar) one would symbolize age and night. These associations could connect the staves with the death and rebirth of the king, which in myth and literature was linked to the cycles of the sun and moon.

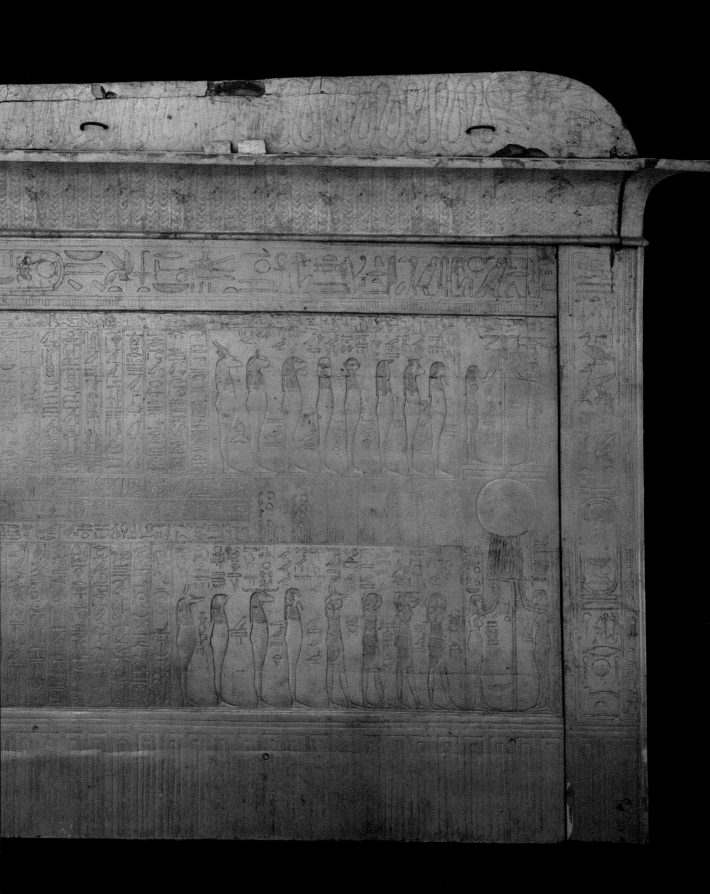

THE SECOND SHRINE

Gilded wood
Height 199 cm
Carter 237

Despite his ongoing struggles with the Egyptian government, and especially with the head of the Antiquities Service, Pierre Lacau, Carter continued to work in the tomb. In mid-December 1923, he and his team dismantled and removed the outermost shrine, and by 2 January 1924 had finished removing the linen pall, adorned with golden rosettes and draped over a wooden frame, that hid the second shrine nested inside. This magnificent shrine takes the shape of a *per-wer* ("great house"), associated from the earliest periods of Egyptian history with Upper Egypt. It is believed that a shrine of this shape, with a sloping roof and cavetto cornice, had once housed a cult image of the region's tutelary goddess, Nekhbet.

Decorating the gilded walls of the shrine, both inside and outside, are excerpts from various funerary texts, including spells and images taken from the *Book of Coming Forth by Day* (commonly known as the *Book of the Dead*). Of the two doors, one, which opened to the east, is adorned with an image of the goddess Isis presenting the king to her brother-husband, Osiris, the king of the netherworld (p. 85). On the other, Ma'at, the goddess of order, leads Tutankhamun to meet the sun-god Re-Horakhty (p. 86). These two scenes provide a good example of the way that netherworld and solar imagery were merged in royal funerary art. Both realms were necessary to ensure the eternal afterlife, expressed in a cycle that began with the king's death and descent to the netherworld, where he would join with Osiris, followed by his identification with Re, so that he could rise with the sun and thus be reborn. On the ceiling of the interior of the shrine, Nut, the goddess of the sky, extends her wings over the body of the king.

The shrine was built of 16 separate elements held together by tenons of wood and copper, a construction method that allowed all four nesting shrines to be assembled in the Burial Chamber, following the hieroglyphic directions written in black ink on the various pieces. The shrines fitted within each other so tightly that it appears that force had to be used in some places to piece them together. Carter noted traces of re-carving in the king's cartouches, and believed that Tutankhamun's names replaced earlier ones that incorporated the word "Aten." It is thus likely that this shrine, like many of the objects in the tomb, was salvaged from the Amarna period burial equipment of an earlier king.

At 3:00 in the afternoon on 3 January 1924, Carter's team, in the presence of officials of the Antiquities Service, cut the seals of the third shrine (having already opened the second shrine) and opened its doors. Inside was a fourth nested shrine, its doors bolted shut but unsealed. Although it was difficult to achieve with the second and third shrines still *in situ*, Carter succeeded in opening the doors to reveal the magnificent quartzite sarcophagus that lay inside. Over the next weeks, the archaeologists focused on dismantling the shrines without damaging them, an extremely complex task.

All four great golden shrines that surrounded the sarcophagus of the king went on display in the Egyptian Museum, Cairo, where conditions of preservation were not always good, because of fluctuations in humidity and temperature in the glass vitrines they were kept in. The wax that Carter's chemist, Alfred Lucas, used on the gessoed and gilded wood was the best material available at the time, but also caused problems. Like other objects from Tutankhamun's tomb, the shrines will receive conservation and be moved to the Grand Egyptian Museum.

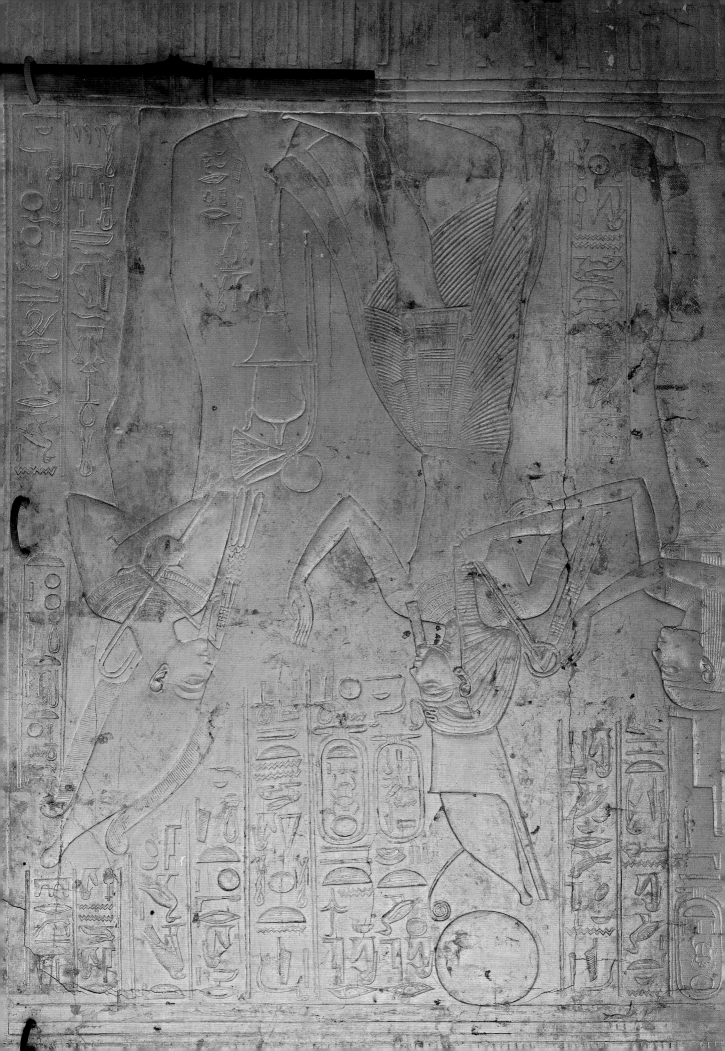

sits upon the sign for gold and is topped by a sun disk. A *was* scepter and *shen* sign, symbols of the king's authority, flank the two names. On either side is a vulture, one wearing the white (here light blue) crown of Upper Egypt and the other the red crown of Lower Egypt. The vultures, standing on the sign for gold, stretch out their wings to protect the king's names. The palm has been pierced around its edge to receive 41 ostrich feathers, scant remains of which were found by Carter. When discovered, the wooden core had shrunk, causing the gold sheathing to buckle and some of the inlay to fall out; it was later restored at the Egyptian Museum.

The gilded wooden "ostrich hunt" fan (pp. 91–93) is among my favorite objects from the tomb. The decoration, in repoussé with engraved details, tells the story of a trip that Tutankhamun took to the eastern desert to hunt young ostriches. On one side of the palm the hunt itself is represented: the king drives his own chariot, drawn by two stallions whose forward motion is conveyed through a pose known as the flying gallop, while his pet dog runs alongside the horses. An anthropomorphized *ankh* sign follows behind the chariot holding a fan (shaped exactly like the ones seen here), providing the breath of life to Tutankhamun. The king is dressed in his hunting costume of knee-length pleated kilt, corselet (p. 44), broad

collar, bracelet, archer's wristguard and the short "Nubian" wig favored by both men and women of the Amarna and post-Amarna periods.

The king steers the chariot by means of the reins wrapped around his waist, so that his hands are free to use his bow. Two young ostriches flee in front of the chariot horses, pierced by the royal arrows: one has fallen; the other is still attempting to escape. The inscriptions associated with the scene identify the king as "the good god, Nebkheperure, given life like Re forever" and "Lord of might."

On the other side of the palm the homeward journey of the triumphant hunter is shown. Here, the chariot horses walk

CARTOUCHE FAN

Wood, decorated with sheet gold
and inlays of glass and calcite
Length 12.7 cm
Carter 245

OSTRICH HUNT FAN

Wood, sheet gold
Length 105.5 cm
Carter 242

Fans and sunshades, quite apart from their everyday usefulness in Egypt's hot and sunny climate, were symbols of breath and thus of life. The position of "fan-bearer to the king" was an important ceremonial and functional office throughout Egyptian history. Carter found both the fans illustrated here on 31 January 1924, lying on the ground between the third and innermost shrines.

Attendants would have held the two fans by the long stocks as they waved them over the king to cool him and keep away flies. The shaft of the cartouche fan (above) is made of solid ebony, decorated with six wide bands of sheet gold with elaborate geometric inlays of calcite and colored glass. At its upper end, the shaft terminates in the shape of a papyrus flower, which is sheathed in gold, with the petals at the bottom inlaid with colored glass. Engraved on this upper terminal are three hieroglyphs: *nefer* ("goodness," "perfection"), *beka* ("rule"), and *ankh* ("life").

A flat semicircle of red wood (the "palm"), to which the feathers were once attached, is joined to the papyrus flower. This is again covered on both sides with sheet gold and has a border of rectangles inlaid in calcite and colored glass framing the central space. In the middle are cartouches containing the throne and birth names of the king (Nebkheperure and Tutankhamun, respectively), under the hieroglyphic sign for "sky." Each name

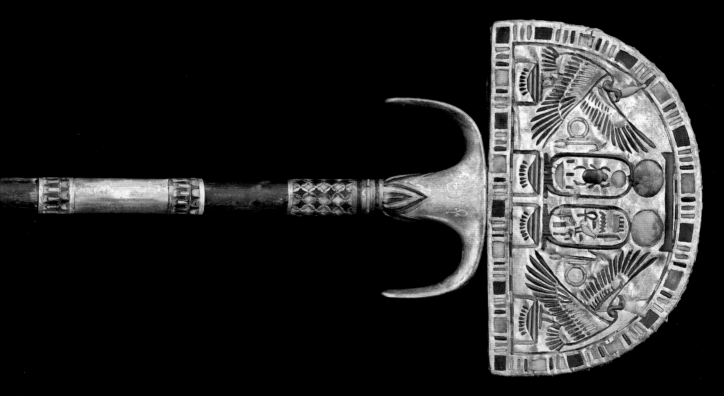

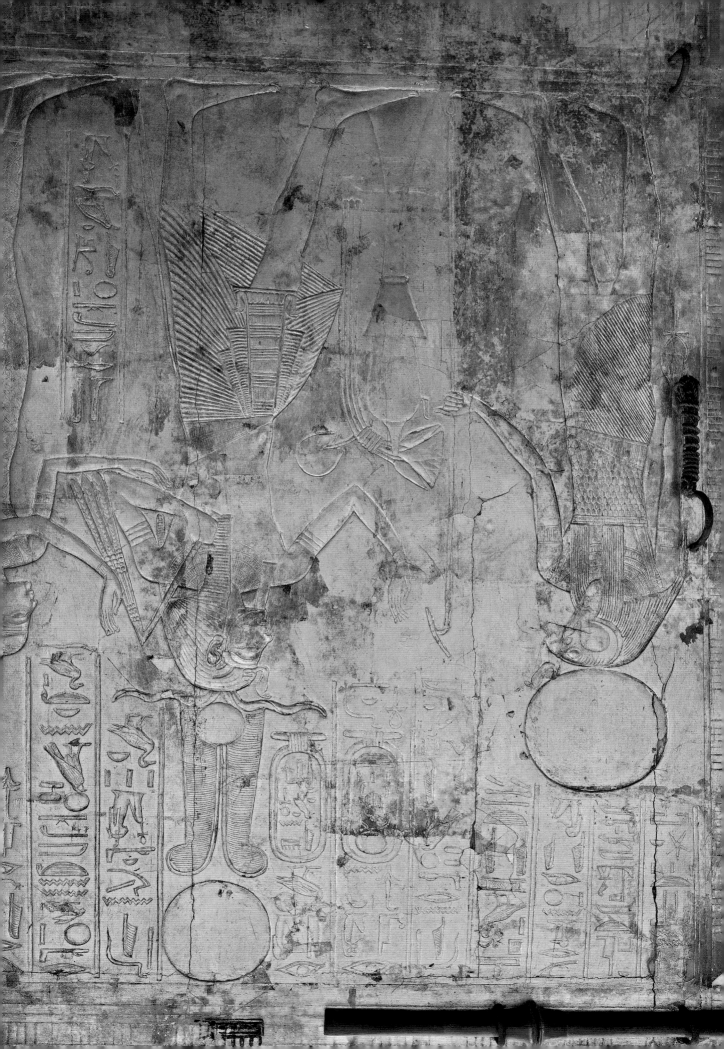

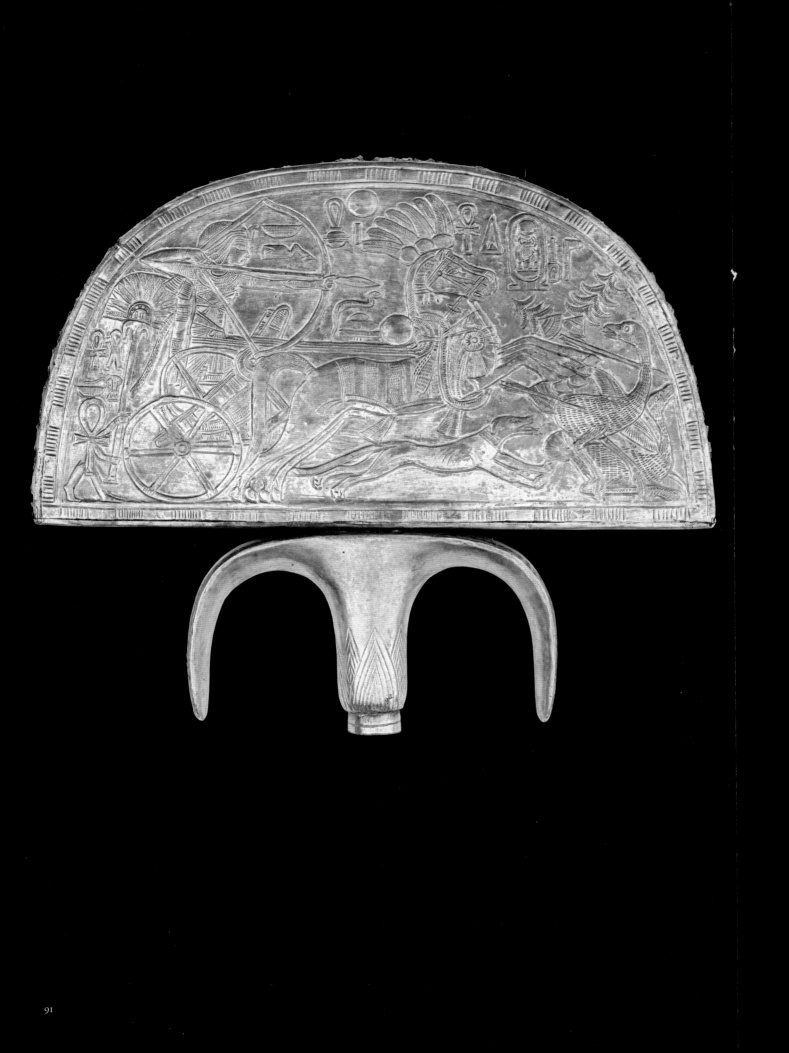

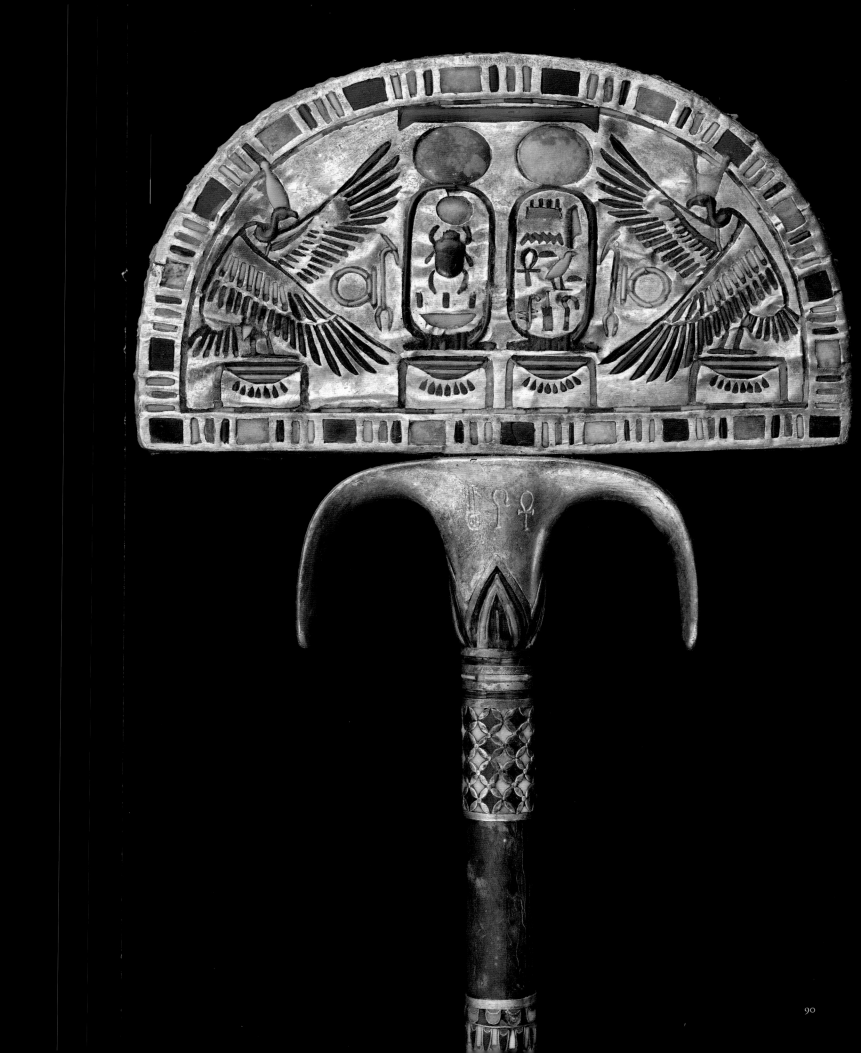

rather than run, taking the king back to his palace (or, more likely, to a royal hunting lodge, perhaps even Tutankhamun's rest house at Giza). The downed ostriches are carried by two bearers, while the king holds a bunch of feathers under his arm.

When Carter discovered this fan, it still had what he describes as "a mass of debris of insect-eaten ostrich feathers." There had originally been 30 of these, alternating brown and white, set into holes around the edge of the palm. According to the long inscription on the stock, these feathers were taken from the actual ostriches depicted on the fan plate, which were caught and killed in the desert east of Heliopolis (near modern Cairo) by the king.

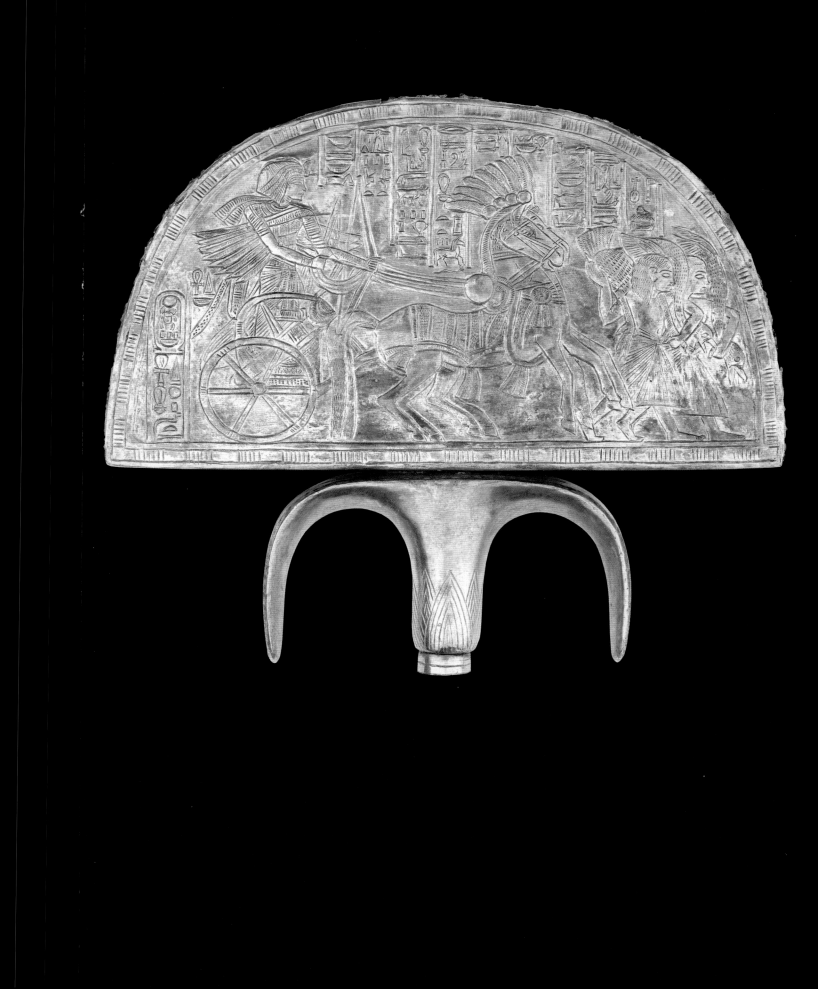

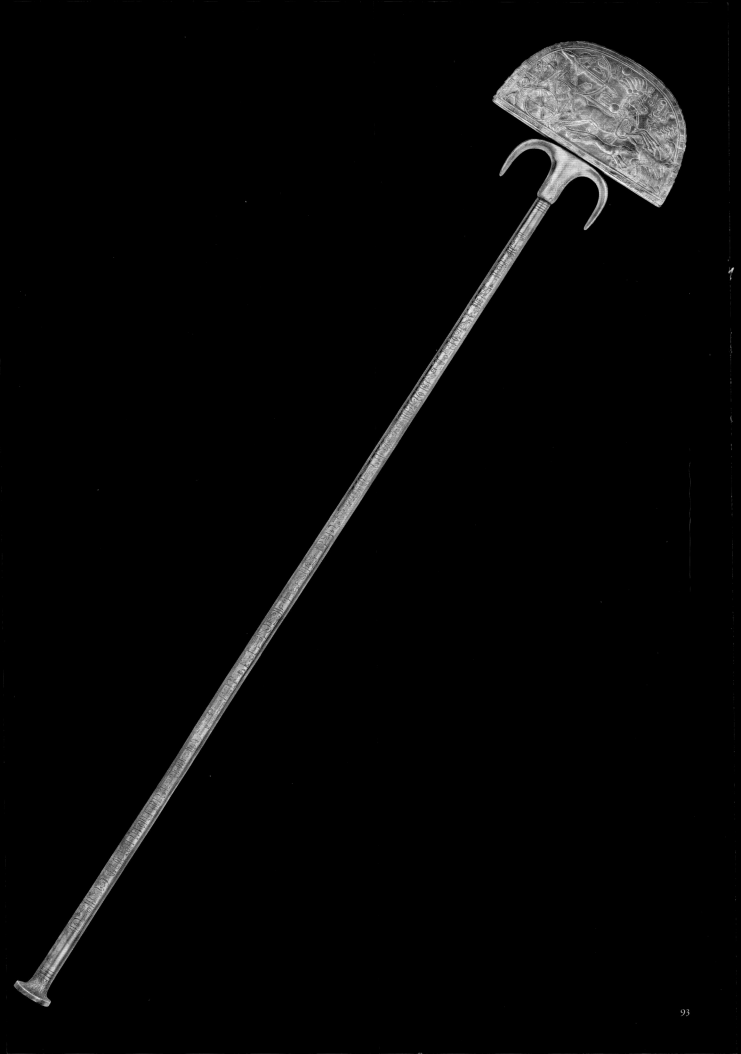

CARTOUCHE COSMETIC BOX

Gold, carnelian, colored glass, silver
Height 16 cm, width 8.8 cm, depth 4.3 cm
Carter 240bis

Discovered, according to Carter, inside the sarcophagus (but perhaps found instead between the two outermost shrines), this clever and highly symbolic cosmetic box is a tribute to the ingenuity of the ancient Egyptian master artisan. Made of gold, with inlays of carnelian and colored glass, the double container takes the form of two cartouche-shaped elements mounted on a flat base of silver. Sun disks flanked by the ostrich plumes that signify *ma'at*, the proper order of the universe, top each container.

Each of the four cartouches thus created – two on the front and two on the back of the box – contains decoration in the form of cryptographic writings of the king's throne name, Nebkheperure. On one face of the box the king is shown in both cartouches as a child, with shaved head and sidelock, sitting with his knees up on top of a basket (technically a *heb* sign, meaning festival, but here to be read as a *neb* basket) and holding the crook and flail (p. 124) in his hands. These regalia, along with the *uraeus* on his forehead, indicate that he is a king. Above his head is a sun disk (*re*) with pendant *uraei* holding *ankh* signs. The royal figure here can be interpreted as *kheper*, the sun at dawn, usually shown in the form of a scarab beetle; thus the entire name, *Nebkheper(u)re,* is spelled out. The equation of the child-king as *kheper* carries connotations of rebirth: like the scarab beetle Khepri, the king too will be reborn as a child at dawn. The figures of the king on the other face (shown opposite) appear older, and wear the blue crown of the heir apparent. One figure has black skin, indicative of fertility and resurrection.

The sides of the box (p. 96) are adorned with figures of the god Heh, wearing a pleated kilt, corselet, and broad collar, kneeling on a basket (here the sign for festival) and holding an *ankh* and a pair of notched palm ribs resting on *shen* rings (the sign for eternity) and tadpoles (meaning 100,000), to symbolize many years of reign. The throne name of the king, Nebkheperure, is shown above the god; here the *kheper* is a winged scarab beetle. On the underside of the silver base is a naturalistic representation of a marsh, with flying ducks and clumps of plants.

When Carter opened this box, it contained an unpleasant-smelling brown powder, the remnants of what once must have been a perfumed ointment of some sort. Its findspot close to the body suggests that its contents might have been used for a funerary ritual dedicated to rebirth and resurrection.

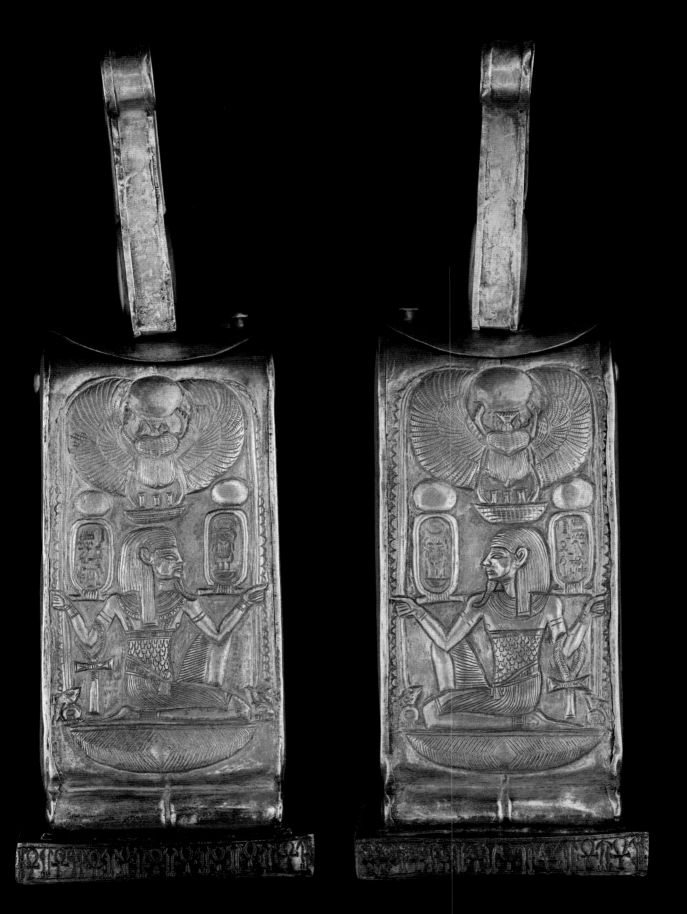

THE DECORATION OF THE BURIAL CHAMBER

All four walls of the Burial Chamber were covered with painted decoration, most of which is still intact today. Unfortunately, Carter's team had been forced to destroy much of the southern wall in order to gain access to the chamber, but they were able to recover most of the pieces and reconstruct the scene.

The decoration was painted onto a thick layer of mortar; the figures – short and soft, reflecting the influence of the Amarna period – appear on a background of golden yellow, the color of divinity. The majority of the figures are based on a grid of 20 squares, as used in the Amarna period, rather than the 18-square grid that was standard in art before and after this period.

The sequence of scenes, all of which relate to the successful transition of the king to his eternal afterlife, begins on the eastern wall, where the royal funeral is represented.

A group of 12 nobles pulls a sledge, on which rests a boat with a shrine containing the mummy, toward the tomb. They welcome the king "in peace to the West."

The scenes are to be read from right to left, and the sequence now moves to the north wall, where there are three vignettes. First is Tutankhamun's successor Ay, wearing the blue crown and the costume of a *sem* priest as he performs the ritual of the Opening of the Mouth on Tutankhamun's mummy. Through this sacred rite, thought to be linked with birth, the body of the king was revivified and made magically effective in the world beyond. Next is Nut, the sky goddess, offering a greeting involving pure water libations (the *ny-ny*) to a figure of Tutankhamun holding a staff in one hand and a mace (p. 80) and an *ankh* in the other. In the final scene, Tutankhamun, accompanied by a representation of his *ka*,

or lifeforce, embraces Osiris (these last two scenes are visible above).

The west wall (pp. 98–99) is dedicated to the first hour of the night, as described in an ancient funerary text called the *Imyduat*, or *What Is in the Netherworld*. The top register is occupied by the solar bark, in which rides the scarab beetle Khepri, identified with the sun at dawn. Two male figures, labeled as Osirises, raise their arms to him in homage. Before the bark walk five netherworld gods. The majority of the wall is divided into boxes, 12 in all, each of which holds the figure of a baboon. These are linked to the 12 hours of the night, through which the king had to travel to be reborn.

On the damaged south wall were vignettes of the king with various gods: Hathor, Anubis, and Isis (who makes the *ny-ny* gesture); behind Isis squat three netherworld deities.

SARCOPHAGUS

Yellow quartzite and painted red granite
Maximum length 274 cm
Carter 240

OUTER COFFIN

Gilded wood, sheet gold, colored glass,
semiprecious stones, faience, calcite, obsidian, silver
Length 223.5 cm
Carter 253

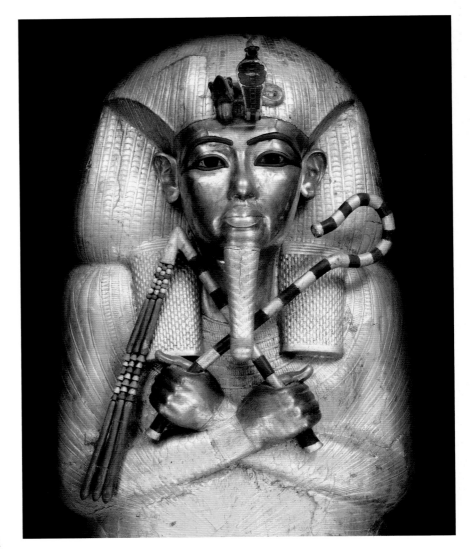

On 3 February 1924, Carter and his team dismantled the fourth shrine and revealed the sarcophagus within. This was, to their amazement, "intact, with the lid still firmly fixed in its place, just as the pious hands had left it." The body of the sarcophagus was magnificent, carved from a single block of golden yellow quartzite, but the lid was of inferior construction – yellow-painted granite – which appeared to Carter's eyes to be "makeshift." This had cracked right across in antiquity and been repaired with gypsum plaster.

The guardian goddesses Isis, Nephthys, Neith, and Selket are carved in high relief at the four corners of the sarcophagus, extending their wings along its sides across vertical columns of text. These are mainly "words spoken" (spells) by the gods responsible for keeping the body safe. A *wedjat* eye (the mythical eye of the falcon god Horus), serving both as protection and as a portal through which the deceased could look out, was carved at the westernmost end of each of the long sides. The lid of the sarcophagus is in the sloping shape of the *per-wer* shrine and is also carved with spells spoken by various gods.

During the following week, Carter was busy negotiating with the Egyptian government, in particular with the new Minister of Public Works (the department responsible for the Antiquities Service), Morcos Bey Hanna. The new minister told Carter that his exclusive contract with the *The Times* had been a mistake. Carter replied that this had been primarily Lord Carnarvon's decision, and that he was forced to honor it until April of that year. Antiquities head Pierre Lacau joined the discussion, but it seems nothing was completely settled. All did agree, however, to proceed as planned with the opening of the sarcophagus on 12 February. Carter invited Minister Morcos, who declined when he learned that the corpse of the king was not likely to be immediately visible, but instead hidden within a nest of coffins.

On the great day, a crowd of dignitaries gathered in excited anticipation to witness the opening of the sarcophagus. As the heavy lid was raised by an elaborate system of pulleys, the onlookers were able to catch their first glimpse of the shrouded form of an anthropoid coffin on a lion-headed wooden bier. When the linen coverings were drawn back, a magnificent effigy of the king in the pose of Osiris was revealed.

Carved in wood covered with a thick layer of sheet gold, this coffin takes the form of Tutankhamun wearing an unusual royal headdress, resembling the *khat* (symbolizing the nighttime half of the cycle of death and rebirth) over a ceremonial wig, and holding the crook and flail in his hands. A garland of olive leaves and cornflowers had been draped around the bronze *uraeus* and gilded wooden vulture with ebony beak, their details inlaid in colored glass, obsidian, and faience, which protected the king's brow. The eyes of the king are of calcite and obsidian, and his brows are of dark blue glass; the braided divine beard attached to his chin is gessoed and gilded.

The body of the coffin was covered with a pattern known as *rishi*, in imitation of feathers. Figures of Isis and Nephthys are represented on the sides, their winged arms embracing the king's body. Isis appears again on the coffin's foot, kneeling upon the sign for gold.

The lid of this coffin was fastened to its shell by 10 solid silver tenons, each one inscribed with the king's name and describing him as "beloved of" a god or goddess. The tenons were held in place by gold-headed silver pins. Before these pins were inserted, the lid had been lowered into place by means of two silver handles on each side.

During Tutankhamun's funeral, the burial party had discovered that the foot of the coffin would not fit into the sarcophagus, and so had to chip parts away; Carter found pieces of gilded wood lying on the bottom of the sarcophagus.

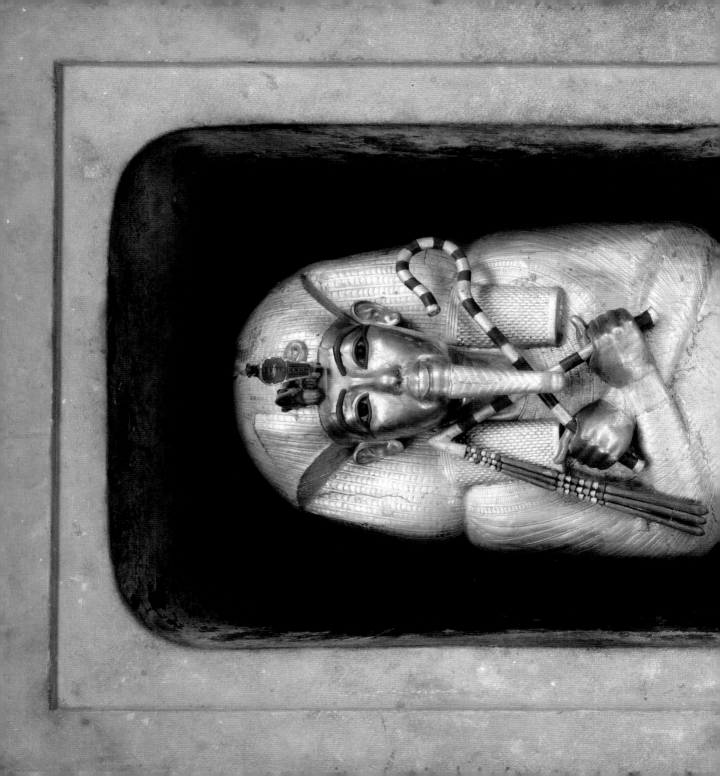

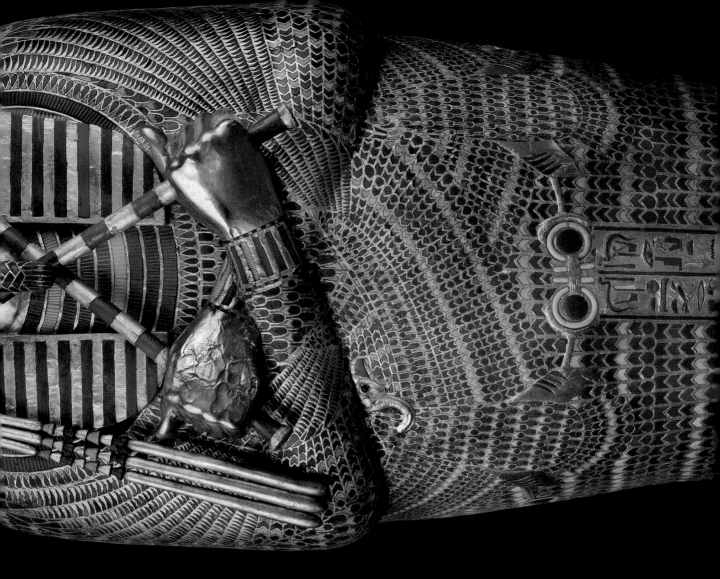

sarcophagus and then slid wooden planks underneath to support it.

Carefully removing the fine linen that shrouded it, Carter revealed the second coffin, which was even more spectacular than the first. As Carter put it: "… the fairness of the work is superior to that of the first coffin, in so much that it is more delicate and purer in line and conveys almost greater feeling."

dazzling effect. Here, instead of Isis and Nephthys, the vulture (Nekhbet) and cobra (Wadjet) goddesses of Upper and Lower Egypt protect the king's body with their wings (side view, pp. 107–8).

The king's eyes and eyebrows are inlaid with stone and glass. The *nemes* headdress, which represented the solar half of the cycle of death and rebirth, is inlaid in dark blue glass; at the front, the vulture has an ebony

inlaid in faience and glass. The foot of the lid of the coffin (p. 106) is decorated with a figure of Isis, with outspread wings, kneeling on the *nub* sign for gold.

It has been suggested that the facial features of this coffin differ from those of the other two, possibly indicating that it was not made originally for Tutankhamun but was usurped for use in his burial. The candidate most often proposed for its

A gap of more than a year would intervene between raising the lid of the sarcophagus and the opening of the outer coffin. Carter had invited a group of ladies, mostly the wives of his team members, to come to the tomb on 13 February 1924, the day after the official event, to see the sarcophagus. But at 6:40 on the morning of the planned visit, he was notified that permission had been denied. This, on top of the continued acrimonious debate over various issues surrounding his work, was too much for Carter, and he decided to close the tomb temporarily in protest, leaving the heavy sarcophagus lid suspended precariously in the air by pulleys. The government responded by locking him out and revoking his concession.

Carter was furious, and brought two court cases against the government, asking for a half share in the antiquities and suing for the right to carry out restoration on the artifacts. As usual, he was not very politic, accusing Morcos Hanna of being a thief (and, to add insult to injury, hiring a lawyer who had earlier prosecuted the Minister for treason).

Fortunately, a number of important Egyptologists interceded on behalf of both Carter and the tomb. Eventually, Hanna agreed that the archaeologist could return, but set the following conditions: he must apologize, give up his quest to receive a share of the artifacts for himself and Lady Carnarvon, and put in writing that the Ministry of Public Works had the right to supervise the clearance of the tomb. Carter remained recalcitrant for several more months, but finally agreed to comply with Hanna's terms.

It was not until late January 1925 that Carter arrived once more in Luxor, and he found that a significant amount of damage had occurred in his absence. The linen pall had been left out in the sun and was beyond hope; the wooden artifacts were deteriorating; and even the jewelry had begun to change color. The remainder of this season was dedicated to putting things back in order and conserving

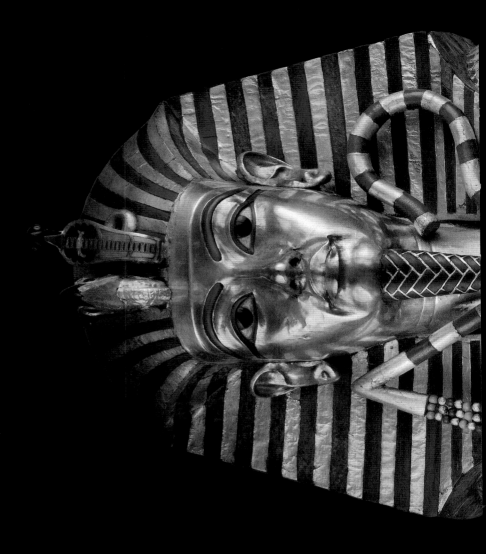

raise the lid of the outer coffin. Because of the tightness of the space between this coffin and the sarcophagus, he had to saw in half the silver pins holding the tenons in place. Using a pulley-and-tackle system, the team was then able to raise the lid. Within lay a second coffin, covered by what Carter described as "gossamer" linen. On top were two garlands: one, positioned on the chest,

from humidity were apparent, even through the cloth shroud.

Since the sarcophagus constrained their movements, the team removed the lid to their nearby conservation lab and, using a system of pulleys and slings, lifted the trough of the outer coffin, together with all its contents, out of the sarcophagus. This proved to be surprisingly heavy and

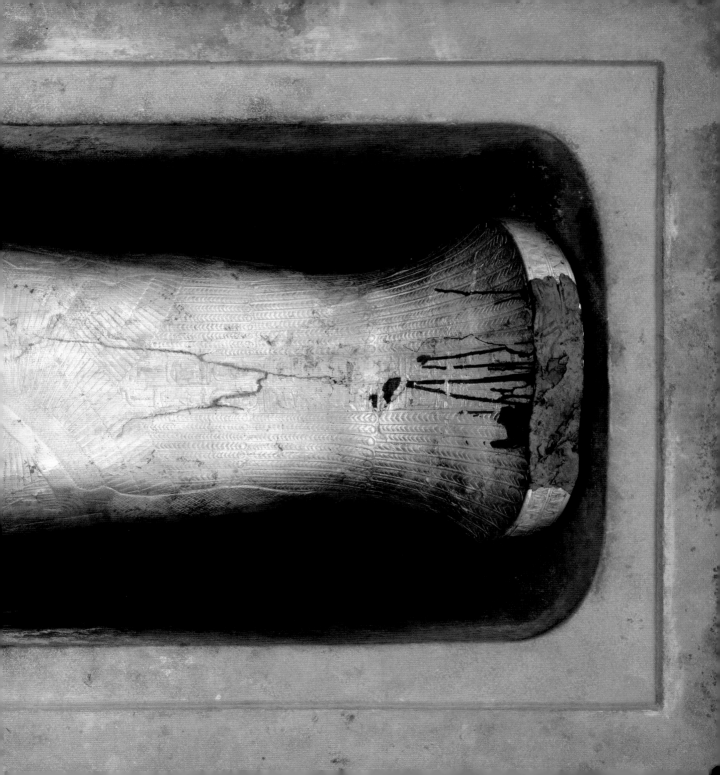

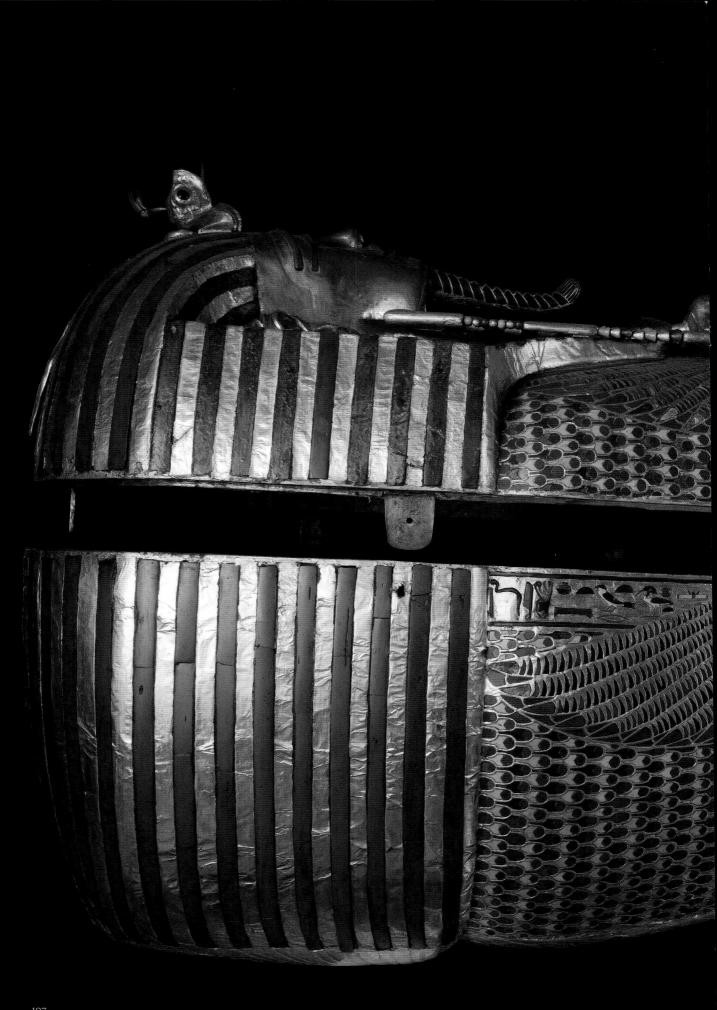

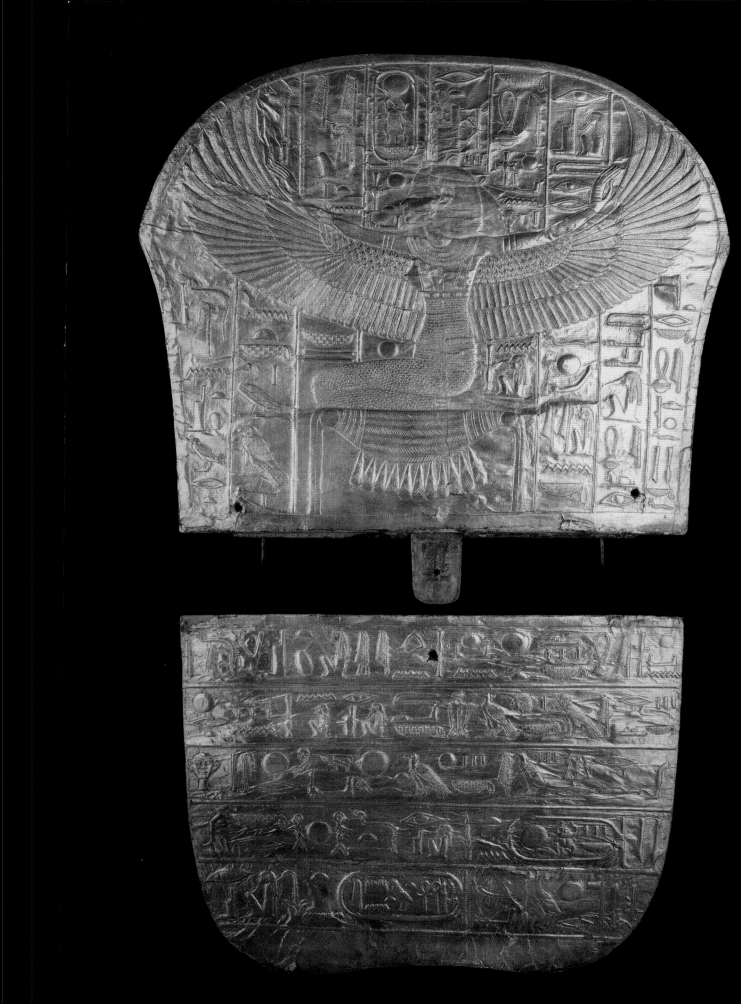

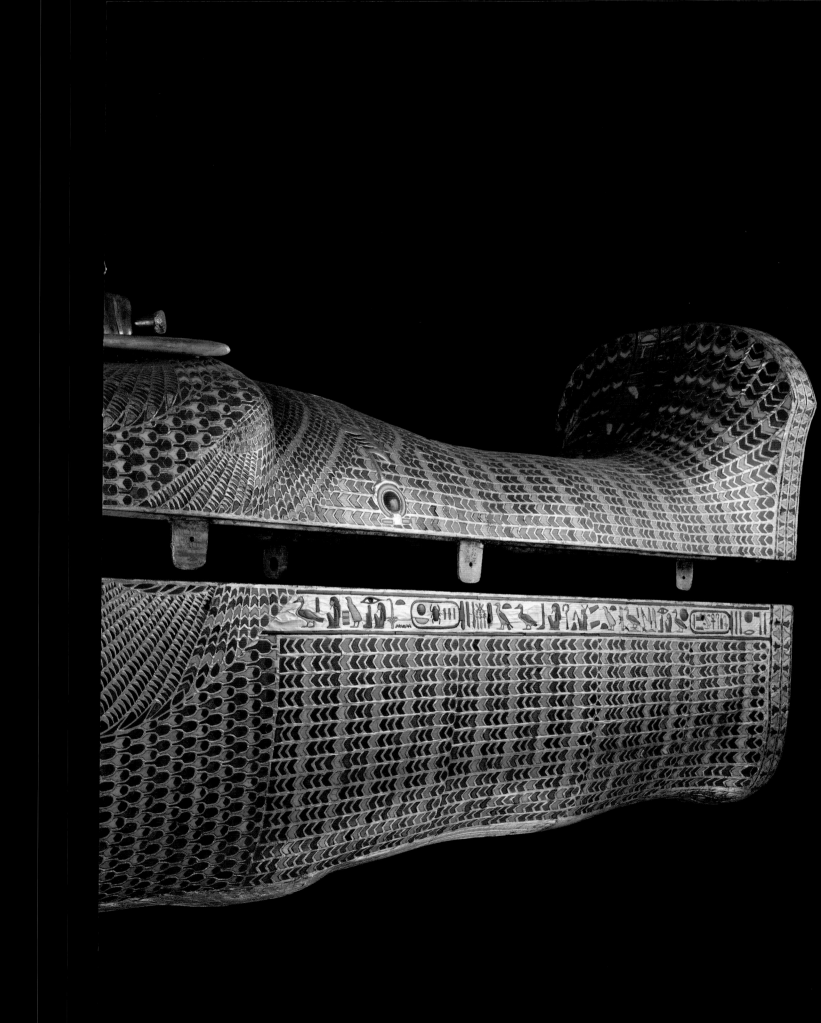

THIRD COFFIN

Gold, glass, semiprecious stones, obsidian
Length 187.5 cm
Carter 255

The second coffin had no handles and fitted closely inside the first; there was also almost no gap between its lid and its shell. Thus the task of extracting it and raising its lid presented the archaeological team with an immensely difficult challenge. Carter's diary for Tuesday, 20 October 1925, expresses his feelings at this time:

Without some experience of handling heavy and yet fragile antiquities under very difficult circumstances, few can realize that nerve racking undertaking and responsibility. The raising of a lid of a coffin or lifting the coffin itself seems a comparatively simple job; but when one realizes that it is deep down in the interior of a sarcophagus where it fits quite closely, that it is in a very fragile condition, that it is immensely heavy, that the overhead room in the chamber is very limited, and that one does not even know whether its wood is sufficiently well preserved to bear its own weight, the reader will perhaps begin to realize what an anxious work it really is.

After consultation with one's colleagues and careful consideration, a plan of action is formed, you begin to carry it out – probably the preparation of which has taken several days, special appliances are devised, and as far as it is humanly possible you have taken every precaution. Everything goes well until suddenly, in the middle of the process, you hear a crack – little pieces of surface ornament fall clink clink on the floor of the sarcophagus or chamber – the only space available is now crowded with your men, and in a moment you have to discover what is happening – what is the trouble, and what immediate action is required to prevent a catastrophe. The reader will perhaps realize that strain upon the nerves.

Again, the interest of seeing some fresh and beautiful object exposed as a lid is being raised will often distract your workmen, for a moment they forget their duty and irreparable damage may be done.

Such is more than often an archaeologist's lot, and afterwards he is asked what were his sensations when so and so was first discovered!

I myself can vouch for the enormous stress that comes with being the one ultimately responsible for the safety of a priceless artifact.

Carter's team solved the problem of raising the second coffin out of the first by pulling the pins that held the lid to the shell partway out, and using them for purchase. Wires were attached to these pins, and then separate wires were threaded through metal eyelets screwed into the shell of the outermost coffin. All the wires were attached to a scaffold. The wooden planks supporting all the coffins were removed and the outer coffin was lowered back into the sarcophagus, where it remains to this day.

Next, a new wooden tray was slid beneath the second coffin to support it, and preparations were made to remove the fragile lid. Again using a system of modern metal eyelets, screwed in where they were least likely to disfigure the decoration, the team succeeded in raising the lid. Beneath was a third anthropoid form, shrouded this time with a pall of reddish linen. The face had been left uncovered, and gleamed with gold. A wide collar of beads and real flowers had been sewn onto the shroud.

When they had first raised the nested coffins, the excavators had been surprised by their great weight. As they removed this garland and linen pall, the mystery was solved: the innermost coffin was of solid gold, tribute to the great wealth commanded by the pharaohs of the 18th Dynasty. Carter cleaned off the dark, resinous material with which it had been coated during the funeral ceremonies, making it possible to appreciate the exquisite piece. "Both technically and artistically," Carter commented, the coffin is "a unique example of the metal-worker's art." It is made of beaten solid gold, ranging in thickness from 2.5 to 3 mm, with details skillfully chased into the surface. Like the second coffin, it takes the form of the king as Osiris, wearing the *nemes* headdress with cobra and vulture, and holding the crook and flail. Two gold and faience *shebyu* collars (p. 38) were hung around Tutankhamun's neck, emphasizing the deceased king's divinity. The body is covered with a *rishi* pattern, and is here protected by Nekhbet and Wadjet across the king's chest, just below his crossed arms, and Isis and Nephthys over his legs. Various parts of the decoration, especially on the headdress, face, and upper part of the body, were added in sheet gold and inlaid in colored glass and semiprecious stones; the other details were engraved into the surface. The calcite used for the whites of the eyes had decayed, leaving behind only the obsidian pupils.

The sticky, hardened unguents poured over the innermost coffin during the funeral had attached it firmly to the second coffin. Carter therefore decided to raise the lid of the third coffin before trying to remove it from the second, and moved both together into the Antechamber, where there was more space. The lid of the innermost coffin was joined to its shell by gold tongues sunk into sockets and fixed in place with gold pins. The pins were extracted using long screwdrivers as levers and the lid was raised on 28 October. Underneath was the "very neatly wrapped" mummy of the king himself, his head covered by the gold mask that has become a symbol for the glory of ancient Egypt.

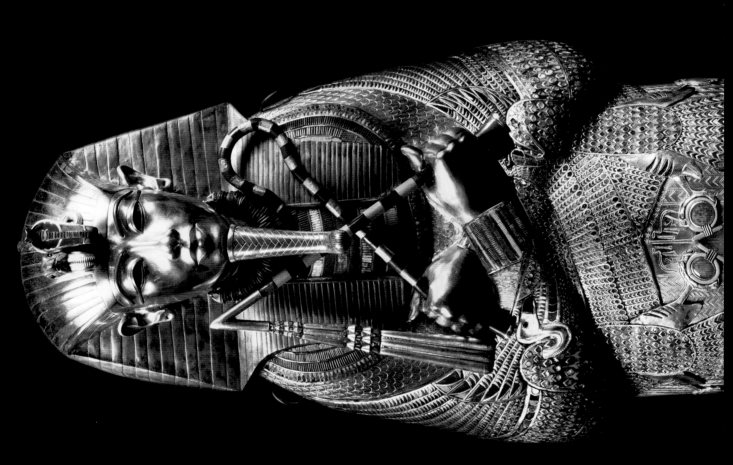

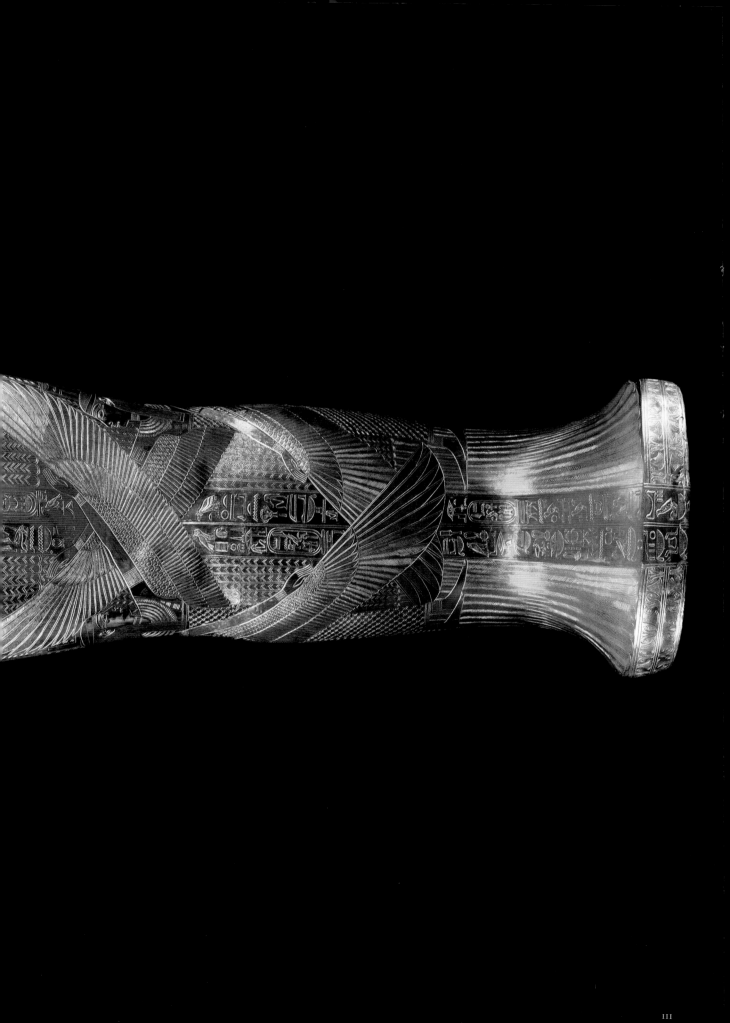

GOLDEN MASK

Gold, carnelian, lapis lazuli, amazonite, quartz,
obsidian, faience, glass
Height 54 cm, width 39.3 cm, weight 11 kg
Carter 256a

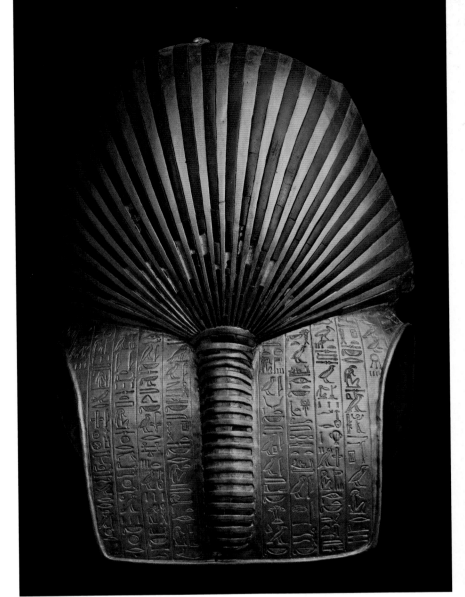

This spectacular mask represents an idealized portrait of the king. Intrinsically beautiful due to the precious materials and masterful workmanship that went into its creation, it was also an essential item of the royal burial equipment, serving as an image that the soul could enter and occupy during the afterlife if something happened to the body.

Carter found that the resinous material that had been used to anoint the body during mummification and the funeral had left this mask stuck to the king's head and shoulders. After several failed experiments, he ended up using hot knives to cut the mask free, removing the mummy's head in the process.

This mask is always in my mind. I imagine that it is 1925, and I am seeing it for the first time, hiding the head and chest of the king. Do I remove the mask and damage the mummy, or do I leave it in place and exhibit the mummy with the mask? I would do what Carter did, and take the mask off, even if I had to dismantle the mummy to do so.

The artisans who crafted this masterpiece began by hammering together two thick sheets of gold, thought by the ancient Egyptians to echo the flesh of the gods. They then shaped this metal into the likeness of the king wearing the striped *nemes* headcloth, using inlays of semiprecious stones and colored glass to add color and detail. The whites of the eyes were inlaid with quartz, and obsidian was used for the pupils. Red paint was lightly brushed into the corners of the eyes, subtly increasing their realism. X-ray analysis of the mask by Professors Uda and Yoshimura of Waseda University showed that a very thin layer of a silver-rich gold, whiter than the core of the mask, was added to the burnished surface of the face to enhance its radiance.

The cosmetic lines around the eyes and the curving eyebrows were inlaid with lapis lazuli. The earlobes were pierced with large holes, which were then covered with gold foil that was present at the time of the discovery but has since been removed. Two horizontal lines were engraved on the front of the neck; this feature, along with the almond-shaped eyes, full lips, and elongated face, identifies the mask as a product of artists trained during the Amarna period.

Glass inlays of deep blue, imitating lapis lazuli, form the stripes of the headcloth. The vulture and cobra adorning the king's brow, images of the protective goddesses of Upper and Lower Egypt respectively, were made of solid gold with inlays of lapis lazuli, carnelian, faience, and glass. The long curled beard on the king's chin, emblematic of divinity, is made of blue glass laid into a golden framework.

Covering the chest is an elaborate broad collar, consisting of 12 rows of beads made of lapis lazuli, carnelian, amazonite, and glass paste. The clasps of the collar take the form of the head of the falcon god Horus. Such collars were traditionally worn for festival and cultic celebrations.

On the shoulders and the back of the mask is a magical text that refers to the different parts of the body and mask, and their connection to particular gods or goddesses. This served to protect the king's body and render it functional for the afterlife.

Although the Golden Mask formed part of the original Tutankhamun touring exhibition in 1972, it has not left Egypt since the early 1980s, and will not travel again. I am often asked about the mask, and whether it will ever go on exhibition outside Egypt again. I reply that it is too fragile to travel, and that taking it away from Egypt would disappoint the thousands of tourists who come to Cairo just to see this unique object.

Whenever a television program wants to interview me about the golden king, I go directly to the mask. While the film crew is setting up the cameras, I have a chance to look again at the mask and I always discover something new. Each time, its beauty makes my heart tremble.

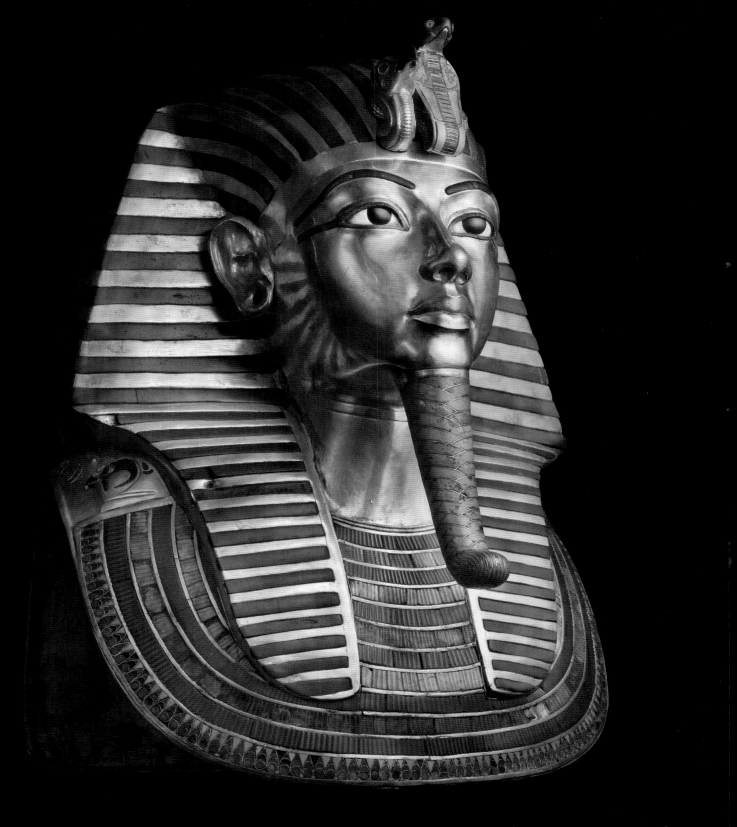

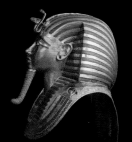

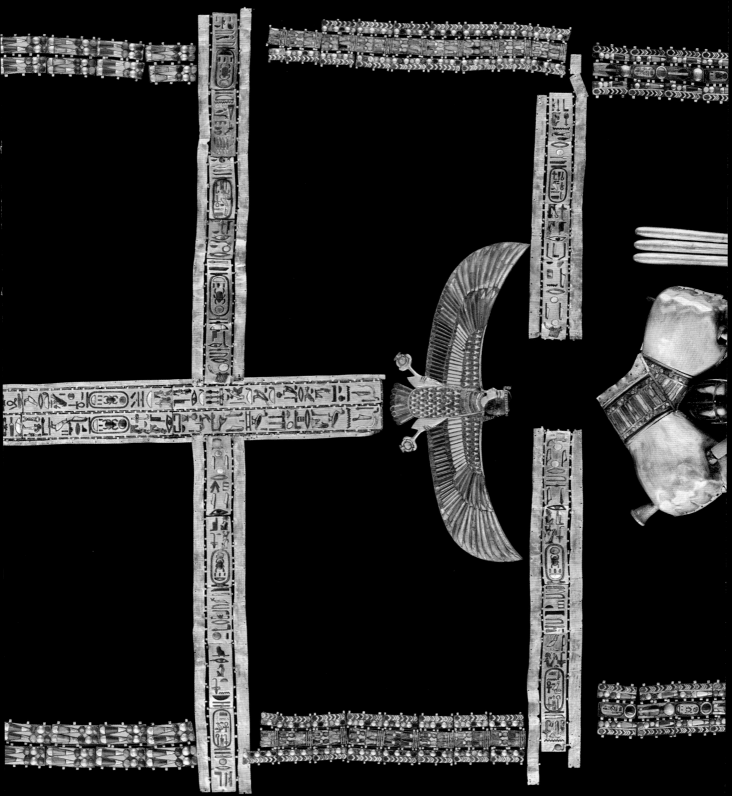

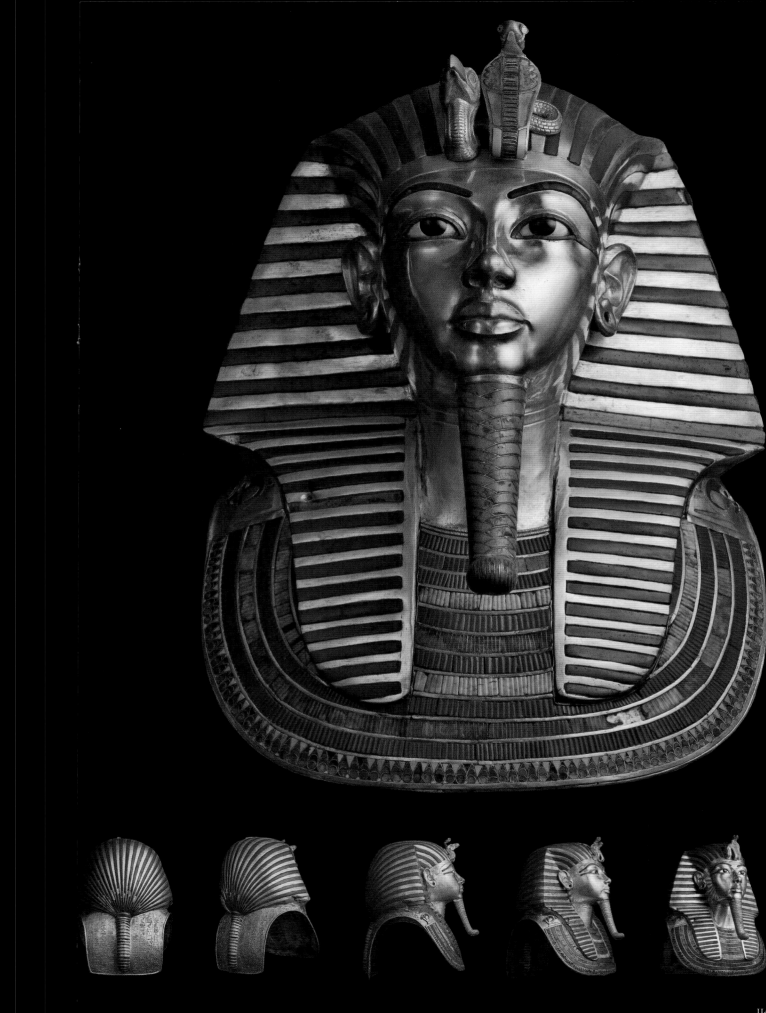

EXTERNAL TRAPPINGS OF THE MUMMY

Gold, glass, semiprecious stones, silver, resin
Bands: approximate average width 5 cm; lengths vary
Bird pectoral: height 12.5 cm, width 33 cm
Carter 256b

Tutankhamun's magnificent gold mask is generally considered the definitive icon representing the tomb's treasures. It is often the only piece that the public remembers, neglecting the more than 5,000 additional objects found in the tomb. However, spectacular as the mask is, it was only one part of several nested layers of protection for the king. In the layer dominated by the mask were also the beautiful external trappings illustrated here, found sewn onto the outermost linen bandages.

Fabulous in their own right, these trappings consist of eight golden mummy bands, imitating the linen bands that, on an earlier or poorer mummy, would have served to hold the final layer of bandages in place; a pair of golden hands grasping a crook and flail; a golden chain from which hung a scarab of black resin; and a pectoral in the shape of a human-headed bird.

Four of the mummy bands were laid vertically, from the throat or shoulders to beneath the toes (two in the center and one along each side), while the other four were wrapped horizontally around the body. Each band consists of a series of plaques decorated with hieroglyphs inlaid with colored glass. The texts include the names of the king, protective spells spoken by different gods, such as the sky goddess Nut, the embalming god Anubis, and the Four Sons of Horus who guarded the viscera (see p. 170), as well as decorative elements.

Carter found that the texts on these bands did not always follow consecutively, and the ancient numbers on some were out of order. He also noted that most, but not all, of the original cartouches on the underside of the bands had been cut out

and replaced with plain gold. The cartouche that had been missed contained the name "Ankhkheperure," one of the names of Smenkhkare, the co-regent and successor of Akhenaten and perhaps the brother of Tutankhamun. This was also one of the names of a shadowy ruler named Neferneferuaten, whom some people believe was actually Queen Nefertiti ruling under a different name. Like a number of other objects in the tomb, it is assumed that these bands were taken from Ankhkheperure's burial equipment and used for the new king.

The royal hands are of burnished gold, adorned with wristlets of colored glass and carnelian. The crook and flail (p. 124), the fundamental emblems of royal power, are made from silver cores covered with alternating bands of glass and gold, with the beads of the flail made of glass, gold, and carnelian. The resin scarab is inscribed with a spell from the *Book of the Dead* and the bands from which it hung were also originally made for Ankhkheperure.

The human-headed bird (pp. 120–23, front and back) represents a *ba*, the part of the human "soul" believed to fly from the body at the moment of death, and thus identified with breath and movement. For the person to be resurrected properly, it was essential that the *ba* be reunited both with the body and also with a third aspect of the personality, the *ka*. The pectoral here was made of gold inlaid with glass to mimic turquoise, lapis lazuli, and carnelian. In the bird's claws are *shen* signs, rings that symbolized the eternal circuit of the sun. This is a beautiful piece, the human face rendered with exquisite sensitivity.

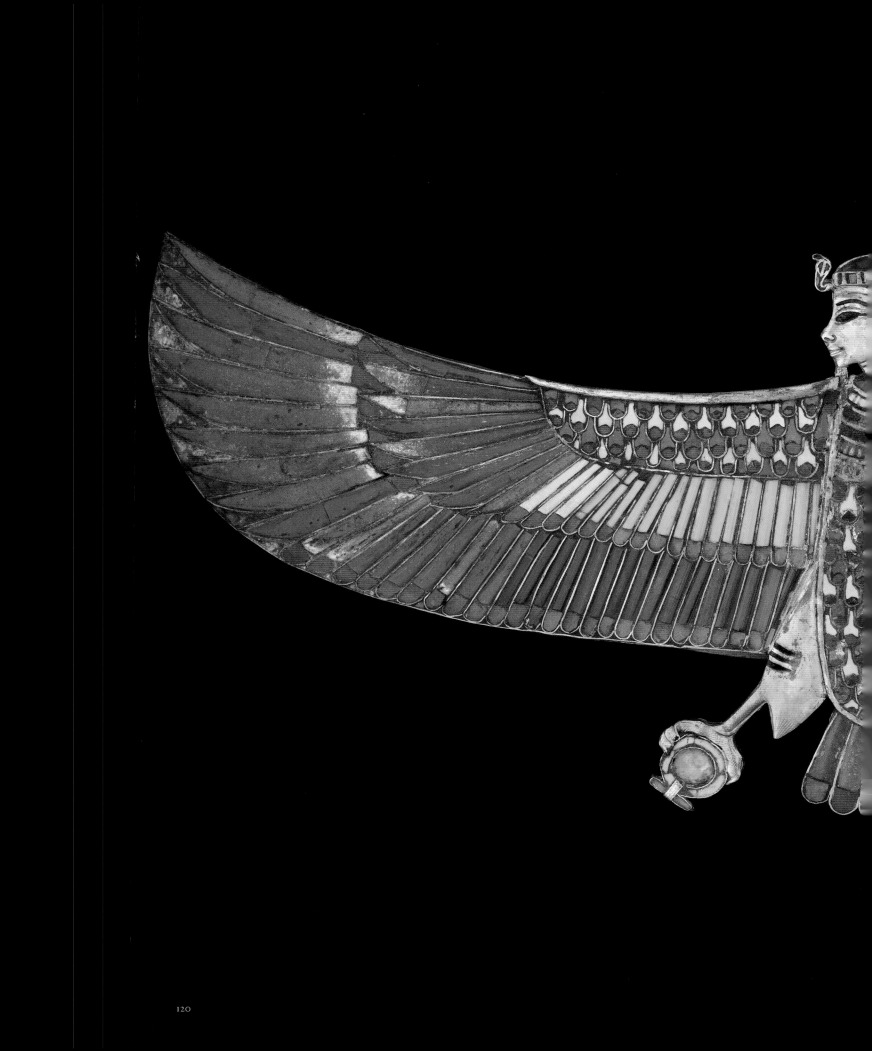

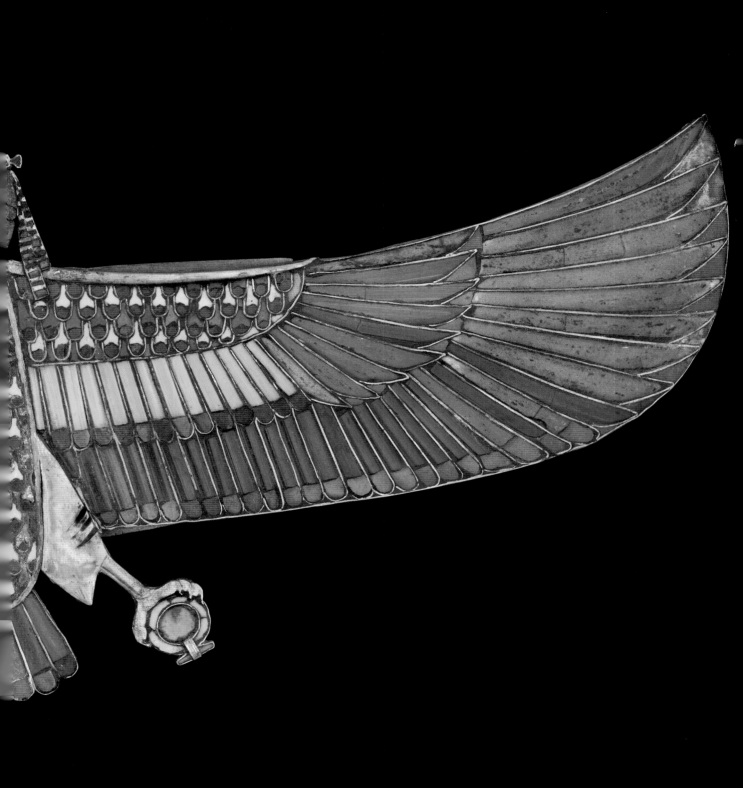

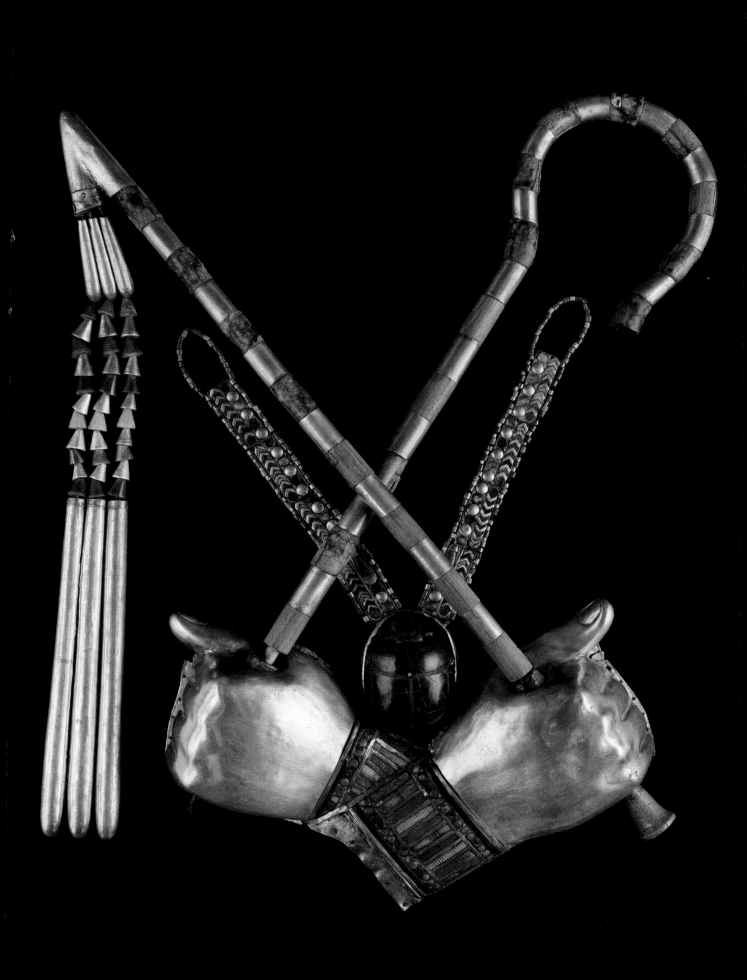

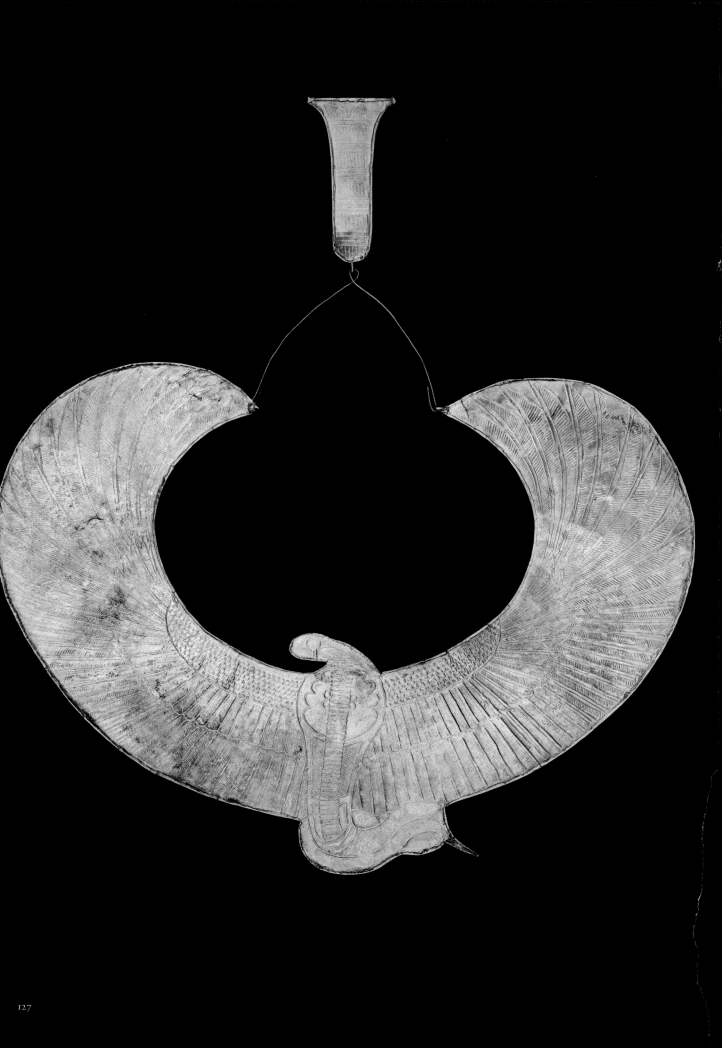

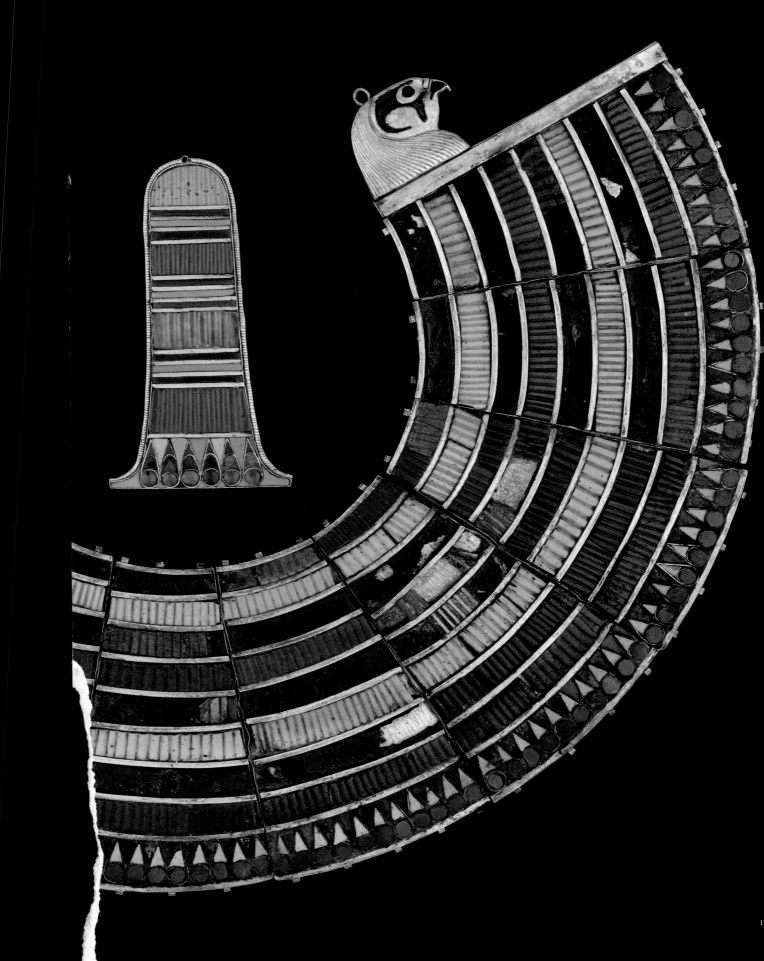

BROAD COLLAR

Gold, inlaid with carnelian and colored glass
Width 36 cm
Carter 256aa(1)

Several of these flexible, multicolored collars,
known as *wesekh* (meaning broad), were
included among the ornaments that adorned
Tutankhamun's mummy. Such collars were
among the most common items of jewelry
in ancient Egypt, and are shown being worn
by men, women, and gods alike throughout
pharaonic history. Thought to mimic
garlands of real flowers, they were worn
primarily for ritual or official occasions.

This example, found crushed and folded
across the king's lower thighs and knees, is
composed of 11 separate gold plaques,
decorated on the back with chased designs
and on the front with rich inlays banded
to resemble tubular beads. These alternate
between glass of dark blue (imitating lapis
lazuli), light blue (for turquoise), and red
(for carnelian), and are set into nine
concentric bands; the lowest band contains
a geometric floral pattern thought to
represent poppy petals.

The plaques are held together at the
edges by threads strung through loops.
When Carter discovered this collar, it
consisted of 10 plaques; an eleventh was
added later at the Egyptian Museum.
At each end of the collar are profile
falcon heads of gold with glass inlay.
A counterpoise in the shape of a lotus
blossom, also inlaid with carnelian and
colored glass, was suspended from a gold
wire threaded through tiny loops soldered
to the falcons' heads.

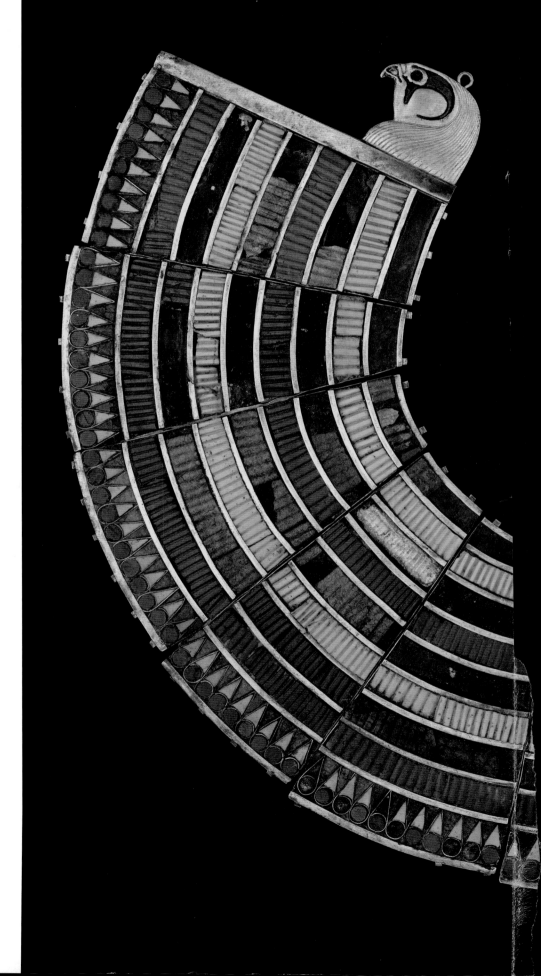

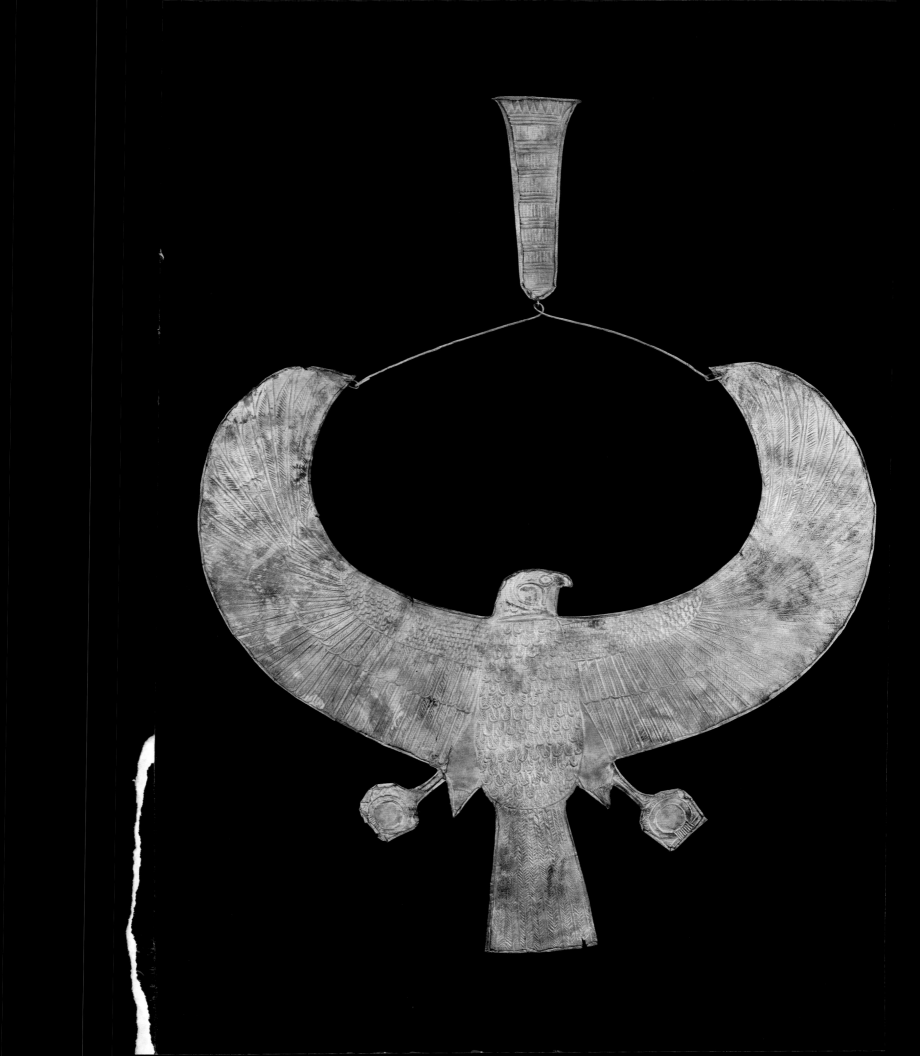

COLLARS
Gold

Cobra collar
Width 33 cm
Carter 256g

Falcon collar
Width 30 cm
Carter 256t

"Two Ladies" collar
Width 29.5 cm
Carter 256f

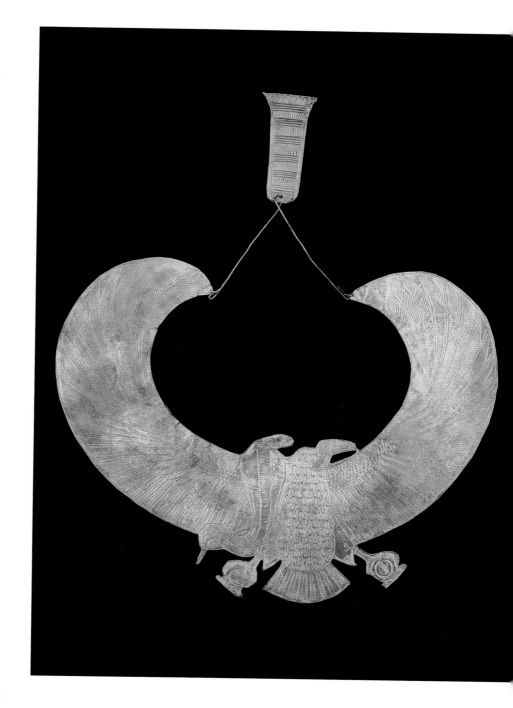

As Carter unwrapped the mummy, he found layer upon layer of exquisite jewelry and amulets wound into the bandages. These necklaces of thin sheet gold, three of the numerous examples of this type found, are decorated with detailing chased into their front surfaces. The wingtips of each are pierced with tiny holes through which gold wires are threaded. Counterpoises in the shape of elongated lotus blossoms are suspended from these wires.

The first collar here has a head in the shape of a cobra (p. 127), the poisonous snake associated with the tutelary goddess of Lower Egypt, Wadjet. As was the case with many of the dangerous creatures that inhabited the land of Egypt, the cobra was turned into a protective symbol, and is seen guarding the forehead of the monarch from the Old Kingdom on.

The falcon head of the second collar (p. 128) is associated with Horus. The king was identified with this god, son of alternatively Osiris or Re, throughout Egyptian history. One of the earliest attested Egyptian deities, Horus was thought to soar through the sky as a falcon, and thus was both a sky and sun god.

The third collar (above) combines the Wadjet cobra with the Nekhbet vulture, symbol of the goddess of Upper Egypt. After the mythical unification of the Two Lands, these "Two Ladies" became symbolic of the king's rule over both the distinctive regions – the Delta and the Nile Valley – that made up the land of Egypt. The vulture of Nekhbet was a particular favorite of the kings of the 18th Dynasty, whose ancestral roots were at Thebes in Upper Egypt, and she is seen next to Wadjet on the front of the pharaoh's crown, helping to protect the king.

TRIPLE RINGS WITH SCARAB BEZELS

Resin, gold, feldspar, colored glass
Height including figures c. 4 cm
Carter 256ff5 (right) and Carter 44i (opposite)

These intricate, nearly identical rings were
discovered far from one another: that
opposite was found in the Antechamber,
wrapped in a shawl with a group of other
rings and put into Box 44; while the other
(right) was wrapped against the mummy's
right hand, along with four additional rings.

Both rings were crafted in a similar
fashion. Their triple shanks are made of
resin covered in gold foil, with the ends of
each shank wound round with gold wire;
the three shanks were then bound together
with more gold wire. One ring (opposite)
has an inlay of dark blue glass on the center
shank; the other (right) has similar inlay on
the two outer rings. Bouquets of lotus or
papyri, made of gold with green feldspar
inlay, flanked by poppies of carnelian, sit
at the junctures of shank and bezel.

The bezels take the shape of the royal
cartouche, atop which sit scarabs, formed
of lapis lazuli-colored glass and wearing
elaborate headdresses of gold. At one end
of each bezel is a bark with solar and lunar
disks; at the other is a falcon with a sun disk
on its head, probably a symbol of the god
Re-Horakhty. This falcon distinguishes the
two rings: on the ring found near the king's
hand it is inlaid with feldspar and red and
blue glass, but is plain gold on the other.
The former is lightly inscribed on the
underside of the bezel with "the good god,
Lord of the Two Lands, Nebkheperure,
beloved of Thoth." Since Thoth, god of
wisdom and writing, was associated with
the moon, this is an appropriate legend for
this ring. It is likely that the young king
wore both rings during his lifetime.

AMULETIC BRACELET

Gold, lapis lazuli
Length of bead 4.5 cm, diameter of bracelet 7.4 cm
Carter 256hh(1)

Three gold bracelets were found on the chest of the king's mummy. This one, consisting of a barrel-shaped bead of lapis lazuli mounted in gold, was positioned under the right pectoral. The second features an iron *wedjat* eye, and the third includes a bead of red chalcedony.

Lapis lazuli was one of the favorite semiprecious stones used by the ancient Egyptians, prized for its intense blue color. It is likely that it came from what is now Afghanistan, in an area where lapis is still mined. In ancient times, this area was controlled by one of the Indus Valley civilizations, and the stone was traded along routes that passed through Mesopotamia and the Syro-Palestinian region.

CEREMONIAL DAGGERS AND SHEATHS

Iron, gold, glass, semiprecious stones, rock crystal

Gold dagger: blade: length 31.9 cm; sheath: length 21 cm
Iron dagger: blade: length 34.2 cm; sheath: length 22.3 cm
Carter 256dd (gold) and Carter 256k (iron)

Tutankhamun is not traditionally thought of as a warrior king. However, despite his youth (he was only about 19 when he died), his tomb was full of weapons of various sorts, including bows and arrows, throwsticks and boomerangs, slings, clubs, and swords. Some of these are child-sized, while others were made for an adult. Evidently, the young king was trained in the arts of hunting and war from an early age, and may even have led the army into battle.

Clearly, the king did not want to go into the afterlife unarmed, as two daggers were found wrapped with his mummy. One, with a gold blade, was tucked into the golden girdle that hung around his hips, and the other, of iron, was laid along his right thigh. Both daggers are spectacular examples of the jeweler's art, with elaborately inlaid hilts and decorated sheaths. Many of the motifs seen on these weapons show overseas influence, and it is possible that they were prestige gifts from foreign kings or princes.

The first dagger seen here is of solid gold. Granulation and cloisonné, both very advanced techniques, have been used to decorate the hilt with geometric and floral patterns inlaid in gold, red, and blue. Note especially the running spiral at the base of the hilt, a hallmark of the Aegean repertoire. The golden blade itself, evidently meant for ceremonial rather than actual use, is engraved on both sides with floral and diamond motifs. The sheath is also elaborately

adorned: on one side with a pattern of scales, a band of lilies, and the head of a canine; and on the other (illustrated here), with a stylized hunting scene, again non-Egyptian in flavor. An inscription at the top of the sheath reads "the good god, lord of might, Nebkheperure, given life." On top of the pommel are the king's cartouches, surrounded by a ring of stylized lilies. This dagger is one of the pieces I admire the most, because of the intelligence it took to create such a stylish piece.

The second dagger (pp. 135–36) is one of the few iron objects known from Egypt from this era – iron was not worked locally until many centuries later. Like its golden brother, it has a hilt adorned with cloisonné-work and granulated gold. A knob on the top is made of rock crystal. The sheath is of gold, with palmette and rope patterns on the front and a feather pattern and jackal's head on the back. A letter found at el-Amarna from the king of the Mitanni to Amenhotep III mentions an iron dagger that was given as a gift to the Egyptian king – it is tempting to wonder whether this might be the same dagger.

Both daggers make me think of Carter, and how he must have felt as he unwrapped the mummy of the king. I also like to close my eyes and imagine Tutankhamun in his magical boat, using these daggers to kill dangerous netherworld creatures on his way to meet Osiris and enter his eternal afterlife.

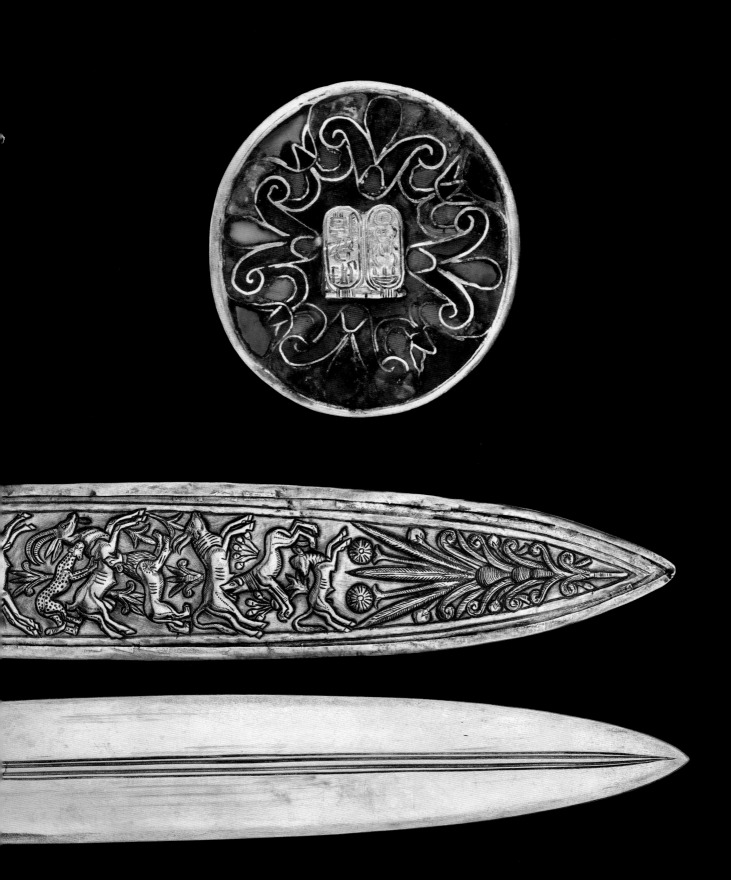

NECKLACE WITH A FALCON PENDANT

Gold, semiprecious stones, colored glass

Pendant: height 8.5 cm, width 9 cm
Chain: length 65 cm
Carter 256uuu0

While much of the jewelry found on Tutankhamun's mummy was probably created especially for burial with the king, Carter noticed that this piece, along with two others which lay near it on the king's chest, showed signs of wear. The body of the falcon is formed of an openwork gold cage enclosing a green stone, possibly a kind of chalcedony. The head is made of gold, with details such as eyes and markings chased into the surface, and has a solar disk of carnelian set on top. Unusually, this falcon is seen in frontal view rather than profile. The outspread wings are decorated with feathers indicated by cloisons of gold that hold inlays of lapis lazuli and carnelian. The chevron design of the tail is made in a similar manner.

The pendant is suspended from an intricate gold chain terminating in a linen thread. Hung from this thread is a counterpoise – necessary to balance the weight of the pendant – made of two carnelian beads and a carnelian heart (the Egyptian version of this organ, which resembles a real heart considerably more closely than our Valentine one). The heart is partly enclosed in gold, inlaid on each side with the king's throne name between *uraei* in dark blue, light blue, and red glass. On the back of both pendant and counterpoise (pp. 139–40) the same details that appear on the front are chased into the gold, a common practice for Egyptian jewelry.

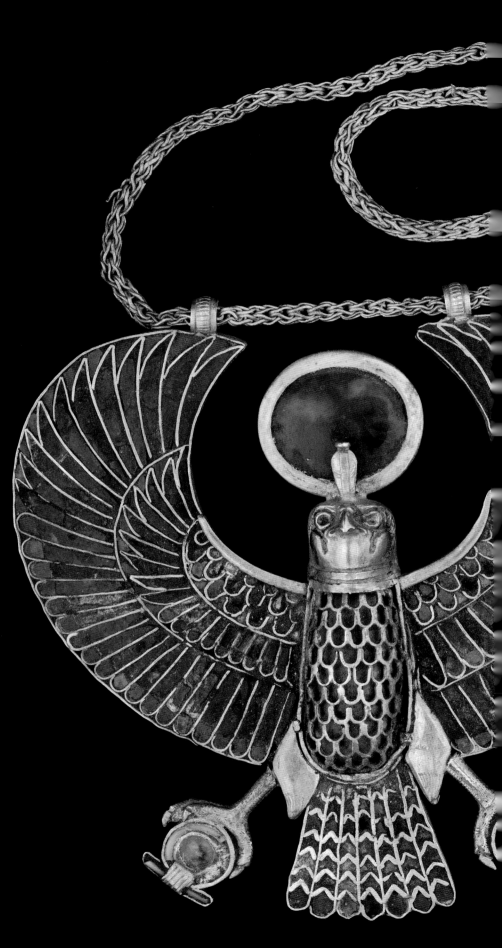

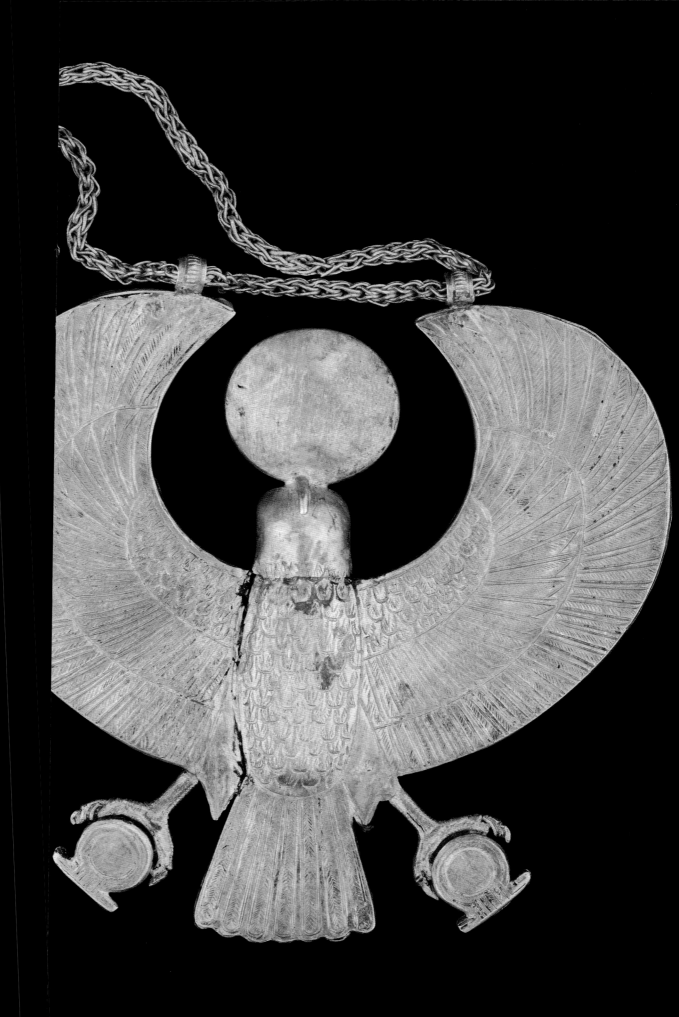

NECKLACE WITH WEDJAT EYE PENDANT

Gold, colored glass, semiprecious stones
Width of pectoral 9.5 cm, length of chain 33 cm
Carter 256vvv

Found hung around the king's neck, between the 12th and 13th layer of bandages, this necklace features a pendant in the shape of a *wedjat*, the eye of Horus, inlaid in calcite and lapis lazuli. A powerful protective symbol, this eye was linked with the mythical combat between Horus, rightful heir to the throne of his father Osiris, and his uncle Seth, who had murdered Osiris and usurped the crown. Born after his father's death, Horus waited until he reached his majority, then challenged Seth in order to avenge Osiris and reclaim the throne. During one battle, Seth tore out Horus' left eye. The god Thoth healed it and gave it back to Horus; it subsequently became a symbol of the moon, which wanes and waxes each month. The right, undamaged eye was associated with the sun. This pectoral represents the right eye, and can thus be understood as having solar connotations.

In front of the *wedjat* is a hooding cobra in the red crown of Lower Egypt, representing Wadjet, the patron goddess of that region. Behind the eye, the vulture-goddess Nekhbet of Upper Egypt, wearing the tall crown of the south flanked by ostrich plumes (the *atef* crown), spreads her wings in a protective gesture. Both *uraeus* and vulture are inlaid with lapis lazuli and colored glass, pieces of which are missing from the *uraeus*. The entire design is supported on a bar inlaid with colored glass, and the back of the piece is engraved with a design matching that on the front. The pectoral is hung from three strings of gold and colored glass beads. The counterpoise, inlaid with carnelian, feldspar, and lapis lazuli, is in the form of a *tjet* knot (sacred to Isis) flanked by two *djed* pillars (associated with Osiris).

NECKLACE WITH THREE SCARABS

Gold, feldspar, lapis lazuli, glass, electrum
Pectoral: height 11.5 cm, width 9 cm
Carter 256000

This necklace was draped around the king's neck, with the pectoral lying in the center of his chest. The pendant consists of three lapis lazuli scarab beetles set atop *neb* baskets inlaid with green feldspar (close-ups of the beetles – both front and back, with the fine details modeled in the gold – are shown opposite). The two outer scarabs support sun disks made of gold with their forelegs, while the center one holds up a lunar disk and crescent made of electrum, a mixture of gold and silver. The arrangement of the three scarabs, *neb* baskets, and disks echoes the hieroglyphic spelling of the king's throne name (the three beetles here forming the equivalent of the three strokes that usually indicate the plural). Beneath the scarabs, lotus flowers and buds inlaid with colored glass dangle from a horizontal bar decorated with rosettes.

The counterpoise, which is attached to the pendant by 10 strings of gold beads, lay at the nape of the king's neck. It features a male god, with a *uraeus* cobra in the white crown of Upper Egypt before him and a *djed* pillar and *was* scepter (signifying stability and dominion respectively) behind; he is kneeling and holding a cartouche inscribed "the good god, Nebkheperure, chosen by Amun-Re." Carter suggested that this god might be Heh, the god of eternity. Shu, the god of the air, is another possible identification, particularly as he is often shown supporting the sky in the same way that the god here holds up the king's name.

In ancient Egypt both pendant and counterpoise (*menkhet*) were essential parts of any necklace. The counterpoise helped to balance the weight of the pendant, both so that the neck would be protected from its excessive weight and also to ensure that the necklace hung properly. Since Egyptian men often wore only kilts, both counterpoise and pendant would have shown up beautifully against their naked skin.

AMULETS
Gold

Double *uraeus*
Height 7 cm
Carter 256,4,g

Human-headed *uraeus*
Height 9 cm, width 13.8 cm
Carter 256,4,f

Vulture
Height 6.6 cm
Carter 256,4,h

Amulets – decorative objects thought to have special magical properties – were used both as cult objects and in jewelry. They come in many shapes, such as hieroglyphs, gods, or animals – anything whose attributes could be thought either to protect the wearer or to imbue him with part of the power of whatever they represented. The Egyptian belief in the importance of providing magical protection to the body of the deceased is demonstrated by the abundance of amulets and amuletic jewelry found layered into the king's mummy wrappings. These three pieces were in the inner bandages, hung by linen threads around the king's neck. They are made of thin sheets of gold, with details chased into their surfaces.

The first (p. 144) represents an identical pair of *uraei*. Wadjet and Nekhbet, patron goddesses of the Two Lands, are sometimes represented in this manner rather than as a cobra and a vulture. The second (left, above) is a *uraeus*-serpent with the head of a human woman. Although a number of goddesses can take the form of a cobra, they are usually depicted as either entirely human or entirely reptile. Two, Meretseger (protectress of the Theban massif) and Weret-hekau ("great one of magic"), are shown as composite creatures, and it is possible, though not certain, that the latter is represented here, as she also appears elsewhere in Tutankhamun's tomb. Weret-hekau was associated with Isis in her role as powerful enchantress.

Of the eight amulets that made up this group, five were vultures, like the one shown left. Given the frequency with which the vulture seems to appear as a symbol of the Upper Egyptian goddess Nekhbet, it is tempting to assume that she is represented here. The vulture, however, was also sacred to the mother-goddess Mut and it might be she who is depicted. Carter's remark that the amulets were of a "significance unknown" is still essentially accurate today.

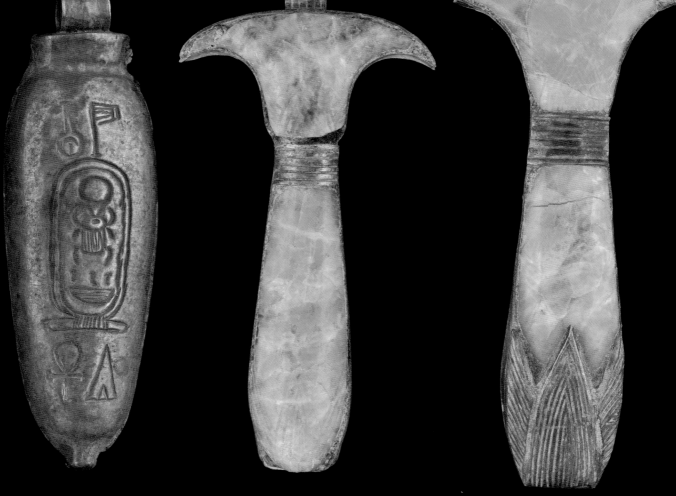

AMULETS

Pendant
Gold
Length 5.5 cm
Carter 620(69) (left)

Papyrus amulet
Gold, feldspar
Length 5.5 cm
Carter 256,4,b (center)

Papyrus amulet
Gold, feldspar
Length 6.3 cm
Carter 256ggg (right)

In addition to symbolizing the region of
Lower Egypt, the papyrus plant, which
grew in abundance in the marshes of the
Nile Delta (as well as in the low-lying edges
of the floodplain of the Nile Valley), could
serve as a sign for life and youth. Amulets
in the shape of a flowering stalk of this
plant were often made of green feldspar, a
material which had the same connotations
as the plant itself.

These amulets, called *wadj* (green) in
ancient Egyptian, were, according to the
prescriptions in the *Book of Coming Forth
by Day*, to be placed at the throat of the
deceased as part of the collection of
protective ornaments that were embedded
in the mummy wrappings. Although many
of Tutankhamun's other amulets were not in
their proper, prescribed locations, the two
papyrus amulets shown here were exactly
where they were supposed to be on the
king's body, suspended from thin wires.

Illustrated next to them on the left is
a hollow pendant of gold (found in the
Annexe), inscribed "the good god,
Nebkheperure, given life."

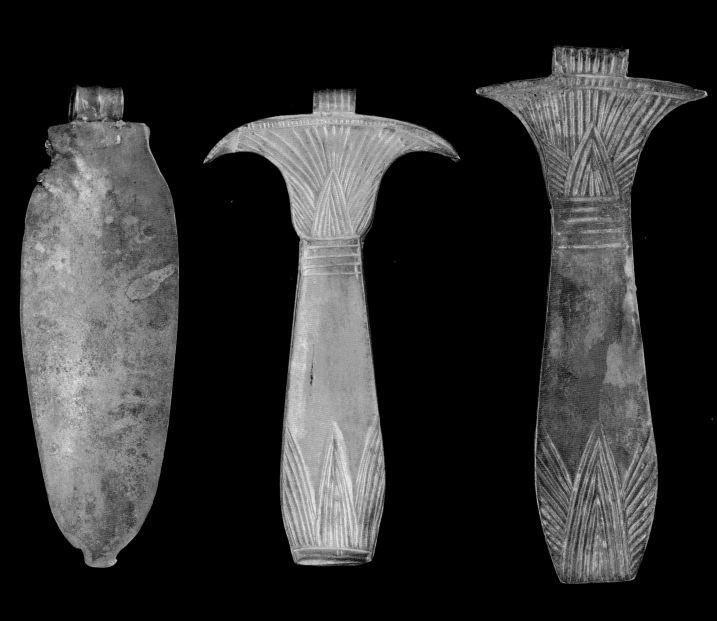

AMULETS

Thoth
Gold, feldspar
Height 5.5 cm
Carter 256,4,a (left)

Horus
Gold, lapis lazuli
Height 4.6 cm
Carter 256yyy (center)

Anubis
Gold, feldspar
Height 5.5 cm
Carter 256xxx (right)

These three amulets were found hung by gold wire around the king's neck, protecting his throat. The one on the left, of gold inlaid with green feldspar, is in the form of the ibis-headed god Thoth, usually thought of as the god of wisdom. He was believed to supervise writing, medicine, and the sciences, and can also be depicted as a baboon. That in the middle, inlaid with lapis lazuli, represents Horus, the falcon-headed son of Isis and Osiris and the special protector of the living king. Anubis, the jackal-headed god of embalming, is on the right. Like the Thoth amulet, it is inlaid with green feldspar.

The material from which an amulet was made was of great significance, and could enhance its effectiveness. The green feldspar with which the Thoth and Anubis examples were made was associated with the life-giving waters of the Nile, while the lapis lazuli of the Horus amulet was thought to resemble the night sky.

DJED AMULETS

Gold, faience
Length 8.8 cm
Carter 256hhh (left)

Gold
Length 9 cm
Carter 256kk (right)

The *djed* pillar was one of the most common of the many different amulets produced in ancient Egypt. It has been interpreted variously as the representation of a column wrapped with sheaves of grain or other vegetation, a sacred tree, and a human backbone. Closely linked to Osiris, the god of the underworld, the *djed* pillar symbolized stability and endurance, and was frequently depicted on funerary equipment. The lower parts of many coffins are decorated with a large *djed* pillar, positioned so that the spine of the deceased would lie along it, and *djed* amulets were considered necessary for inclusion within the mummy wrappings.

These examples were found around the neck of Tutankhamun's mummy, suspended from wires of beaten gold. That on the left is of gold inlaid with dark blue faience, while that on the right is entirely of gold, with details, including hieroglyphs, chased into the surface. On the upper part is a cartouche enclosing the name of the king; below is a spell.

BRACELET

Gold, electrum, turquoise
Diameter 5.5 cm
Carter 256ww

This heavy gold bracelet, one of my favorites from the tomb, is set with a piece of Sinai turquoise, mined in the desert east of the Nile Delta from the earliest periods of Egyptian history until the fall of the pharaohs. Turquoise was much prized by the Egyptians as a symbol of the sky, and was considered the sacred stone of the goddess Hathor.

Around the stone is a border of granulated beads and spirals of gold wire.

The bracelet is opened by a hinge on one side of the center plaque, and held closed by means of a pin inserted through loops on the other. The shank is composed of five bands, two of which are made of electrum rather than gold. These bands, which are bound together in three places, are to be understood as the stalks of the papyrus blossoms in which they terminate at either end, just next to the hinge on one side and the loop and pin closure on the other.

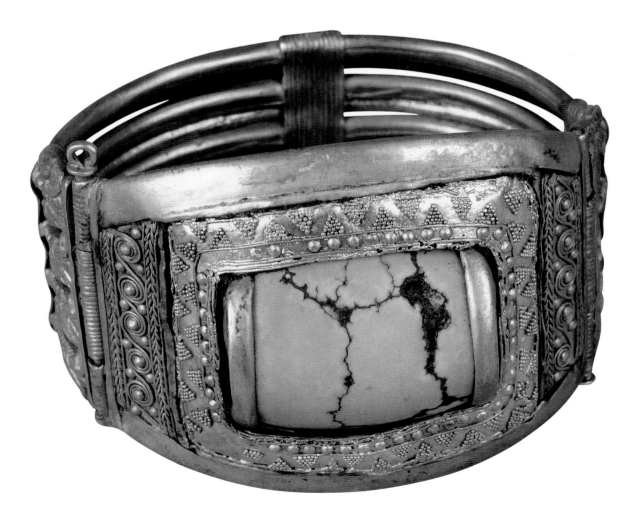

SANDALS, TOE-STALLS,
AND FINGER-STALLS OF THE MUMMY

Gold
Toe- and finger-stalls: sizes vary; sandals: length 29.5 cm
Carter 256ll

These golden sandals and toe covers (stalls) were discovered on the feet and toes of Tutankhamun's mummy; the finger-stalls were on his fingers. Each toe and finger of the king had been wrapped separately with fine quality linen, and then these finger- and toe-stalls were placed over them

individually. Made entirely of gold, the stalls vary in size in order to fit the king's digits. Details such as nails and knuckles were engraved on their surfaces.

Many pairs of sandals were found in the tomb: some were made of leather, but most were of rush or papyrus. The soles of the

sandals here, made of solid gold and thus specifically for funerary use, have been chased with a pattern that imitates rushwork. The straps that ran over the instep are decorated to mimic cording. The style of the sandals, with a thong that passed between the big and second toes, conforms to the

usual type seen in pharaonic art, and to actual examples found in tombs. When discovered, the tips of these gold sandals were turned up to cover the king's middle toes, and in this they resemble, for example, the sandals worn by the figures (pp. 29–30) that guarded the entrance to the Burial Chamber.

The position of sandal-bearer to the king was an important one; evidence for this office goes back as far as the Early Dynastic period, as seen on the Narmer Palette.

The use of precious metal for these sandals and stalls associates the king with the gods, whose flesh was thought to be golden.

FLEXIBLE URAEUS

Gold, glass, faience, carnelian, obsidian
Height of *uraeus* 6.3 cm; length of flexible body
and tail 18 cm
Carter 256,4,q

DIADEM WITH URAEUS
AND VULTURE

Gold, glass, faience, semiprecious stones, obsidian
Diadem: maximum diameter 19.9 cm;
streamers: maximum length 31.5 cm
Uraeus: length 28.5 cm
Vulture: height 4 cm
Carter 256,4,o (diadem)
Carter 256r (*uraeus*)
Carter 256s (vulture)

The flexible *uraeus* seen on these pages had been sewn, along with a golden vulture, onto a linen headdress, of either the *khat* or *nemes* type, that had been bound around the head of Tutankhamun's mummy by a gold band, but of which only the pigtail portion at the back of the neck survived.

The *uraeus* is made up of 12 separate body segments of gold bordered on both sides by rows of small beads, strung together with thread, a construction which allowed the body and tail to curve over the king's skull. The rearing hood is of gold, inlaid with carnelian and dark blue glass, and was fixed to the segmented portion by gold wire threaded through small eyelets. The serpent's head is of blue glass, with eyes of obsidian.

The diadem (pp. 154–55), probably made to be worn over a wig, was found in place on the king's mummy, on top of the beaded skull-cap which covered his shaved head. Clearly made expressly to fit the young king, it is comprised of a solid gold fillet, or headband, inlaid with turquoise- and lapis lazuli-colored glass and ornamented with circles of carnelian-colored glass, each with a central gold boss. At the back (p. 154), it is closed by a symmetrical bow-shaped clasp made of a sun-disk of chalcedony flanked by papyrus flowers inlaid with malachite. Four golden "streamers" extend from the fillet: two near the clasp, and one to each side. These are decorated to match the headband, and two are flanked by rearing *uraei*.

The *uraeus* and vulture were found in the mummy wrappings over the king's thighs, perhaps to prevent them from being damaged, as there would not have been room for them under the Golden Mask. Sockets at the back allowed them to be fastened to the front of the fillet. Once in place, the body and tail of the *uraeus* ran across the top of the king's head, helping the diadem to hold its shape. The head of the *uraeus* is made of dark blue faience, and its upper body is covered in inlay, with details chased into the gold. The vulture's head is of gold, its eyes inlaid with obsidian. The two creatures represent the patron goddesses of Upper and Lower Egypt, important symbols of the king's dominion over the Two Lands.

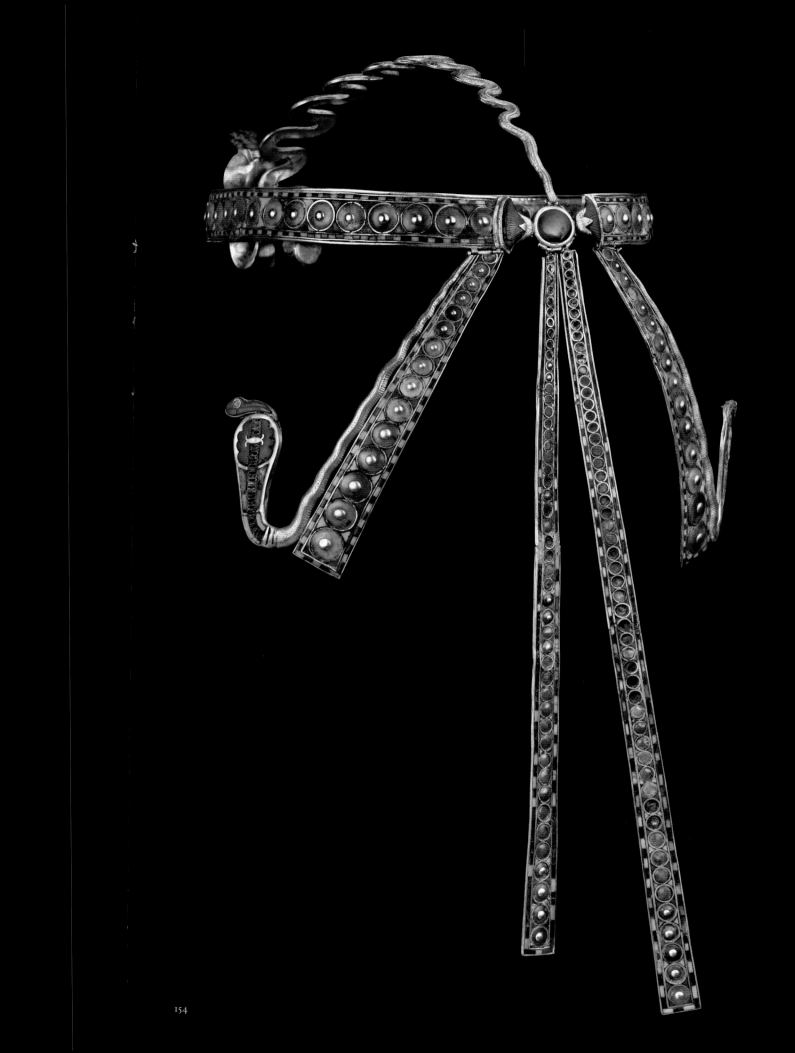

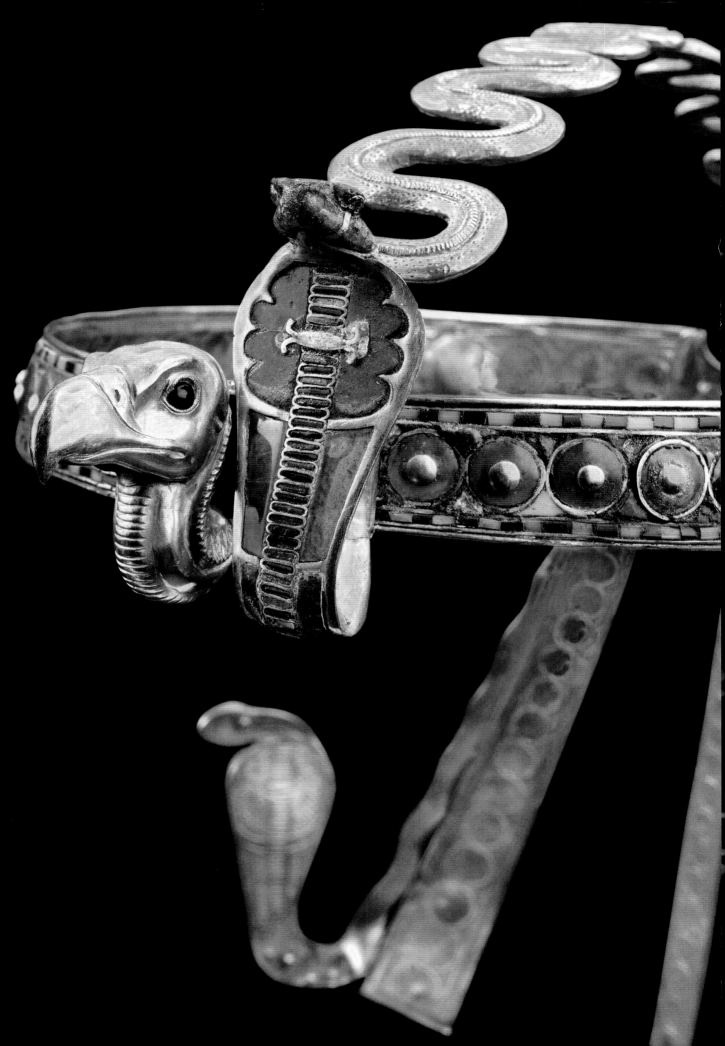

THE TREASURY

The entrance to the Treasury was guarded by this over life-size figure of the god Anubis, draped with a linen shawl, atop a shrine-shaped box. Photograph by Harry Burton.

AFTER THE POLITICAL STRUGGLES and personal tragedies of the first years following the great discovery, work on the tomb proceeded fairly smoothly. Carter had set up a storeroom for supplies and what archaeologists call "minor objects" (mostly small objects other than jewelry) in the tomb of Ramesses XI (KV 4), and a laboratory and photographic studio in the tomb of Seti II (KV 15). The now-empty KV 55 (a small tomb found crammed with Amarna period objects, including a royal sarcophagus containing a mummy) was used by photographer Harry Burton as his darkroom.

Carter packed up the innermost coffin and the golden mask, and took them to the Cairo Museum on 31 December 1925, and then returned to the tomb. He spent the next three and a half months working on the artifacts found wrapped with the mummy, and then, in late May 1926, headed back to England.

The next season began in late October 1926, and work began on what Carter at first called the "store-room," but later became known as the Treasury. The entrance to this room opened from the north end of the Burial Chamber's east wall. Set just inside, as if to guard the fabulous objects within, was an over life-size figure of the jackal-god Anubis on top of a gilded shrine (pp. 158–59).

Against the east wall of the Treasury, across from the entrance, was the great canopic shrine (pp. 164–65) that housed the viscera of the king. The walls of the chamber were lined with shrines containing gilded statues of the king and various gods, and boxes and chests filled with an assortment of items, including much fabulous jewelry. The tomb robbers had braved Anubis and entered this room, opening many of the boxes and evidently taking some of the jewelry before they were stopped or caught. Work on the clearance of the Treasury occupied the remainder of the 1926–27 season, and carried over, after the summer break, into the fall of 1927.

ANUBIS SHRINE

Painted and gilded wood, silver, quartz,
calcite, obsidian
Shrine: length 95 cm, width 37 cm, height 54.3 cm
Jackal: height 60 cm
Carter 261

The Treasury was guarded by this magnificent shrine, surmounted by a figure of Anubis, protector of the dead. When discovered by Carter, the super-jackal representing this god was still wrapped in a shawl of linen, dated by an inscription in black ink to Year 7 of Akhenaten's reign, and had a floral collar around its neck.

Anubis is made of wood gessoed and painted black, with details such as the insides of the ears, the collar, and the scarf around his neck (of a type often used to indicate divinity) highlighted with gilding. His eyes are inlaid with calcite and obsidian, and his claws are inset with silver.

The role of Anubis as guardian of the necropolis dates back to the earliest periods of Egyptian history. The archaeological record has yielded numerous depictions of priests wearing Anubis masks overseeing the embalming of the body, attesting to the importance of this god's association with mummification. Anubis was identified as the guide to the netherworld, and played an essential part in the Weighing of the Heart, the trial at which the deceased was judged and either accepted into the ranks of the blessed dead or forced to die forever, his heart fed to the monstrous Ammut (see p. 32).

The shrine, which is really an elaborate box divided into compartments, takes the form of a pylon, the massive gateway that guarded the entrance to Egyptian temples. It is constructed of wood that has been gessoed and gilded; the decoration is of alternating *djed* and *tjet* emblems, symbols respectively of Osiris and Isis. The box sits on a sledge with four carrying poles.

On the floor in front of the shrine was a "magical brick" made of unbaked clay. From the 18th Dynasty on, four of these were sealed into the walls of royal burial chambers. Each brick was surmounted by a different figure (of Osiris, an Anubis jackal, a reed torch, and a *djed* pillar) and inscribed with a slightly different spell from the *Book of the Dead*. The walls of Tutankhamun's burial chamber concealed four magical bricks; this represents a fifth, evidently placed at the entrance to the Treasury to protect it from intruders. Carter's translation of the inscription on this brick reads: "It is I who hinders the sand from choking the secret chamber. I cause the path to be mistaken. I am for the protection of the deceased." (Letter, Carter to Mrs. Robinson, 10 February 1927.)

It is ironic that this artifact was used as evidence for a curse. The "Curse of the Pharaohs," visited upon those who disturbed ancient tombs and mummies, had been invented long before the 1920s, but stories about such a curse were revived and enlarged upon greatly in the aftermath of Carter and Carnarvon's discovery. Carnarvon's death, less than six months after the opening of the tomb, was seized upon by a number of journalists, led by the novelist Marie Corelli, as evidence for this curse. All sorts of rumors, and even outright lies, were circulated. For example, the text on the magic brick in front of the Anubis shrine was deliberately mistranslated as: "I will kill all of those who cross this threshold into the sacred precincts of the royal king."

For the next several years (and, sometimes, still even today), the deaths of anyone who had anything at all to do with the tomb of Tutankhamun were attributed to the mysterious curse. Even the death of Jean-François Champollion (who died in 1832, almost a century before the discovery) was laid at the door of the pharaohs. In fact, there is no evidence for such a curse, and my life as an archaeologist – during which I have had several extremely narrow escapes from disaster – could be used as evidence to refute it.

As for the purported curse of Tutankhamun, it cannot have been very effective: Carter died 17 years after the tomb was opened, at the age of 64; and Carnarvon's daughter, Lady Evelyn Herbert, one of the first to enter the tomb, was 79 when she died in 1980.

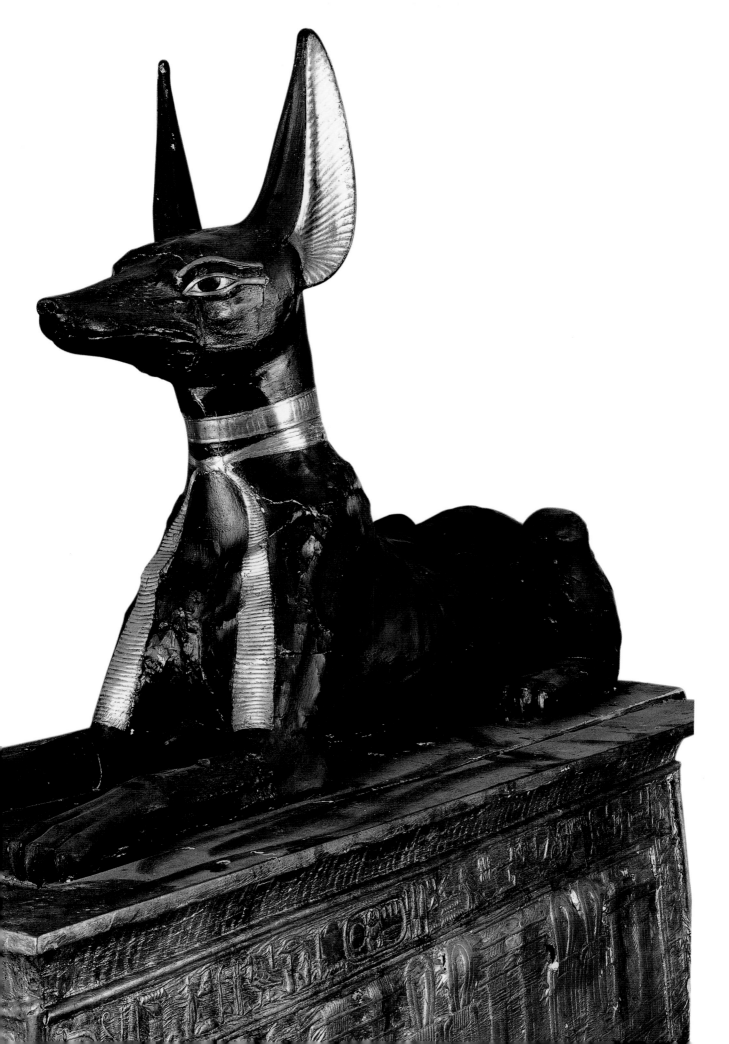

INLAID PECTORALS

Djed pillar with sun disk flanked
by Isis and Nephthys
Gold, silver, quartz, colored glass
Height 12 cm, width 16.3 cm
Carter 261i (above)

Osiris/deceased king between Nephthys and Isis
Gold, silver, carnelian(?), colored glass
Height 15.5 cm, width 20 cm
Carter 261o (p. 162)

Winged Nut
Gold, silver, carnelian(?), colored glass
Height 12.6 cm, width 14.3 cm
Carter 261p(1) (p. 163, above)

Pectoral with heart scarab
Gold, rock crystal, carnelian, feldspar, glass
Height 16.5 cm, width 24.4 cm
Carter 261m (pectoral) and Carter 269a(4)
(heart scarab) (p. 163, below)

Among the objects found in the Anubis
shrine (clearly breached by the ancient
robbers) were a number of wonderful
pectorals, including the four illustrated here,
which the king might have worn during
ceremonial occasions such as temple rituals.
All are in the form of pylon-shaped shrines,
evoking the structures in which such rites
might in reality have been carried out.
However, most of the symbolism here is
funerary, so they may also have been made
specifically for the tomb. The pectorals are of
relatively poor-quality gold, with details of
the figures inlaid in glass and semiprecious

stones on the front and engraved onto the
back. When found, they had beaded strings
attached to them, by which they would have
been suspended.

The first pectoral here (above, front and
back, and detail opposite) has in its center a
djed pillar, identified as the backbone of
Osiris, with a sun disk resting on top of it.
To the right is Isis, and to the left Nephthys,
both sisters and protectors of the king of the
dead. Between the wings of these goddesses
are cartouches containing the names of
Tutankhamun; on their heads, as well as
above their wings, are their own names.

Next is a pectoral featuring a
mummiform figure of Osiris (p. 162, front
and back), or perhaps the deceased king
after his transformation into this god,
protected by a winged cobra wearing the
red crown of Lower Egypt to one side and
a vulture in the plumed white crown of
Upper Egypt to the other, to be interpreted
either as Wadjet and Nekhbet or as Isis and
Nephthys. In fact, it is probable that both
interpretations, that is the central figure as
Osiris guarded by Isis and Nephthys, and
the central figure as the deceased king
flanked by Wadjet and Nekhbet, are
simultaneously valid. This was found,
along with the winged Nut pectoral and
the pectoral with the heart scarab, as well
as several additional pectorals, wrapped in
a linen cloth.

Third in the series here is an elaborately
inlaid figure of Nut (p. 163, above), goddess

of the sky, with her wings outstretched.
Her skin, like that of Isis and Nephthys in
the first pectoral, is a bright turquoise blue,
associated with the day sky and thus with
rebirth. Nut utters a protective spell, which
is inscribed in columns of text around her
body. According to Carter's notes, the
cartouches at the top of this pectoral
originally contained Akhenaten's names
(although not all Egyptologists agree with
this suggestion). Since the fittings for
suspension are on the sides rather than the
top, Carter thought that this jewel was the
centerpiece of some sort of belt. It is also
different from the others in that it is solid
rather than openwork.

The most important of the pectorals
here is the last (p. 163, below), which depicts
Isis and Nephthys kneeling, flanking a large
scarab of green feldspar. The scarab itself was
found in the cartouche box (p. 197), and is
the king's heart scarab, more usually found
wrapped into the mummy bandages close
to the chest.

On the back is carved the "heart spell"
from the *Book of the Dead*, which asks the
heart of the deceased to bear witness before
the divine judges at the Weighing of the
Heart ceremony by pronouncing the
"negative confession," in which the dead
person claims to have done no evil in his
or her lifetime. At the top of the pectoral
is a winged sun disk, symbol of Horus the
Behedite, and the names and epithets
of Tutankhamun.

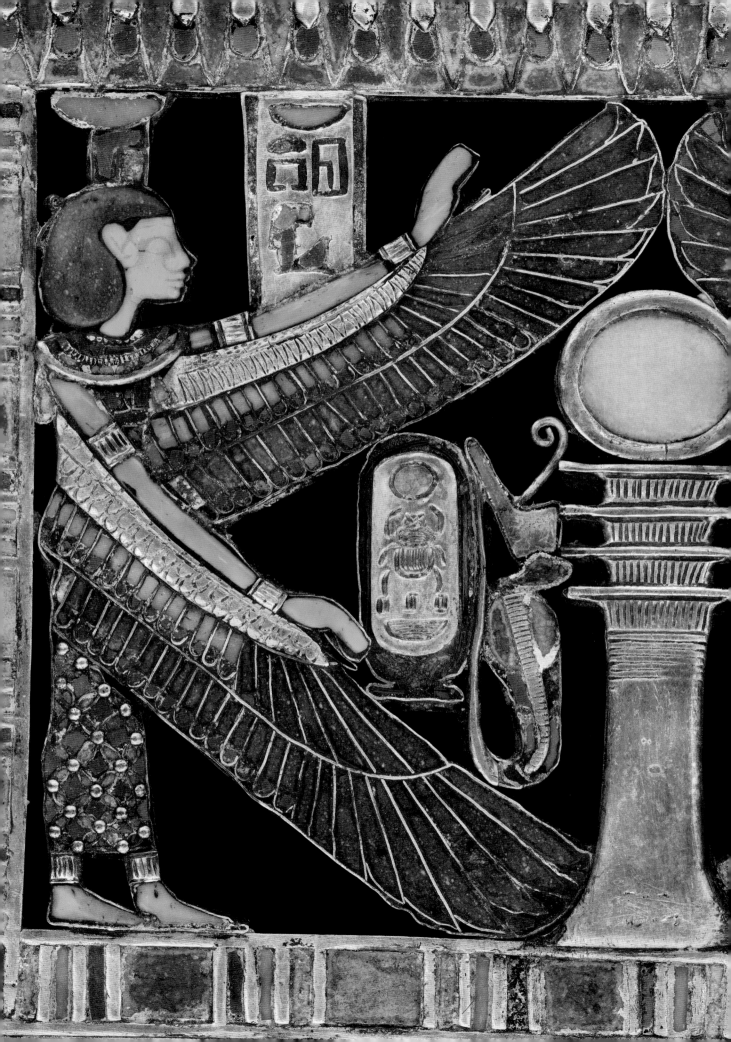

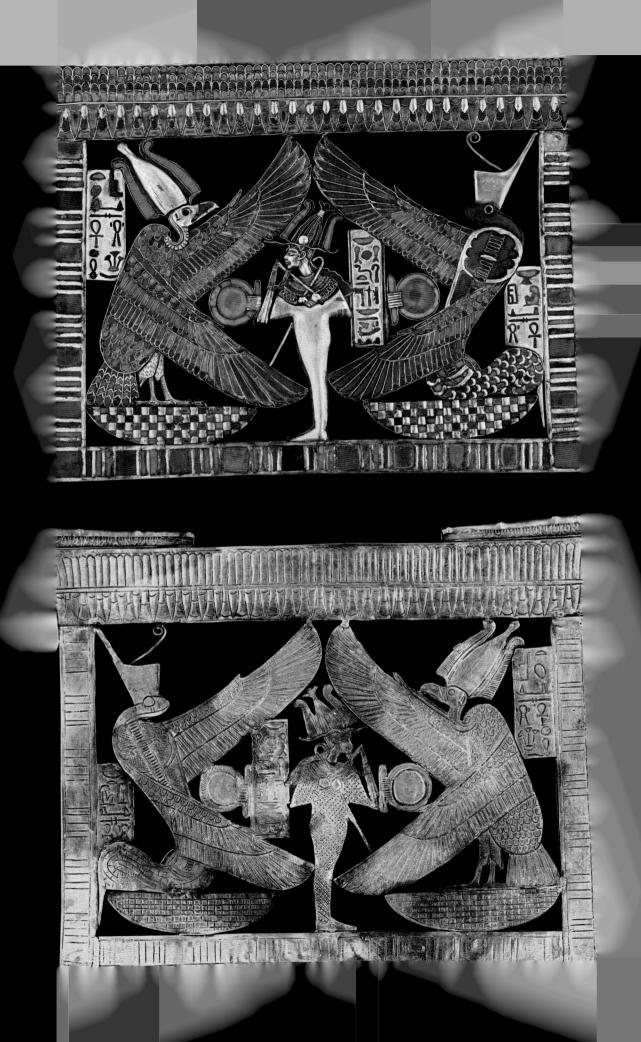

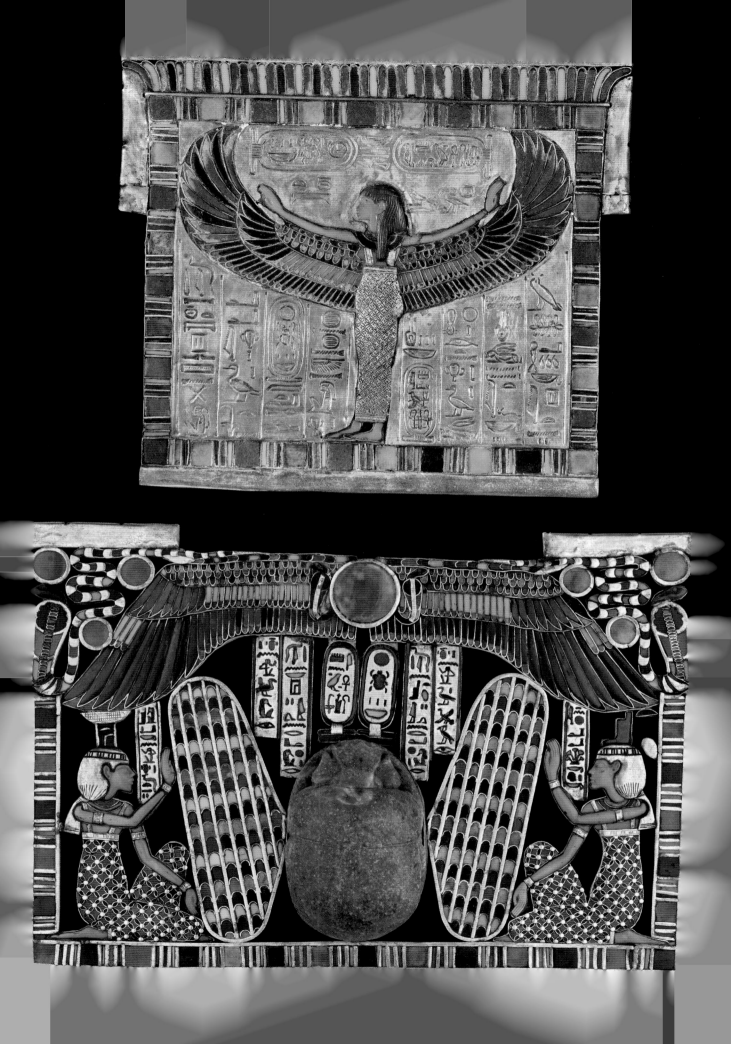

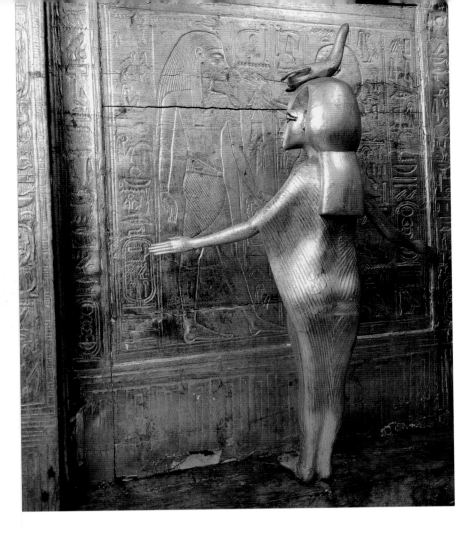

CANOPIC SHRINE AND CANOPY

Gilded wood, pottery, copper, glass;
interior of shrine coated in black resin
Canopy: height 200 cm
Shrine: height 136 cm, width 90 cm
Carter 266 (canopy) and 266a (shrine)

This gilded wooden canopic shrine and its matching canopy were set against the eastern wall of the Treasury, positioned facing west, the land of the dead. The canopy consists of four posts, inscribed with the names, titles, and epithets of Tutankhamun, supporting architraves topped by a cavetto cornice that imitates the top of a reed wall. Around the upper edge of the canopy rears a frieze of solar *uraei* (cobras with sun disks on their heads) of blue-glazed pottery and wood inlaid with copper and colored glass. At the bottom the posts fit into the runners of a sledge; both canopy and sledge are gessoed and gilded with thin gold foil. On the roof are engraved spells spoken by Nut, Isis, and Nephthys.

The shrine within the canopy takes the form of the *per-wer*, the sacred cult structure originally associated with Upper Egypt; on top is another frieze of solar *uraei*. The walls are gessoed and gilded, and decorated with paired images of the goddesses and gods charged with protecting the viscera of the king: on the west are Isis and Imsety (the liver); on the south are Nephthys and Hapy (lungs); to the north are Neith with Duamutef (stomach), accompanied by the earth god Geb; and on the east are Selket and Qebehsenuef (intestines), with the creator god Atum and the composite funerary god Ptah-Sokar-Osiris. These images are surrounded by hieroglyphic spells spoken by the various divinities. On top of the shrine are written spells to be uttered by Nut, Imsety, and Hapy, along with other religious formulae.

This shrine was also the subject of rumors of a curse and was reported to bear the inscription: "Those who will enter the sacred tomb, they will be visited by the wings of death quickly."

Exquisitely carved and gilded figures of the four tutelary canopic goddesses stand on the sledge: Isis to the west; Nephthys to the east; Neith to the north; and, my personal favorite, Selket (seen here), to the south. Each is dressed in a pleated dress and bead collar and identified by a large hieroglyphic symbol on her head. The four graceful figures face inward, with their heads turned slightly to one side and their arms outstretched to protect the shrine. It is interesting to note that the figures of Nephthys and Selket were switched.

The statuette of Selket was sent abroad with the Tutankhamun exhibition in the 1970s and 1980s. While she was in Germany, the scorpion hieroglyph on her head was damaged. Fortunately, it was repaired, but this accident caused the Egyptian Parliament to decide that the treasures of Tutankhamun should not be allowed to travel in the future. This ban was later lifted, although some of the most important artifacts from the tomb will never again leave Egypt.

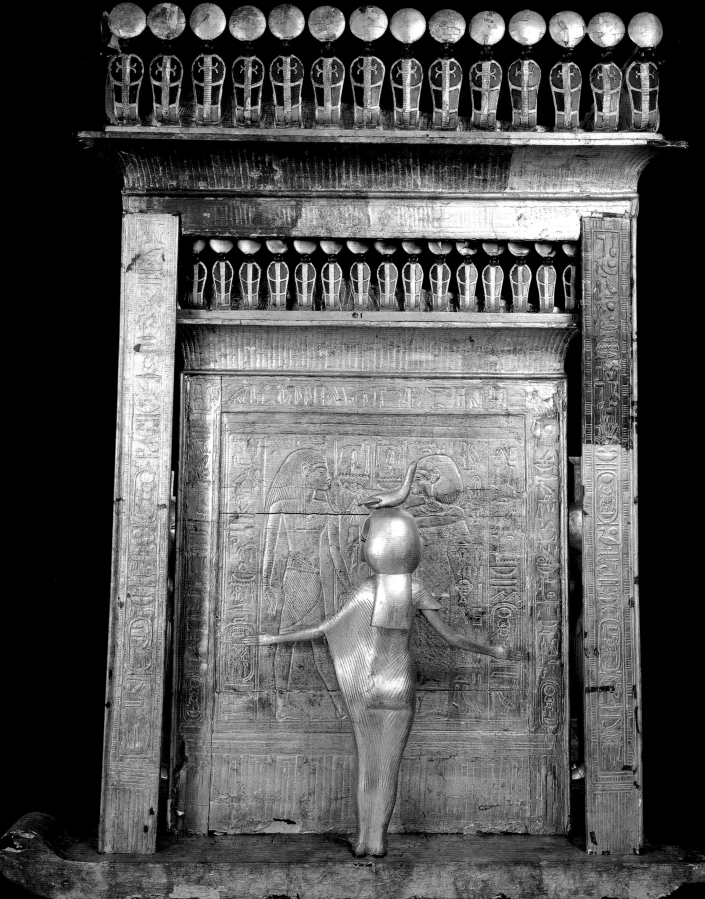

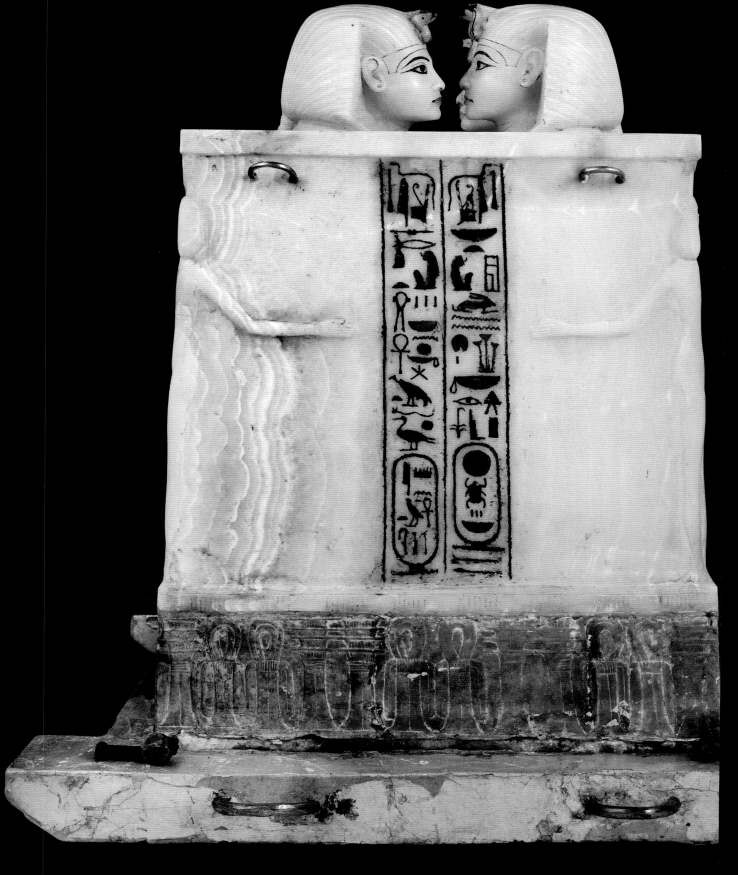

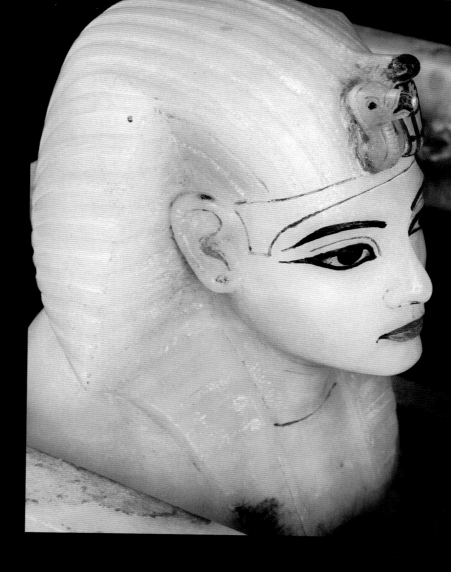

CANOPIC CHEST

Painted calcite (Egyptian alabaster)
Height of box with lid 77.2 cm,
maximum width 57.5 cm
Carter 266b

HUMAN-HEADED STOPPERS

Painted calcite (Egyptian alabaster)
Height 24 cm
Carter 266c, d, e, and f

The canopic shrine (p. 164) had no bottom, and inside it, atop a smaller sledge with silver-coated runners, stood a chest carved from a single block of calcite. Draped over this was a folded linen sheet. The lid of the chest (removed in the photo opposite) echoes the sloping *per-wer* roof of the outer shrine and canopy, while its sides are inclined slightly inward, and are decorated at their corners with carved images of the same four protective goddesses who stood on each side of the canopic shrine.

The interior of the chest is of unusual design. Where one would normally expect to find four separate compartments, each containing an actual canopic jar, there are instead indications of the divisions for the four sections carved into the solid body of the chest, each occupied by a cylindrical hollow with a raised rim in imitation of a jar. Each of the "jars" thus formed is topped with a separately carved human-headed stopper in the form of the king in a *nemes* headdress, also made of calcite, with details such as eyes, lips, and ornaments on the

red and black paint. The four stoppers faced inward toward the center of the chest. All are marked underneath with a symbol indicating their correct position. Inside the hollows were the four canopic coffinettes (pp. 170–83).

Whether these stoppers were in fact carved for Tutankhamun is the subject of some controversy. The facial features of the four lids vary slightly, but all show the same large, almond-shaped and heavy-lidded eyes, narrow nose, turned-down mouth, and squared but delicate chin. Because these characteristics do not exactly match those found on the majority of the portraits of Tutankhamun (for example, the Golden Mask, p. 112), it is possible that the chest, like a number of other objects in the tomb, was actually carved for his predecessor, Ankhkheperure. It is unclear how these then became part of Tutankhamun's burial assemblage. Perhaps they were left in storage when fresh ones were made for their intended owner, or they may have been used in the earlier tomb and then

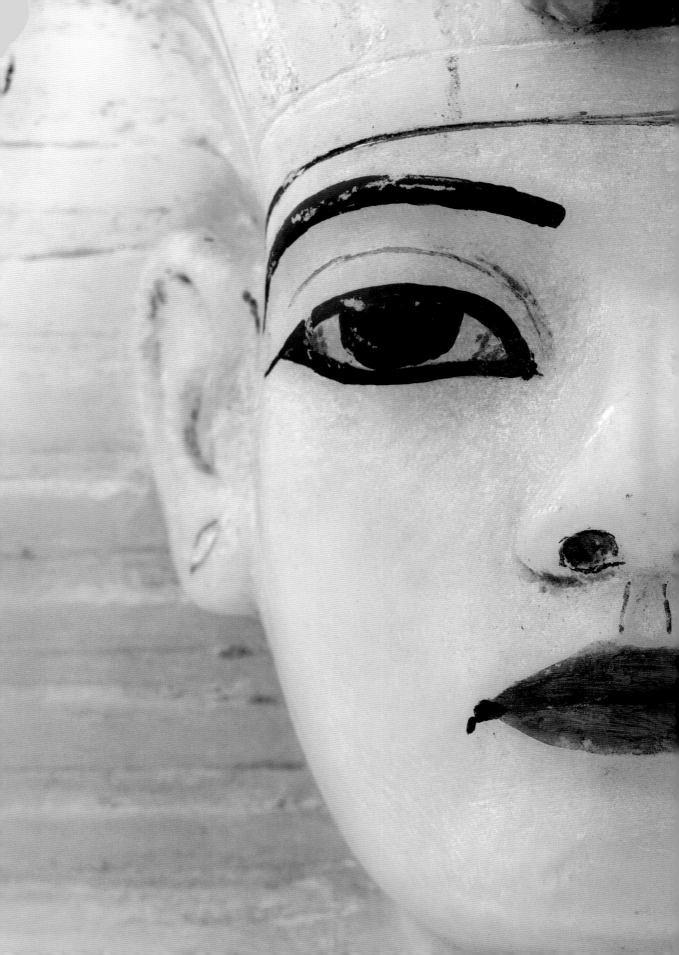

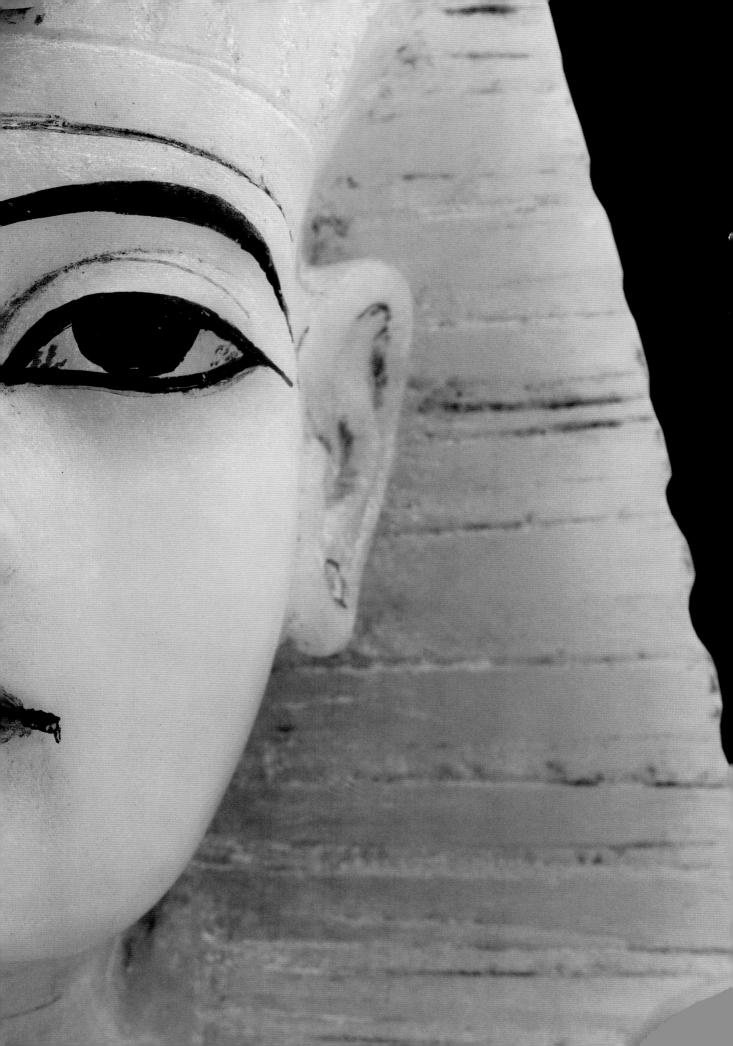

CANOPIC COFFINETTES

Gold, lapis lazuli, colored glass
Maximum length 39 cm

Imsety: Carter 266g(1) (pp. 177–83)
Duamutef: Carter 266g(2) (pp. 171–72)
Hapy: Carter 266g(3) (pp. 173–74)
Qebehsenuef: Carter 266g(4) (pp. 175–76)

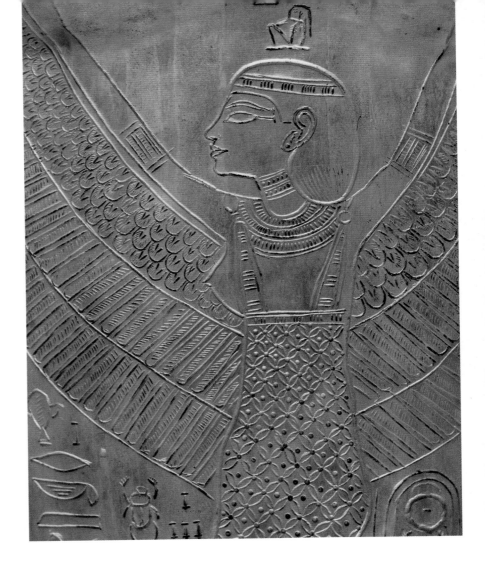

Inside the canopic chest of Tutankhamun (p. 167), within the hollowed-out cavities topped by human-headed stoppers, were these four coffinettes, miniature versions of the royal coffins, which contained the embalmed and wrapped viscera of the king. Each container, made of solid gold with inlays of colored glass and lapis lazuli, is a remarkable, finely crafted work of art.

As with Tutankhamun's own inner coffins, they take the form of mummiform figures of the king in the *nemes* headcloth fronted by the protective cobra of the north and vulture of the south. On the chin of each is the long, curled beard of divinity; and each wears a broad collar (p. 125) and wristlets; the ears are pierced for earrings; and the hands grasp a crook and a flail (p. 202), symbols of royal authority.

The features of the faces are very similar to those of Tutankhamun, and at first glance, immediately bring the famous golden mask to mind. However, on closer inspection, differences emerge: the lips and nose are thinner, the eyes are larger, and the

shape of the face is not quite the same. In fact, Egyptologists who have studied these objects closely have discovered that the cartouches that form part of the inscriptions have been replaced, and traces remain of the name Ankhkheperure, one of the names of both Smenkhkare and Neferneferuaten (see also pages 103 and 117).

Like the coffins, the coffinettes are adorned to look as if they are covered with feathers, a style known as *rishi*. On the sides are figures of the protective goddesses Wadjet and Nekhbet as birds, their wings outstretched to wrap around and thus embrace the king. In their talons the goddesses hold *shen* rings, symbols of eternity. Down the center of each lid is a single line of inscription. These are spells to be recited magically by the four canopic goddesses, promising to guard the viscera and the canopic genii (the Four Sons of Horus) associated with them, and thus keep Tutankhamun in the form of Osiris safe. The stomach, linked with Duamutef (often seen with a jackal head), was protected by

Neith; the liver (human-headed Imsety) was guarded by Isis; the lungs (baboon-headed Hapy) were kept safe by Nephthys; and the intestines (falcon-headed Qebehsenuef) were defended by Selket.

On the interior of the lid of each coffinette is engraved an image of the goddess Nut standing on the hieroglyph for the sky (of which she is the divine incarnation), her winged arms outstretched to protect the king on his journey to the next world. On the inside of the lower half of the coffinettes are inscriptions also designed to guard the king on his trip to the afterlife.

These masterpieces in miniature serve to remind us once more that all the objects in the tomb have their own unique styles. One has to marvel at the craftsmanship of this work, the details of the inlaid inscriptions, the painstaking work necessary to create the individual "feathers" that cover the surfaces, and the fine features of the faces.

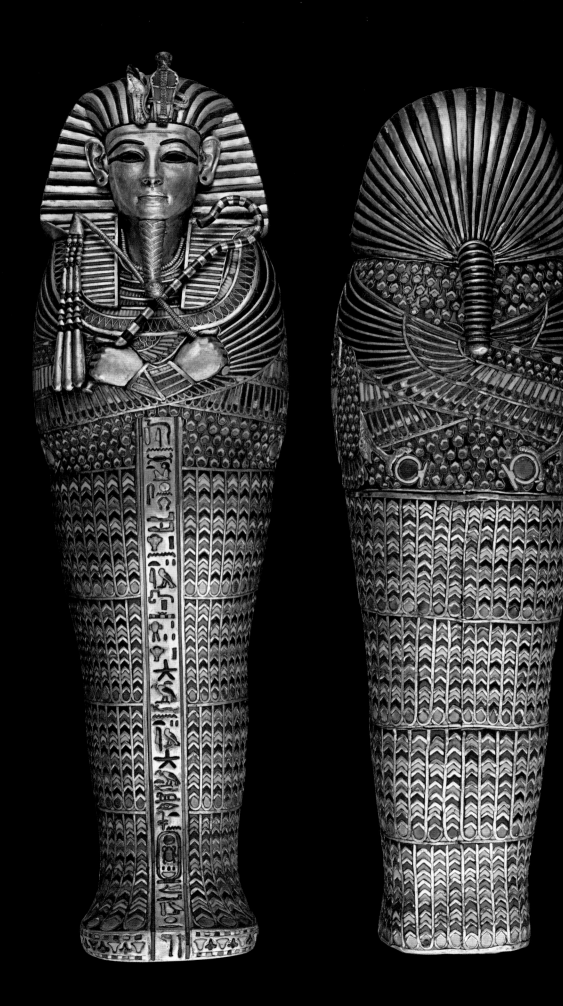

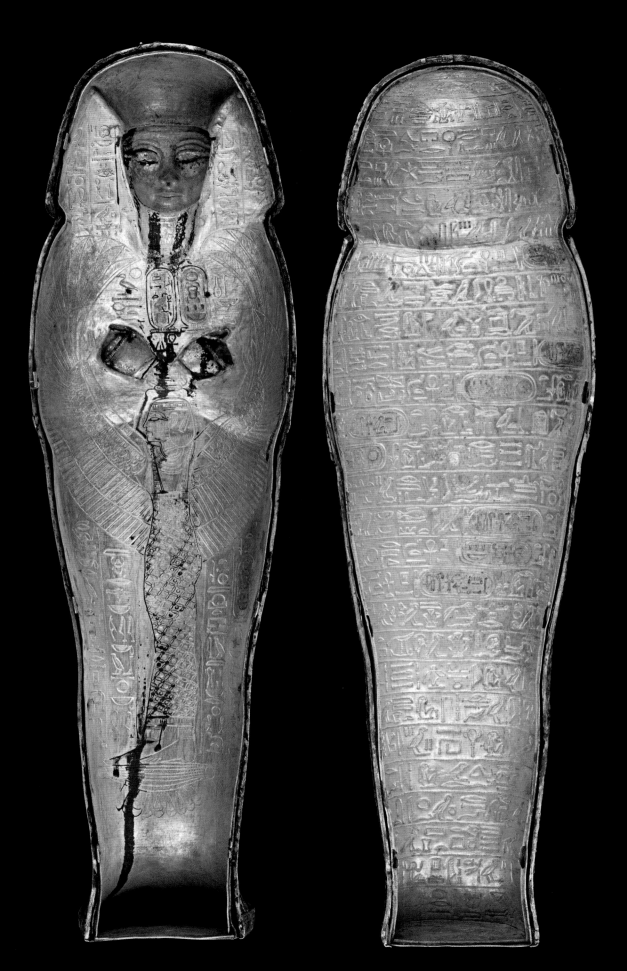

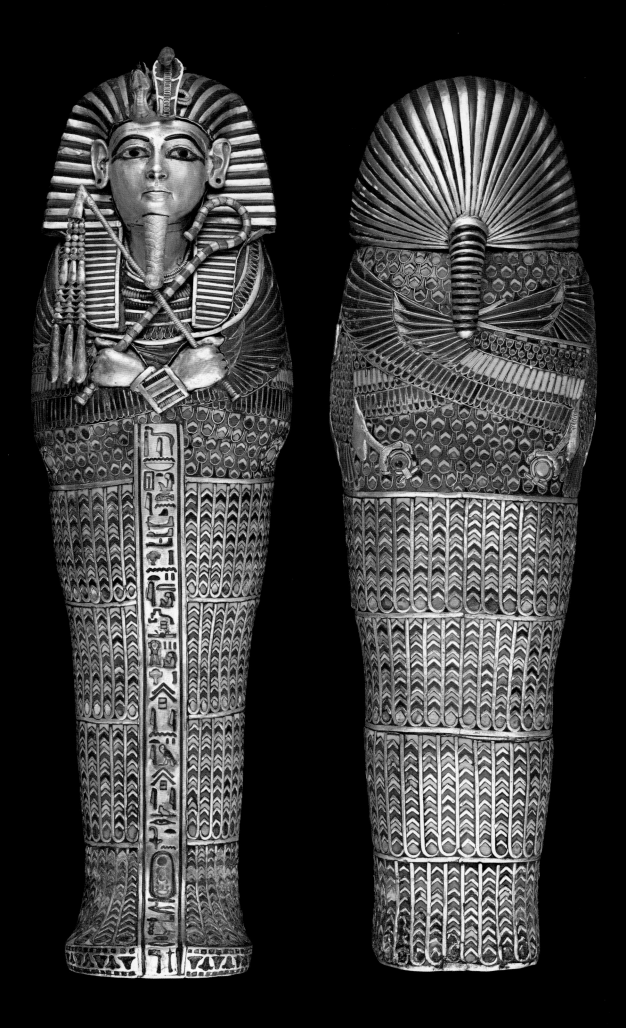

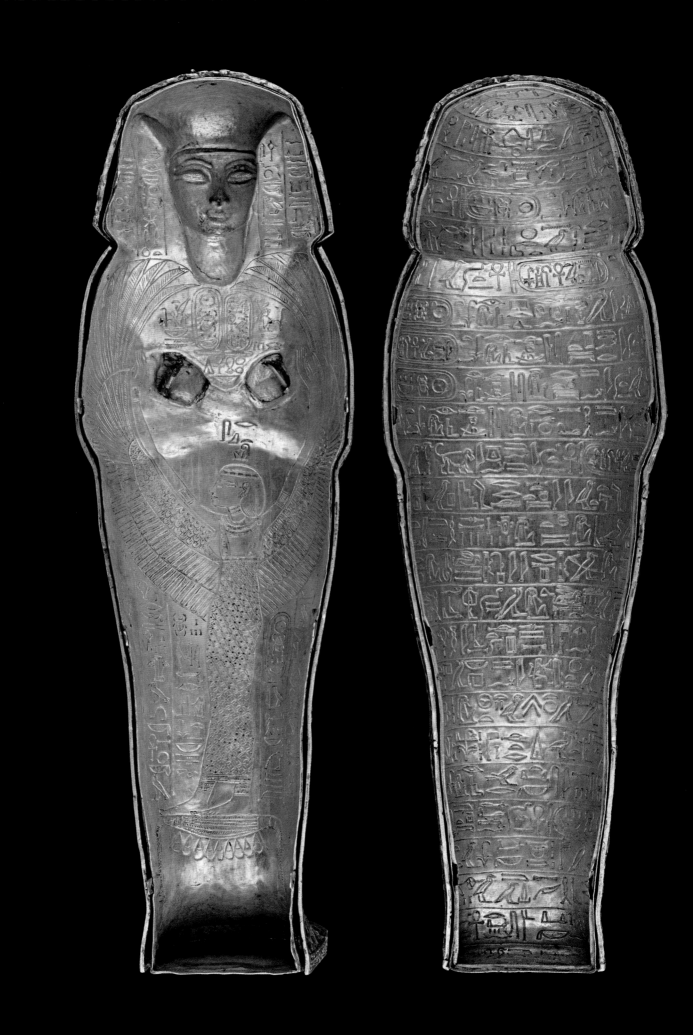

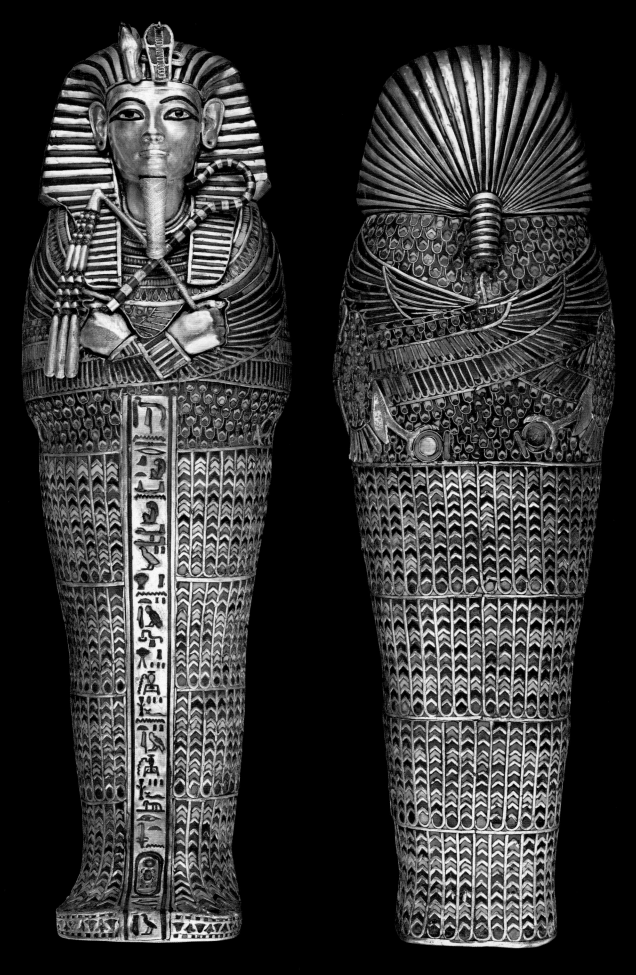

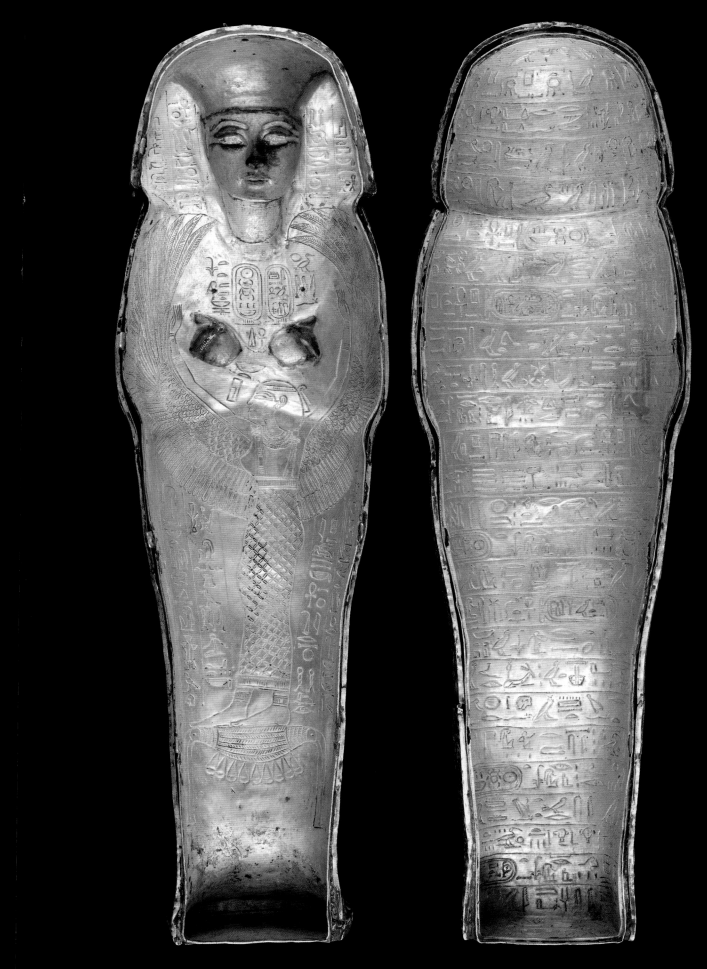

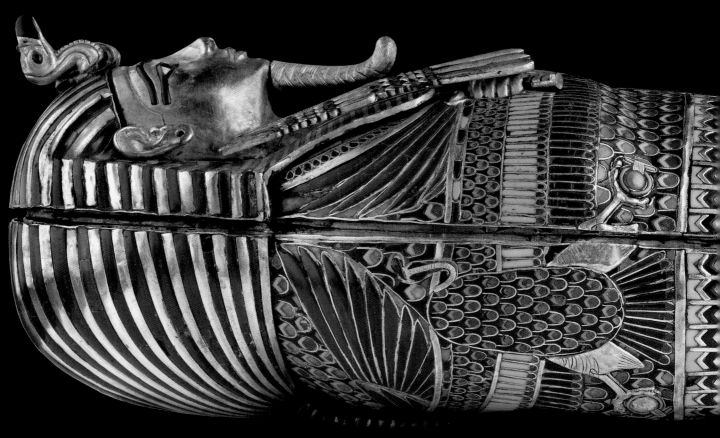

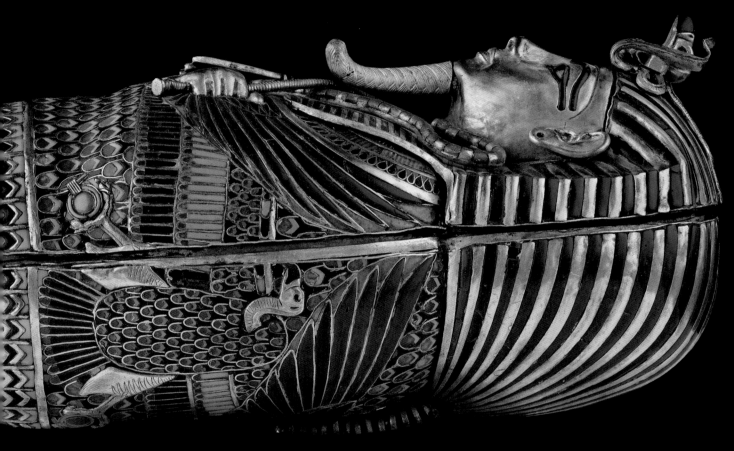

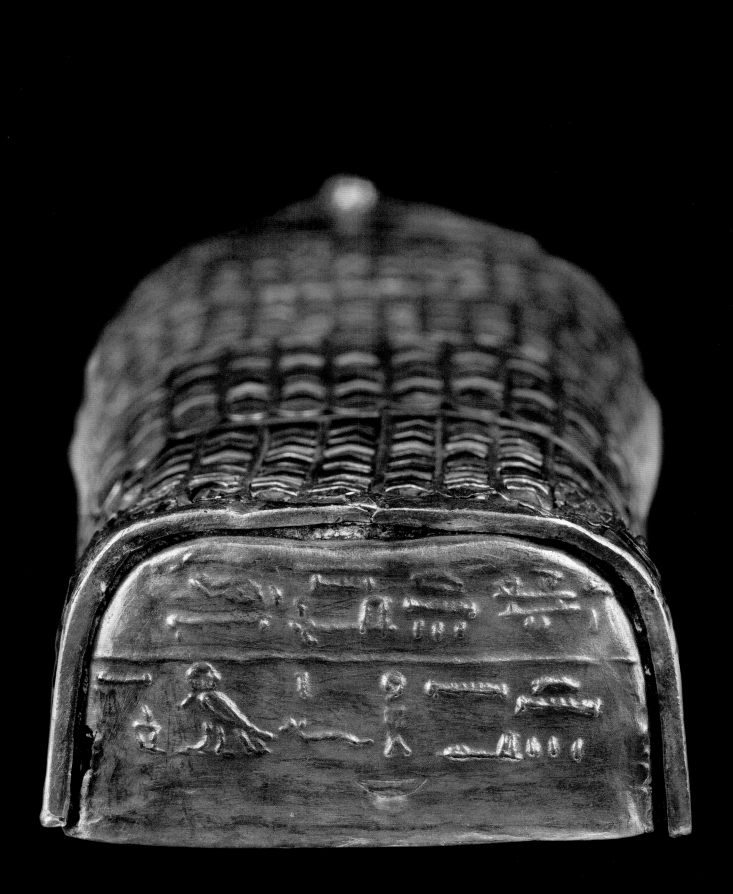

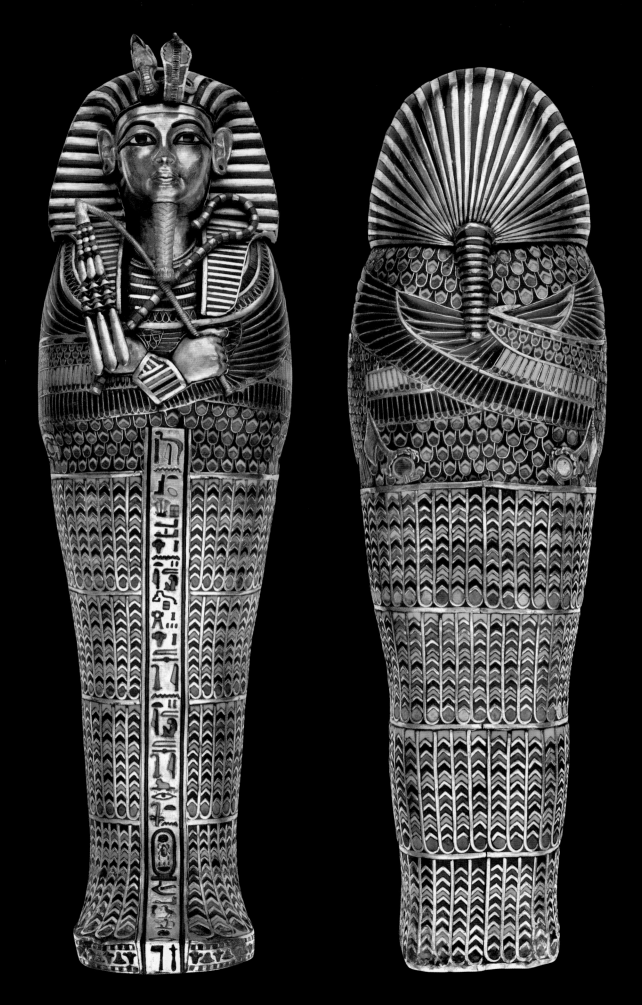

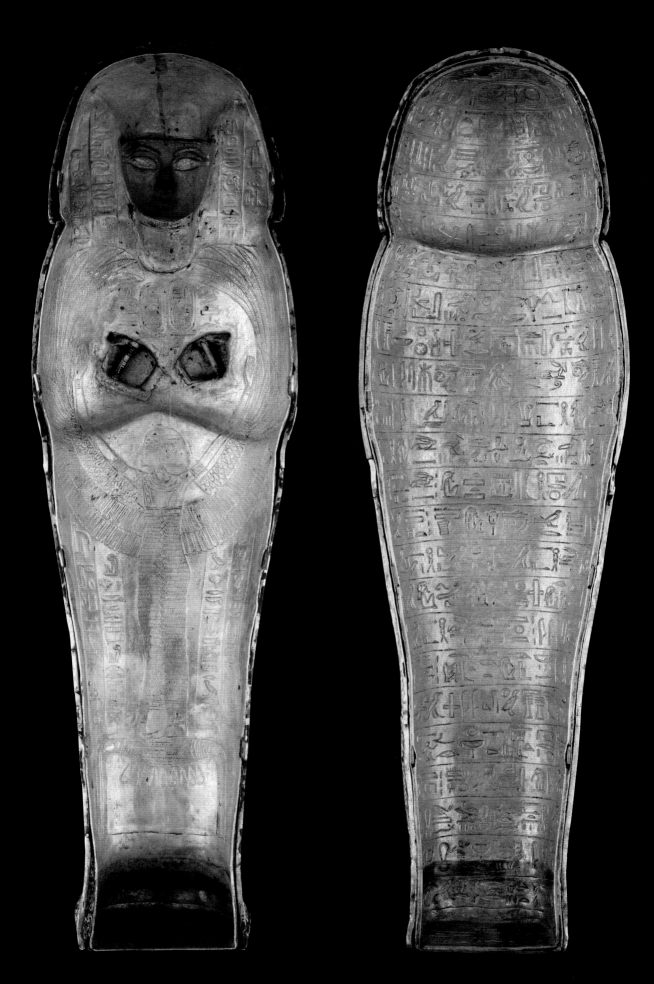

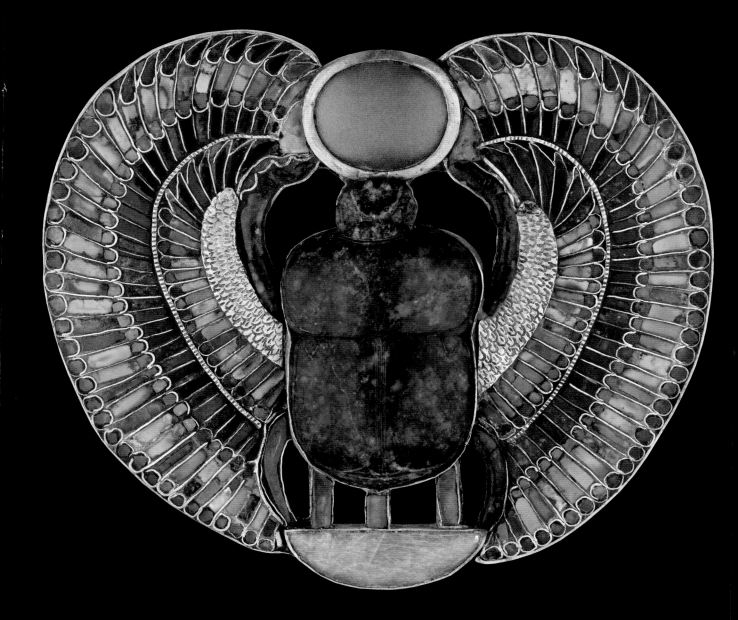

NAME PENDANT
OF TUTANKHAMUN

Gold, semiprecious stones
Height 9 cm, width 10.5 cm
Carter 267a

This pendant was discovered in one of a row of caskets of varying sizes that lay between the Anubis shrine (p. 158) and the canopic shrine (p. 164). The chest's seal had been broken and its contents disturbed, although enough remained for Carter to conclude that it had originally contained jewelry wrapped in linen. An inscription on the box, translated for Carter by the great Egyptologist Sir Alan Gardiner, reads "Jewels (?) of gold of the procession made in the bed-chamber of Nebkheperure."

This elegant pectoral forms a rebus for Tutankhamun's throne name, Nebkheperure. Like many of the other jewels from the tomb, it is made of gold set with inlays of colored glass and semiprecious stones in a cloisonné technique. The name is formed of three elements: at the bottom is a basket of turquoise, the sign for *neb*, "all." Above this is a lapis lazuli scarab, *kheper*, meaning "creation" or "form," with three strokes to indicate a plural (in ancient Egyptian, *kheperu*). With its front legs, the beetle pushes a sun disk inlaid with carnelian, forming the name of the sun god, *Re*. The scarab has curved wings of gold, exquisitely inlaid with carnelian, lapis lazuli, and turquoise, which sweep over its head to embrace the sun disk and stretch down to the base of the jewel. These wings bring a sense of movement to the composition, and unify the elements of the design. The back of the pendant is carefully engraved to echo the details of the front. A chain would have been passed through the hollow tube attached to the center of the sun disk at the back in order to suspend the pendant.

This pectoral is an extremely ingenious creation. In addition to spelling out the king's name, it served as a symbol, and thus a magical guarantee, of rebirth and resurrection, since the scarab beetle was both a manifestation of the sun at dawn and its messenger, pushing it over the horizon to create the day. This association is thought to have been made by the ancient Egyptians because these beetles push sun-shaped balls of dung across the sand; in addition, they store their eggs inside the balls, so that their young hatch from them.

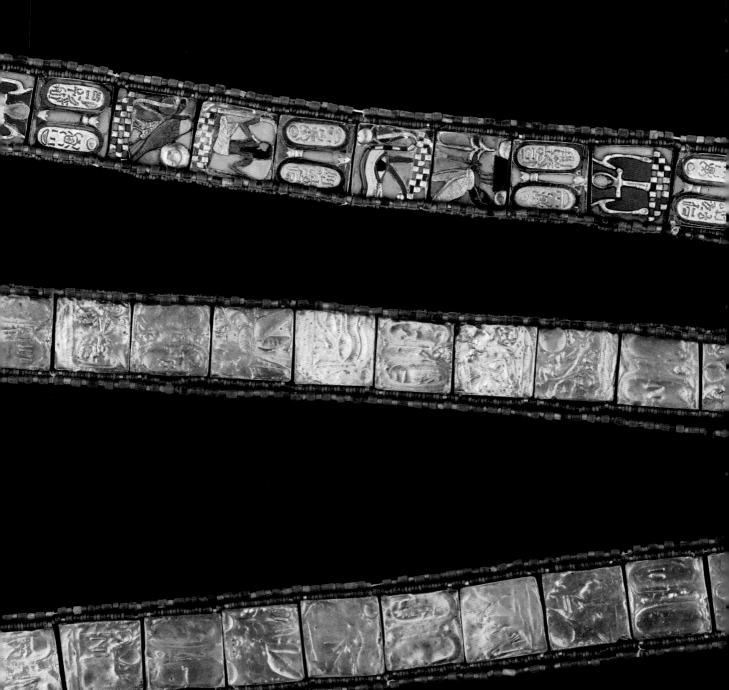

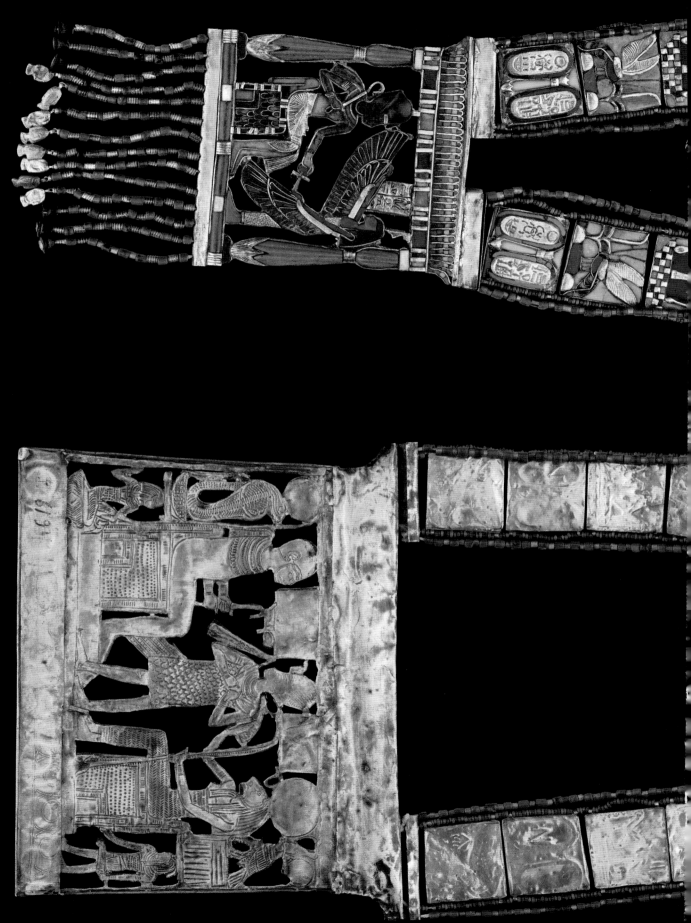

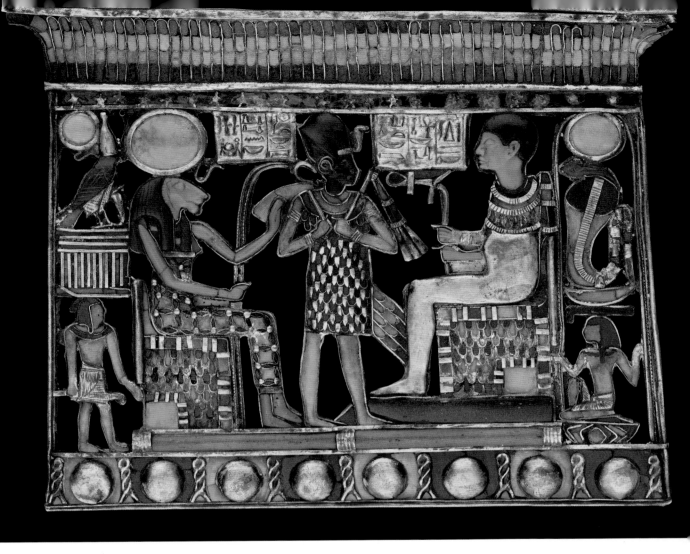

"CORONATION" PECTORAL, BANDS, AND COUNTERWEIGHT

Gold, silver, glass, semiprecious stones
Pectoral: height 11.5 cm, width 14.1 cm
Carter 267q (pectoral), Carter 269i (bands), and
Carter 269j (counterweight)

This spectacular pectoral was also found in Box 267, though the bands and counterweight that were originally attached to it were found in the large cartouche-shaped box (p. 197), further evidence that the robbers had breached this chamber.

Intricately wrought of openwork gold inlaid with semiprecious stones and colored glass, this elaborate jewel clearly served a special purpose. The central figure is the king himself, clad in a golden corselet (p. 44) that reaches to his knees, a broad collar (p. 125), and the *khepresh* crown, also known as the war helmet. In his hands he holds the crook and flail (p. 202). The skin of his body

is the traditional brown of the Egyptian male, but his face is black, linking this image to fertility and resurrection. Seated on a throne facing the king is Ptah, guardian of Memphis and patron of artisans. The mummiform body of this god is inlaid in silver, and his hands and face are turquoise, a color associated with new plant growth and thus also with rejuvenation. Ptah, given here his epithet "Lord of *ma'at*," says to Tutankhamun: "I give to you life, dominion, and all health." Behind Ptah is a small figure of the god of eternity, Heh, holding in his hands notched palm ribs that symbolize millions of years. Above him is a cobra atop a basket, a sun disk set on its head, together forming a cryptographic writing of Tutankhamun's throne name, Nebkheperure.

Behind the king sits Ptah's consort, the lioness-headed Sekhmet. Goddess of war and reconciliation, she is shown in a long, tight-fitting dress, a broad collar, and a long wig of dark blue. The sun disk on her head is made of carnelian. As "mistress of the sky," she touches Tutankhamun's shoulder and

tells him: "I am giving to you years of kingship for eternity." Sekhmet is followed by the king's *ka*, or spirit double, with a niched rectangle known as a *serekh*, traditionally used to hold certain of the king's names, on his head.

The wide bands and counterpoise are equally elaborate. The decoration of the bands, consisting of cartouches alternating with various hieroglyphic symbols, has been carefully arranged so that all its elements would be viewed right side up when it was worn. On the counterweight, the king again wears the war helmet, here with a pleated kilt, broad collar, and jewelry. He sits on a throne and holds a crook in his right hand. A winged figure of Ma'at, goddess of justice and truth, holds out an *ankh* to him.

Each of the major elements here has been carefully chosen for its association with both the coronation and the Sed Festival, the ritual of rejuvenation thought to have been celebrated by the king first after 30 years on the throne, and repeated at regular intervals thereafter.

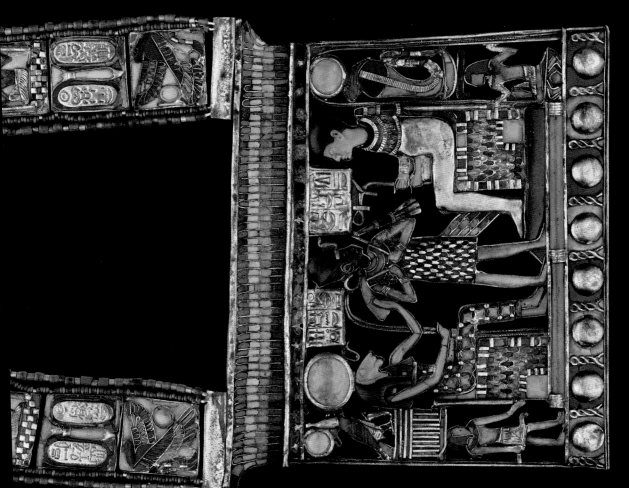

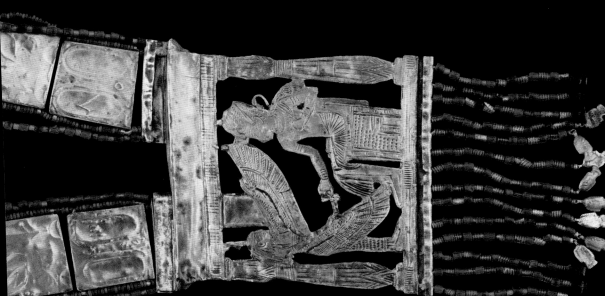

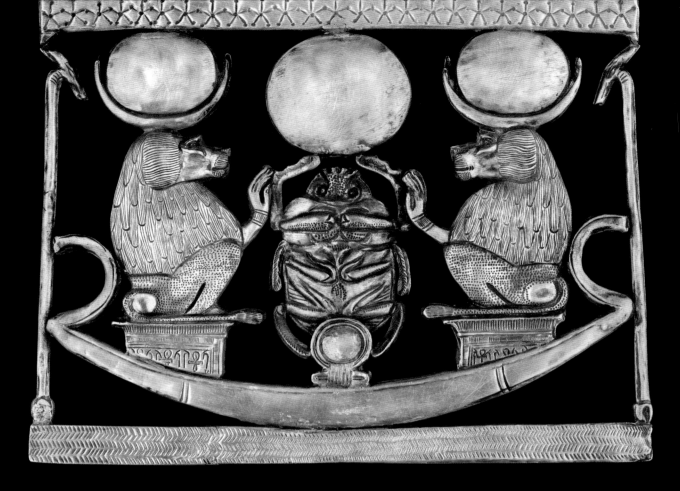

NECKLACES

The necklaces, pendants, and counterpoise illustrated on the following pages, all of gold with cloisonné work, come from Box 267, the same box inlaid with ebony and ivory in which the Name and "Coronation" pectorals (pp. 184 and 186) were discovered. All these pieces are distinctive in their individual compositions, though they share common elements, and all have symbolism relating to the essential funerary themes of resurrection and eternal life in the hereafter. They vary in the quality of their materials and workmanship, thus some may have been used during the king's life and others made specifically for his burial.

The first necklace, for which all elements (pectoral, bands, and counterpoise) have survived, features two baboons, animals sacred to the god Thoth (the reverse of the pectoral is seen above and the whole necklace opposite). In keeping with this deity's identification as a lunar god, the apes have moon symbols (a combination of the full and crescent moons) atop their heads. They flank a lapis lazuli scarab beetle that

holds a *shen* ring, symbol of eternity, in its hind legs, and pushes a carnelian sun disk with its front legs. Both baboons lift their forelimbs in adoration of this symbol of the rising sun, an artistic rendering of the morning behavior of real baboons, who have been observed to face the eastern horizon and scream at dawn. The baboons and beetle sit in a papyrus skiff, with the star-studded hieroglyph for sky framing the scene above, a band of water below, and *was* scepters, symbols of dominion, on either side. The counterpoise (seen opposite, at the top) contains an image of the god of eternity, Heh, flanked by cobras wearing the white and red crowns respectively. The bands that connect pectoral and counterpoise are equally elaborate, with alternating groups of inlaid hieroglyphs.

The next pendant (p. 192) also combines solar and lunar imagery. The solar scarab that takes center stage here is made of green chalcedony, and has been provided with wings. Its hind legs (metamorphosed into the talons of vultures) clutch *shen* rings and

bundles of plants (lilies on one side and lotus on the other, both symbols of Upper Egypt). With its forelegs, it pushes a sky bark bearing a *wedjat*, in this case the lunar left eye, above which is a lunar crescent of gold and a full moon disk of silver. Three golden figures have been soldered onto the moon: the king, a lunar symbol on his head, with Thoth as an ibis behind him and Re-Horakhty before him. *Uraei*, also linked to the rising sun, flank various parts of the design, and an elaborate floral band hangs below the scarab.

The third pendant (p. 193, front and reverse) spells out a lunar version of Tutankhamun's throne name. In the center is a winged scarab of lapis, perched on three plural strokes and a basket. Instead of the sun disk, the beetle pushes a moon symbol. The central image is flanked by solar *uraei*, with small *ankh* signs and *wedjat* eyes occupying the space between them and the scarab. The band on which all these elements sit is filled with a line of small circles; below hang more circles, lotus blooms, and cornflowers.

The solar imagery of the previous jewels is seen again in the fourth necklace (pp. 194–95, front and reverse), which features a lapis lazuli scarab, topped by a carnelian sun disk, seated in the morning solar bark, which sails on a band of dark blue. The scarab is flanked by solar *uraei* and vertical columns of hieroglyphs. The counterpoise here is relatively simple – two cobras facing one another – and is attached to the bands of the necklace by short strings of beads. The bands themselves echo the imagery of the pendant, and also spell out the king's throne name. At the back, the bands end in vultures, holding the beads that attach to the counterpoise in their beaks.

The last piece in this series is a counterpoise (p. 196), which has not been convincingly matched up with any of the pendants found in the tomb; it is possible that the rest of the necklace to which it belonged was stolen by the ancient robbers. In the center here is the god of eternity, Heh, kneeling and holding a lunar *wedjat* eye above his head. The high quality of the workmanship of this piece is evident in the way the artist has inlaid translucent calcite over a reddish paste to form the god's skin. Behind Heh is a *tjet* amulet, symbol of the goddess Isis. This central composition is flanked by solar *uraei* and framed by notched palm ribs atop tadpoles and *shen* rings, symbolizing a long reign.

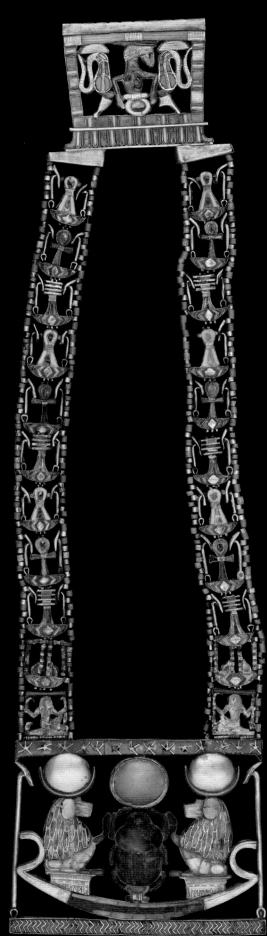

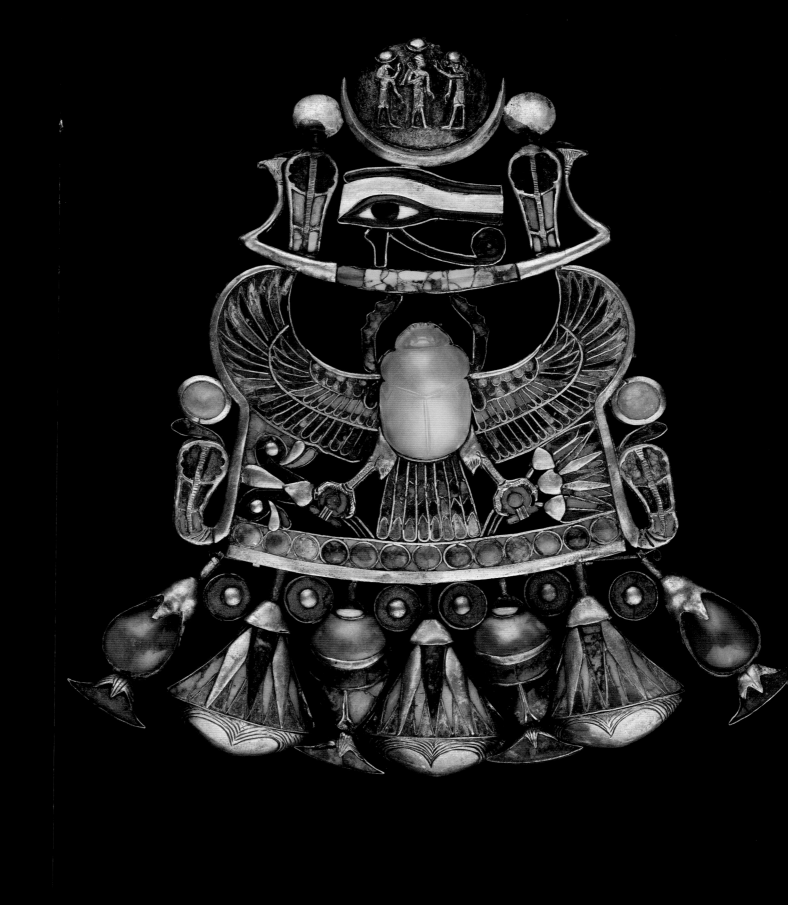

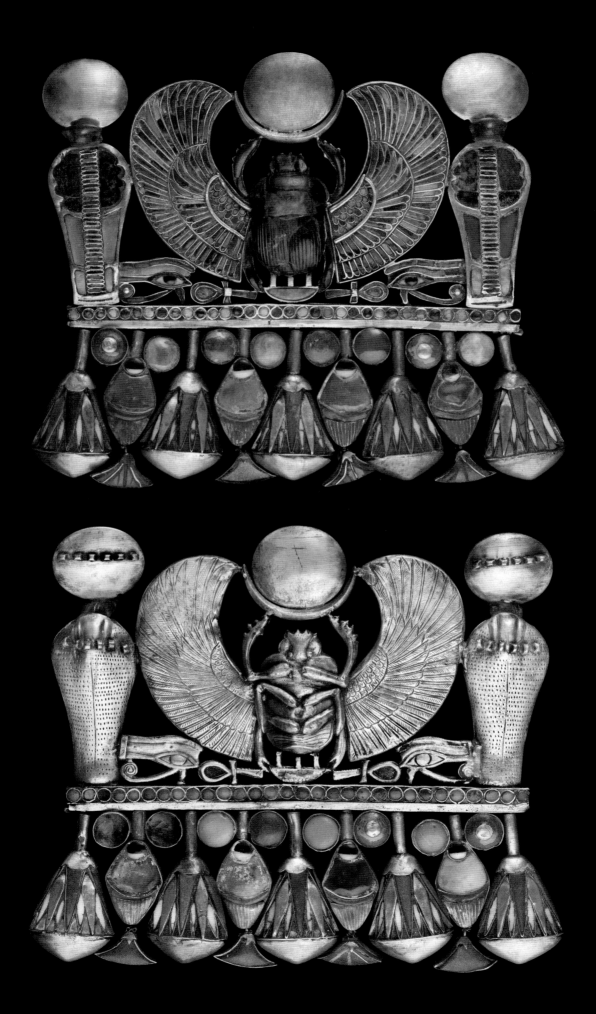

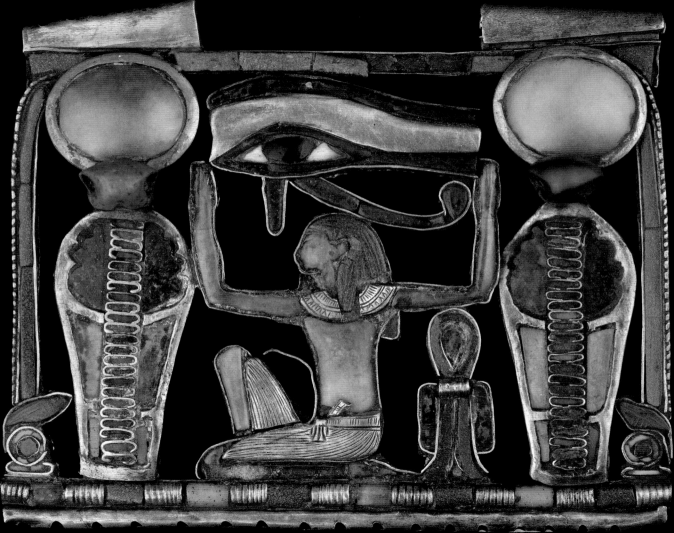

DUCKHEAD EARRINGS

Gold, quartz, calcite, glass, faience
Length 10.9 cm, width 5.2 cm
Carter 269a(1)

Representations of Tutankhamun generally show him with pierced ears; and indeed the ears of his mummy have holes for earrings. However, at least as an adult, Tutankhamun is never actually shown wearing such jewels. In ancient Egypt, both males and females adorned themselves with earrings, although it seems that they were worn mainly by children. Earrings were attached to the ear with thick bars, and during the late 18th Dynasty, some mummies and representations have double piercings, evidently to support especially heavy jewels rather than for an additional pair.

A number of pairs of earrings were found in the tomb, and the example here is both clever and beautiful. The central feature is what can best be described as a falcon with a duck's head, its wings creating a sweeping circle around its head and its talons clutching *shen* rings. Beneath the tail feathers is a bar decorated with circles, from which hang five strings of gold and glass beads ending in pendant *uraei*. These earrings show signs of wear, and were perhaps favorites of the king when he was a child.

BOX IN THE SHAPE OF A CARTOUCHE

Wood, ebony, ivory, frit
Length 63.5 cm, width 30.2 cm,
height with lid 32.1 cm
Carter 269

The largest of four cartouche-shaped boxes found in the tomb (see also p. 27), this was one of the row of five caskets set against the north wall of the Treasury. The body of the box is made of a reddish wood, probably imported, which was veneered with ebony. Originally the box would have been fastened in the usual fashion, with a string wrapped around a knob on the body and another on the lid, and then sealed with a lump of mud into which a signet was impressed. However, as was the case with the other boxes, the seal had been broken, presumably by the tomb robbers.

The top of the box was covered with gesso and then gilded. Large hieroglyphs made of ivory and ebony were inlaid to form the king's birth name: "Tutankhamun, Lord of Southern Iunu [Heliopolis]." Each beautifully detailed hieroglyph is a work of art in its own right. For example, all the squares of the game board (*men/mun*), as well as the game pieces shown above it in typical Egyptian "perspective," have been inlaid separately, in ivory that has been stained white or red. The spines of the reed

leaf (*i*) are carefully indicated, and details of the quail chick (the *u* in *tut*) have been inlaid separately or picked out in paint. The fastening knobs on top and front are painted with figures of the god Heh with a sun disk on his head, kneeling on the sign for gold and holding palm ribs symbolizing millions of years. On the lid, a band of inscription in the ring enclosing the royal name includes more names and epithets of the king. Still more appear in three bands of inscription on the curved sides of the box. In a panel on the one flat end are Tutankhamun's birth, throne, and Horus names. All the inscriptions have been carved and then filled with blue frit (a type of silicate).

Inside were many important pieces of jewelry, including the counterpoise and chain of the "Coronation" Pectoral (p. 186), the heart scarab (p. 160), crooks and flails (p. 202), and various other jewels and items of clothing. Based on its contents, it is likely that this box was used to store the regalia used during the king's coronation ceremonies, or other rituals that reinforced his right to rule.

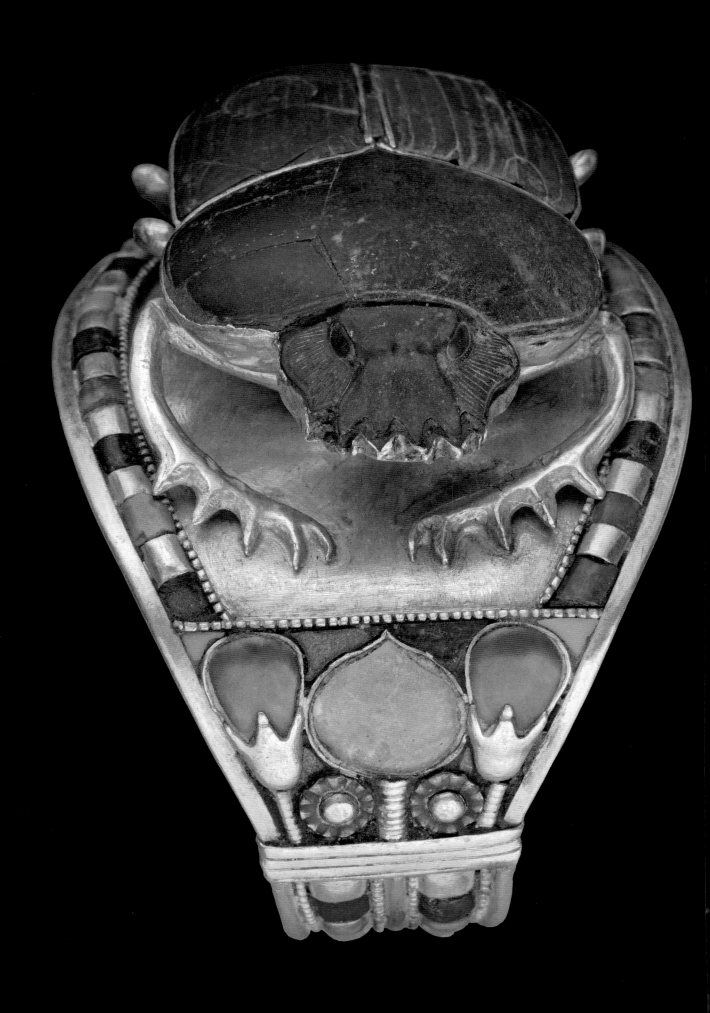

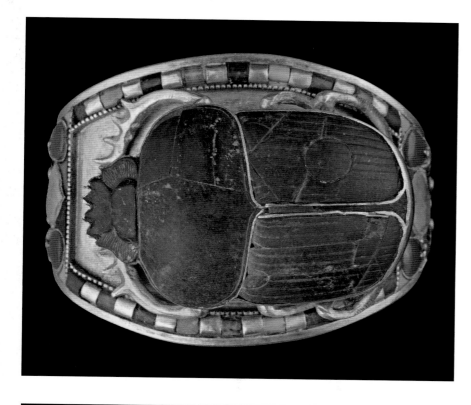

BRACELET
WITH SCARAB

Gold, lapis lazuli, quartz, turquoise, carnelian, glass
Diameter 5.4 cm
Carter 269n

Several bracelets were found in the large
cartouche box (p. 197), including this
example formed of a wide band of gold on
the top of which is perched a scarab of lapis
lazuli set into cloisons of gold. The bracelet
is decorated with further cloison inlays:
below the scarab on both sides is a stylized
floral pattern consisting of a mandrake
flower with poppies to either side, and on
the lower part are bands of alternating gold
and colored glass framed by golden granules.

The bracelet was hinged on one side
so that it could be opened and slipped
around the royal wrist and then held closed
with a pin that fitted through rings on the
opposite side. The small size of this jewel
suggests that Tutankhamun wore it when
he was a child.

CROOKS AND FLAILS

Gold, base metal, wood, carnelian, blue glass

Small crook
Length 33.5 cm
Carter 44u

Small flail
Length 33.5 cm
Carter 269f

Large crook
Length 43.5 cm
Carter 269h

Large flail
Length 43 cm
Carter 269e

In addition to the regalia found clasped in the golden hands placed on top of the royal mummy (p. 124), three crooks and two flails were found in the tomb. The crook and flail are often depicted in Egyptian art, but these are the only royal examples that have survived intact from the New Kingdom. Of these, two of the crooks and one of the flails are adult-sized; the other crook and flail are significantly smaller (this page), and clearly belonged to Tutankhamun when he first came to the throne at the age of about nine. The end cap of each flail is inscribed with the king's throne name, Nebkheperure, while the crooks carry both his throne name and birth name. On the larger crook, the name is given as Tutankhamun, as shown here (p. 203), but on the smaller one it is Tutankhaten, the name the young king received at birth and under which he first ascended the throne. This name honored the Aten, the god whom Akhenaten, his probable father, worshiped above all other deities. It was not until the second year of his reign that the king changed his name to Tutankhamun, compounded with the name of Amun. This name change is accepted by scholars as firm evidence of the point at which the king abandoned Akhenaten's Atenist heresy and restored the worship of Amun.

Each of the examples shown here has a core of either wood or metal, covered in alternating bands of gold and blue glass. The "strings" of the flails are made of gold and colored blue glass beads in the smaller flail, and gold, blue glass, and carnelian beads in the larger flail.

The crook and flail are the archetypal symbols of royal authority. The crook is a short, hand-held adaptation of the shepherd's crook, while the flail is thought perhaps to be derived from a flywhisk. As symbols of authority, the crook and flail are often found as attributes of deities, particularly Osiris, the god of the netherworld.

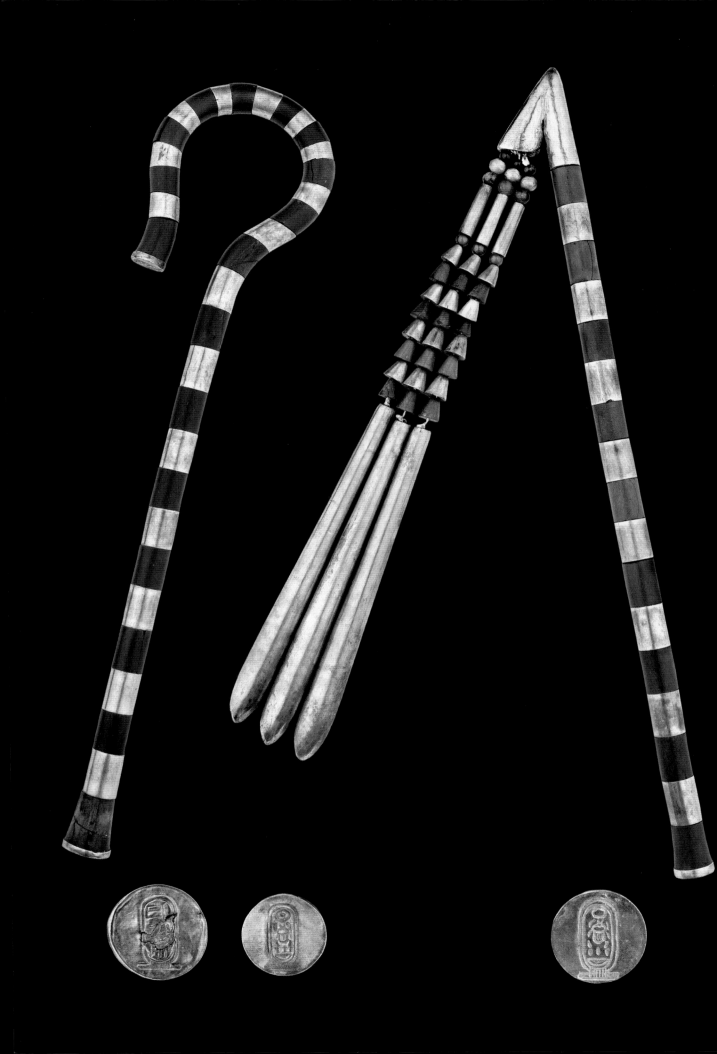

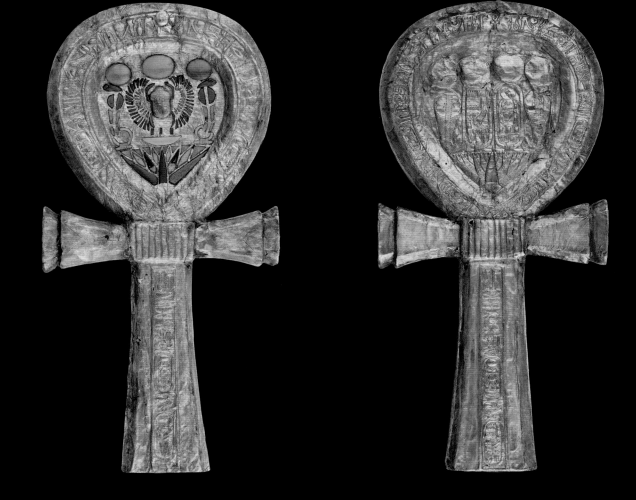

MIRROR CASES

Ankh case
Wood, gold and silver leaf, glass, semiprecious stones
Height 27 cm, width 13.2 cm, depth 4 cm
Carter 269b

Heh case
Gilded wood, gold leaf
Length 27 cm, width 15 cm
Carter 271c,d

Two mirror cases were found in the tomb. One (above) was in the large cartouche box (p. 197), and the other (opposite) was in Box 271 (also in the Treasury). Thieves had apparently stolen the mirrors, most likely made of precious metal, that were once inside. Mirrors were used for practical purposes, such as for the application of makeup, but also had important symbolic overtones as icons of resurrection and eternal life.

Both cases are of gilded wood, one (the *ankh* case) covered on the inside with silver and the other (the Heh case) with gold. The first case (above) is in the shape of the *ankh*, the hieroglyph for life. This word also means "mirror," making it an appropriate choice for this object, both symbolically and in terms of its shape. There is still debate among Egyptologists as to what the *ankh* actually represents: suggestions range from a sandal strap to a ceremonial girdle; some believe that it might be the combined symbols for male and female.

The lid, which could be removed completely, could be "locked" to the bottom of the case with the usual knobs, here in silver. Texts featuring the names and epithets of the king decorate the shaft and loop of the *ankh*. In the center of the loop is the king's throne name, its hieroglyphs inlaid in colored glass to imitate lapis lazuli and turquoise, with a *kheper* beetle of steatite

and a sun disk of carnelian. Two *uraeus* serpents coiled on top of *shen* signs with carnelian sun disks on their heads flank the name of the king, and below the basket (*neb*) sign of the name is an opened lotus blossom. This can be interpreted as the king emerging from the lotus, and thus associates him with the god Nefertem (p. 16), ensuring his eternal rebirth.

The second case (opposite) takes the form of the god Heh holding notched palm ribs resting on tadpoles and *shen* rings. Hanging from the ends of the palm ribs are cartouches with the names of the king. Above the god's head, the upper part of the box, which would have protected the disk of the mirror, is carved with the king's throne name. Around this is a border decorated with running spirals, a motif imported from Syria or the Aegean. On the interior of the box, the body of the god is hollowed out to receive the handle of the mirror.

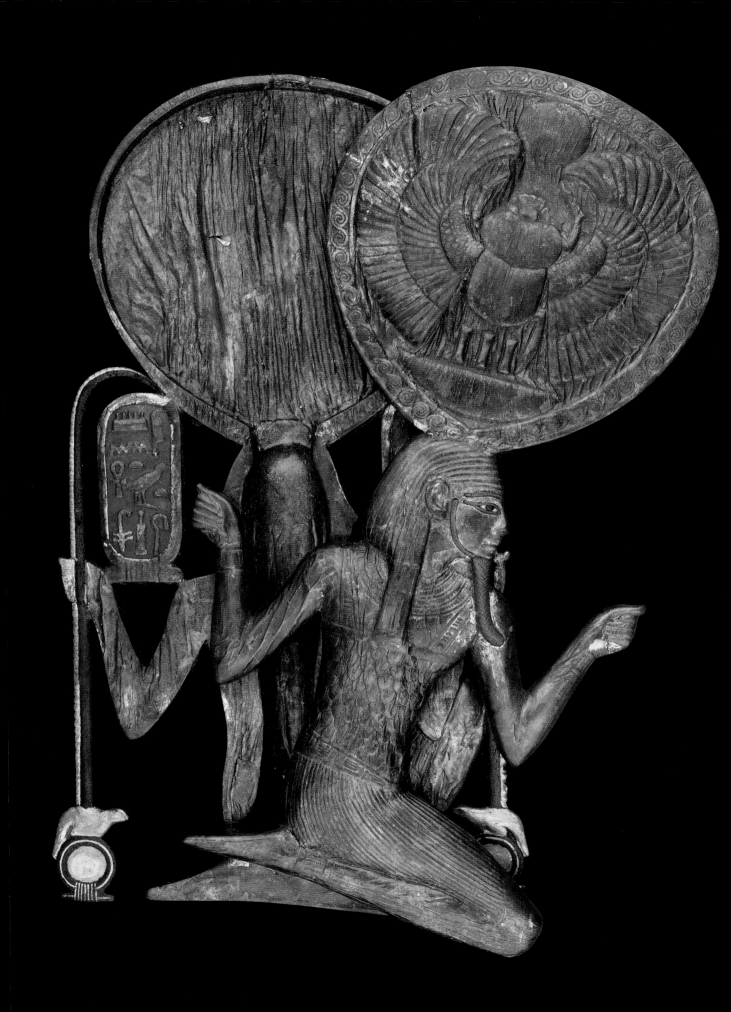

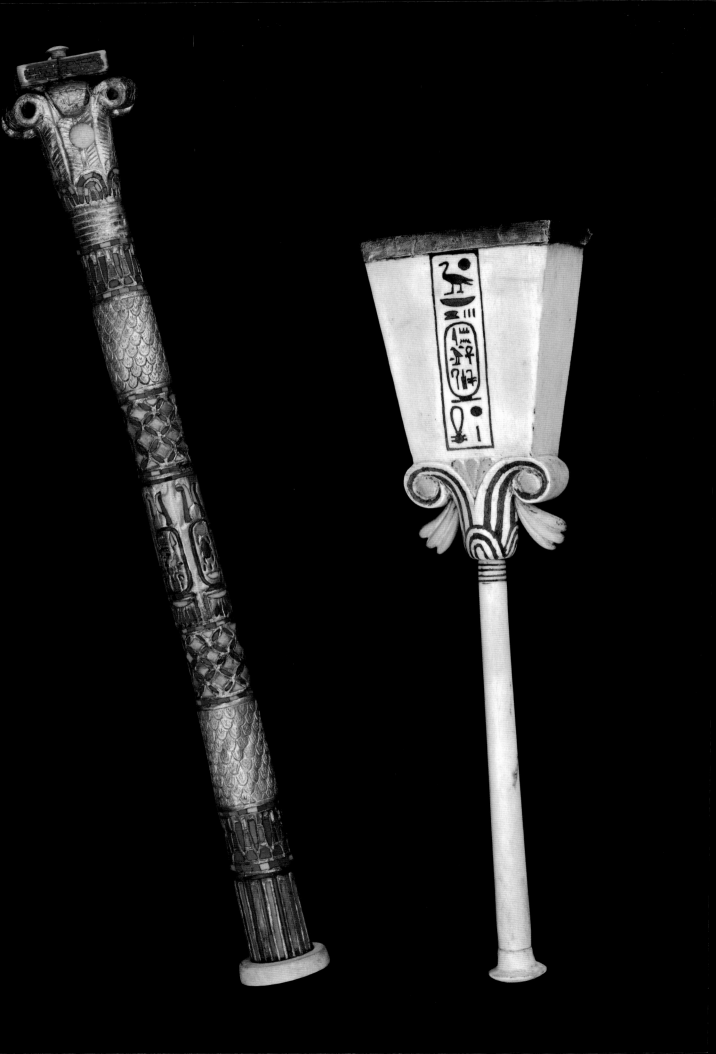

SCRIBAL KIT

Brush holder
Gilded wood, obsidian, carnelian, glass
Length 30 cm, diameter 2.1 cm
Carter 271e(1)

Papyrus burnisher
Ivory, gold, linen
Length 16.5 cm, width 4.4 cm
Carter 271g

Scribal palette
Gilded wood
Length 30.3 cm, width 4.4 cm
271e(2)

Ivory palette of Meritaten
Ivory
Length 21.9 cm, width 2.5 cm
Carter 262

Model palette
Schist, wood, glass, calcite
Length 28 cm, width 5.8 cm
Carter 620(92)

Only a small percentage of the Egyptian population was literate, and there is still debate as to whether or not the royal family was among them. My opinion is that they could read and write, and the fact that a number of writing utensils belonging to Tutankhamun and his family were found in his tomb supports my belief.

Papyrus was the principal writing material for the ancient Egyptians, the equivalent of our paper. Strips of papyrus stalks were laid across each other and then pressed and dried. Less expensive "ostraca" – potsherds or limestone flakes – were also used, but the king would probably have had an endless supply of papyrus. The papyrus sheet would first have been prepared with a burnisher, and then the king would have written on it in a cursive form of hieroglyphs called hieratic, dipping his reed pens in water to wet the blocks of colored pigments.

Shown here are two real palettes (below, left and center), with their inkwells and reed pens. The first is of gilded wood, and is inscribed at the top with the early cartouches

of the king, Nebkheperure Tutankhaten, along with his Horus name. He is identified as beloved of Thoth, patron god of scribes. The second is of ivory, with wells for white, yellow, red, green, blue, and black pigments. This was found between the paws of the Anubis jackal (p. 158), and is inscribed for the princess Meritaten, both sister-in-law and half-sister of Tutankhamun. The third palette (below right), found in the Annexe, is a model made for funerary use: the inkwells are filled with inserts of glass and translucent calcite with red cement underneath, and representations of reed pens have been carved on its surface.

The gilded brush holder (opposite left) takes the shape of a column with a palm tree capital. The decoration is chased into the surface or inlaid with semiprecious stones and glass. The burnisher (opposite right), with a long handle ending in a lily flower, is made of ivory, with details picked out in blue and yellow paint and a cap of gold. The cushion of linen on the top would have been rubbed over a sheet of papyrus to smooth it.

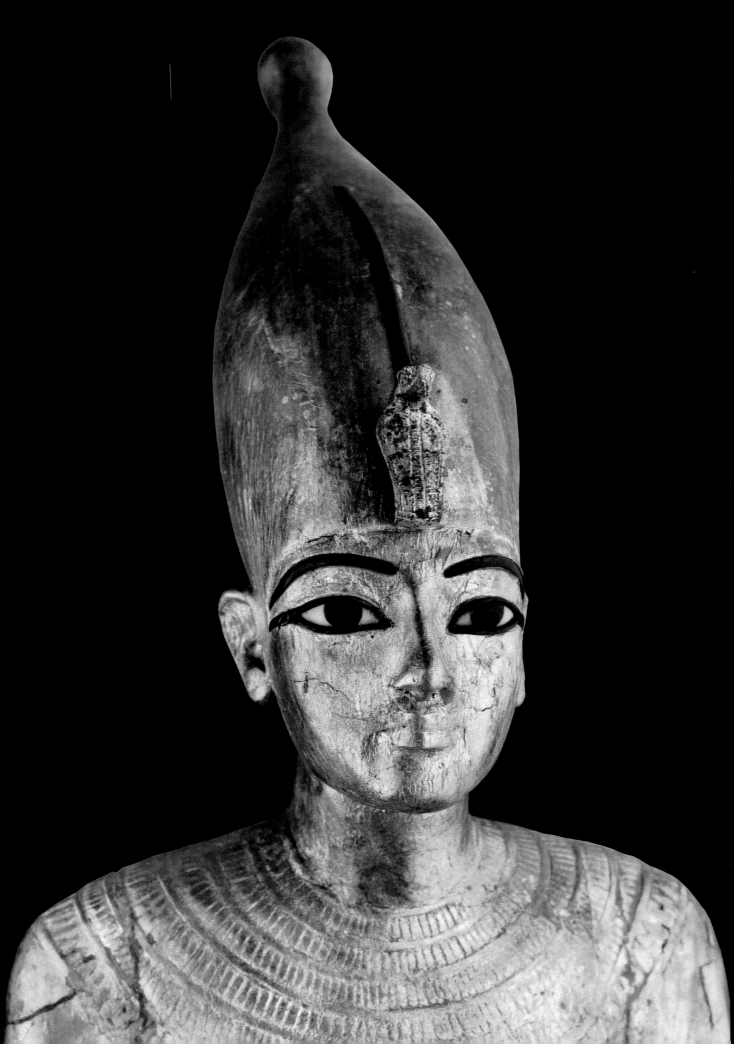

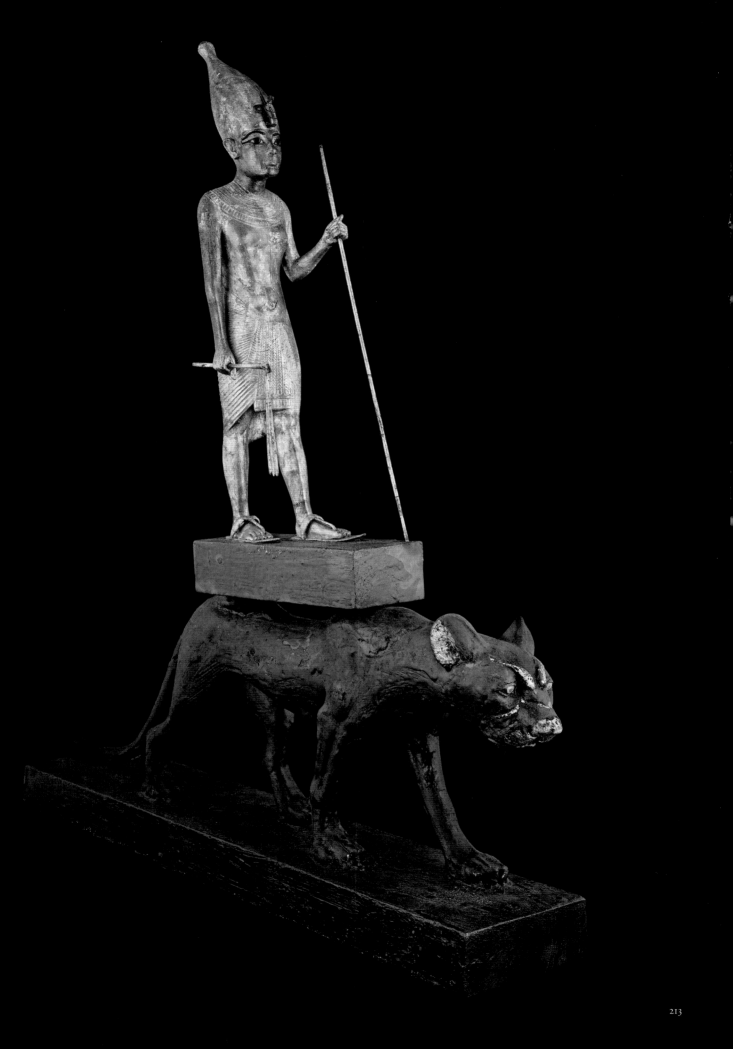

TWO FIGURES
OF THE GOD IHY

Wood, resin, gold, calcite
Heights 60.5 cm
Carter 275a and Carter 289c

MENKARET
CARRYING
THE KING

Wood, limestone, obsidian(?), glass
Height 84.5 cm
Carter 296a

SEKHMET

Wood, gessoed and gilded, glass
Height 55.2 cm
Carter 300a

The two identical figures seen here, shown naked and wearing the sidelock of youth, are not inscribed, but can easily be identified from their iconography: they represent the child Ihy, son of Hathor. Each holds in his right hand a sistrum (p. 52), the sacred rattle of his mother, composed of a handle bearing the head of the goddess in full frontal view with her cow ears visible to either side, topped by a shrine. In a real sistrum, instead of this model shrine there would have been a metal loop strung with wire sounders.

Ihy was a sky god, linked with rebirth through his role as guide and protector of the deceased as he or she traveled across the horizon. In the Coffin Texts that preceded the *Book of the Dead* this deity is attested as one of the divinities into which the deceased would be transformed, and was also one of the gods to whom the deceased spoke aloud the Negative Confession, swearing that they had done no wrong in their life on earth.

One of the most unusual of the ritual figures in the tomb is of the little-known deity Menkaret carrying a seated mummiform representation of the king in the red crown (p. 216). When Carter discovered this statuette, both figures were individually wrapped in their own pieces of linen. The god wears a corselet (p. 44) and a royal kilt; his feet are bare. On the pedestal is an inscription which reads: "the good god, Nebkheperure, true of voice, beloved of Menkaret."

One of my favorites among Tutankhamun's ritual figures is this exquisite image of the goddess Sekhmet (p. 217), daughter of Re, wife of Ptah, and mother of Nefertem (p. 16). Associated with the lioness, Sekhmet took on that animal's most distinctive attributes: dangerous power, but also a strong maternal instinct.

The figure here was found with a floral wreath around her neck and wrapped in two linen cloths, one of which bore a hieratic inscription mentioning the Aten. The figure itself is of gessoed and gilded wood, and depicts the goddess with the body of a woman and the head of a lioness. She wears an elegant tight-fitting dress of archaic design covered with a bead net. On her head is a sun disk, and her nose is of dark glass. Her name is painted in yellow onto the statue's black-varnished pedestal, a portion of which had been cut off because it was too big for its shrine.

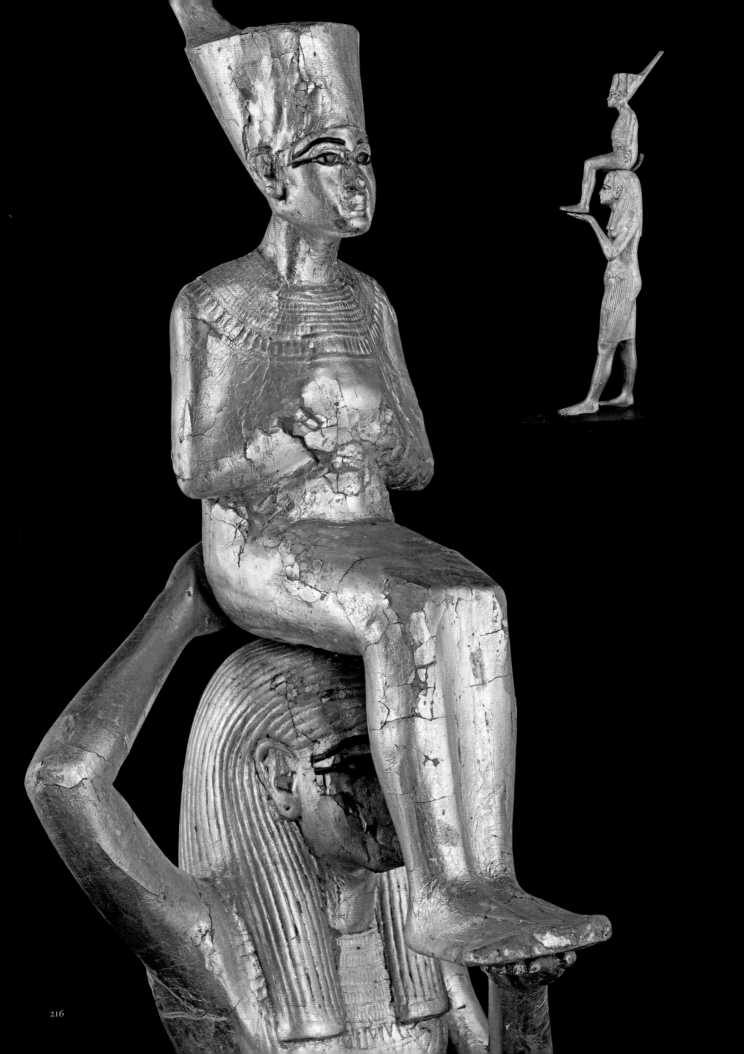

216

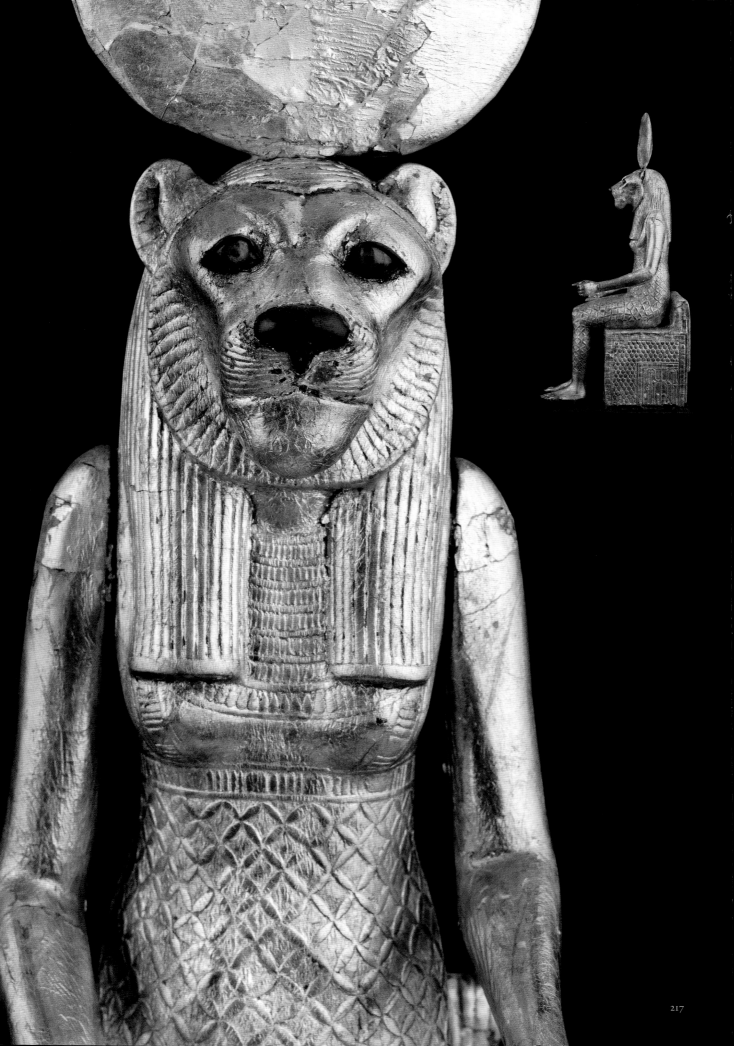

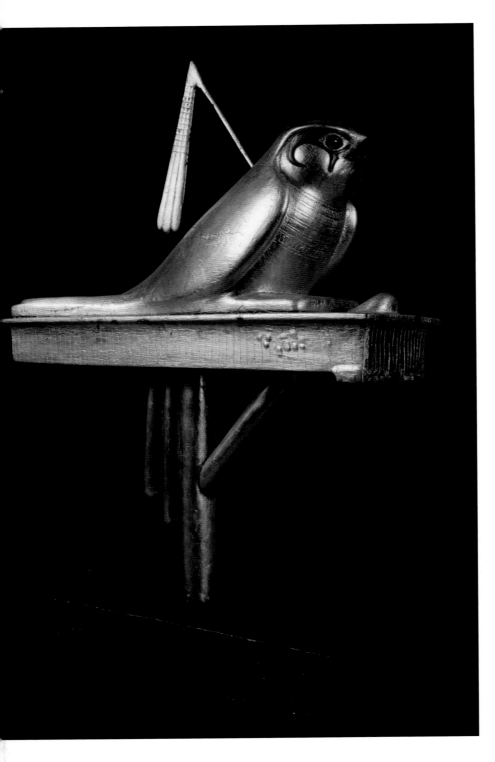

GEMEHSU FALCON
Wood, gessoed and gilded, obsidian, glass, silver, bronze
Height 59 cm
Carter 283c

SOPED FALCON
Wood, gessoed and gilded, glass
Height 65.5 cm
Carter 283b

Illustrated here are two of the few non-human ritual figures from the tomb. Found in Shrine 283, along with a serpent statue, both represent falcon deities perched on standards (the ancient Egyptian equivalent of a flag). First is a "Gemehsu" falcon (left), discovered with a linen cloth around its neck. The falcon itself is of wood, gessoed and gilded, with the eyes and facial markings inlaid with obsidian and dark blue and red glass. The beak is of silver, a much rarer metal than gold in pharaonic times. On its back is a flail of gilded bronze, symbol of royal authority, and around its neck is a broad collar. Yellow hieroglyphs on the base spell out "the Osiris Nebkheperure, true of voice, beloved of Gemehsu."

The form of the second figure (right) is very similar to the first, and it, too, was found with a cloth around its neck, and is of gessoed and gilded wood with details inlaid in glass. In general, Carter felt that the materials and workmanship of this statue were inferior to those of the Gemehsu. The inscription on the base reads: "The Osiris Nebkheperure, beloved of Soped," a god attested from the Old Kingdom onward as "lord of the foreign lands," who was seen as holding sway over the desert outside Egypt's borders.

The principal iconographic difference between the two falcons is that Soped has two "Shu" feathers, plumes traditionally associated with the god of the air, on his head.

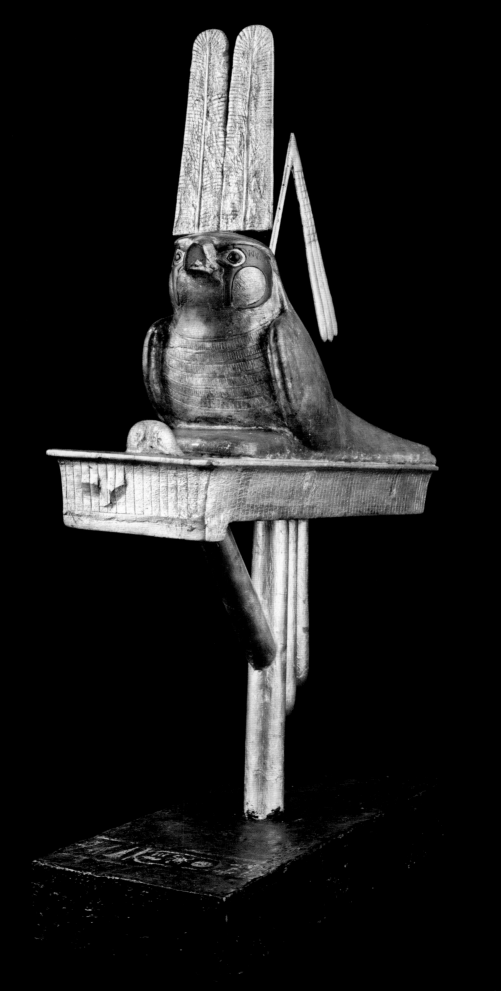

NEST OF COFFINS

Small coffin
Gilded wood
Length 78 cm, width 28.5 cm
Carter 320

Second coffin
Gilded wood
Length 74 cm
Carter 320a

Third coffin
Wood
Length 21.3 cm
Carter 320b

Fourth coffin
Wood
Length 13.2 cm
Carter 320d

Gold figure of the king
Gold, glass, linen
Height 5.4 cm; length of chain 54 cm
Carter 320c

This extraordinary set of small coffins reminds me of nothing so much as a Russian matryoshka, or nesting, doll. All four coffins wear royal headdresses, although *uraei* are missing from their brows.

The mummiform outermost coffin (below left), painted black with gilded bands, is in a style popular among the elite of the 18th Dynasty. The deceased here wears the *afnet*, or bag wig, and a broad collar; his hands are crossed to hold a crook and flail, and his torso is protected by a Nekhbet vulture. The inscriptions on the bands identify the deceased as Tutankhamun himself, and recite words spoken by the king asking his "mother" Nut (goddess of the sky) to protect him from eternal death.

When Carter opened this coffin, he found another, smaller one inside (below and pp. 225–26). This, like Tutankhamun's actual inner coffins, was glued to the outer coffin by hardened unguents. It is clear, therefore, that the contents of these coffins were given some sort of ritual burial involving hot liquids that later solidified. The second coffin (of which only the lid could be removed – the trough is still stuck inside the outermost coffin) is covered with gilding, with the eyes and eyebrows picked out in black paint. The king, again identified by the inscription as Tutankhamun, here wears the *nemes* headdress. His body is protected by the vulture and the cobra, both in bird form,

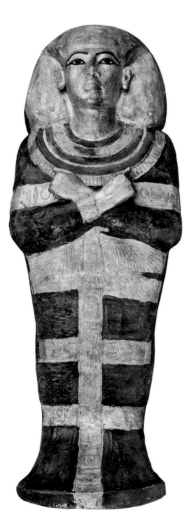

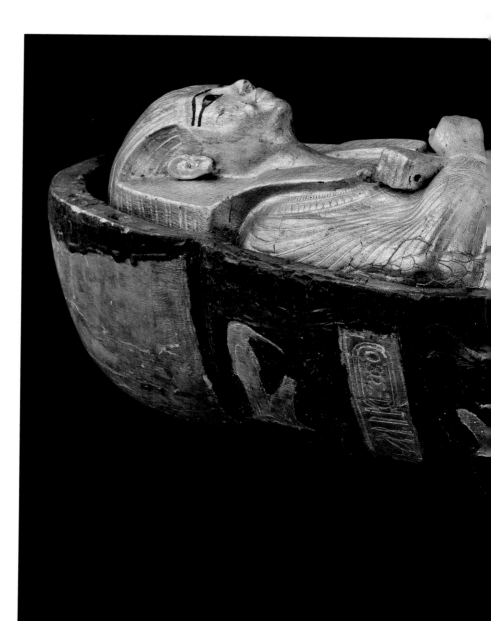

GERMINATING OSIRIS FIGURE

Wood, linen, soil, barley
Length 190 cm, width 75 cm
Carter 288a

The oblong box with slightly rounded lid in which this figure was found lay on the floor in the southwest corner of the Treasury, with the head end to the west. The figure itself was facing north. It had been covered with a folded linen sheet and wrapped in bandages, as if it were an actual mummy. Made from a large plank of wood carved into a two-dimensional outline, this strange figure represents the mummiform god Osiris in his traditional *atef* crown (the tall "white" crown of Upper Egypt flanked by ostrich plumes). The head and legs are seen in profile, while the torso is represented frontally; the outlines of the elbows, together with the projecting ends of a crook and flail, show that he is intended to be seen as having his arms crossed on his chest, holding the traditional royal regalia.

The interior of the figure is hollowed out and the trough thus formed inside was lined with linen then covered with a layer of soil containing a high concentration of quartz, presumably from the bank of the River Nile. Barley had been sown in this soil, and had grown to about 7.5 cm in height. From a practical point of view, therefore, this was much like a modern planter used for germinating seeds.

This fascinating and strange object symbolized fertility and thus was linked with rebirth and resurrection. The Osiris myth, which tells how the god was murdered by his brother Seth then mummified and resurrected by his sister-wife Isis, led to his intimate connection with these themes. The Egyptians turned to Osiris to pray for the fertility of the land and an abundant harvest, and his skin is often painted black, the color of the rich Nile silt from which Egypt's crops sprouted, or green, the color of the crops themselves. The Osiris bed is thus a very literal representation of the god's role.

who stretch out their wings to enfold him; these may represent Isis and Nephthys as his guardians. In the vertical band down the king's body is inscribed the same prayer to Nut as is found on the outer coffin.

Inside the second coffin was a third, much smaller one, of plain wood (visible inside the outer coffins, pp. 227–28) that appears once to have been painted yellow with black details. Within this was a linen bundle that held a miniature coffin (p. 229) and a small figure cast of solid gold (pp. 230–31). Just 5.4 cm tall, this figure has nonetheless been worked in meticulous detail. The king's tiny face is perhaps even recognizable as Tutankhamun's, as it has his snub nose, full lips, pierced ears, and slightly receding chin. However, Carter believed that it represented Amenhotep III, although that pharaoh is not shown with pierced ears.

The king is depicted seated on a flat base, with his knees to his chest, wearing a pleated kilt. His left hand is held just over his left leg in a gesture of respect or adoration. In his other hand he holds both crook and flail. On his head is the blue war helmet (*khepresh*), the metal disks that would have covered an actual example (assumed to be of leather) indicated by small circles. Around the neck of this figure is a collar of glass beads that resembles the *shebyu*, awarded to officials for great service to their monarch, and believed by scholars to be connected with the solar cult (see p. 38).

Amenhotep III is frequently shown wearing this type of collar, underlining his devotion to the sun god. A golden chain, with linen tassels at the ends which could be tied together, passed through a ring on the back of the figure's neck, allowing it to be worn as a pendant.

The fourth, tiny, coffin (p. 229), which was found wrapped in linen with a band of the same material tied around the ankles, bore inscriptions dedicating it to the Great Royal Wife Tiye, chief queen of Amenhotep III. Inside was a lock of auburn hair. In my view, Amenhotep III and Tiye were Tutankhamun's grandparents, and the hair was thus an heirloom from the king's grandmother.

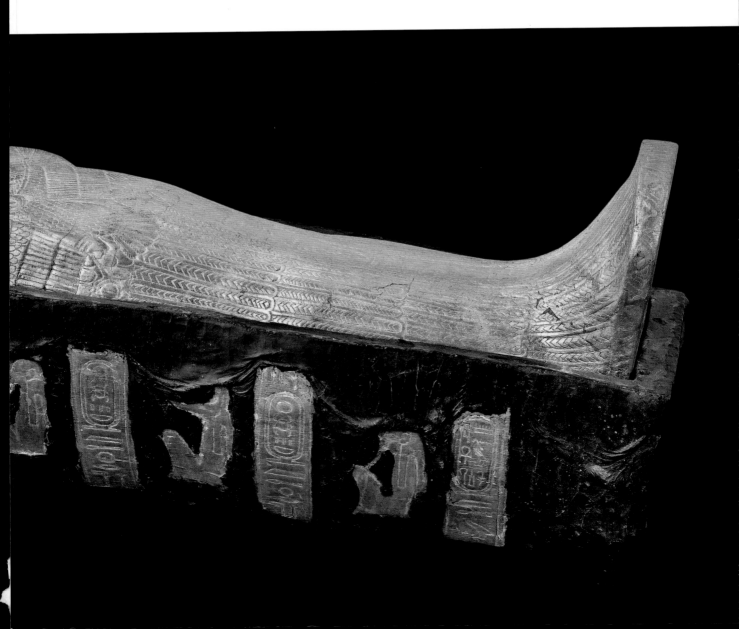

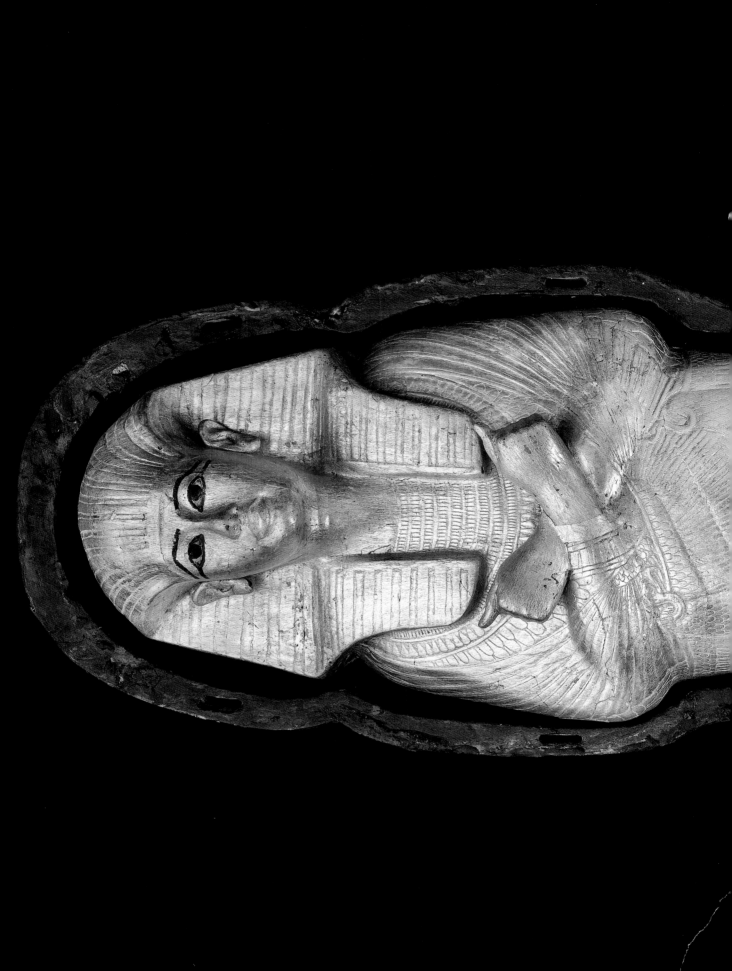

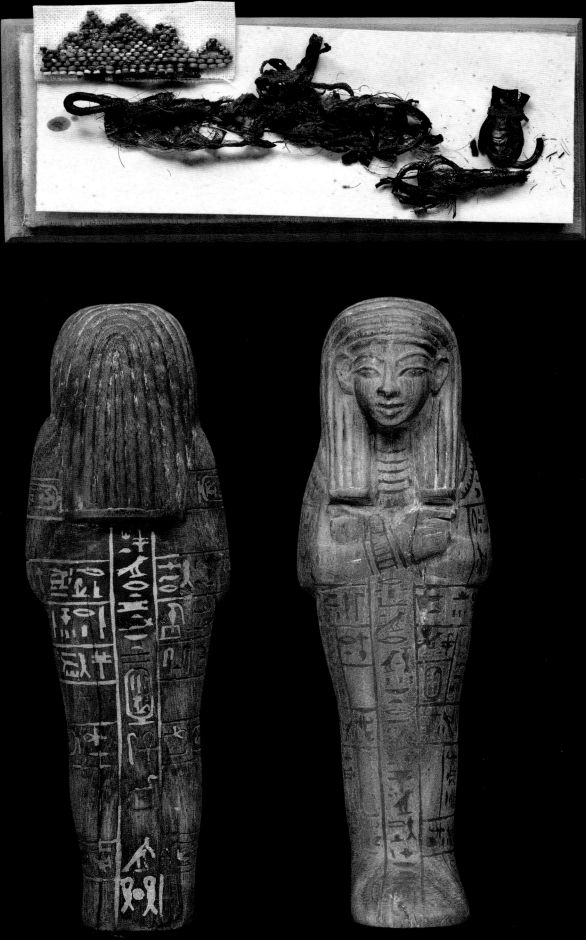

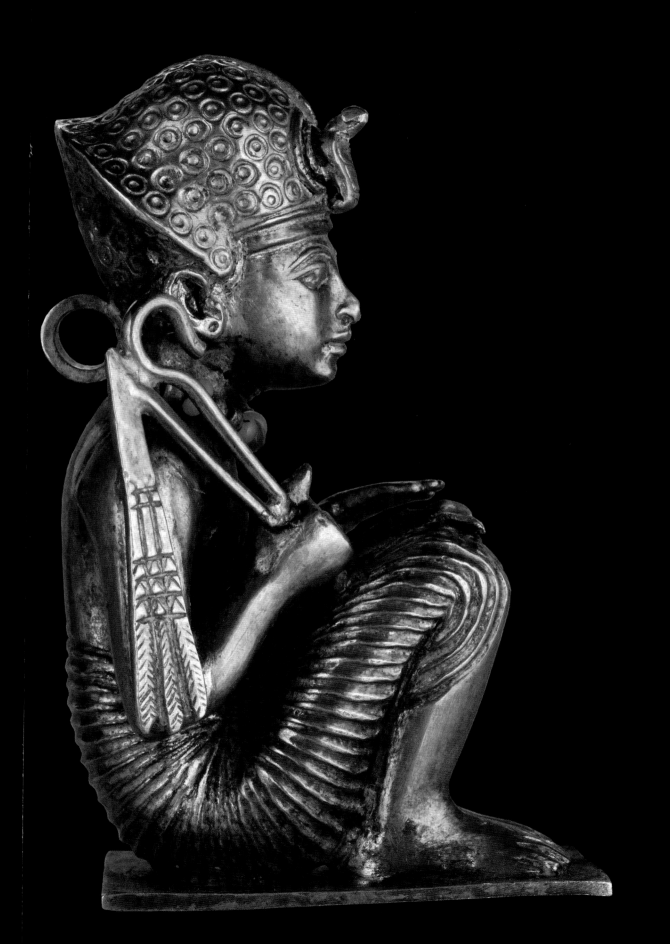

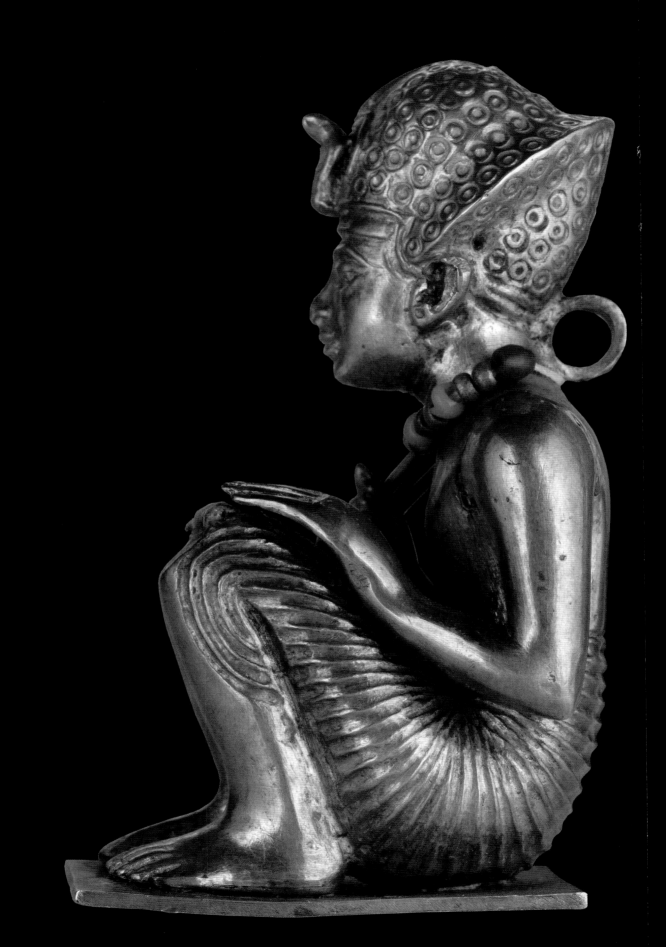

CHEST

Wood, interior coated in black resin
Length 61 cm, width 42.5 cm,
height with lid 50 cm
Carter 317

This simple wooden chest is one of several almost indistinguishable examples. Its gabled lid over cavetto cornices would have been fastened to the body by a string wound around the ebony knobs. It was discovered on the top of a pile of boxes in the northwest corner of the Treasury, with its lid removed and placed behind another chest.

The box is remarkable not for its form, but for its contents: two sets of small, nested anthropoid coffins held closed with linen bandages tied around their neck and ankles and stamped with the necropolis seal of a jackal above nine captives. Each contained the tiny mummy of an infant or fetus. The smaller of the two babies had been delivered very prematurely, probably no more than five months into its mother's pregnancy. A small section of the umbilical cord was still attached to its abdomen.

The second child had been born somewhere between seven months and full term, but had died at or around the time of its birth. An X-ray examination carried out by Professor R. G. Harrison at the University of Liverpool in 1978 concluded that this child had probably suffered from a syndrome known as Sprengel's deformity, which includes scoliosis and spina bifida.

There were no personal names on the coffins: both were simply labeled "the Osiris." Both have been identified as females. It is probable that these two tiny mummies are the children of the young king and his wife, Ankhsenamun, buried in their father's tomb so that they could share in his eternal life. In this they were treated like other 18th Dynasty royal children who predeceased their parents: equipment from princely burials was found in the tombs of Amenhotep II and Thutmose IV. Tutankhamun and his queen had no offspring to survive them, and when the young king himself died, his aged advisor Ay took the throne.

ANTHROPOMORPHIC DEITIES

Gilded wood, bronze, glass, obsidian, faience

Tata
Height 70 cm
Carter 303a

Sened
Height 58.5 cm
Carter 294a

Tatanen
Height 57.5 cm
Carter 292a

Ptah
Height 60.2 cm
Carter 291a

Shu
Height 74 cm
Carter 282a

Many of the ritual figures found in the Treasury represented anthropomorphic gods. These tend to be quite similar to one another: almost all are mummiform. They usually wear broad collars (p. 125) and "tripartite" wigs – long wigs that are divided into three sections, with the bulk of the hair hanging down the back and locks in front of each shoulder. Most have divine (curled) beards of bronze attached to their chins. The individual figures in this group can be distinguished from one another by details of their iconography, and by the inscriptions on their bases.

The first figure in this series (below left) is Tata, a little-known deity who is distinguished by his "white" crown of Upper Egypt, though here the crown appears more red than white, due to the reddish hue of the iron-rich gold with which it has been gilded. Next to him (below, center) is Sened, another obscure divinity with no identifying characteristics whatsoever. To the right is Tatanen, a great earth god associated with the deepest realms of the netherworld.

Patron god of Memphis, Ptah (p. 234) is easily recognizable by his cobalt blue skullcap of glass and his bronze scepter, formed of the hieroglyphs *djed* (stability), *was* (dominion) and *ankh* (life). His costume is also distinctive, as his shroud is covered with a feather pattern. This statue was found with a linen cloth and a wreath around its shoulders.

Shu (p. 235), identified here both by an inscription and the plumes on his head, was the god of air and sunlight. In the second generation of gods of the Heliopolitan pantheon, he was the son of the creator god Atum. Married to his sister Tefnut, he engendered the earth, Geb, and the sky, Nut.

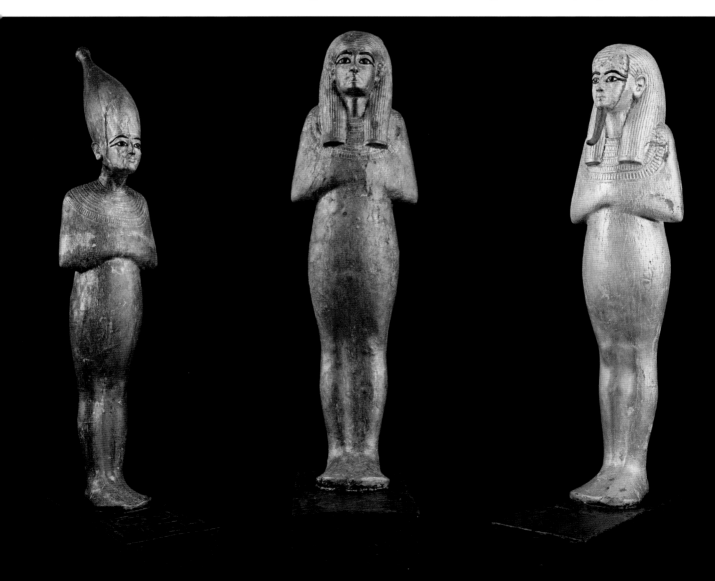

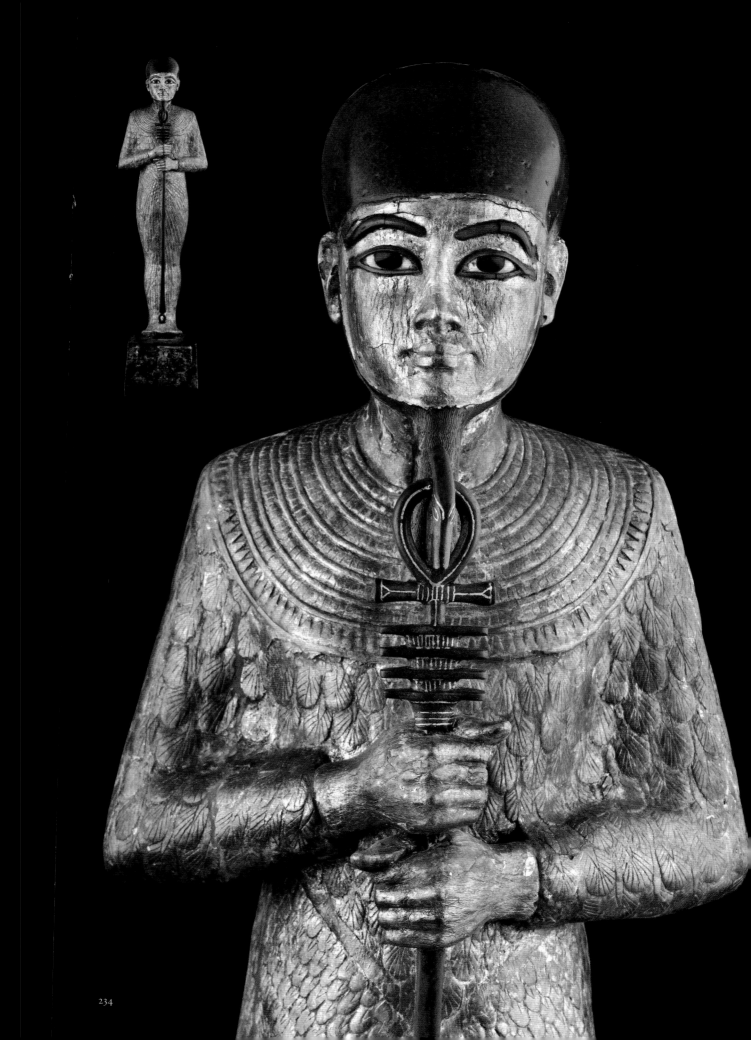

234

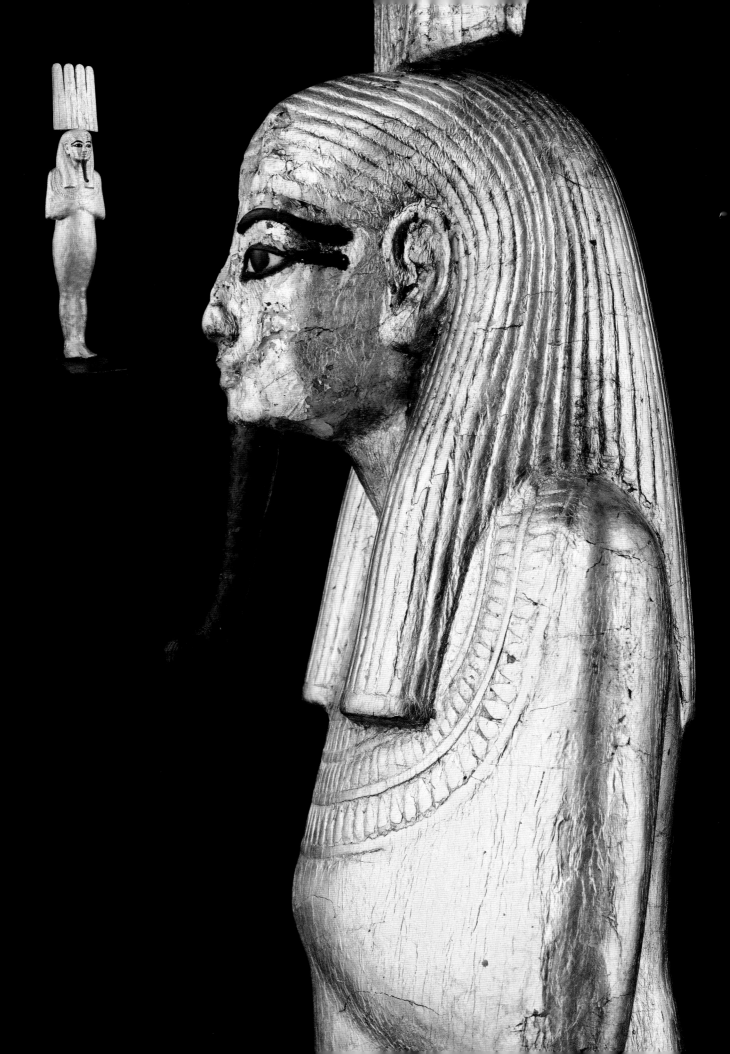

MODEL BOATS

Wood, linen
Length 110 cm
Carter 336

Wood
Length 110 cm
Carter 273

A total of 35 model boats were found in the tomb: 18 in the Treasury, mostly piled on top of the shrines that held the ritual figures, and 17 in the Annexe. Boats were an important element of royal funerary equipment from the Early Dynastic period onward. The earliest actual examples of funerary boats, found in the royal necropolis at Abydos, consist of a group of 14 full-size wooden boats encased in mud brick and moored in the desert near the huge enclosures where the mortuary cults of kings of the 1st and 2nd Dynasties were celebrated.

At Giza, two huge boats of imported cedarwood, complete with cabins and oars, were dismantled and buried in pits next to the Great Pyramid of the 4th Dynasty king Khufu. Full-size royal vessels dating from the Middle Kingdom have also been found, and many other examples of such boats are represented now only by hull-shaped pits. By the New Kingdom, the burial of actual boats had been replaced by models such as the ones shown here. Boat models are also known from the earliest periods of Egyptian history, attesting to their importance.

The first model illustrated here (pp. 237–38) is also one of the most spectacular of Tutankhamun's boats. It stood in the northwest corner of the Treasury, leaning against the west wall, and was in excellent condition when Carter found it, requiring very little conservation or restoration work. Made of wood and painted in a variety of colors, with some added gilding, it represents a sailing boat, clearly meant for royal use. It has a tall mast with elaborate rigging, and a square sail of linen has been attached to the yards. The steering paddles have tops ending in human heads. Pavilions at each end include openwork images of the monarch: on the forecastle he is seen as a sphinx and on the poop as a bull. The king would presumably have traveled inside the central cabin.

The second boat (pp. 239–40) is a simpler river-going barge. Like the sailing boat, it had two steering paddles, although one had fallen off and is no longer with the boat. The cabin in the center is large, with a stepped roof, and on the prow and stern are enclosed pavilions. This example was found in the southwest corner of the Treasury, on top of two strainers that had been placed on the shrine that contained one of the Ihy figures (p. 214), two statues of the king in the red, flat crown of Lower Egypt (p. 209), and the two harpooners (p. 211).

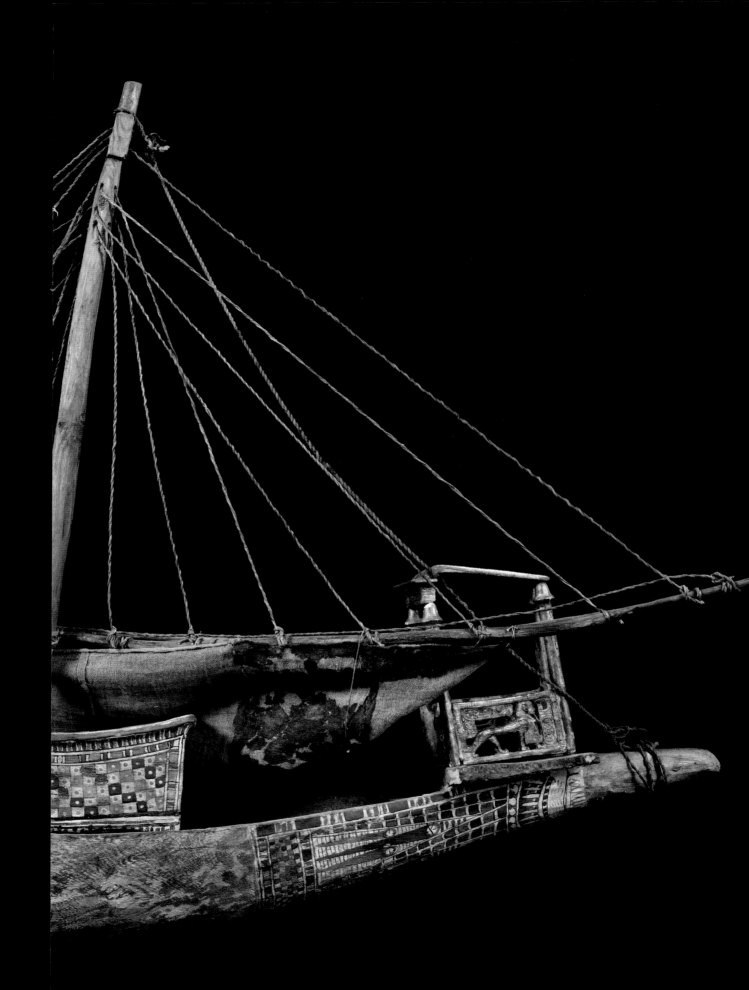

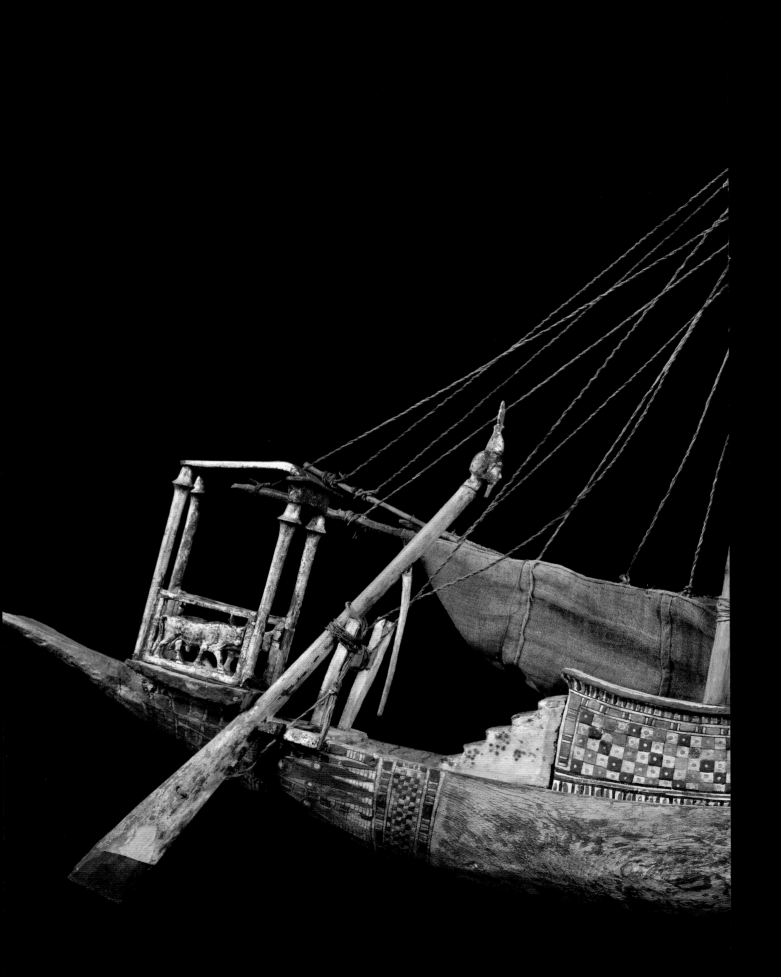

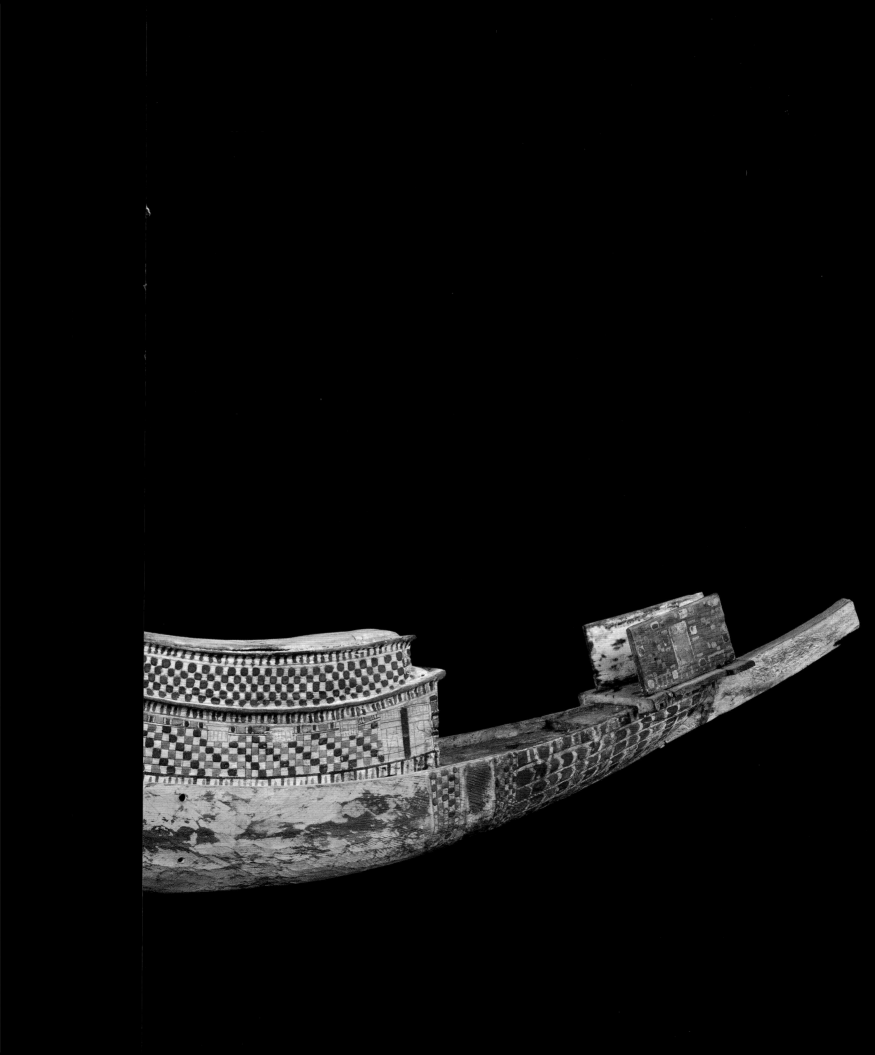

KING UPON A BIER

Wood
Box: length 48 cm, width 20.7 cm
Figure: length 41 cm, width 12 cm
Carter 331 (chest) and Carter 331a (figure)

This wooden mummiform figure of the king laid on a leonine bed was found inside its own small wooden chest, painted black like the shrines that contained the ritual figures. When Carter found it, the chest was standing on one end, and he concluded that it had been disturbed by the robbers, who had also lifted up the linen pad that protected the figure inside.

In several respects, this piece echoes Tutankhamun's nest of coffins, which were also set upon a lion-shaped bed much like this one. As on the second and third coffins, the king here wears the *nemes* headcloth, though in this case with *uraeus* only, rather than *uraeus* and vulture. His arms are crossed on his chest and his hands are clenched, as if he once held a crook and flail of a different material that were perhaps taken by the thieves. A set of miniature agricultural tools was also found in the box.

This figure is made unusual, indeed unique, by the addition of two birds that perch beside the king on the bier, their wings outstretched to protect his body. On one side the bird is clearly a falcon, perhaps to be identified with Horus, or the *ka* (lifeforce) of this god; on the other is a human-headed bird that is probably to be seen as the *ba* (p. 117), the aspect of the deceased able to travel outside the tomb.

On the body are carved strips imitating mummy wrappings and bands (p. 117). The central vertical band bears a spell spoken by the king asking for the protection of Nut, while on the horizontal ones are short inscriptions identifying the king as honored before each of two canopic genii and Anubis, Osiris, and Horus.

Hieroglyphs on the base give the name and titles of Tutankhamun's treasurer and superintendent of building works in the necropolis, Maya, who states that he had this made for his king. Maya also contributed a large wooden shabti to the burial equipment.

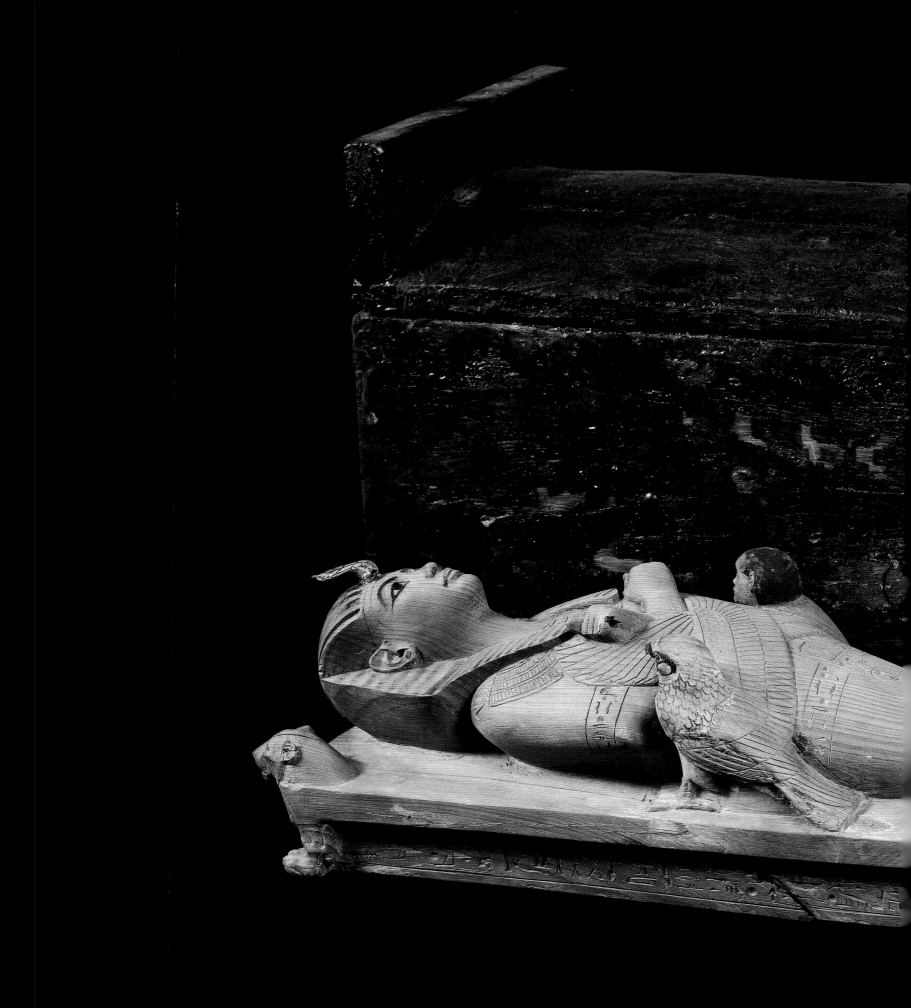

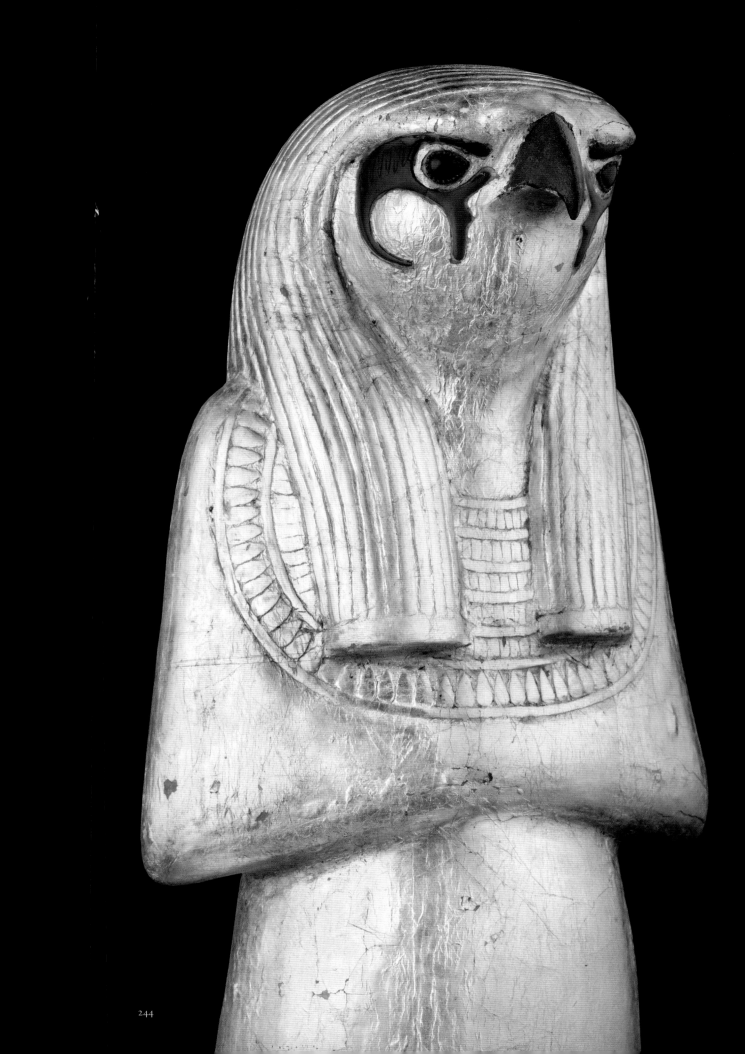

244

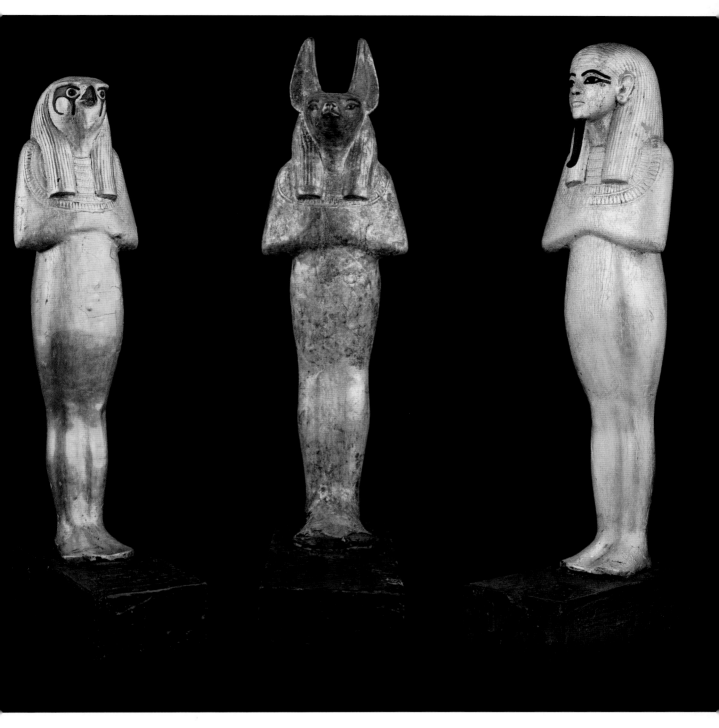

RITUAL FIGURES

Gilded wood, glass, obsidian, calcite, bronze, ebony

Herwer (Horus the Great)
Height 56.8 cm
Carter 293a

Jackal-headed Duamutef
Height 58 cm
Carter 304b

Human-headed Duamutef
Height 57.8 cm
Carter 302a

The ritual figures from the tomb include both animal- and human-headed examples. The first one shown here (left) is one of a number of falcon-headed statuettes, in this case of Herwer, "Horus the Elder" (Haroeris in Greek). Specifically, this was the form of Horus who, after reaching maturity, battled his uncle Seth to reclaim the throne of his father Osiris. In contrast there was also Hersaiset, "Horus the son of Isis," or Harsiese – Horus as a child.

The other two figures here (center and right) both represent the canopic genius Duamutef, one of the "Four Sons of Horus." These divinities were responsible for guarding the viscera of the deceased. Duamutef, seen here in his jackal- and human-headed forms, was protector of the stomach. It is interesting to note that the jackal-headed statuette was found without a cloth wrap or wreath, and is of inferior workmanship to most of the others.

SHABTIS

The principal purpose of a properly executed funeral was to enable the deceased to negotiate the dangerous entrance to the afterworld, braving demons and passing difficult tests, until they reached the Hall of Judgment, where the Weighing of the Heart took place. There, if their heart balanced when weighed against the feather of Ma'at (provided they had done no evil during their life), they would be welcomed by Osiris into the Fields of Iaru – the land of the Blessed Dead. Deceased kings (and at a later period private people as well) would also, in a parallel conception, join the sun god in his bark and travel with him through the day and night skies, dying again each night and being reborn each morning.

The ancient Egyptians envisaged the Fields of the Blessed as an idealized version of the earthly realm. There the dead would eat, drink, and participate in many of the activities that had been important to them in life. Since agriculture was central to existence in Egypt, the deceased might be called upon to perform mundane but essential tasks such as plowing, sowing, or harvesting. And so to avoid the possibility of an eternity spent laboring in the fields, the dead were buried with figurines called shabtis.

These figurines evolved from the late Old Kingdom tradition of placing servant statuettes – stone and clay figures of men and women carrying out jobs such as brewing beer or baking bread – in tombs. These might either replace or reinforce scenes of labor that were traditionally carved and painted on the walls of tomb chapels; the purpose of such scenes at one level was to ensure an endless supply of food and drink for the afterlife. In the early Middle Kingdom, these servant figures, which were often represented with model equipment such as grinding stones and brewing vats, developed into elaborate models of bakeries, butcher shops, sailing and rowing boats, and even gardens, which included scale figures of the people engaged in various activities.

Tomb models gradually fell out of use, but shabtis had followed their own parallel development. Funerary figurines appeared as single examples in the First Intermediate Period. These were made of wax, and from the beginning were primarily mummiform (although some wear the clothes of the living). In their earliest incarnation they clearly represent the tomb owner. Other materials, such as stone, wood, faience, pottery, and sometimes glass, were also used. By the early 18th Dynasty, shabtis (which in later Egyptian history can be called ushabtis, and are also known as shawabtis), had multiplied – eventually there might be over 400 in a single tomb. By the reign of Thutmose IV, shabtis were usually identified clearly as agricultural workers by the miniature tools they held. Overseers and supervisors carrying flails or other insignia of authority also began to appear.

Many shabtis bear only the name and title of their owner, but others carry a spell from Chapter 6 of the *Book of the Dead* inscribed on the body and legs, promising to work on behalf of the deceased should he or she be called upon to join the divine corvée (specifically to cultivate fields, carry out irrigation projects, or carry sand from one place to another).

A total of 413 shabtis were buried with Tutankhamun: one for each of the 365 days of the year, 36 for overseeing the 10-day weeks, and 12 supervisors for the 30-day months. Made from a great variety of materials, including faience, wood, limestone, granite, calcite, and quartzite, they come in a wide range of sizes (from 10 cm to over 60 cm in height) and forms. All are mummiform figures of the king himself wearing a royal headdress or wig of some sort. The majority are inscribed only with one or two of Tutankhamun's names and epithets and only 29 bear Chapter 6 from the *Book of the Dead*. One was found in the Antechamber (p. 253 left), and the rest were found in the Treasury (176) and the Annexe (236). They had originally been stored in shabti boxes.

The most spectacular of the shabtis are of wood, and are significantly larger and better crafted than the rest. Of these, six had been donated to the king's burial equipment by two of his high officials, his general Nakhtmin (p. 251 right and p. 253 center), evidently the son of Ay – who would succeed Tutankhamun – and the treasurer Maya.

(see p. 252, right)

Shabti in white crown with shabti spell
Painted and gilded wood
Height 60.6 cm
Carter 330e

Shabti in red crown with shabti spell
Painted and gilded wood
Height 63 cm
Carter 330c

Shabti in double crown with shabti spell
Painted and gilded wood
Height 63 cm
Carter 330f

Series of shabtis in *nemes* headcloth
Painted quartzite
Heights from c. 22 cm to 28 cm
Various Carter numbers

Shabti in short wig and fillet with shabti spell
Painted and gilded wood
Height 53.2 cm
Carter 330h

Shabti in short wig with shabti spell
Painted and gilded wood
Height 53.2 cm
Carter 325a

Shabti in short wig with shabti spell
Painted and gilded wood
Height 52.2 cm
Carter 325b

Shabti in short wig with shabti spell
Painted and gilded wood, ebony,
bronze
Height 53.8 cm
Carter 326a

Shabti in *nemes* with shabti spell
Wood, gessoed, gilded, and painted
Height 53.5 cm
Carter 110

Shabti in *nemes*, dedicated by Nakhtmin
Wood, gessoed, gilded, and painted
Height 52.9 cm
Carter 330j

Shabti in blue crown, dedicated by Nakhtmin
Wood, gessoed, gilded, and painted; crown of ebony
Height 48 cm
Carter 318a

Shabti in long wig
Painted quartzite
Height 26.1 cm
Carter 605g

Shabti in *nemes* headcloth
Painted quartzite
Height 25.7 cm
Carter 514a

Shabti in round wig
Painted calcite
Height 27.1 cm
Carter 380f

Shabti with *khat* (bag) headdress
Painted calcite
Height 22.2 cm
Carter 328n

Shabti in *nemes* headcloth
Painted calcite
Height 26.5 cm
Carter 459g

Shabti in *nemes* headcloth
Painted quartzite
Height 26.5 cm
Carter 329i

254

Shabti in long wig
Limestone
Height 27 cm
Carter 330m

Overseer shabti in short wig
Dark blue faience
Height 29.6 cm
Carter 326e

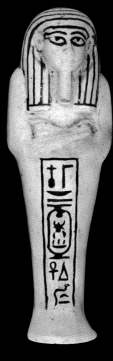

Shabti in long wig
Painted wood
Height 26.5 cm
Carter 323f

Shabti in tripartite wig
White faience
Height 17.6 cm
Carter 519f

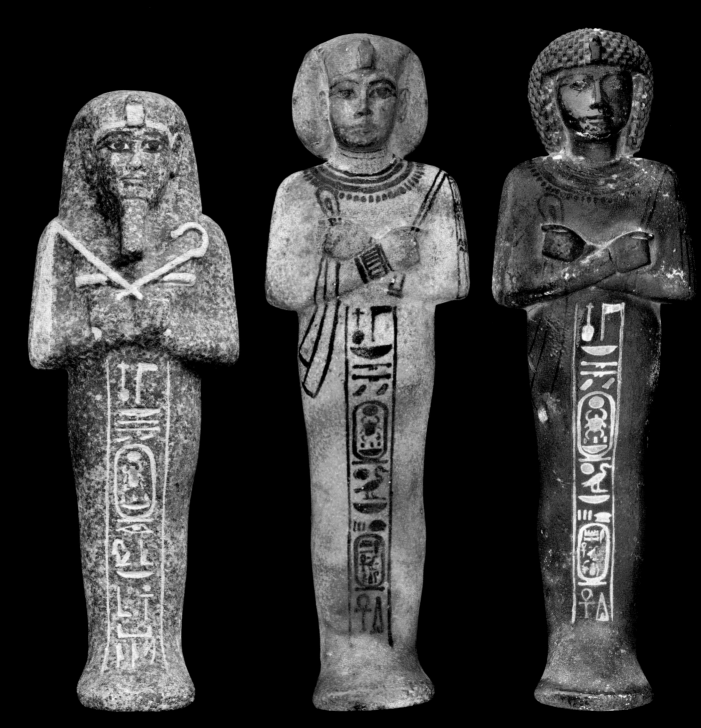

Shabti in long wig
Painted gray granite
Height 26.5 cm
Carter 322h

Overseer shabti in bag headdress
Blue faience
Height 30 cm
Carter 519b

Overseer shabti in short wig
Violet faience
Height 29.3 cm
Carter 326d

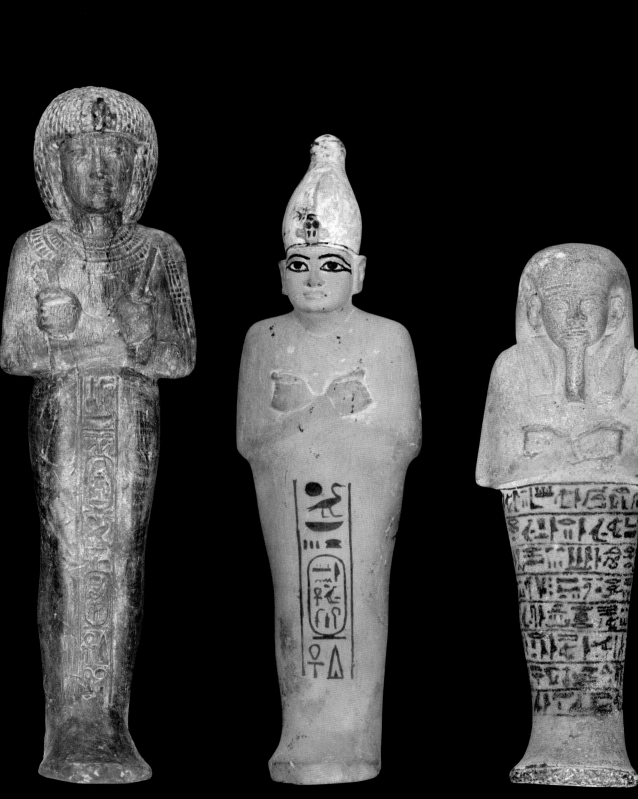

Shabti in short wig
Gilded wood
Height 30.7 cm
Carter 326b

Shabti in white crown
Painted limestone
Height 21 cm
Carter 605a

Shabti in long wig with shabti spell
Blue faience
Height 17 cm
Carter 496d(3)

THE ANNEXE

Carter found the Annexe filled with a jumble of boxes, jars, baskets, models, furniture, and other miscellaneous items, as can be seen here. He likened the clearance of this room to a game of pick-up-sticks. Photograph by Harry Burton.

B Y THE END OF OCTOBER 1927, Carter and his team had finished clearing the Treasury, leaving behind only the canopic shrine (p. 164) and three boats for Harry Burton to photograph. The last chamber to be cleared was the Annexe, which was officially opened on 27 November 1927. Entered through a small doorway at the south end of the Antechamber's north wall, this room had been crammed full of over 2,000 miscellaneous artifacts, and presented quite a challenge for the archaeologists. Its floor, which lay about 1 m below that of the Antechamber, was covered with a great jumble of furniture, boxes, and vessels to a height of almost 2 m. In Carter's own words, "The state of this chamber … simply defies description." In order to avoid crushing the often precariously perched objects beneath them, the team began their work suspended from rope slings.

It took less than a month for Carter to clear the Annexe, a remarkable feat considering the vast number of individual objects involved. The archaeologists were able to determine that the chamber had most likely been originally intended as a store for foodstuffs, wines, and precious oils and unguents, with the overflow from the other rooms (especially the Antechamber and Treasury) added to it. Its disorganized condition when found was probably due to the activities both of the robbers, who had searched it for valuable items, and of the officials who cleaned up after them, who seem to have supplemented its contents with anything that they could not fit back into the Antechamber.

The Final Years

The tomb was opened to the public on 8 January 1928, after Carter and his team had emptied it of the 5,398 objects or artifact groups it had once contained, and the rest of the 1927–28 season was spent conserving and photographing each priceless piece. The following season was interrupted by the ill-health of both chief-conservator Alfred Lucas, who developed paratyphoid, and photographer Harry Burton, who came down with dengue fever. Carter himself suffered from a bad cold, and became even more short-tempered than usual. Both Lucas and Burton had recovered by early December, and the rest of the season was uneventful.

The 1929–30 season was yet again frustrating; it appears that it was taken up entirely with negotiations between Carter and the Egyptian government. Presumably following Carter's advice, Lady Carnarvon had given up the concession to the tomb as of October 1929. However, this left the archaeologist with no official right to enter the tomb, and, to his surprise, the Antiquities Service decided to stand on ceremony and refuse him access. Banned from the tomb, Carter focused his efforts on obtaining some compensation for Carnarvon's heirs. In this at least he was successful, and in September 1930, the estate was paid a lump sum of over £35,000 sterling as reimbursement for excavation expenses, a percentage of which later came to Carter himself.

The 1930–31 season began in early October. To his great annoyance, Carter was supervised at all times by an Antiquities Service inspector, who held the keys to the tomb and

laboratory and hovered over him while he worked. His excavation diaries end in late 1930, though the work was not completed until February 1932, almost 10 years after the great discovery.

The decisions to grant exclusive media rights to *The Times* of London and to fight for a share in the finds were Lord Carnarvon's, and Carter himself may not have agreed with his patron. However, he was left to cope with the consequences of these decisions, as well as the difficulties inherent in being in charge of the most important discovery in the history of Egyptology. As a result of Carnarvon's wishes, Carter was harassed and criticized by the Egyptian press, and he was forced into exhausting battles with the Egyptian government on Lady Carnarvon's behalf. He was also deluged with visitors, both Egyptian and foreign, who took up large amounts of his time and threatened the safety of the tomb. I myself faced similar problems after my discovery of the Valley of the Golden Mummies in the Bahariya Oasis, which lies in Egypt's Western Desert. The international media were fascinated by this discovery, and the site became famous around the world. Large numbers of people, Egyptians and foreigners alike, came to the oasis to visit the site. So many people coming to the Valley disturbed our work; in addition, I feared damage to the mummies and tombs, and I can sympathize with Carter and the sorts of problems he encountered.

In spite of the fact that Carter faced many major challenges during the clearance of the tomb, he still managed to achieve an enormous amount of excellent work. He did not allow the difficulties he had to overcome to interfere with the important task at hand. As an archaeologist, I can appreciate what an impressive job he did of recording and conserving all the objects. He was aided in this by experts such as Alfred Lucas, who had a thorough knowledge of ancient Egyptian materials of all sorts, including stone, ivory, wood, silver, and gold.

The relatively few years of Carter's life remaining after the official close of work on Tutankhamun's tomb appear to have been quiet, occupied mainly with plans for a definitive scientific publication of the tomb, which unfortunately never came to fruition (although the three popular volumes he published during the excavations remain classics), and some dealing in antiquities. He spent part of each year in London, and the rest in Luxor, and seems to have passed his time primarily relaxing and meeting with friends. His health was not good, and he developed Hodgkin's disease in the mid-1930s. His decline was gradual but steady, and by 1939 he was bedridden. Carter died on 2 March 1939, and was buried in England, in a ceremony attended only by his closest surviving friends and relatives.

SMALL WOODEN CHAIR

Painted wood
Height 73 cm
Carter 349

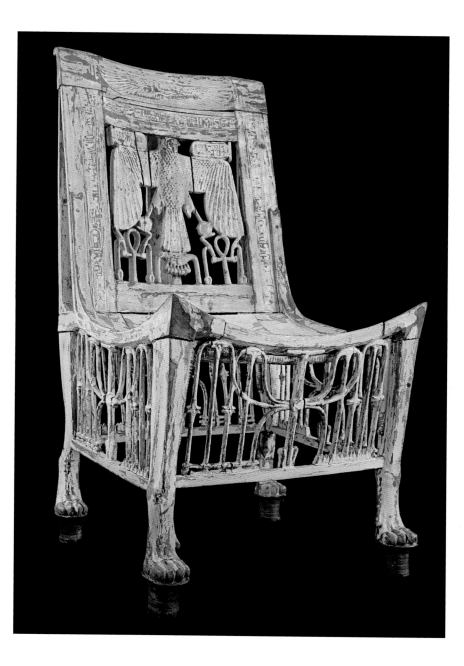

Found thrown upside-down on top of a pile of furniture in the southeast corner of the Annexe, this child-sized chair was clearly used by the king in his youth. The legs of the chair take the shape of lion's limbs, symbolizing protection and rebirth in the next world. The seat is doubly curved and the back is sloping; like many Egyptian chairs, this example has no arms. Between the legs are openwork panels which serve as struts; these are decorated with lily and papyrus plants, the heraldic symbols of Upper and Lower Egypt. The plants are woven around a hieroglyph in the form of the lungs and windpipe of an animal – *sema* – meaning "to unite." Taken together, this functional ornamentation represents the unification of the Two Lands (the Delta and the Nile Valley).

On the high back is an image of Horus in the shape of a falcon spreading his wings, as if to protect the king when he sat in the chair. Below the falcon is the sign for gold, identifying him as the golden Horus. In his talons he holds *shen* signs, signifying eternity. Below his wings are *ankh*s, symbols of life, between *was* scepters, emblems of power and dominion. Above Horus' wings are the cartouches of the golden king; thus Horus protects both the names of the king and the king himself. The king was an incarnation on earth of this god, who is the victorious one, avenger of his father Osiris.

In daily life, chairs were used only by royalty and the elite. The craftsmanship of this example is excellent, but as it was intended for everyday or funerary use rather than ceremonial occasions, it is not adorned with gold and inlays, as was the Golden Throne (p. 56).

Chairs were an important part of the royal funerary equipment, along with beds, stools, vessels, and boxes full of clothing and jewelry. Many of these artifacts were made of wood, and have needed the attention of restorers over the years. Fortunately, however, Tutankhamun's funerary furnishings were found in relatively good condition, certainly as compared to the wooden objects from the much earlier tomb of Queen Hetepheres (Old Kingdom; c. 2550 BC), discovered at Giza in 1925 by George Reisner. Most of the wooden pieces in that tomb were badly decayed, and had to be reconstituted using modern materials. Our great Egyptian restorer, Hag Ahmed Youssef, spent more than a year reconstructing one magnificent wooden box from Hetepheres' tomb. This highly skilled man, who was also responsible for rebuilding Khufu's boat at Giza and whom I met when I was very young, told me that Reisner had challenged him to restore the box, which was found decayed almost beyond recognition. When I re-visit the beautiful canopy belonging to this queen, mother of Khufu and wife of Sneferu, along with her carrying chair, bed, and the box restored by Hag Ahmed, I realize that nothing in the Egyptian Museum in Cairo can compare with this furniture, except for the funerary equipment of Tutankhamun. The chairs that belong to Tutankhamun are magnificent, worthy of a place inside a palace, and are an important part of the story of the child-king.

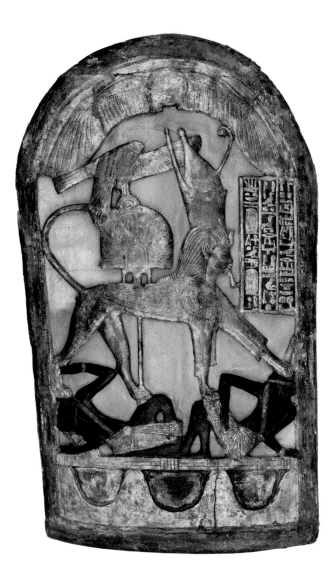
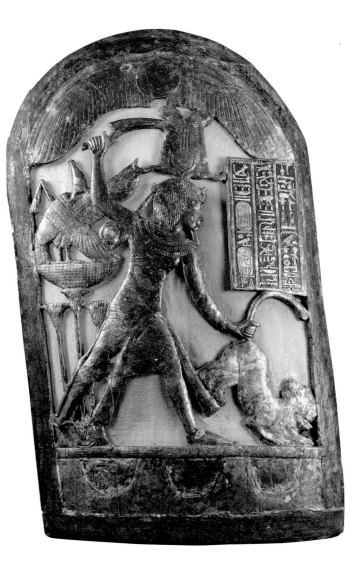

TWO OPENWORK SHIELDS

Gilded wood, hide
Heights 89 cm (379a); 88 cm (379b)
Carter 379a (king as sphinx, left)
Carter 379b (king smiting lions, right)

Carter found a total of eight shields in the Annexe. Four, made of solid wood covered with animal skins, were apparently functional. The remaining four, of which two are shown here, were carved with openwork designs and lavishly gilded. Although they were backed for strength with hide, Carter suggested that they were ceremonial in nature. All four of these shields bear decoration related on one level to the king's prowess at hunting and war,

and on a deeper, more symbolic level, to the king's identification with the creator god and the proper functioning of the Egyptian cosmos. That on the left is decorated with the image of a sphinx (a lion with a king's head) trampling two Nubian enemies beneath its paws. An inscription identifies this sphinx with Tutankhamun himself, and describes him as being like Montu, the ancient war-god of Thebes. A falcon, the bird identified both with Montu and with Horus, hovers behind the king, a *shen* ring gripped in its talons. The hieroglyphic sign for "foreign land," a row of undulating hills, extends across the bottom of the shield. Egyptian sphinxes had close links to the sun god, and were associated with the solar cycle, itself a daily echo of the creation myth.

Tutankhamun is again identified with Montu in the inscription on the other shield

shown here (right), but in this example he is shown in human form, holding two lions by the tail and raising his scimitar to deliver the *coup de grâce*. In addition to their role as symbols of the pharaoh himself, lions, denizens of the desert that bordered the fertile floodplain of Egypt proper, were seen as representations of the chaotic forces that surrounded and constantly threatened the created world. By demonstrating his power over these creatures, Tutankhamun both identified himself with the creator god and played the role of protector of Egypt. Behind the king, Nekhbet, the vulture-goddess of Upper Egypt, stretches her wings protectively from her perch on a basket held up by the papyrus plants symbolic of the Delta region of Lower Egypt. Taken as a whole, this image emphasizes the king's role as ruler and defender of the Two Lands.

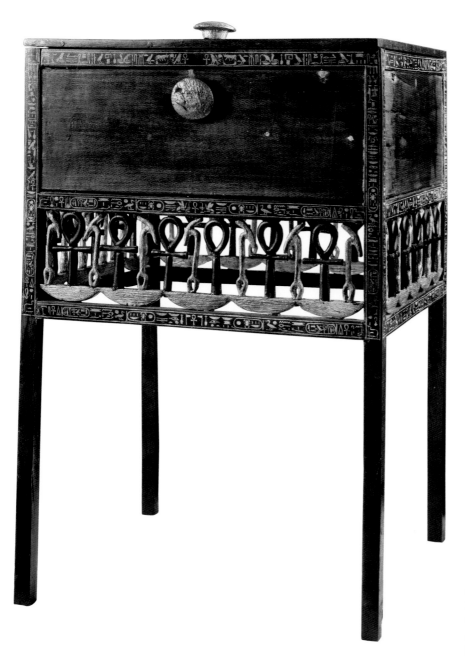

CHEST WITH LONG LEGS AND DECORATIVE FRETWORK

Painted wood, partially gessoed and gilded, colored paste, copper
Height 70 cm, width 43.5 cm, depth 40 cm
Carter 403

Both simple and elegant, this chest, almost square in shape, stands on four long, slender legs. It was made of wood painted reddish brown in imitation of expensive imported cedarwood from Lebanon, with a framework made to imitate ebony. The details of the decoration have been added in black paint and gilding.

Stretchers for reinforcement run along all four sides, and the space formed between them and the chest is filled with openwork panels comprising *ankh*s (life signs) flanked by *was* scepters (the hieroglyph for dominion) on top of baskets (*neb* signs, signifying "all"). Bands of inscription give names and epithets of the king. Some of the epithets used here seem to refer to pious acts that the king carried out when he reopened temples that had been closed during the Amarna period.

The lid is attached to the box by means of a copper hinge and opens upwards. The fastening knobs are covered with gold foil impressed with the king's names. As was the case with many of the other boxes, a string would have been wrapped around these knobs and daubed with mud which was then impressed with a seal. A similar system is still used in Egypt today, except that the string has been replaced by wire and the mud by soft lead, into which identifying seals are stamped.

This chest lay on top of a pile of miscellaneous furniture in the center of the Annexe (it is visible on the right side of the photograph by Burton on p. 258). It had been wrenched open by the robbers, who apparently emptied it of its original contents. Inside, Carter found only four headrests (see pp. 264–65) and a scrap of clothing.

HEADRESTS

Headrest with the god Shu
Ivory
Height 17.5 cm, length 29.1 cm
Carter 403c

Turquoise glass headrest
Glass
Height 18.5 cm, length 28.1 cm
Carter 403a

Bes headrest
Ivory, gold
Height 20 cm, length 19.5 cm
Carter 403d

Cobalt glass headrest
Glass
Height 17.5 cm, length 28.3 cm
TR 2.3.60.1

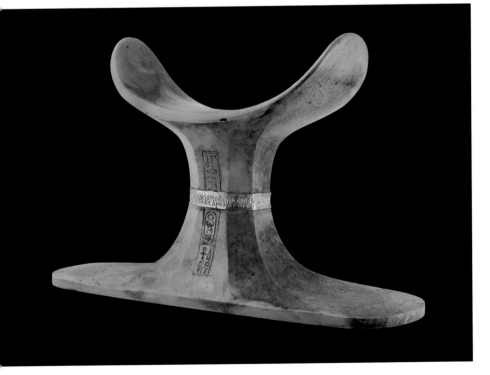

One of the many types of object which had both a practical function in daily life and a symbolic role in the burial was the headrest. Its basic purpose was to support the head of a sleeper, occupying the space left by his shoulders as he lay on his side. The typical shape consists of a wide base, tapering up to a waisted portion in the center, which was often, but not always, in the form of a pillar. The sleeper's head would have rested on the narrow, curved surface that topped the center support. Everyday headrests intended for use by the living would have been made of wood, and provided with linen cushions for comfort. From the Old Kingdom on, such headrests are often found in Egyptian burials.

Three of the headrests illustrated here were certainly found in Box 403 (p. 263). The "Shu" headrest (left, above) substitutes the god of the air for the pillar that normally supports the cradle, who thus holds the sleeper's head on his shoulders, just as he was thought to hold up the heavens, separating them from the earth. The lions on either side of the base represent the eastern and western mountains of the horizon, between which the sun rose each day. The image of

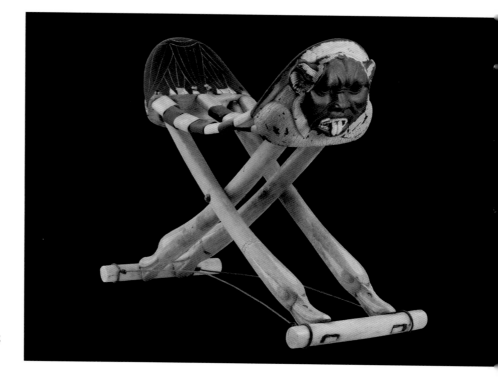

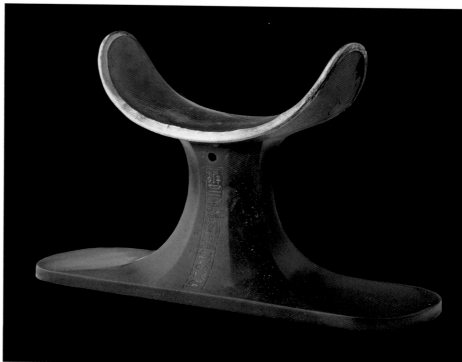

the sun rising on the horizon was a recurring symbol of rebirth. This headrest is made of two separate pieces of ivory, joined in the center of Shu's body by a wooden dowel and two golden pins.

The second and fourth headrests (right and opposite below) are made of glass, in one case of a turquoise color and in the other a deep cobalt blue. The Egyptians became expert glassworkers during the New Kingdom, adapting techniques developed in the Near East. Both of these headrests are inscribed for Tutankhamun, but the dark blue one was evidently given to King Fouad I by Howard Carter during the excavations, and was never recorded in Carter's notes.

One of the most inventive headrests found in the tomb is the folding example (above right), the sides of its cradle adorned with heads of the god Bes, protector of the household and especially of women and children. Since people were considered to be particularly vulnerable when sleeping, apotropaic imagery such as these heads was incorporated into the design of headrests in order to ward off dangerous magical forces.

SMALL GAME BOARDS

Ivory

Length 13.4 cm, width 4 cm, height 2.8 cm
Carter 393 (above and opposite below)

Length 13.5 cm, width 4.1 cm, height 2.7 cm
Carter 585r (opposite above, with detail)

Shown here are two of the game boards
buried with Tutankhamun. One (Carter
585r: opposite above, with detail;) was
found inside a wooden "knick-knack" chest,
part of a pile of objects stacked against the
south wall of the Annexe. The interior of
this chest had been cleverly divided into a
variety of compartments of differing shapes
and sizes, much like a modern jewelry box.
It had been badly damaged by the thieves,
and the priests had repacked it with a variety
of objects, including bracelets of ivory,
wood, limestone, and leather; some leather
gloves; two slingshots; a fire drill; and this
game board. The second board (above and
opposite below; Carter 393) was found loose
in the doorway of the Annexe.

Both boards, each carved from a single
block of ivory, are extremely similar – they
are almost identical in size and designed to
be used for two board games. Each has one
side divided into 20 squares and two oblong
spaces, for a game known as Twenty Squares
(*Tjau*), and the other into 30 squares for use
in *Senet*. A small drawer for the playing
pieces, closed by an ivory bolt passed
through two gold staples, was set into one
end of each box. The ivory gaming pieces
that went with Carter 585r, consisting of five
red disk-shaped pieces, five white pawns,
and two knucklebones, were still in the
drawer; the pieces for the other board
(of which one gaming piece and one
knucklebone were missing) were found
scattered around the floor of the Annexe and
Antechamber. (The red disk-shaped pieces
were found with Carter 585r and the white
disk-shaped ones belong to Carter 393; in
the photo above, there is an extra white
pawn that goes with Carter 585r.)

Prayers containing different names
and epithets of the king were engraved
along the long sides of both boards and
filled with blue pigment. When discovered,
Carter 585r was badly disfigured by leather
that had melted and adhered to it in a
gelatinous mass. However, it was successfully
cleaned with warm water, revealing, on one
end, a lovely image of the king and queen
(detail opposite).

Actual board games are attested as early
as the Predynastic period in Egypt, and
depictions are known throughout Egyptian
history. By the New Kingdom, *Senet*
(Passing), was the most popular game, and
is seen, for example, in the tomb of Nefertari
(queen of Ramesses II), who plays against an
invisible opponent, as well as in the temple
of Medinet Habu, where Ramesses III is
shown challenging his daughters.

To play, the opponents threw
knucklebones or casting sticks and moved
their pieces accordingly. The playing path
wound around the board, with good and
bad luck squares. The goal, much like in
modern Parcheesi/Pachisi or Ludo, was
for one player to remove all of his or her
pieces before their opponent did.

In addition to its entertainment value,
Senet was also a metaphor for the journey
of the sun god and the deceased through the
dangerous realm of the netherworld, so that
finishing the game magically guaranteed
rebirth and resurrection. Twenty Squares was
a simpler game: the players just had to move
their pieces into the central line of squares.

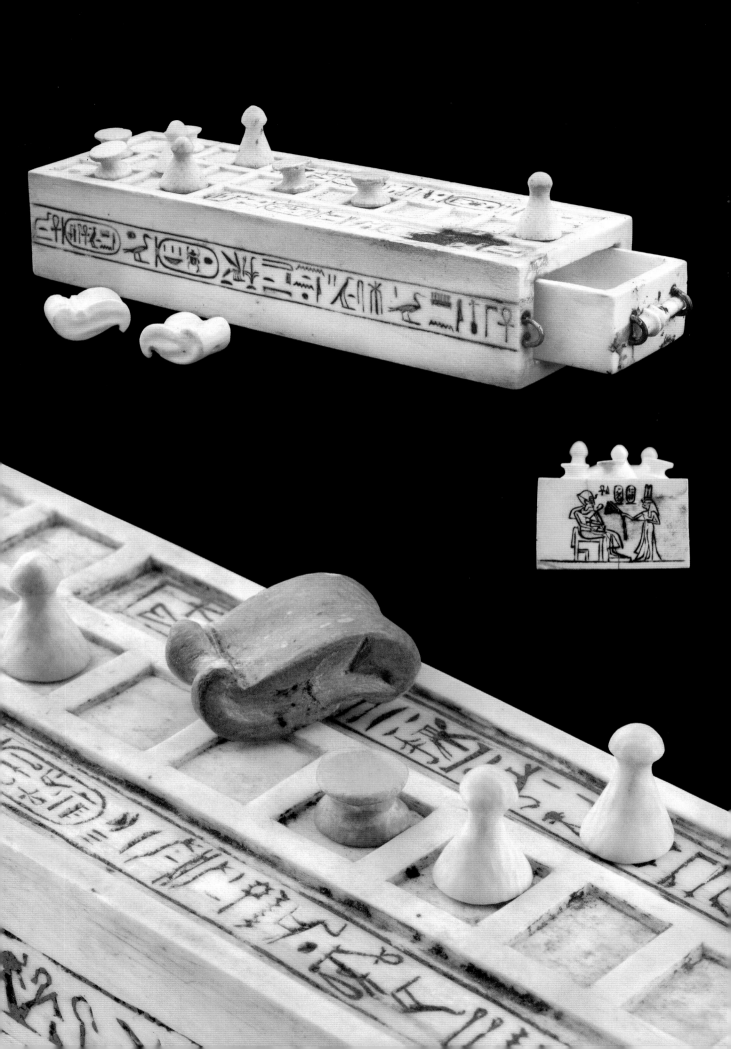

BELL-SHAPED VESSEL ON A STEM

Calcite
Height 58.5 cm
Carter 520

UNGUENT VASE

Calcite
Height 25.8 cm
Carter 420

Numerous calcite vessels were found in the Annexe. Since stone stays cool longer than other natural materials and thus retards spoiling, such vessels were used to hold precious unguents and perfumed fats. These fats and unguents were luxury items of great value and were a primary target for tomb robbers, as they were portable and could not easily be identified. Most of Tutankhamun's supply of unguents (estimated by Carter to be about 350 liters in total) had been carried off by the ancient thieves.

This round-bellied jar on a tall stand (right) was described by Carter as a bell-shaped krater. It was found on its side, with its lid under a bed, in the northeast corner of the chamber, and still contained a considerable amount of the unguent or perfume with which it had originally been filled. Carter suggested that the vessel as a whole was meant to represent a papyrus umbel tied at the neck and base. Just below the lip is carved a wide band of buds and petals which were softly painted; below this, and also on the lid and above the base, are bands of geometric floral patterns. On the belly is a panel of inscription bearing the names and epithets of the king and his queen, along with the wish that they be granted eternal life.

The second vase (opposite) takes the shape of a situla, a type of bucket used in religious rituals. It is actually two vessels, one fitted inside the other. The outer vase (itself made in two pieces) was carved in an openwork pattern, which reveals the plain inner one. The base was made to represent the calyx of a lily or lotus plant, and the band below the rim is filled with a geometric pattern. The openwork design of the central register (two overlapping parts of which are seen here) includes two sets of winged solar cobras (the sets divided by a

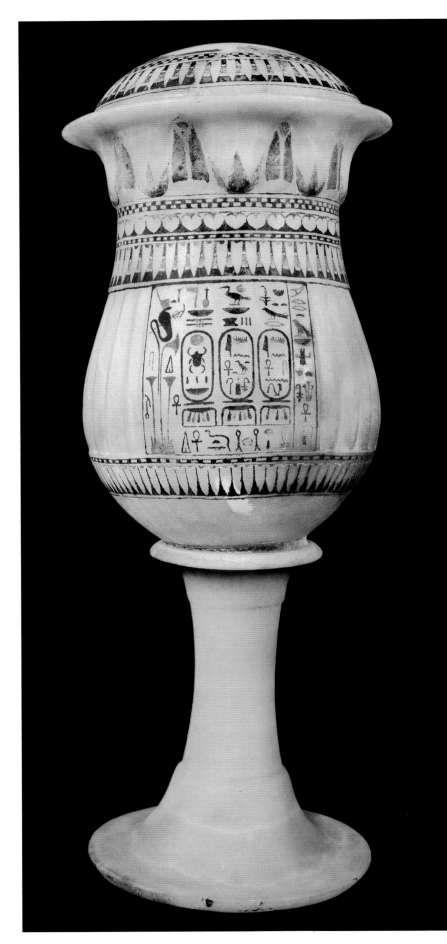

nefer sign, meaning beautiful) holding up the cartouches of the king and flanked by *ankh*s, as well as a large image of the king's throne name: a winged scarab with plural strokes on a basket pushing a sun disk. The situla had once contained unguent, but the thieves had emptied it, leaving the marks of their fingers behind. Enough residue remained for Carter to conclude that the original contents "… must have been of the nature of a still ointment (such as the consistency of cold cream of today)."

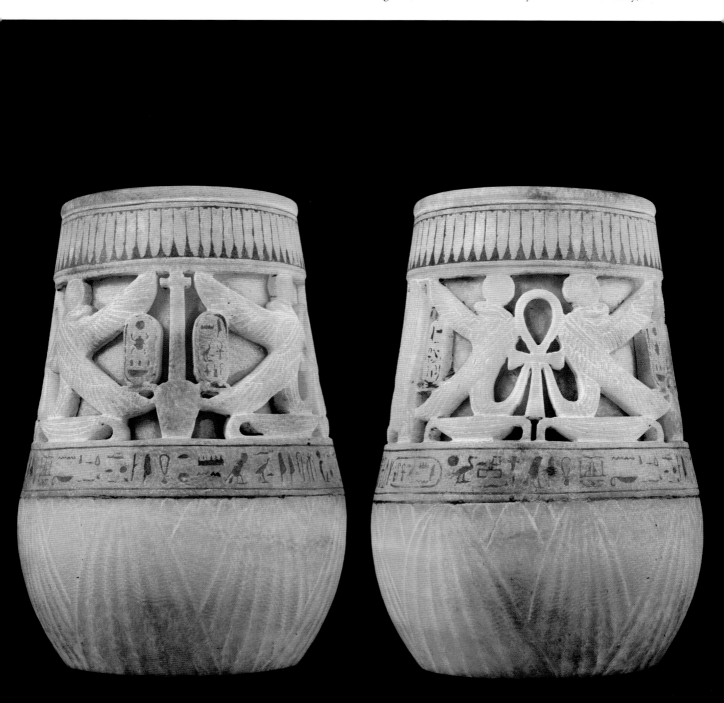

LONG-NECKED VASE
Calcite, faience
Height 62 cm
Carter 344

DOUBLE AMPHORA
Calcite
Height 28.3 cm
Carter 417

The tall thin vase (left) and the double amphora (opposite) were discovered in different piles of jumbled objects in the Annexe. The vase, which had been carved in one piece, was decorated around its long neck with three registers of triangles intended to echo lotus petals, each topped by a band of black and white squares. The upper and lower registers are inlaid with dark turquoise faience, while the central register alternates inlays of calcite and dark green faience.

The double amphora was also carved from a single block of calcite. The concept of two vessels joined together was known in Egypt from Predynastic times, but the amphora shape was introduced from abroad.

UNGUENT VESSEL IN THE FORM OF A LION

Calcite, gilding, paint, ivory
Height 60 cm
Carter 579

This whimsical vessel in the form of a rampant lion was discovered standing in the southwest corner of the chamber. The lion rests his left paw on the hieroglyph for protection (*sah*) and raises his right, as Carter put it, "clawing the air in a noble rage." From his open mouth hangs a long tongue of red-stained ivory; his nose was painted blue, his eyes were painted and gilded, and his mane is indicated by curls around the head and neck. His large, protuberant ears are pierced for earrings, although none survive. A floral crown is set upon his head. The powerful chest, with its clearly modeled ribs, is inscribed with the names of Tutankhamun and Ankhsenamun. The entire vessel, which had been carved from a number of separate pieces of calcite, is set onto a trellised stand, also of calcite.

The body of the lion is hollow, and held traces of a fatty substance when Carter found it. The floral crown that formed the neck of the vase was no longer attached to the vessel, but was still covered with a lid, fixed to it with linen. The obvious assumption was that the ancient thieves had pulled the neckpiece from the lion's head, although the excavator also proposed the unlikely possibility that gases created by the contents had blown it off.

BOAT IN TANK

Calcite, gold, colored glass, ivory
Height 37 cm, length 58.3 cm
Carter 578

The base of this unique object consists of a rectangular tank, inscribed on its front with the names of the king and queen. Set into the middle of the tank is a trapezoidal support on which rests a boat adorned on prow and stern with ibex heads that have real horns, pierced ears (one still containing an earring), and collars inlaid with gold and colored glass.

The principal part of the boat is occupied by a shrine or canopy with four elaborate columns and four screen walls. Seated in front of the shrine is a servant girl, wearing only gold earrings, gold armbands, and a bead bracelet; she holds a lotus made of ivory in her left hand. Such "concubine" figures carried connotations of fertility and thus of regeneration: nakedness was an erotic signal, and the lotus was an important symbol of rebirth. Standing at the stern is a female dwarf, originally holding a sounding pole in both hands. Dwarves were considered sacred to the sun god, reinforcing the theme of solar rebirth.

Carter suggested that this sculpture was used as a centerpiece of some sort. The tank would probably have held water or another liquid, so that the boat would have appeared to be floating.

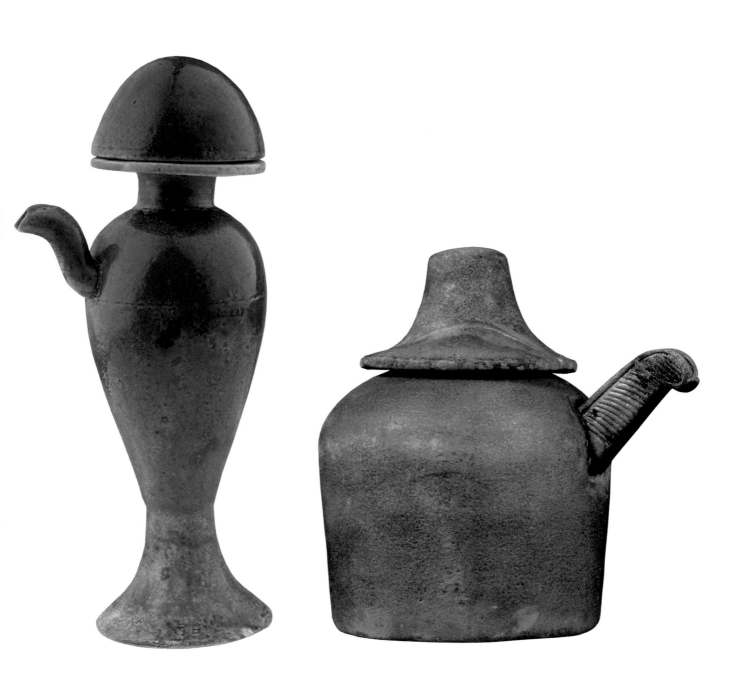

HESET VASE

Faience
Height with lid 19.5 cm
Carter 461r

NEMSET VASE

Faience
Height 13.8 cm
Carter 461b

These two ritual vessels were discovered in Box 461, which was found lying broken at the south end of the Annexe. They are two of 25 such vases, most of which are in the squat *nemset* form.

The *heset* vase (above left), one of eight found in this box, takes the shape of the hieroglyph for "to praise." The form overall is one of the most pleasing of Egyptian vessel shapes, with its slender, curving body, narrow neck, and flaring foot. Such vases were used for purification rituals, libations, and ceremonies such as the Opening of the Mouth, which served to revivify the mummy or images of the deceased. The

example shown here is one of the most elegant of the objects from Box 461: it has a deep, even glaze of a rich turquoise blue and bands of yellow around the bottom of the lid and the foot.

Also of faience, but of a greenish-yellow color that resembles bronze (the color resulting most probably from an inferior glaze), the *nemset* vase (above right) has an unusual spout in the form of a feather. This is probably intended to represent the ostrich plume of *ma'at*, the proper order of the Egyptian cosmos. By using this as the spout, all liquids poured from the vessel would magically be imbued with this quality.

SCIMITAR (KHEPESH) AMULETS
Gold
Lengths 8.2 cm and 9 cm
Carter 620(60) (left) and Carter 620(61) (right)

The jumbled mass of debris on the floor of the Annexe included these two miniature *khepesh* swords. Two actual bronze scimitars of this type, which originated in Syria and was introduced into Egypt during the New Kingdom, also came from this chamber. One of the real swords was full-sized, with a handle inlaid with various woods. The other was much smaller, and Carter concluded that it had been manufactured for Tutankhamun's use while he was still a child. This speaks strongly of the importance of military skills for royal males, as the crown prince was probably expected to lead the Egyptian troops into battle on his father's behalf.

These golden examples served some sort of amuletic purpose, most likely concerned with protecting the king from the dangers of the afterworld.

HEART AMULET
INLAID WITH
A HERON

Gold inlaid with glass
Height 5.8 cm
Carter 620(67)

This is one of my favorite amulets from the
tomb. It is a hollow, heart-shaped pendant
of gold, with the heron on the front inlaid
in colored glass. On the back (below) is
inscribed the throne name of Tutankhamun.
The fine work necessary to craft this tiny
jewel, found with a number of similar pieces
scattered on the floor of the Annexe, is
remarkable – equal to any modern artistry.

The heron, known to the Egyptians as
the *benu* bird, was linked with the gods
Atum, Re, and Osiris (three of the nine gods
that formed the pantheon worshiped at
Iunu, or Heliopolis, the center of the sun
cult). The name *benu* shares a root with
weben, "to rise," and also with the *ben-ben*,
the sacred stone whose shape the pyramids
were thought to echo. In Egyptian
mythology, this bird was said to have flown
over the endless waters that filled the universe
before Atum brought the world into being,
and to have assisted the creator god in his
primeval work. During the New Kingdom,
as an aspect of the soul of Re, the *benu* bird
was often represented in the solar bark.

Through its connection with the creator
god and the sun, the *benu* bird was thought
to be self-generating, and thus became
associated with the phoenix of Greek
mythology. Writing in the 5th century BC,
the Greek historian Herodotus relates a myth
(which is not, however, mentioned in any
Egyptian sources) in which the *benu* lived
for 500 years, then burned itself in a fiery
nest. The new bird would arise from the
conflagration and take the ashes of its
progenitor to Heliopolis.

The inclusion of this amulet with the
burial equipment was yet another attempt
to ensure eternal rebirth for the king.

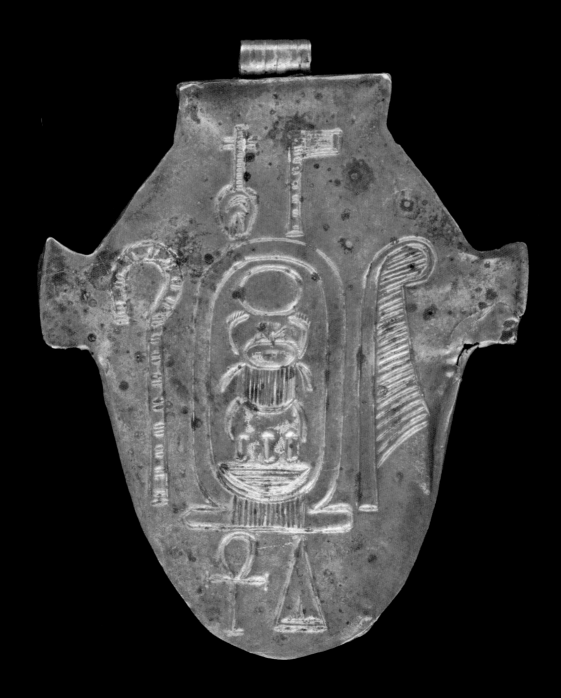

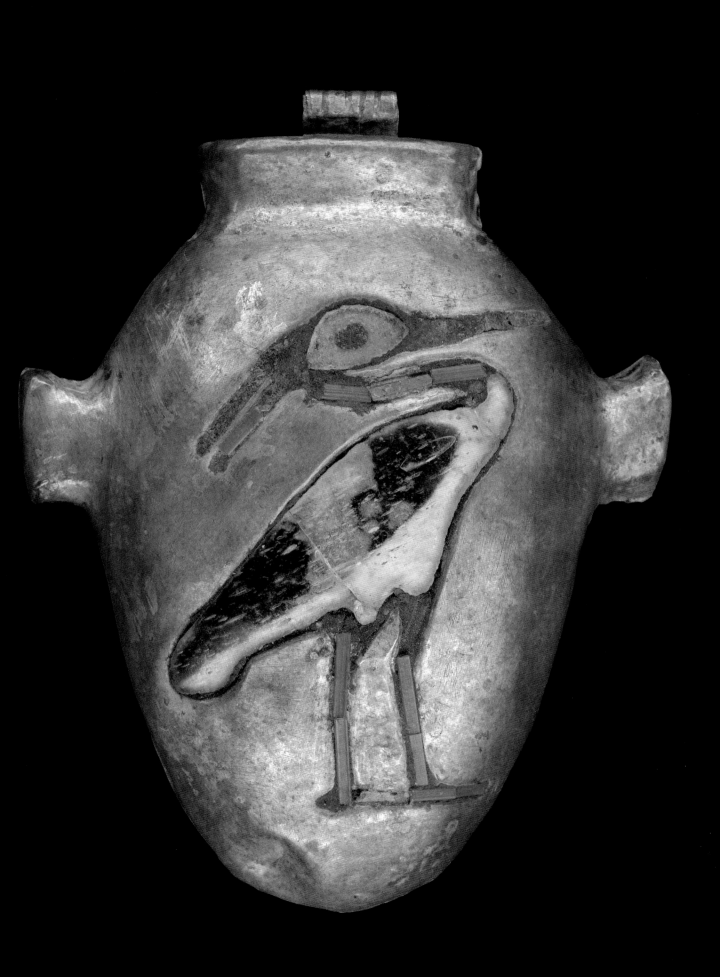

The third boat (pp. 283–84) has been carved and painted to resemble a bundle of papyrus stalks that have been tied together in the form of a skiff. Papyrus skiffs are thought to have been the earliest types of boat built in Egypt, and probably remained in use throughout Egyptian history. Their most important function was in rituals involving hunting and fishing in the swamps.

Such rites, depicted for example on the walls of tombs and temples, show kings and nobles hunting in the marshes at the edges of the floodplain and in the Delta. These swamps represented the fringes of the ordered universe; the wild creatures hunted there, such as migratory birds, fish, and hippopotami, symbolized the forces of chaos that pressed upon and

threatened the created cosmos. For his afterlife, the king needed such boats in order to continue to perform the role of the creator god by fulfilling these rituals. Another use of the papyrus skiff, described in a spell from the *Book of the Dead*, was for traveling in the Field of Reeds (or of the Blessed), where the blessed dead were thought to spend eternity.

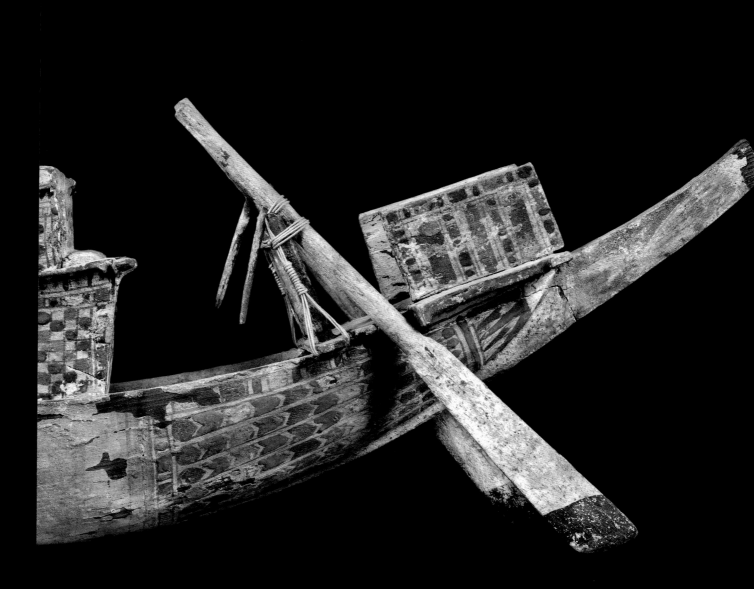

MODEL BOATS

Model boat with cabin and lookouts
Painted wood
Length 78 cm
Carter 597

Model of a ceremonial barge
Painted wood
Length 124.3 cm
Carter 437 and Carter 491

Model of a reed skiff
Painted wood
Length 124 cm
Carter 464

Seventeen of the 35 model boats buried with Tutankhamun were found in the Annexe. The three here illustrate a good cross-section of the types that the king needed for his afterlife. The most elaborate of the three (below) has a large double-roofed cabin with open kiosks at front and back. Small lookouts adorn both prow and stern of the vessel. The boat was steered with double paddles; neither sail nor mast was found with it. The carvel-built hull (with planks laid smoothly against one another), cabin, and lookouts are all painted with geometric and feathered patterns in red, green, blue, and yellow. A simpler example of the same sort of ceremonial barge can be seen on pages 281–82, in this case with one steering oar, a mast, and a small cabin with a single roof.

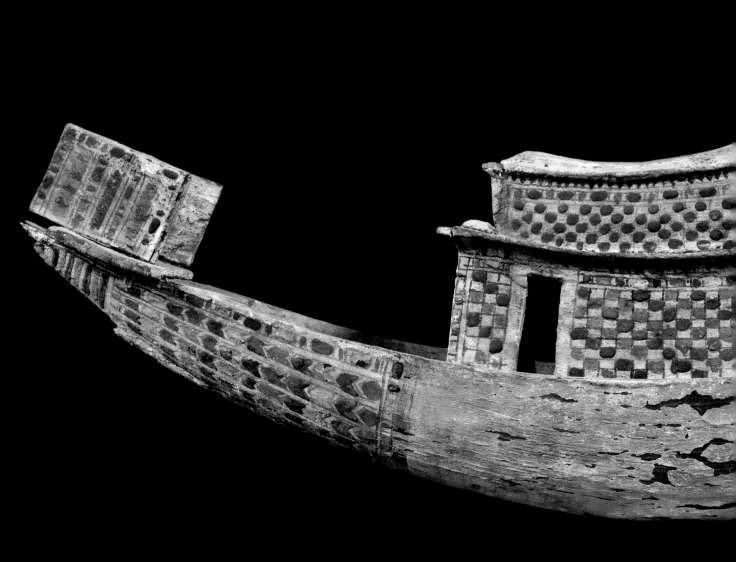

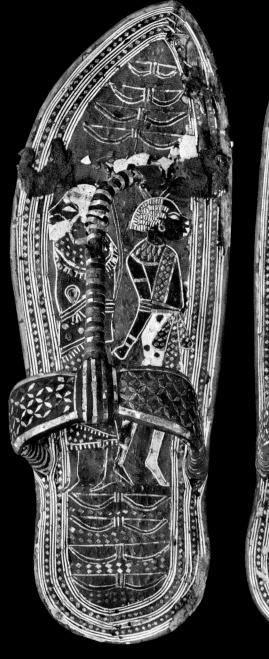
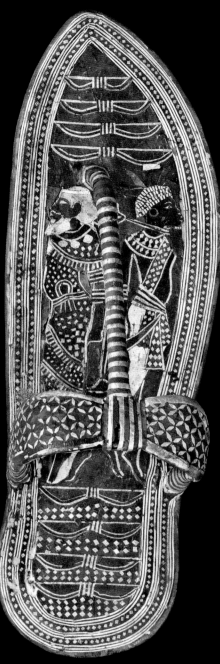

SANDALS WITH ENEMY FIGURES

Wood, bark, leather, gold
Length 28.4 cm
Carter 397

Carter found almost 100 pieces of footwear, some complete and some fragmentary, in the young king's tomb. They range from simple examples made of papyrus and rushes, to the sheet gold sandals found on the mummy itself (p. 151). A number of sandals were stored neatly in boxes along with other garments; others were discovered scattered about the Annexe and Antechamber. In many cases, the leather had disintegrated by the time Carter found them, to the point where they could barely be identified as sandals.

The soles of this well-preserved and elaborately decorated pair are made of wood, with applied marquetry decoration of leather, bark, and gold; the straps are of bark decorated with gold leaf. On the upper surface of the soles are depicted four enemy prisoners, one Nubian and one Asiatic on each sandal, their arms tied uncomfortably behind their back at the elbows and ropes around their necks. Each pair of prisoners has four archers' bows above their heads and four below their feet, symbolizing the traditional enemies of Egypt. Normally there were nine of these bows: three, used to indicate a plural, multiplied by three, thus equaling all possible enemies. It is likely that the choice of eight here was made for reasons of symmetry and balance. If he had worn these sandals, Tutankhamun would have symbolically crushed the bound prisoners under his feet every time he took a step; however, they show no sign of use.

CONCLUSION

Writing this book has been an adventure, and has brought me close to Howard Carter. I imagined Carter discovering and then clearing the tomb, supervising the conservation work, writing his notes and making the exquisite sketches that are such an important part of his excavation diaries. I wondered about the love between him and Lady Evelyn Herbert, and about the artifacts that were stolen from the tomb. I pictured him looking at the treasures of the tomb with both the eyes of an archaeologist and the eye of an artist. I have tried to answer many questions in this book, and make it different from the others written about the tomb of King Tutankhamun. The wonderful photographs of Sandro Vannini are an important part of what makes this book unique: studying these images, which sometimes show us things that are hard or impossible to see with the naked eye, has given me new ideas about some of Tutankhamun's treasures.

One question I frequently ask myself is what I would do if I found the tomb today, and opened the gilded coffins, slowly uncovering the mummy that lay inside. What if I was the one who saw in front of me the beautiful mask that hid the face of the king, and I had to make the choice of damaging the royal remains to remove this treasure? Would I unwrap the mummy to recover the many golden amulets that were hidden inside the bandages? When I saw for myself the terrible damage that Carter's team had done to the mummy, my first reaction was that I would leave the mask and the amulets in place and put the mummy in a special museum. But I later found out that it is not always the archaeologist in charge who makes the final decision: I believe now that it was Douglas Derry, head of Carter's forensic team, who was responsible for the mutilation of the mummy.

Fortunately, technology has improved enormously since Carter and Derry's time. I was able to study the remains of the boy king using the most modern CT-scanning technology, without doing any additional injury to the body. Although mysteries still remain, we were able to ascertain that Tutankhamun died at about the age of 19, and that he was not murdered, at least not by a blow to the head, as had been suggested by a number of people previously.

New technologies continue to aid us in our quest to reveal the secrets of the Valley of the Kings. Another major discovery was the identification of the mummy of the great Queen Hatshepsut. My search for this mummy was one of my greatest adventures as an archaeologist, although it involved no excavation. I began my quest by entering the subterranean sepulcher of Hatshepsut and her father Thutmose I – KV 20 in the Valley of the Kings – following once more in the footsteps of Howard Carter, who had cleared the tomb in 1903. I also explored KV 60, a small tomb near KV 20, where two unidentified female mummies were discovered in 1903, again by Carter. I then descended into the deep shaft and tunnels that hid the first Royal Mummy Cache at Deir el-Bahari, where many of the kings and queens of the New Kingdom were hidden during the Third Intermediate Period, and visited KV 35, the tomb of Amenhotep II, where more of the royal mummies were concealed.

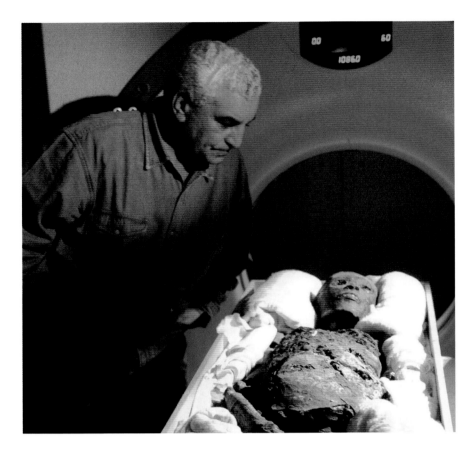

Using a state-of-the-art CT-scan machine, my team, headed by radiologist Dr Ashraf Selim, scanned four unidentified female mummies: the two from KV 60 (an obese older woman, found lying on the floor; and a smaller woman, found in a coffin inscribed for Hatshepsut's own royal nurse [Sitre]-In); one from DB 320 (Unknown Woman A, also known as the Screaming Mummy because of the agonized expression on her face); and one from KV 35 (Unknown Woman D, believed by some Egyptologists to be the 19th Dynasty queen Tausert).

The results of these scans were interesting, but we needed more information before we could come to any conclusions. The key to the puzzle lay in a small wooden box found in DB 320, inscribed with the cartouches of Hatshepsut. We CT-scanned this box, and found inside a package of resin that contained what looked to Dr Selim like mummified viscera: perhaps a liver and part of an intestine. Stuck to the outside of this package, at the bottom of the box, was a tooth, identified by the dentist we consulted as a seventh upper right molar. Our original CT scans had discovered that one of the mummies, the obese woman from KV 60, was missing exactly this tooth. The size was a perfect match, and there was even a root missing from the tooth that was still in the mummy's mouth. As had been suggested in 1966 by researcher and author Elizabeth Thomas, this woman, who had died between the ages of 45 and 60, is almost certainly Queen Hatshepsut.

We also used the quest for Hatshepsut as an opportunity to develop further another new technology that had never before been used successfully in the study of mummies: DNA analysis. The DNA of mummies is badly degraded, by age and by the techniques

used in mummification, and it is difficult to get an adequate sample. Previous studies had also been considered unreliable due to problems of contamination. The Discovery Channel, as part of a special program on Hatshepsut, donated a modern DNA lab, built in the basement of the Egyptian Museum, Cairo, and dedicated exclusively to the study of mummy DNA, to the Supreme Council of Antiquities. An international team of experts worked to analyze both nuclear and mitochondrial (passed down through the maternal line) DNA from the mummies of Hatshepsut and some of her closest relations, including the woman who may have been her grandmother, Ahmose-Nefertari, her half-brother and husband, Thutmose II, her stepson and nephew Thutmose III, and an unidentified male once thought to be her father, Thutmose I. This last mummy is definitely not Thutmose I, but may still be a member of the family.

The identification of Hatshepsut was a great event, one which fascinated the world. Over 500 reporters from all over the globe covered the announcement, and we were able to remind the public that there are still important discoveries to be made in the land of the pharaohs. New evidence about Tutankhamun is still coming to light. When I announced the results of the Tutankhamun CT-scan, many people thought that there was nothing left to uncover about the golden boy pharaoh. But this is not true – fascinating new finds continue to be made and new theories proposed about both the tomb itself and the king. For instance, part of a limestone block carved with an image of Tutankhamun smiting foreign enemies was found beneath the house of an old man in a small village between the Giza pyramids and Saqqara, on the edge of the desert west and south of Cairo. This relief suggests that the boy- king built or added to a temple at Memphis, the remains of which may still lie beneath the sand.

Indeed, Tutankhamun's tomb still has secrets to reveal. On one visit, I went into the Treasury, and found that Carter had left eight boxes there. These were a surprise to me, as I had never heard them mentioned. They contained a large number of mud sealings bearing the cartouches of the king, which will be conserved, studied by scholars, and matched up to the sealings mentioned in Carter's notes. Another time I was in Luxor, I also found a number of objects from Tutankhamun's tomb, including 20 completely sealed pottery vessels, some dom nuts, and bark baskets of different sizes, in a storage magazine. We are also always considering how best to conserve and display the tomb of Tutankhamun and his mummy, to protect and preserve them and allow the public to view them in some way.

One of my dreams is to conduct my own excavations in the Valley of the Kings. I am especially interested in the area around KV 8, the tomb of Merenptah, as I feel that the tomb of Ramesses VIII may be somewhere nearby. I am delighted to be part of these new discoveries in the Valley of the Kings, and hope that we can solve more mysteries in the years to come.

Zahi Hawass
Cairo

BACKSTAGE

SANDRO VANNINI'S REMARKABLE PHOTOGRAPHS of the treasures of Tutankhamun's tomb reproduced in this book were achieved using today's most advanced digital technologies. However, they can also be seen as belonging to a long history of the photographic documentation of cultural and artistic masterpieces.

In 1851, over a century and half ago now, but just 12 years after the invention of photography, the Commission des Monuments Historiques in France appointed five photographers to record the country's cultural heritage in order to assess its condition and determine what restorations might be necessary. A second, but no less important, purpose of this grand project was to present to the world at large, through photographic means, the artistic masterpieces of France that only relatively few people at that time were able to come and admire in person. In Italy one year later, in 1852, the studio of Fratelli Alinari was established, which has since then created an unparalleled catalogue of Italian artistic heritage. It is an interesting thought that for decades, throughout the world, Michelangelo's *David* was in some ways Alinari's *David*, as it was known only through the photographs – and the point of view – of one of the anonymous photographers assigned by the Florence studio. The same is true for many other masterpieces of Italian art.

Although today traveling has become much easier, photography is still the most powerful instrument in bringing great works of art to people around the world, and Sandro Vannini is one of the leaders in this field.

It is probably true to say that such documentary photography is the Cinderella of this medium. The attention of both critics and public is mostly focused on photojournalism and photography as art, but this neglects the fact that documentary images of cultural heritage also call for great creativity. They combine intense study and knowledge with a highly developed sensitivity in interpreting the object being photographed. The photographer has to know how to put his or her own personality to one side to let the object express its beauty, apparently without any artifice or assistance.

The Technique
Sandro Vannini works with a Silvestri Bicam II camera, a development of their monorail view camera, a relatively straightforward camera consisting of a flexible diaphragm, or bellows, linking two rigid plates, or standards – one in front, which holds the lens, and the other at the rear, which holds the film (in sheets not rolls). Such cameras have not changed fundamentally for a century. In the Silvestri Bicam II camera the traditional bellows is replaced by a set of rigid, lightproof elements of various lengths. This camera has a greater flexibility, making it easier to use outside the studio, and also offers better protection from dust. Using this configuration, the minimum focusing distance is 1 m. To focus on small objects closer than this, Sandro Vannini had to use special adaptations. The lenses are Rodenstock Apo-Sironar HR, specifically made for digital photography, with an electronic shutter controlled by computer. Just three focal lenses were used: 35, 60 and 100 mm, the last being used for 75 per cent of the photographs seen here. The great innovation compared

with the traditional monorail view camera is the replacement of film with a digital sensor, Imacon Ixpress (22 megapixel), directly controlled by computer, as is the focusing and framing. The technology of the Imacon camera and its handling software (particularly its multishot function) can create images of very high resolution, which in turn allows for significant enlargements that would be impossible using film. Such enlargements mean that the objects can be examined in enormous detail, revealing previously unseen features that display the extraordinary abilities of the ancient craftsmen even in the smallest elements. These are often not visible to the naked eye, and certainly not in a museum situation.

In discussing the technical aspects of the photographs in this book we should also not overlook the unusual and difficult conditions in which they were taken. A special set was created consisting of a stand and several backcloths to shoot the objects against, lit by lamps with special screens made by Gamma Progetti. The whole set could be moved around the rooms of the Cairo Museum, in particular the one currently containing the Tutankhamun treasures – the special strong room always full of guards and thronged with visitors.

Every year more than a million visitors pass through the doors of the Cairo Museum – thousands every day. It is easy to imagine the length of time involved in taking just a single shot – first the museum curators must open the case in order to move the object to the photographic set, surrounded by crowds of curious people, then replace it and write down by hand all the details of this operation in a large, old-fashioned register.

The success of this project is the result of a combination of the photographic art and technical abilities of Sandro Vannini, but it also could never have happened without the enlightened and full cooperation of the Egyptian Supreme Council of Antiquities, and in particular Dr Zahi Hawass, who was able to solve all the problems associated with taking photographs inside the Museum. Given all these circumstances, it seems quite reasonable to propose that this book presents the boy-pharaoh's treasure in a way never seen before.

Lello Piazza

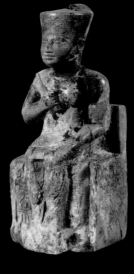

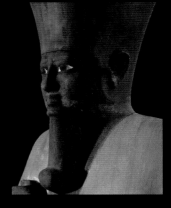

Early Dynastic Period,
Narmer Palette

Old Kingdom, 4th Dynasty,
statuette of Khufu

Middle Kingdom, 11th Dynasty,
head of statue of Mentuhotep

CHRONOLOGY

EARLY DYNASTIC PERIOD
0 – 2nd Dynasties *c.* 3050 – *c.* 2650 BC

OLD KINGDOM
3rd – 6th Dynasties *c.* 2650 – *c.* 2175

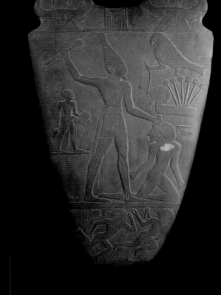

FIRST INTERMEDIATE PERIOD
7th – 11th Dynasties *c.* 2175 – *c.* 2080

MIDDLE KINGDOM
11th – 13th Dynasties *c.* 2080 – *c.* 1630

SECOND INTERMEDIATE PERIOD
14th – 17th Dynasties *c.* 1630 – *c.* 1539

Old Kingdom, 4th Dynasty, pyramid of Khafre, Giza

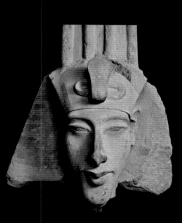

New Kingdom, 18th Dynasty,
statue of Thutmose III

New Kingdom, 18th Dynasty,
head of Akhenaten

New Kingdom, 19th Dynasty,
bust of Ramesses II

Ptolemaic Period,
statue of Cleopatra

NEW KINGDOM
18th – 20th Dynasties *c.* 1539 – *c.* 1069

18th Dynasty	*c.* 1539 – *c.* 1292
Ahmose	*c.* 1539 – *c.* 1514
Amenhotep I	*c.* 1514 – *c.* 1493
Thutmose I	*c.* 1493 – *c.* 1481
Thutmose II	*c.* 1481 – *c.* 1479
Thutmose III	*c.* 1479 – *c.* 1425
Hatshepsut	*c.* 1473 – *c.* 1458
Amenhotep II	*c.* 1426 – *c.* 1400
Thutmose IV	*c.* 1400 – *c.* 1390
Amenhotep III	*c.* 1390 – *c.* 1353
Amenhotep IV (Akhenaten)	*c.* 1353 – *c.* 1336
Smenkhkare	*c.* 1335 – *c.* 1332
Tutankhamun	*c.* 1332 – *c.* 1322
Ay	*c.* 1322 – *c.* 1319
Horemheb	*c.* 1319 – *c.* 1292

19th Dynasty *c.* 1315 – 1201

20th Dynasty *c.* 1200 – 1081

THIRD INTERMEDIATE PERIOD
21st – 25th Dynasties *c.* 1069 – 657

LATE PERIOD
26th – 31st Dynasties 664 – 332

PTOLEMAIC PERIOD 332 – 30 BC

LIST OF OBJECTS

FURTHER READING

Aldred, C., *Tutankhamun's Egypt* (London, 1972)

Aldred, C., *Akhenaten and Nefertiti* (London & New York, 1973)

Aldred, C., *Akhenaten, King of Egypt* (London & New York, 1988)

Aldred, C., *Tutankhamun: Craftsmanship in Gold in the Reign of the King* (New York, 1979)

Anthes, R., *Tutankhamun Treasures* (exhibition catalogue: Washington, 1961)

(Anon.) *The Tombs of the Kings: a handbook to the objects directly relating to Akhenaten and Tutankhamen in the British Museum* (London, 1923)

Assaad, H. & Kolos, D., *The Name of the Dead: Hieroglyphic Inscriptions of the Treasures of Tutankhamun Translated* (Mississauga, 1979)

Brackman, A. C., *The Search for the Gold of Tutankhamun* (New York, 1976)

Breasted, J. H., *Some Experiences in the Tomb of Tutankhamon* (Chicago, 1923)

Brier, B., *The Murder of Tutankhamun* (London, 1998)

Budge, E. A. W., *Tutankhamen, Amenism, Atenism and Egyptian Monotheism* (London, 1923)

Capart, J., *The Tomb of Tutankhamen*, translated by Warren R. Dawson (London, 1923)

Carnarvon, The Earl of, & Carter, H., *Five Years' Explorations at Thebes. A Record of Work Done, 1907–1911* (Oxford, 1912)

Carter, H. (with Mace, A. C.), *The Tomb of Tut.ankh.Amen*, 3 vols. (London, 1923–33)

Cerny, *Hieratic Inscriptions from the Tomb of Tutankhamun* (Oxford, 1965)

Cone, P. (ed.), *The Discovery of Tutankhamun's Tomb* (New York, 1976)

Cottrell, L., *The Secrets of Tutankhamun* (London & New York, 1978)

Davies, N. M. & Gardiner, A. H., *Tutankhamun's Painted Box* (Oxford, 1962)

Davis, T. M. & others, *The Tomb of Harmhabi and Touatânkhamanou* (London, 1907)

Desroches-Noblecourt, C., *Tutankhamen. Life and Death of a Pharaoh* (London, 1963)

Eaton-Krauss, M., *The Sarcophagus in the Tomb of Tutankhamun* (Oxford, 1993)

Eaton-Krauss, M. & Graefe, E., *The Small Golden Shrine from the Tomb of Tutankhamun* (Oxford, 1985)

Edwards, I. E. S., *Treasures of Tutankhamun* (exhibition catalogue: London, 1972 & New York, 1976)

Edwards, I. E. S., *Tutankhamun: His Tomb and Its Treasures* (New York, 1976)

Edwards, I. E. S., *Tutankhamun's Jewelry* (New York, 1976)

El-Khouli, A. & others, *Stone Vessels, Pottery and Sealings from the Tomb of Tutankhamun* (Oxford, 1993)

Fazzini, R., *Tutankhamun and the African Heritage: A View of Society in the Time of the Boy King* (New York, 1978)

Fox, P., *Tutankhamun's Treasure* (London, 1951)

Freed, R., Markowitz, Y., & D'Auria, S., *Pharaohs of the Sun* (Boston & London, 1991)

Hawass, Z., *Secrets from the Sand, My Search for Egypt's Past* (New York, London, & Cairo, 2003)

Hawass, Z., *The Hidden Treasures of the Egyptian Museum* (Cairo, 2003)

Hawass, Z., *Hidden Treasures of Ancient Egypt* (Washington, D. C., 2004)

Hawass, Z., *Tutankhamun and the Golden Age of the Pharaohs* (Washington, D. C., 2005)

Hawass, Z., *The Royal Tombs of Egypt: The Art of Thebes Revealed* (London & New York, 2006)

Hepper, F. N., *Pharaoh's Flowers: Plants of Tutankhamun's Tomb* (London, 1990)

Hope, C., *Gold of the Pharaohs* (exhibition catalogue: Sydney, 1988)

Hoving, T., *Tutankhamun: The Untold Story* (New York, 1978)

Ikram, S. & Dodson, A., *The Mummy in Ancient Egypt: Equipping the Dead for Eternity* (London & New York, 1998)

James, T. G. H., *Howard Carter: The Path to Tutankhamun* (London, 1992)

James, T. G. H., *Tutankhamun: The Eternal Splendour of the Boy Pharaoh* (London & New York, 2000)

Jones, D., *Model Boats from the Tomb of Tutankhamun* (Oxford, 1990)

Kemp, B., *Ancient Egypt: Anatomy of a Civilization* (London & New York, 3rd ed. 2018)

Kemp, B., *The City of Akhenaten and Nefertiti: Amarna and its People* (London & New York, 2013)

Leek, F. F., *The Human Remains from the Tomb of Tutankhamun* (Oxford, 1977)

Littauer, M. A. & Crowel, J. H., *Chariots and Related Equipment from the Tomb of Tutankhamun* (Oxford, 1985)

McLeod, W., *Composite Bows from the Tomb of Tutankhamun* (Oxford, 1970)

McLeod, W., *Self Bows and Other Archery Tackle from the Tomb of Tutankhamun* (Oxford, 1982)

Manniche, L., *Musical Instruments from the Tomb of Tutankhamun* (Oxford, 1976)

Murray, H. & Nuttall, M, *A Handlist to Howard Carter's Catalogue of Objects in Tutankhamun's Tomb* (Oxford, 1963)

Perepelkin, G., *The Secret of the Gold Coffin* (Moscow, 1978)

Piankoff, A., *The Shrines of Tut-Ankh-Amon* (New York, 1955)

Redford, D. B., *History and Chronology of the Eighteenth Dynasty of Egypt: Seven Studies* (Toronto, 1967)

Redford, D. B., *Akhenaten: the Heretic King* (Princeton, 1984)

Redford, D. B. (ed.), *The Oxford Encyclopedia of Ancient Egypt*, 3 vols. (New York, 2001)

Reeves, N., *The Complete Tutankhamun* (London & New York, 1990)

Reeves, N., *The Valley of the Kings. The Decline of a Royal Necropolis* (London & New York, 1990)

Reeves, N., *Akhenaten, Egypt's False Prophet* (London & New York, 2005)

Reeves, N. & Taylor, J. H., *Howard Carter before Tutankhamun* (London & New York, 1992)

Reeves, N. & Wilkinson, R. H., *The Complete Valley of the Kings* (London & New York, 1996)

Romer, J., *Valley of the Kings* (London & New York, 1981)

Saleh, M. & Sourouzian, H., *The Egyptian Museum, Cairo: Official Catalogue* (Mainz, 1987)

Schaden, O. J., *The God's Father Ay* (University Microfilms, 1978)

Silverman, D. P., *Masterpieces of Tutankhamun* (New York, 1978)

Smith, G. E., *Tutankhamen and the Discovery of his tomb by the late Earl of Carnarvon and Mr Howard Carter* (London, 1923)

Tait, W. J., *Game-boxes and Accessories from the Tomb of Tutankhamun* (Oxford, 1982)

Tiradritti, F., *The Cairo Museum. Masterpieces of Egyptian Art* (London & New York, 1999)

Wilkinson, A., *Ancient Egyptian Jewellery* (London, 1971)

Winlock, H. E., *Materials Used at the Embalming of King Tût-'ankh-Amun* (New York, 1941)

Winstone, H. V. F., *Howard Carter and the Discovery of the Tomb of Tutankhamun* (London, 1991)

Sources of quotations: quotations by Howard Carter are from his excavation diaries, which can be found online on the website of the Griffith Institute: griffith.ox.ac.uk/discoveringTut under the section 'Tutankhamun: Anatomy of an Excavation' along with definitive information and records about the tomb and its discovery.

ILLUSTRATION CREDITS

All photographs are by Sandro Vannini except for the following:
pp. 8, 14, 22, 72, 156, 258 Copyright: Griffith Institute, University of Oxford
p. 12 John Carter Collection
p. 286 Brando Quilici
pp. 288–89 Daniele Vita

Line drawings pp. 15, 23, 73, 157, 259 Drazen Tomic, after the Theban Mapping Project: www.thebanmappingproject.com/

Acknowledgments
The work of taking the photographs for this book in the museum in Cairo took around a year, and many people were involved. First, I would like to thank Dr.Wafaa el Saddik, Director of the Egyptian Museum in Cairo, who was a wonderful host for my team and myself, and also her staff: Mona Abdelnazir Sayed, Fatmaelzahraa Ahmed Ragie and Albert Girgis Ghaly, who helped me with all the bureaucratic requirements. I would next like to acknowledge Mrs. Hala Hassan Abdelhamid, Chief of Section No. 1, and Mr. Mokhtar Abdou Abdelraziek, first curator in the same section, for their

patience over the many long hours the work took. Similarly, I would like acknowledge Ahmed Mousa Ibrahim, Islam Hamdy Abdelhamid, Mohamed Abdelkhalek Ahmed, and Moustafa Bakr Mohamed, all responsible for security.

A work such as this is a team effort, impossible to realize without the people who work in my offices in both Cairo and Italy: my assistants Daniele Vita and Mohamed Yehie, as well as the staff in Cairo Museum, Ramadan Elsayed Abdelmotelb, Ramadan Hamed Khalaf, Abdallah Hassan Helmy and Mounir Lotfy Abdalliem. In my office in Viterbo, where all the digital was

completed, I would like to acknowledge Eraldo Gabrielli, the oldest (in terms of time – we have worked together for a very long time!) of my assistants, and Massimo Luciani, responsible for the digital elaboration of all the images, as well as Lello Piazza, the photo editor.

And last but not least, my wife Maria Rita Goletti, the main coordinator of all our work.

Sandro Vannini

INDEX